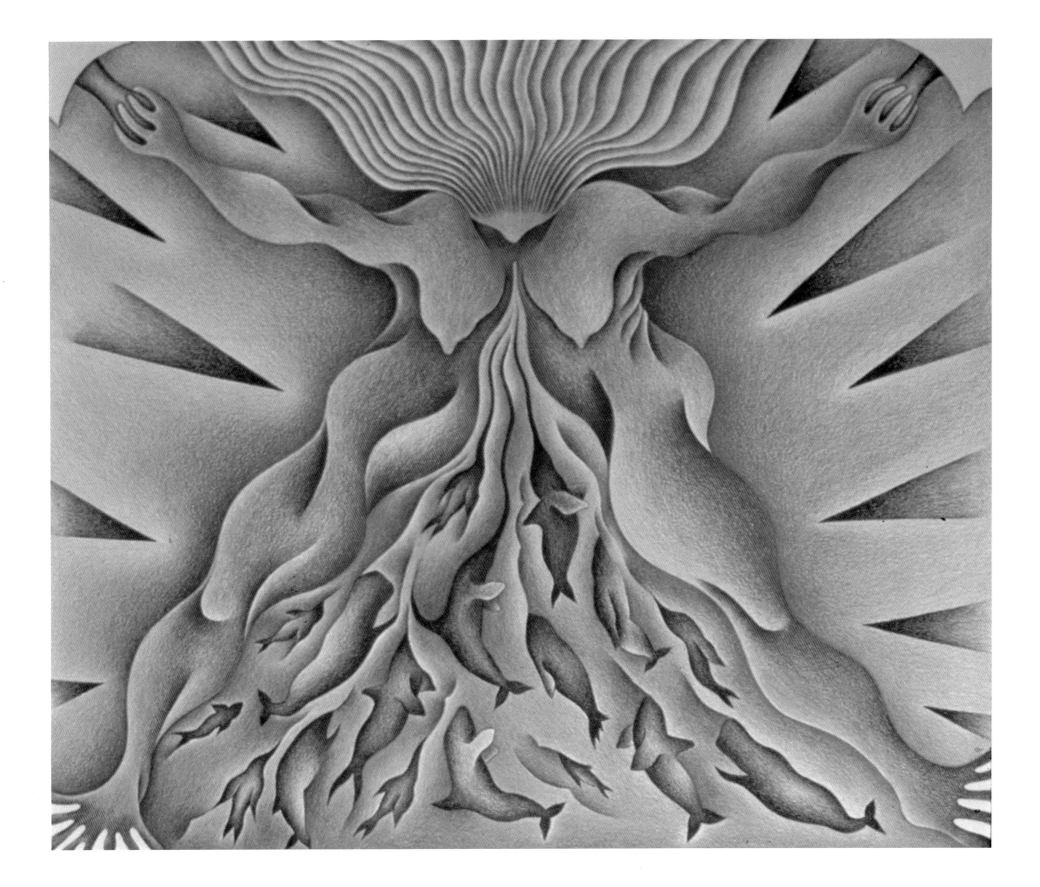

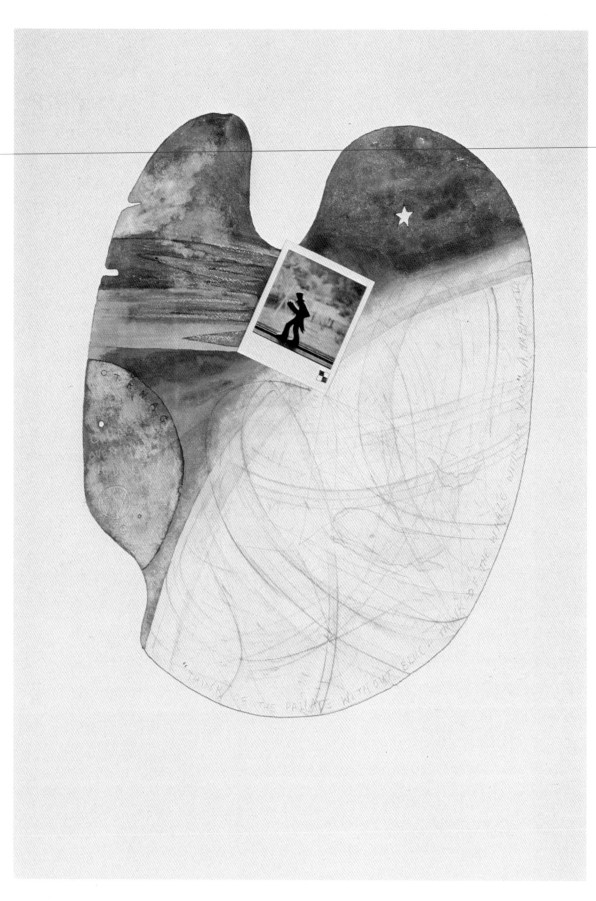

WILLIAM WILEY
"For The Whale" 1980
watercolour, coloured pencil, photo
collage, 75 x 56 cm

preceding page
JUDY CHICAGO
"The Rainbow Warrior who
descends to intercede on behalf of the
whales and the birds and all living
creatures" 1980
Prismacolor on rag paper,
57.5 x 72.5 cm

WHALES: A CELEBRATION

W·H·A·L·E·S
A Celebration

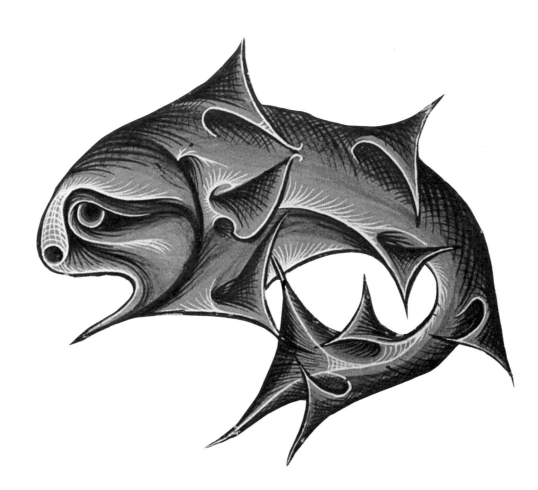

EDITED BY GREG GATENBY

LITTLE, BROWN AND COMPANY BOSTON TORONTO

Printed in Canada and bound in the U.S.A. for

Little, Brown and Company

preceding page
Detail from 12th c. English bestiary;
see p. 127

This book is dedicated to those who shared the labour, and believed in the need,

and to M.T. and N.H. who have been the best of friends.

Acknowledgements

A book as detailed as this one comes to fruition only with the immense help of many generous people. Foremost among these is my agent, Lucinda Vardey, whose loyalty and tenacity have been essential and, personally, deeply moving. My Canadian publishers, Louise Dennys and Malcolm Lester, and Wally Matheson, through their courage and belief in the volume, have ensured that *Whales* originated as a proudly Canadian project. The designers, Helen Mah and Bill Ross, have performed feats far above and beyond the call of duty, and for their sensitivity to the nuances of the artistic goals of the book I will always be very grateful. Traditionally, editors working for publishing houses are reluctant to be acknowledged, but the assistance tendered by Alberto Manguel to bring the book home merits a substantial accolade. Thanks, too, to Janice Whitford, who was there with her support when the book needed it most.

To the Explorations Programme of the Canada Council, I am grateful for a grant which enabled me to do some research essential to the project. The editors who recommended me for Ontario Arts Council grants also deserve gratitude for their help; the funds provided by the Ontario Arts Council gave me research time as well. And I will never cease to be amazed at the generosity of time and spirit shown by the wonderful employees of museums and art galleries, who bore my elementary questions and requests for photos with aplomb, and responded with exemplary haste. *Festina lente!*

Many thanks also to Graphic Litho-Plate for their co-operation and understanding, and to Norgraphics for their patience, their advice, and their excellent printing.

Each of the following deserves to be singled out for help extended during the six years this book has taken to compile. I thank them all:

Anita Aarons, Robert Aitken, Clive Allan, Nancy Bird, David Brooks, Judy Brown, Michael Butler, Claudine Carpenter, Leo Castelli, Paula Chabanais, Charles Chadwick, Pamela Clunies-Ross, John Robert Colombo, Glen Cumming, Carol Ann Davidson, Mirta de Cohen, Joost de Wit, Gabriel Del Re, Rolf Denker, Christie Edwards, Olwen Ellis, Elve Foote, Barb Forrest, Northrop Frye, Marg Gatenby, Roy Gatenby, Marty Gervais, Mark Gomes, Branko Gorjup, Nancy Hawkins, Otmar Hegyi, Karen Hendrick, Ihor Holubizky, Alan Hoover, Av Isaacs, Hans Jewinski, Patricia Jewinski, Ivan Karp, Milton T. Kelly, Lynn King, James Kirkup, Brigitte Kleer, Anton Kuerti, Jocelyn Laurence, Liz Lochhead, Gwen MacEwen, Corona Machemer, Catherine MacLeod, Scott McIntyre, Kenneth McRobbie, David McTaggart, John Miller, Aaron Milrad, Patrick Moore, Gael Moreau, Daniel David Moses, Emmanuel Mouroulis, Henry Mutsaers, Roald Naasgard, Stanislao Nievo, Debra Ratner, Marja-Leena Rautalin, Lisa Sabetti, Mary Sabetti, Tom Sandler, Rosario Santos, Susan Schelle, Jack Shoemaker, Richard Sinclair, Josef Skvorecky, Robert Stanley, Stefani Suszko, Kent Thompson, Ann Tindal, Tanya Vajk, Francesca Valente, Luisa Valenzuela, Edwina Vardey, Etienne Wermester, Karen Wilkin, Jim Wright, Sophia Yurkevich.

Contents

xii

Introduction

My intention in compiling this unique anthology has been to create not only a work of fine art, writing, and music, but one which states with a single voice that the world wants an end to the commercial killing of whales. Never before has one volume gathered together so many renowned contemporary novelists, poets, painters, sculptors, and composers, all addressing themselves, in their different media and styles, to a single social issue. It is the unanimity of their response which is the theme of this book, linking together, as it does, the many people and countries that are represented.

But man's concern and affection for whales and dolphins – or cetaceans, as they are more correctly called – is by no means a recent phenomenon engendered by the news media. Throughout our history the whale and the dolphin have been metaphorically close to humankind; they evoke images of majesty and playfulness, vast strength and gentleness, intelligence and mystery – ideas which have always been important and intriguing to artists, ideas which artists have often sought to articulate in their various styles. *Whales: A Celebration* documents, selectively but definitively, this fascination which is as old as art itself.

Today, though, our sympathy with cetaceans has a new and alarming urgency. Whales and dolphins are being slaughtered around the world, with increasingly brutal efficiency, and are in grave danger of extinction. The thought that these wonderful creatures may be destroyed for ever is terrible in itself; it is also a foreboding of man's inability to control his greed and selfishness. And so the major purpose of *Whales: A Celebration* is to gain support, both financial and moral, for the cause of the cetaceans: to demonstrate the strong international objection to their destruction and raise funds for the Greenpeace Foundation's "Save the Whales Campaign".

How does one begin to collect material for an anthology which covers so many lands and ages? I began by approaching the world's leading contemporary artists, visual, musical, and literary. The response was outstanding.

Over two hundred came forward to donate their work – in most cases offering pieces created especially for this volume – and waiving all the usual fees so that the book's royalties might assist the "Save the Whales Campaign" One could hardly ask for a more impressive testimony of the respect today's artists have for the whale and the dolphin, both as animals and as symbols.

I then set about making the selection of historical material – man's visual and literary depictions of the cetaceans from the paleolithic to the present. The choice was made with the very generous support of recognized scholars in the appropriate fields, but I hasten to say that any errors of fact or balance are strictly my own.

The abundance of certain images and stories deserves a word of explanation. The dolphin-rider is an archetype common to all cultures related to the sea: in European art, the rider is a boy, sometimes representing Eros, the god of love. In the opening chapter I have included different versions of several dolphin-rider stories, not only because of their literary charm, but because it is interesting to follow the evolution of a legend through its various retellings up to its use in the writings of our time; Plutarch and Aelian are the two most influential sources from antiquity, and so I have included a number of their stories. Their influence can be seen in the work of contemporary writers such as Roy Fuller and George Woodcock, whose poems are also included in our first chapter.

To the ancient Greeks the dolphin was not only a well-loved animal but also a god-like creature: Apollo, in the shape of a dolphin, founded the Delphic oracle, and Aphrodite (or Venus) chose the dolphin as her playmate and symbol. The Greek words for "Delphi" and for "dolphin" both evolve from the word "womb" – perhaps one reason for the dolphin's association with Eros and Aphrodite. The whale, on the other hand, was a creature rarely seen by the artists of antiquity. They depended on descriptions supplied by sailors and travellers returning from uncharted seas, and their

depictions are often fantastic – more like sea-monsters than whales. I have however included those clearly inspired by whales (fishes, for example, with the characteristic double spout, or blowhole, on top of the head). The fish-like attributes sometimes applied to whales in these paintings also stem from the belief, sadly prevalent even today, that whales are fish. To add to the confusion, Hebrew scribes lacked a word for whale, and therefore described the swallower of Jonah as a "great fish". The story of Jonah and the whale is one of the most popular of all the Old Testament tales, and has been depicted over 1,500 times, making it one of the most common subjects in Western religious painting.

With the contemporary work, of course, there are no such perplexing questions of identification. The range and breadth of submitted material is astounding. Perhaps one of the reasons for this overwhelming response is that the goal of the "Save the Whales Campaign" is within sight; and the royalties from the book will help Greenpeace continue its struggle against the slaughter of the whales.

Whales: A Celebration has been, for me, a labour of love involving daily work for six years. During that time the contributors, with daunting faith, have responded immediately to my invitation – stopping whatever they might be doing, taking the time and trouble, even when personal problems intervened, to donate something special for this volume. We invite the reader to share in this unique work, in the mysterious rapport which exists between cetaceans and humankind, to help preserve from extinction some of the most magnificent creatures on this planet – to take part in this celebration.

GREG GATENBY
Toronto, 1983

Genius in the Sperm Whale? Has the Sperm
Whale ever written a book, spoken a speech?
No, his great genius is declared in doing nothing
particular to prove it. It is moreover declared in
his pyramidical silence. And this reminds me
that had the great Sperm Whale been known
to the young Orient World, he would have been
deified by their child-magician thoughts....
If hereafter any highly cultured, poetical nation
shall lure back to their birthright, the merry
May-day gods of old; and livingly enthrone
them again in the now egotistical sky; in the
now unhaunted hill; then be sure, exalted to
Jove's high seat, the great Sperm Whale shall
lord it....

HERMAN MELVILLE, *Moby Dick*

Diviner than the Dolphin is nothing yet created

OPPIAN, *Halieutica*

DAVID BLACKWOOD
''Fire down on the Labrador'' 1980
etching, 81 x 50.5 cm
Courtesy of Gallery Pascal

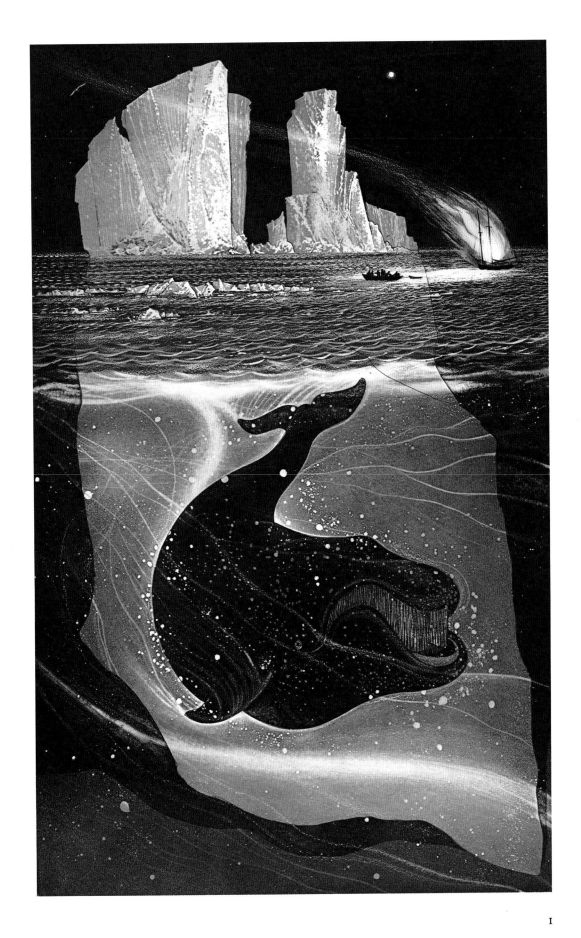

from *The Dinner of the Seven Wise Men*

"...I remember also hearing from some men of Lesbos that the rescue of a certain maiden from the sea was effected by a dolphin, but, as I am not sure of the various details, it is only right that Pittacus, who does know them, should relate the tale."

Pittacus thereupon said that it was a famous story, and one mentioned by many, to this effect. An oracle had been given to those who were setting out to found a colony in Lesbos that when their voyage should bring them to a reef which is called "Midland," then they should cast into the sea at that place a bull as an offering to Poseidon, and to Amphitrite and the Nymphs of the sea a living virgin. The commanders were seven in number, all kings, and the eighth was Echelaüs, designated by the oracle at Delphi to head the colony, although he was young and still unmarried. The seven, or as many as had unmarried daughters, cast lots, and the lot fell upon the daughter of Smintheus. Her they adorned with fine raiment and golden ornaments as they arrived opposite the spot, and purposed, as soon as they had offered prayer, to cast her into the sea. It happened that one of the company on board, a young man of no mean origin as it seems, was in love with her. His name, according to a tradition still preserved, was Enalus. He, conceiving a despairing desire to help the maiden in her present misfortune, at the critical moment hurriedly clasped her in his arms, and threw himself with her into the sea. Straightway a rumour spread, having no sure foundation, but nevertheless carrying conviction to many in the community, regarding their safety and rescue. Later, as they say, Enalus appeared in Lesbos, and told how they had been borne by dolphins through the sea, and put ashore unharmed on the mainland.

Translated from the Greek by F. C. Babbitt

"Jonah and the Whale" illumination, regarded as the finest in "The World History of Rashid al-Din", 1306 A.D., one of the greatest examples of Islamic book art. Courtesy of the University Library, University of Edinburgh

from *Genesis*

AND GOD SAID, Let the waters bring forth abundantly the moving creature that hath life, and fowl that may fly above the earth in the open firmament of heaven.

And God created great whales, and every living creature that moveth, which the waters brought forth abundantly, after their kind...and God saw that it was good.

bottom
"Jonah and the Whale" fresco in the Catacomb of Saints Peter and Marcellinus, Rome; late 3rd c. A.D. The Jonah story is among the most popular in early Christian art; legends of divine salvation were used to reinforce the faith of persecuted believers. Photo: Scala: Editorial Photocolor Archive

Jonah

CHAPTER I

Now the word of the LORD came unto Jonah the son of Ă-mĭt′-tâi, saying, Arise, go to Nin′-ĕ-vēh, that great city, and cry against it; for their wickedness is come up before me.

But Jonah rose up to flee unto Tarshish from the presence of the LORD, and went down to Joppa; and he found a ship going to Tarshish: so he paid the fare thereof, and went down into it, to go with them unto Tarshish from the presence of the LORD.

But the LORD sent out a great wind into the sea, and there was a mighty tempest in the sea, so that the ship was like to be broken.

Then the mariners were afraid, and cried every man unto his god, and cast forth the wares that were in the ship into the sea, to lighten it of them. But Jonah was gone down into the sides of the ship; and he lay, and was fast asleep.

So the shipmaster came to him, and said unto him, What meanest thou, O sleeper? arise, call

upon thy God, if so be that God will think upon us, that we perish not.

And they said every one to his fellow, Come, and let us cast lots, that we may know for whose cause this evil is upon us. So they cast lots, and the lot fell upon Jonah.

Then said they unto him, Tell us, we pray thee, for whose cause this evil is upon us; What is thine occupation? and whence comest thou? what is thy country? and of what people art thou?

And he said unto them, I am an Hebrew; and I fear the LORD, the God of heaven, which hath made the sea and the dry land.

Then were the men exceedingly afraid, and said unto him, Why hast thou done this? For the men knew that he fled from the presence of the LORD, because he had told them.

Then said they unto him, What shall we do unto thee, that the sea may be calm unto us? for the sea wrought, and was tempestuous.

And he said unto them, Take me up, and cast me forth into the sea; so shall the sea be calm unto you: for I know that for my sake this great tempest is upon you.

Nevertheless the men rowed hard to bring it to the land; but they could not: for the sea wrought, and was tempestuous against them.

Wherefore they cried unto the LORD, and said, We beseech thee, O LORD, we beseech thee, let us not perish for this man's life, and lay not upon us innocent blood: for thou, O LORD, hast done as it pleased thee.

So they took up Jonah, and cast him forth into the sea: and the sea ceased from her raging.

Then the men feared the LORD exceedingly, and offered a sacrifice unto the LORD, and made vows.

Now the LORD had prepared a great fish to swallow up Jonah. And Jonah was in the belly of the fish three days and three nights.

CHAPTER 2

Then Jonah prayed unto the LORD his God out of the fish's belly,
And said, I cried by reason of mine affliction unto the LORD, and he heard me; out of the

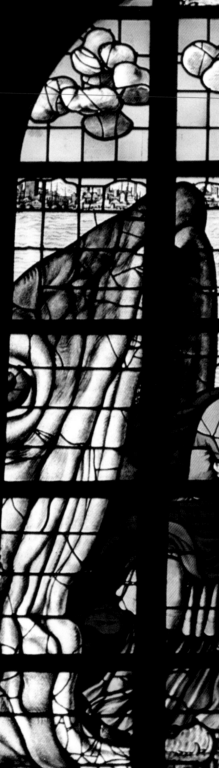

belly of hell cried I, and thou heardest my voice.

For thou hadst cast me into the deep, in the midst of the seas; and the floods compassed me about: all thy billows and thy waves passed over me.

Then I said, I am cast out of thy sight; yet I will look again toward thy holy temple.

The waters compassed me about, even to the soul: the depth closed me round about, the weeds were wrapped about my head.

I went down to the bottoms of the mountains; the earth with her bars was about me for ever: yet hast thou brought up my life from corruption, O LORD my God.

When my soul fainted within me I remembered the LORD: and my prayer came in unto thee, into thine holy temple.

They that observe lying vanities forsake their own mercy.

But I will sacrifice unto thee with the voice of thanksgiving; I will pay that that I have vowed. Salvation is of the LORD.

And the LORD spake unto the fish, and it vomited out Jonah upon the dry land.

CHAPTER 3

And the word of the LORD came unto Jonah the second time, saying,

Arise, go unto Nin'-ĕ-vēh, that great city, and preach unto it the preaching that I bid thee.

So Jonah arose, and went unto Nin'-ĕ-vēh, according to the word of the LORD. Now Nin'-ĕ-vēh was an exceeding great city of three days' journey.

And Jonah began to enter into the city a day's journey, and he cried, and said, Yet forty days, and Nin'-ĕ-veh shall be overthrown.

So the people of Nin'-ĕ-vēh believed God, and proclaimed a fast, and put on sackcloth, from the greatest of them even to the least of them.

For word came unto the king of Nin'-ĕ-vēh, and he arose from his throne, and he laid his robe from him, and covered him with sackcloth, and sat in ashes.

And he caused it to be proclaimed and published through Nin'-ĕ-vēh by the decree of the king and his nobles, saying, Let neither man nor beast, herd nor flock, taste any thing: let them not feed, nor drink water:

But let man and beast be covered with sackcloth, and cry mightily unto God: yea, let them turn every one from his evil way, and from the violence that is in their hands.

Who can tell if God will turn and repent, and turn away from his fierce anger, that we perish not?

And God saw their works, that they turned from their evil way; and God repented of the evil, that he had said that he would do unto them; and he did it not.

CHAPTER 4

But it displeased Jonah exceedingly, and he was very angry.

And he prayed unto the LORD, and said, I pray thee, O LORD, was not this my saying, when I

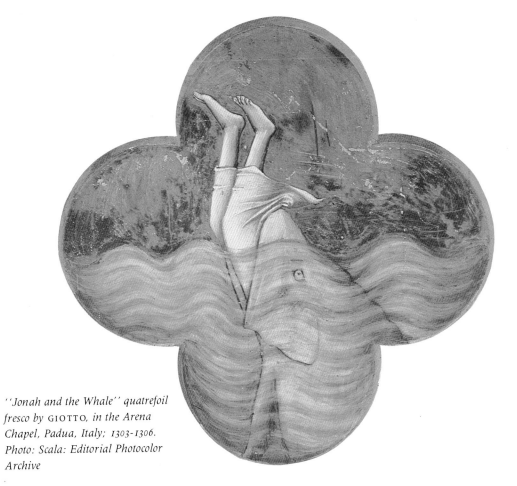

5

The Whale

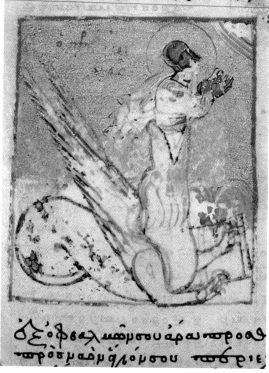

was yet in my country? Therefore I fled before unto Tarshish: for I knew that thou art a gracious God, and merciful, slow to anger, and of great kindness, and repentest thee of the evil.

Therefore now, O LORD, take, I beseech thee, my life from me; for it is better for me to die than to live.

Then said the LORD, Doest thou well to be angry?

So Jonah went out of the city, and sat on the east side of the city, and there made him a booth, and sat under it in the shadow, till he might see what would become of the city.

And the LORD God prepared a gourd, and made it to come up over Jonah, that it might be a shadow over his head, to deliver him from his grief. So Jonah was exceeding glad of the gourd.

But God prepared a worm when the morning rose the next day, and it smote the gourd that it withered.

And it came to pass, when the sun did arise, that God prepared a vehement east wind; and the sun beat upon the head of Jonah, that he fainted, and wished in himself to die, and said, It is better for me to die than to live.

And God said to Jonah, Doest thou well to be angry for the gourd? And he said, I do well to be angry, even unto death.

Then said the LORD, Thou hast had pity on the gourd, for which thou hast not laboured, neither madest it grow; which came up in a night, and perished in a night:

And should not I spare Nin'-ĕ-veh, that great city, wherein are more than sixscore thousand persons that cannot discern between their right hand and their left hand; and also much cattle?

"Jonah and the Whale" illumination from an 11th c. Greek manuscript (Plut. 6.36, fol. 353v). The coiling torso of the animal is less rococo than its Hellenistic model, and shows an evolution towards the whale of the Renaissance. Courtesy of the Biblioteca Medicea Laurenziana, Florence

"Jonah Cast Up by the Whale", marble sculpture, Eastern Mediterranean (probably Asia Minor); ca 270 A.D. Early Christian depictions of Jonah in the round are extremely rare. Courtesy of the Cleveland Museum of Art, John L. Severance Fund

Think nothing of the whale: you may be sure
He thinks nothing of you, and since the grand cetacean
"Conversing chiefly in the northern seas"
Makes no mention of you in his conversation

Except for an expletive when you come near him
– An expletive which is not hard to explain
In view of the charming way in which you accost him –
Why should you exercise your brains about him?

After all, he has the more sizable body
And who are you to threaten his majority
By exhibiting more brains than he has himself?
It is against the supremacy of his thoughtlessness.

Jonah went into the belly of the whale
And prayed when he got there. Is it a mark of enlightenment,
Perhaps, to swallow the whale and assert
That empty seas are an improvement on creation?

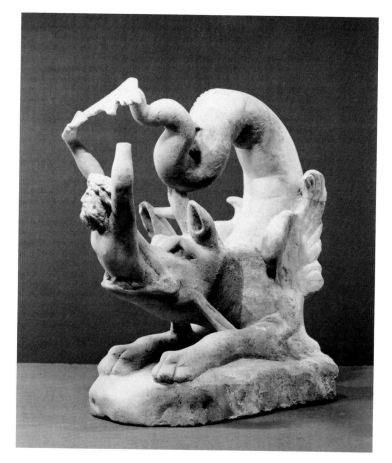

ROCHELLE OWENS

Judgment

After the flood I was saved
I gave to Jonah a glimpse of eternal
Darkness
The seas boiled when I ejaculated
My sperm and when I brought forth
My young whales

Violent heart is against me
Poisonous menace is breath
Of the two-legged beast
Jealous to the ends of the earth
The two-legged beast that kills
Jealous to the ends of the seas.

I was a king and a queen
I was the magnitude of divine strength
I who amazed Jonah in the center
Of my body which is world.

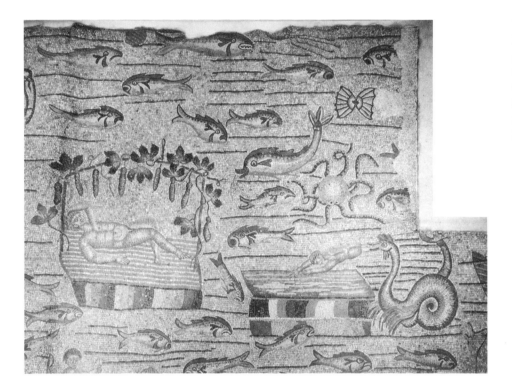

''Jonah and the Whale'' floor mosaic,
South Basilica, Aquileia, Italy;
310-320 A.D. The depiction of the
whale here is completely dependent
on Hellenistic models of sea-monsters.
Probably the earliest mosaic with an
overtly religious subject. Photo: Scala:
Editorial Photocolor Archive

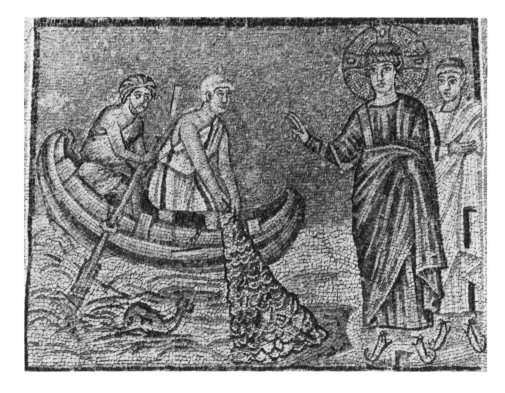

''Miraculous Draught of Fishes''
mosaic, S. Apollinaire Nuovo,
Ravenna, Italy; ca 500 A.D. One of
the clearest examples in antique art
of the belief that dolphins were fish.
Photo: Alinari: Editorial Photocolor
Archive

ANONYMOUS

from Patience

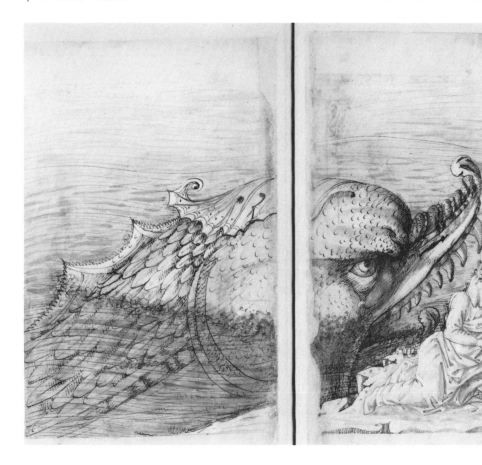

Now is Jonah the Jew judged to be drowned,
For sharply men had shoved him from the ship in distress.
But a wild rolling whale, by warrant of Fate
Beaten up from the abyss, by the boat was floating,

And sensing that sea-goer in search of the depths,
Swiftly glided with gaping gorge to gobble him up.
His feet they still held fast when the fish so seized him,
And without touching a tooth, he tumbled down its throat.

The sea-monster swung away and swept to the bottom
By the sifting surge-floor where stark rocks reared,
With the man in his maw, amazed in dread —
Little wonder it was that woe tortured him!

For had not the mighty hand of high heaven's King
Guarded this guilty one in the guts of hell,
What belief could one allow, by any law of nature,
In a lease of life so long inside there?

By the Lord on throne aloft his life was saved,
Though forlorn of fortune in the fish's belly,
And driven through the deep, darkly wallowing.
Lord, cold was his comfort and cruel his care!

For each part of his plight was plainly apparent —
From craft to quivering sea, then caught by a monster
And thrown down its throat as a thing no more compressed
Than mote entering minster door, so mighty its gullet!

He glided in near the gills, through greasy slime,
Whirled along the weasand as wide as a road,
Ever head over heels hurrying along the gut
Till he staggered into a space like an extensive hall.

There he found his feet and fumbled about,
Standing up in the stomach, which stank like the devil.
In the grease and the grime there, as ghastly as hell,
His sojourn was set, safe from harm.

Furtively he felt about to find the best place
In every nook by the navel, but nowhere found
Any rest or remedy: reeking ooze
Gurgled in every gut: yet God is sweet.

8

Walk Inside a Whale

There to calmness he came at last, and called to the Lord,
'Now Prince, take pity upon your prophet!
Though I am foolish and fickle, and false in my heart,
Make void your vengeance by virtue of your mercy!

'Though I sinned in deceit, the scum of all prophets,
You are God, and garner all good to yourself:
Have mercy on your man and his misdemeanours,
And assert yourself Sovereign of sea and land!'

With that he climbed to a corner and kept still there,
Where no filth or defilement could flow about him,
And sat as safe and sound, except for the gloom,
As in the bowels of the boat, where he had been asleep before.

So in the belly of the beast he breathed in safety
Three days and three nights, ever thinking of the Lord,
His might and his mercy, and his moderation also.
He, estranged from God when safe, in his suffering now knew
 him.

In the welter of the deep wastes the whale ever rolled
Through raging ocean regions, rank in his will,
For that mote in his maw, small though it was,
Made his heart heave, for all his hugeness.

Sailing on the surge in safety, Jonah heard
The mighty billows beating on the beast's back and sides,
And the prophet proffered a prayer forthwith,
Phrased as follows: profuse were his words:

'Lord, in my calamity I lifted my voice
From hell's womb-hole here, and you heard my utterance.
I called, and you caught my obscure cry,
Conducting me from the depths to the dark heart.

'The fierce flow of your flood folded me round;
The flux of your foaming gulfs and fathomless deeps
And the clashing currents from countless channels
In one weltering wave washed me about.

'Yet still I can say, sitting near the sea-bed,
''In my affliction I am flung from before your bright eyes,
Sundered from sight of you; but certain is my hope
Of treading your temple again, attaching my faith to you.''

'I am steeped in the surge till my sufferings stupefy me;
My body is bound by the abyss about me;
The swirling of pure water whirls about my head;
Past the limits of the last mountain I lie fallen.

'The ramparts of every ridge rigorously restrain me,
So that land is lost to reach, and my life is in your hands.
You shall succour your servant, while sleep lulls your justice,
Through the might of your mercy, which is much to be trusted.

'For when the access of anguish was hidden in my soul,
The justice of my generous Lord jumped to my mind,
And I prayed that in pity for his prophet he would hear,
And that my orison might enter his holy house.

'I have communed with your mighty works many a long day,
But I am firm in my faith now that foolhardy people
Who vow their lives to vanities and to vain things
Amounting to mere nothing, find mercy is away.

'But devoutly I vow, and in very truth affirm it,
Solemnly to sacrifice to you when my safety is assured,
And to offer you a holy gift for my happy fortune,
And to carry out your behests: here is my promise!'

Then fiercely our Father ordered the fish
Promptly to spew him out upon dry land.
The whale turned at God's will towards the coast
And ejected Jonah there, as enjoined by the Lord.

He strode out of the sea in his soiled clothes —
Well might he demand that his mantle be washed!
The land that he looked at, lying before him,
Was precisely the same that he had forsworn earlier.

Translated from the Old English by Brian Stone

Through the great gates
of teeth
high as signposts
indicating nothing
I walked alone
in all innocence
into the rough
cavern of the throat
a rosy tunnel
and then
into the bright
belly of ambergris
that precious
scented sickness
where in a swift
revulsive movement
an indisposition I
was vomited out
I was spewed out
O the relief
upon a northern shore
a Baltic beach —

Now I hand my
perfumed ancestry
to all and sundry
a pendant to
history volatilized
on the wrinkled flews
and the leprous armpits
of the Lady Mayoress
rigid and disapproving
in the whalebone corset
of conformity
and quiet
social assassination.

*Translated from the Japanese by
James Kirkup in collaboration with
the poet*

*left
''Jonah and the Whale'' wood
carving on a misericord,
Ripon Cathedral, England; ca 1484.
Courtesy J.C.D. Smith*

9

How the Whale got his Throat

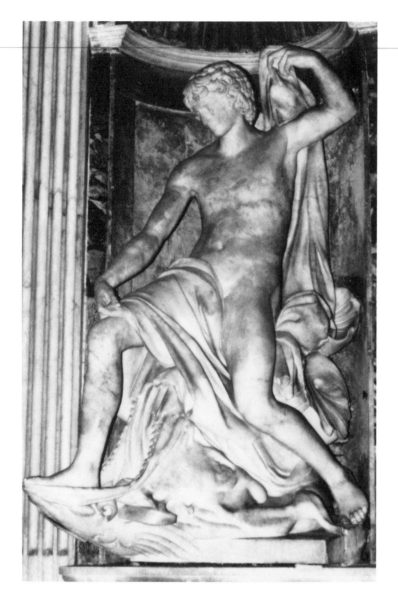

"Jonah and the Whale" marble sculpture by LORENZETTO, *Chigi Chapel, Santa Maria del Popolo, Rome; 1520*

In the sea, once upon a time, O my Best Beloved, there was a Whale, and he ate fishes. He ate the starfish and the garfish, and the crab and the dab, and the plaice and the dace, and the skate and his mate, and the mackereel and the pickereel, and the really truly twirly-whirly eel. All the fishes he could find in all the sea he ate with his mouth — so! Till at last there was only one small fish left in all the sea, and he was a small 'Stute Fish, and he swam a little behind the Whale's right ear, so as to be out of harm's way. Then the Whale stood up on his tail and said, "I'm hungry." And the small 'Stute Fish said in a small voice 'stute voice, "Noble and generous Cetacean, have you ever tasted Man?"

"No," said the Whale. "What is it like?"

"Nice," said the small 'Stute Fish. "Nice but nubbly."

"Then fetch me some," said the Whale, and he made the sea froth up with his tail.

"One at a time is enough," said the 'Stute Fish. "If you swim to latitude Fifty North, longitude Forty West (that is Magic), you will find, sitting *on* a raft, *in* the middle of the sea, with nothing on but a pair of blue canvas breeches, a pair of suspenders (you must *not* forget the suspenders, Best Beloved), and a jack-knife, one shipwrecked Mariner, who, it is only fair to tell you, is a man of infinite-resource-and-sagacity."

So the Whale swam and swam to latitude Fifty North, longitude Forty West, as fast as he could swim, and *on* a raft, *in* the middle of the sea, *with* nothing to wear except a pair of blue canvas breeches, a pair of suspenders (you must particularly remember the suspenders, Best Beloved), *and* a jack-knife, he found one single, solitary shipwrecked Mariner, trailing his toes in the water. (He had his Mummy's leave to paddle, or else he would never have done it, because he was a man of infinite-resource-and-sagacity.)

Then the Whale opened his mouth back and back and back till it nearly touched his tail, and he swallowed the shipwrecked Mariner, and the raft he was sitting on, and his blue canvas breeches, and the suspenders (which you *must* not forget), *and* the jack-knife — He swallowed them all down into his warm, dark, inside cupboards, and then he smacked his lips — so, and turned around three times on his tail.

But as soon as the Mariner, who was a man of infinite-resource-and-sagacity, found himself truly inside the Whale's warm, dark, inside cupboards, he stumped and he jumped and he thumped and he bumped, and he pranced and he danced, and he banged and he clanged, and he hit and he bit, and he leaped and he creeped, and he prowled and he howled, and he hopped and he dropped, and he cried and he sighed, and he crawled and he bawled, and he stepped and he lepped, and he danced hornpipes where he shouldn't, and the Whale felt most unhappy indeed. (*Have* you forgotten the suspenders?)

So he said to the 'Stute Fish, "This man is very nubbly, and besides he is making me hiccough. What shall I do?"

"Tell him to come out," said the 'Stute Fish.

So the Whale called down his own throat to the shipwrecked Mariner, "Come out and behave yourself. I've got the hiccoughs."

"Nay, nay!" said the Mariner. "Not so, but far otherwise. Take me to my natal-shore and the white-cliffs-of-Albion, and I'll think about it." And he began to dance more than ever.

"You had better take him home," said the 'Stute Fish to the Whale. "I ought to have warned you that he is a man of infinite-resource-and-sagacity."

So the Whale swam and swam and swam, with both flippers and his tail, as hard as he could for the hiccoughs; and at last he saw the Mariner's natal-shore and the white-cliffs-of-Albion, and he rushed half-way up the beach, and opened his mouth wide and wide and wide, and said, "Change here for Winchester, Ashuelot, Nashua, Keene, and stations on the *Fitch*burg Road"; and just as he said "Fitch" the Mariner walked out of his mouth. But while the Whale had been swimming, the Mariner, who was indeed a person of infinite-resource-and-sagacity, had taken his jack-knife and cut up the raft into a little square grating all running criss-cross, and he had tied it firm with his suspenders (*now* you know why you were not to forget the suspenders!), and he dragged that grating good and tight into the Whale's throat, and

from *The Quaker Graveyard in Nantucket*

from *The Ivory Trade*

there it stuck! Then he recited the following *Sloka*, which, as you have not heard it, I will now proceed to relate —
By means of a grating
I have stopped your ating.

For the Mariner he was also an Hi-ber-ni-an. And he stepped out on the shingle, and went home to his Mother, who had given him leave to trail his toes in the water ; and he married and lived happily ever afterward. So did the Whale. But from that day on, the grating in his throat, which he could neither cough up nor swallow down, prevented him eating anything except very, very small fish ; and that is the reason why whales nowadays never eat men or boys or little girls.

The small 'Stute Fish went and hid himself in the mud under the Door-sills of the Equator. He was afraid that the Whale might be angry with him.

The Sailor took the jack-knife home. He was wearing the blue canvas breeches when he walked out on the shingle. The suspenders were left behind, you see, to tie the grating with; and that is the end of *that* tale.

This is the end of the whaleroad and the whale
Who spewed Nantucket bones on the thrashed swell
And stirred the troubled waters to whirlpools
To send the Pequod packing off to hell:
This is the end of them, three-quarters fools,
Snatching at straws to sail
Seaward and seaward on the turntail whale,
Spouting out blood and water as it rolls,
Sick as a dog to these Atlantic shoals:
Clamavimus, O depths. Let the sea-gulls wail

For water, for the deep where the high tide
Mutters to its hurt self, mutters and ebbs.
Waves wallow in their wash, go out and out,
Leave only the death-rattle of the crabs,
The beach increasing, its enormous snout
Sucking the ocean's side.
This is the end of running on the waves;
We are poured out like water. Who will dance
The mast-lashed master of Leviathans
Up from this field of Quakers in their unstoned graves?

When the whale's viscera go and the roll
Of its corruption overruns this world
Beyond tree-swept Nantucket and Wood's Hole
And Martha's Vineyard, Sailor, will your sword
Whistle and fall and sink into the fat?
In the great ash-pit of Jehoshaphat
The bones cry for the blood of the white whale,
The fat flukes arch and whack about its ears,
The death-lance churns into the sanctuary, tears
The gun-blue swingle, heaving like a flail,
And hacks the coiling life out: it works and drags
And rips the sperm-whale's midriff into rags,
Gobbets of blubber spill to wind and weather,
Sailor, and gulls go round the stoven timbers
Where the morning stars sing out together
And thunder shakes the white surf and dismembers
The red flag hammered in the mast-head. Hide,
Our steel, Jonas Messias, in Thy side.

Amber is found in great quantities on the Zanj coast and also near Shihr in Arabia.... The best amber is that found in the islands and on the shores of the Zanj sea: it is round and pale blue, sometimes as big as an ostrich egg, sometimes slightly less. The fish called the whale, which I have already mentioned, swallows it: when the sea is very rough it vomits up pieces of amber as large as rocks, and this fish swallows them. It is asphyxiated by them and then swims up to the surface. Then the Zanj, or men from other lands, who have been biding their time in their boats, seize the fish with harpoons and tackle, cut its stomach open, and take the amber out. The pieces found near the bowels have a naus-eating smell, and are called *nedd* by the Iraqi and Persian chemists: but the pieces found near the back are purer than those which have been a long time in the inner part of the body....

Translated from the Arabic by G.S.P. Freeman-Grenville

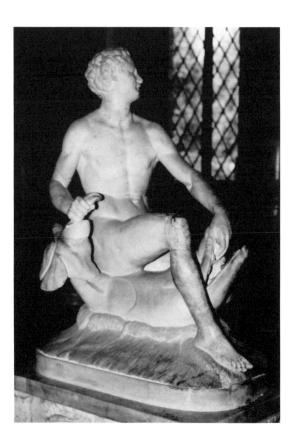

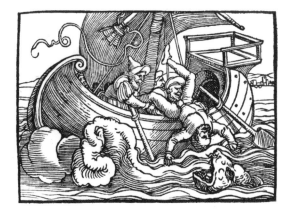

''Jonah Thrown to the Whale'',
HANS SEBALD BEHAM. *Woodcut,*
5 x 7 cm. Courtesy of
Kunstsammlungen der Veste Coburg

right
''Faun on a Dolphin'' marble statue,
probably a Roman copy of a Greek
original, Villa Borghese, Rome

from The Adventures of Pinocchio

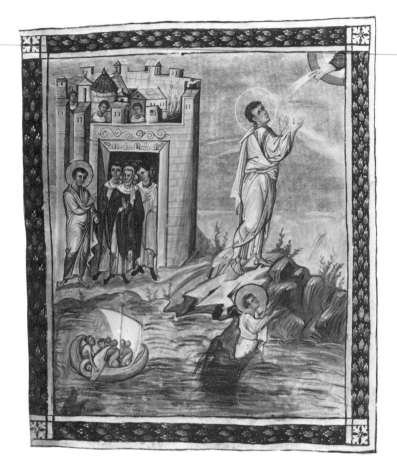

"Jonah and the Whale" illumination, Paris Psalter, middle 10th c. Codex Parisinus Graecus 139, fol. 431v. Courtesy of the Bibliothèque Nationale, Paris

In the twinkling of an eye he had swum so far off that he was scarcely visible. All that could be seen of him was a little black speck on the surface of the sea that from time to time lifted its legs out of the water and leapt and capered like a dolphin enjoying himself.

Whilst Pinocchio was swimming he knew not whither he saw in the midst of the sea a rock that seemed to be made of white marble, and on the summit there stood a beautiful little goat who bleated lovingly and made signs to him to approach.

But the most singular thing was this. The little goat's hair, instead of being white or black, or a mixture of two colours as is usual with other goats, was blue, and of a very vivid blue, greatly resembling the hair of the beautiful Child.

I leave you to imagine how rapidly poor Pinocchio's heart began to beat. He swam with redoubled strength and energy towards the white rock; and he was already half-way when he saw, rising up out of the water and coming to meet him, the horrible head of a sea-monster. His wide-open cavernous mouth and his three rows of enormous teeth would have been terrifying to look at even in a picture.

And do you know what this sea-monster was?

This sea-monster was neither more nor less than that gigantic Dog-fish who has been mentioned many times in this story, and who, for his slaughter and for his insatiable voracity, had been named the "Attila of fish and fishermen."

Only think of poor Pinocchio's terror at the sight of the monster. He tried to avoid it, to change his direction; he tried to escape; but that immense wide-open mouth came towards him with the velocity of an arrow.

"Be quick, Pinocchio, for pity's sake," cried the beautiful little goat, bleating.

And Pinocchio swam desperately with his arms, his chest, his legs, and his feet.

"Quick, Pinocchio, the monster is close upon you! . . ."

And Pinocchio swam quicker than ever, and flew on with the rapidity of a ball from a gun. He had nearly reached the rock, and the little goat, leaning over towards the sea, had stretched out her fore-legs to help him out of the water! . . .

But it was too late! The monster had overtaken him, and, drawing in his breath, he sucked in the poor puppet as he would have sucked a hen's egg; and he swallowed him with such violence and avidity that Pinocchio, in falling into the Dog-fish's stomach, received such a blow that he remained unconscious for a quarter of an hour afterwards.

When he came to himself again after the shock he could not in the least imagine in what world he was. All round him it was quite dark, and the darkness was so black and so profound that it seemed to him that he had fallen head downwards in to an inkstand full of ink. He listened, but he could hear no noise; only from time to time great gusts of wind blew in his face. At first he could not understand where the wind came from, but at last he discovered that it came out of the monster's lungs. For you must know that the Dog-fish suffered very much from asthma, and when he breathed it was exactly as if a north wind was blowing:

Pinocchio at first tried to keep up his courage; but when he had one proof after another that he was really shut up in the body of this seamonster he began to cry and scream and to sob out:

"Help! help! Oh, how unfortunate I am! Will nobody come to save me?"

"Who do you think could save you, unhappy wretch? . . ." said a voice in the dark that sounded like a guitar out of tune.

"Who is speaking?" asked Pinocchio, frozen with terror.

"It is I! I am a poor Tunny who was swallowed by the Dog-fish at the same time that you were. And what fish are you?"

"I have nothing in common with fish. I am a puppet."

"Then if you are not a fish, why did you let yourself be swallowed by the monster?"

"I didn't let myself be swallowed: it was the monster swallowed me! And now, what are we to do here in the dark?"

"Resign ourselves and wait until the Dog-fish has digested us both."

"But I do not want to be digested!" howled Pinocchio, beginning to cry again.

ANONYMOUS

from The Voyage of Saint Brendan

"Neither do I want to be digested," added the Tunny; "but I am enough of a philosopher to console myself by thinking that when one is born a Tunny it is more dignified to die in the water than in oil."

"That is all nonsense!" cried Pinocchio.

"It is my opinion," replied the Tunny; and opinions, so say the political Tunnies, ought to be respected.

"To sum it all up...I want to get away from here...I want to escape."

"Escape if you are able!..."

"Is this Dog-fish who has swallowed us very big?" asked the puppet.

"Big! Why, only imagine, his body is two miles long without counting his tail."

Whilst they were holding this conversation in the dark, Pinocchio thought that he saw a light a long way off.

"What is that little light I see in the distance?" he asked.

"It is most likely some companion in misfortune who is waiting like us to be digested."

"I will go and find him. Do you not think that it may by chance be some old fish who perhaps could show us how to escape?"

"I hope it may be so with all my heart, dear puppet."

"Good-bye, Tunny."

"Good-bye, puppet, and good fortune attend you."

Translated from the Italian by M.A. Murray

WHEN THEY approached the other island, the boat began to ground before they could reach its landing-place. Saint Brendan ordered the brothers to disembark from the boat into the sea, which they did. They held the boat on both sides with ropes until they came to the landing-place. The island was stony and without grass. There were a few pieces of driftwood on it, but no sand on its shore. While the brothers spent the night outside in prayers and vigils, the man of God remained sitting inside in the boat. For he knew the kind of island it was, but he did not want to tell them, lest they be terrified.

When morning came he ordered each of the priests to sing his Mass, which they did. While Saint Brendan was himself singing his Mass in the boat, the brothers began to carry the raw meat out of the boat to preserve it with salt, and also the flesh which they had brought from the other island. When they had done this they put a pot over a fire. When, however, they were plying the fire with wood and the pot began to boil, the island began to be in motion like a wave. The brothers rushed to the boat, crying out for protection to the holy father. He drew each one of them into the boat by his hand. Having left everything they had had on the island behind, they began to sail. Then the island moved out to sea. The lighted fire could be seen over two miles away. Saint Brendan told the brothers what it really was, saying:

"Brothers, are you surprised at what this island has done?"

They said:

"We are very surprised and indeed terror-stricken."

He said to them:

"My sons, do not be afraid. God revealed to me during the night in a vision the secret of this affair. Where we were was not an island, but a fish — the foremost of all that swim in the ocean. He is always trying to bring his tail to meet his head, but he cannot because of his length. His name is Jasconius."

Translated from the Latin by John O'Meara

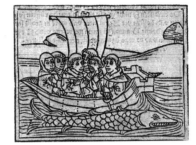

St. Brendan on the whale's back, woodcut from "Sand Brendan's Buch" (Augsburg, 1476). Courtesy of the Pierpont Morgan Library

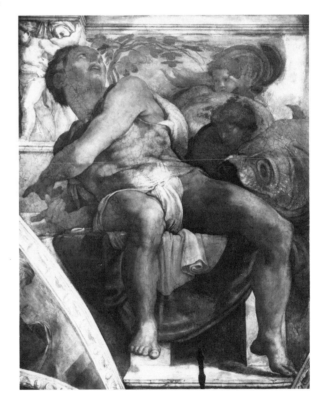

"Jonah and the Whale", MICHELANGELO, *ceiling of the Sistine Chapel, Vatican; 1508-1512 Photo: Alinari: Editorial Photocolor Archive*

left
"Jonah and the Whale" engraving, LUCA CIAMBERLANO; *Italian, early 17th c. 14 x 17 cm. Photo courtesy of the Trustees of the British Museum*

from *A True Story*

Illustration by GUSTAVE DORÉ
*from ''The Adventures of Baron
Munchausen'' (1865)*

It would seem, however, that a change for the better often proves a prelude to greater ills. We had sailed just two days in fair weather and the third day was breaking when toward sunrise we suddenly saw a number of sea-monsters, whales. One among them, the largest of all, was fully one hundred and fifty miles long. He came at us with open mouth, dashing up the sea far in advance, foam-washed, showing teeth much larger than the emblems of Dionysus in our country, and all sharp as caltrops and white as ivory. We said good-bye to one another, embraced, and waited. He was there in an instant, and with a gulp swallowed us down, ship and all. He just missed crushing us with his teeth, but the boat slipped through the gaps between them into the interior. When we were inside, it was dark at first, and we could not see anything, but afterwards, when he opened his mouth, we saw a great cavity, flat all over and high, and large enough for the housing of a great city. In it there were fish, large and small, and many other creatures all mangled, ships' rigging and anchors, human bones, and merchandise. In the middle there was land with hills on it, which to my thinking was formed of the mud that he had swallowed. Indeed, a forest of all kinds of trees had grown on it, garden stuff had come up, and everything appeared to be under cultivation. The coast of the island was twenty-seven miles long. Sea-birds were to be seen nesting on the trees, gulls and kingfishers.

At first we shed tears for a long time, and then I roused my comrades and we provided for the ship by shoring it up and for ourselves by rubbing sticks together, lighting a fire and getting dinner as best we could. We had at hand plenty of fish of all kinds, and we still had the water from the Morning Star. On rising the next day, whenever the whale opened his mouth we saw mountains one moment, nothing but sky the next, and islands frequently, and we perceived by this that he was rushing swiftly to all parts of the sea. When at length we became wonted to our abiding-place, I took seven of my comrades and went into the forest, wishing to have a look at everything. I had not yet gone quite five furlongs when I found a temple of Poseidon, as the inscription indicated, and not far from it a number of graves with stones on them. Near by was a spring of clear water. We also heard the barking of a dog, smoke appeared in the distance, and we made out something like a farmhouse, too.

Advancing eagerly, we came upon an old man and a boy very busily at work in a garden which they were irrigating with water from the spring. Joyful and fearful at the same instant, we stopped still, and they too, probably feeling the same as we, stood there without a word. In course of time the old man said: ''Who are you, strangers? Are you sea-gods, or only unlucky men like us? As for ourselves, though we are men and were bred on land, we have become sea-creatures and swim about with this beast which encompasses us, not even knowing for certain what our condition is — we suppose that we are dead, but trust that we are alive.'' To this I replied: ''We too are men, my good sir — newcomers, who were swallowed up yesterday, ship and all: and we set out just now with the notion of finding out how things were in the forest, for it appeared to be very large and thick. But some divinity, it seems, brought us to see you and to discover that we are not the only people shut up in this animal. Do tell us your adventures — who you are and how you got in here.'' But he said he would neither tell us nor question us before giving us what entertainment he could command, and he took us with him to the house. It was a commodious structure, had bunks built in it and was fully furnished in other ways. He set before us vegetables, fruit and fish and poured us out wine as well. When we had had enough, he asked us what had happened to us. I told him about everything from first to last — the storm, the island, the cruise in the air, the war and all the rest of it up to our descent into the whale.

He expressed huge wonder, and then told us his own story, saying: ''By birth, strangers, I am a Cypriote. Setting out from my native land on a trading venture with my boy whom you see and with many servants besides, I began a voyage to Italy, bringing various wares on a great ship, which you no doubt saw wrecked in the mouth of the whale. As far as Sicily we had a fortunate voyage, but there we were caught by a violent wind and driven out into the ocean for three days, where we fell in with the whale, were swallowed up crew and all, and only we two survived, the others being killed. We buried our comrades, built a temple to Poseidon and live this sort of life, raising vegetables and eating fish and nuts. As you see, the forest is extensive, and besides, it contains many grape-vines, which yield the sweetest of wine. No doubt you noticed the spring of beautiful cold water, too. We make our bed of leaves, burn all the wood we want, snare the birds that fly in, and catch fresh fish by going into the gills of the animal. We also bathe there when we care to. Another thing, there is a lake not far off, twenty furlongs in circumference, with all kinds of fish in it, where we swim and sail in a little skiff that I made. It is now twenty-seven years since we were swallowed. Everything else is perhaps endurable, but our neighbours and fellow-countrymen are extremely quarrelsome and unpleasant, being unsociable and savage.'' ''What!'' said I, ''are there other people in the whale, too?'' ''Why, yes, lots of them,'' said he; ''they are unfriendly and are oddly built. In the western part of the forest, the tail part, live the Broilers, an eel-eyed, lobster-faced people that are warlike and bold, and carnivorous. On one side, by the starboard wall, live the Mergoats, like men above and catfish

below: they are not so wicked as the others. To port there are the Crabclaws and the Codheads, who are friends and allies with each other. The interior is inhabited by Clan Crawfish and the Solefeet, good fighters and swift runners. The eastern part, that near the mouth, is mostly uninhabited, as it is subject to inundations of the sea. I live in it, however, paying the Solefeet a tribute of five hundred oysters a year. Such being the nature of the country, it is for you to see how we can fight with all these tribes and how we are to get a living." "How many are there of them in all?" said I. "More than a thousand," said he. "What sort of weapons have they?" "Nothing but fishbones," he said. "Then our best plan," said I, "would be to meet them in battle, as they are unarmed and we have arms. If we defeat them, we shall live here in peace the rest of our days."

This was resolved on, and we went to the boat and made ready. The cause of war was to be the witholding of the tribute, since the date for it had already arrived. They sent and demanded the tax, and he gave the messengers a contemptuous answer and drove them off. First the Solefeet and Clan Crawfish, incensed at Scintharus — for that was his name — came on with a great uproar. Anticipating their attack, we were waiting under arms, having previously posted in our front a squad of twenty-five men in ambush, who had been directed to fall on the enemy when they saw that they had gone by, and this they did. Falling on them in the rear, they cut them down, while we ourselves, twenty-five in number (for Scintharus and his son were in our ranks), met them face to face and, engaging them, ran our hazard with strength and spirit. Finally we routed them and pursued them clear to their dens. The slain on the side of the enemy were one hundred and seventy; on our side, one — the sailing-master, who was run through the midriff with a mullet-rib. That day and night we bivouacked on the field and made a trophy by setting up the dry spine of a dolphin. On the following day the others, who had heard of it, appeared, with the Broilers, led by Tom Cod, on the right wing, the Codheads on the left, and the Crabclaws in the centre. The Mergoats did not take the field, choosing not to ally themselves with either party. Going out to meet them, we engaged them by the temple of Poseidon with great shouting, and the hollow re-echoed like a cave. Routing them, as they were light-armed, and pursuing them into the forest, we were thenceforth masters of the land. Not long afterwards they sent heralds and were for recovering their dead and conferring about an alliance, but we did not think it best to make terms with them. Indeed, on the following day we marched against them and utterly exterminated them, all but the Mergoats, and they, when they saw what was doing, ran off through the gills and threw themselves into the sea. Occupying the country, which was now clear of the enemy, we

dwelt there in peace from that time on, constantly engaging in sports, hunting, tending vines and gathering the fruit of the trees. In short, we resembled men leading a life of luxury and roaming at large in a great prison that they cannot break out of.

For a year and eight months we lived in this way, but on the fifth day of the ninth month, about the second mouth-opening — for the whale did it once an hour, so that we told time by the openings — about the second opening, as I said, much shouting and commotion suddenly made itself heard, and what seemed to be commands and oar-beats. Excitedly we crept up to the very mouth of the animal, and standing inside the teeth we saw the most unparallelled of all the sights that ever I saw — huge men, fully half a furlong in stature, sailing on huge islands as on galleys. Though I know that what I am going to recount savours of the incredible, I shall say it nevertheless. There were islands, long but not very high, and fully a hundred furlongs in circumference, on each of which about a hundred and twenty of those men were cruising, some of whom, sitting along each side of the island one behind the other, were rowing with huge cypress trees for oars — branches, leaves and all! Aft at the stern, as I suppose you would call it, stood the master on a high hill, holding a bronze tiller five furlongs in length. At the bow, about forty of them under arms were fighting; they were like men in all but their hair, which was fire and blazed up, so that they had no need of plumes. In lieu of sails, the wind struck the forest, which was dense on each of the islands, filled this and carried the island wherever the helmsman would. There were boat-swains in command, to keep the oarsmen in time, and the islands moved swiftly under the rowing, like war-galleys.

At first we only saw two or three, but later on about six hundred made their appearance. Taking sides, they went to war and had a sea-fight. Many collided with one another bows on, and many were rammed amidships and sunk. Some, grappling one another, put up a stout fight and were slow to cast off, for those stationed at the bows showed all zeal in boarding and slaying: no quarter was given. Instead of iron grapnels they threw aboard one another great devilfish with lines belayed to them, and these gripped the woods and held the island fast. They struck and wounded one another with oysters that would fill a wagon and with hundred-foot sponges. The leader of one side was Aeolocentaur, of the other, Brinedrinker. Their battle evidently came about on account of an act of piracy: Brinedrinker was said to have driven off many herds of dolphins belonging to Aeolocentaur. We knew this because we could hear them abusing one another and calling out the names of their kings. Finally the side of Aeolocentaur won; they sank about a hundred and fifty of the enemy's islands; and took three more, crews and all; the rest backed water and fled. After

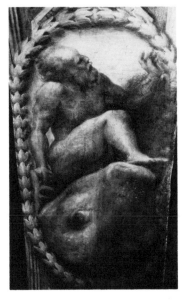

"Jonah and the Whale" fresco, CORREGGIO; 1520 San Giovanni Evangelista, Parma, Italy

The First Voyage of Sindbad the Sailor

pursuing them some distance, they turned back to the wrecks at evening, making prizes of most of them and picking up what belonged to themselves; for on their own side not less than eighty islands had gone down. They also made a trophy of the isle-fight by setting up one of the enemy's islands on the head of the whale. That night they slept on shipboard around the animal, making their shore lines fast to him and riding at anchor just off him; for they had anchors, large and strong, made of glass. On the following day they performed sacrifice on the whale, buried their friends on him, and sailed off rejoicing and apparently singing hymns of victory. So much for the events of the isle-fight.

From that time on, as I could no longer endure the life in the whale and was discontented with the delay, I sought a way of escape. First we determined to dig through the right side and make off, and we made a beginning and tried to cut through. But when we had advanced some five furlongs without getting anywhere, we left off digging and decided to set the forest afire, thinking that in this way the whale could be killed, and in that case our escape would be easy. So we began at the tail end and set it afire. For seven days and seven nights he was unaffected by the burning, but on the eighth and ninth we gathered that he was in a bad way. For instance, he yawned less frequently, and whenever he did yawn he closed his mouth quickly. On the tenth and eleventh day mortification at last set in and he was noisome. On the twelfth we perceived just in time that if someone did not shore his jaws open when he yawned, so that he could not close them again, we stood a chance of being shut up in the dead whale and dying there ourselves. At the last moment, then, we propped the mouth open with great beams and made our boat ready, putting aboard all the water we could and the other provisions. Our sailing-master was to be Scintharus.

On the next day the whale was dead at last. We dragged the boat up, took her through the gaps, made her fast to the teeth and lowered her slowly into the sea. Climbing on the back and sacrificing to Poseidon there by the trophy, we camped for three days, as it was calm. On the fourth day we sailed off.

Translated from the Greek by A.M. Harmon

Know, my friends, that my father was the chief merchant of this city and one of its richest men. He died whilst I was still a child, leaving me great wealth and many estates and farmlands. As soon as I came of age and had control of my inheritance, I took to extravagant living. I clad myself in the costliest robes, ate and drank sumptuously, and consorted with reckless prodigals of my own age, thinking that this mode of life would endure for ever.

It was not long before I awoke from my heedless folly to find that I had frittered away my entire fortune. I was stricken with horror and dismay at the gravity of my plight, and bethought myself of a proverb of our master Solomon son of David (may peace be upon them both!) which my father often used to cite: "The day of death is better than the day of birth, a live dog is better than a dead lion, and the grave is better than poverty." I sold the remainder of my lands and my household chattels for the sum of three thousand dirhams, and, fortifying myself with hope and courage, resolved to travel abroad and trade in foreign lands.

I bought a large quantity of merchandise and made preparations for a long voyage. Then I set sail together with a company of merchants in a river-ship bound for Basrah. There we put to sea and, voyaging many days and nights from isle to isle and from shore to shore, buying and selling and bartering wherever the ship anchored, we came at length to a little island as fair as the Garden of Eden. Here the captain of our ship cast anchor and put out the landing-planks.

The passengers went ashore and set to work to light a fire. Some busied themselves with cooking and washing, some fell to eating and drinking and making merry, while others, like myself, set out to explore the island. Whilst we were thus engaged we suddenly heard the captain cry out to us from the ship: "All aboard, quickly! Abandon everything and run for your lives! The mercy of Allah be upon you, for this is no island but a gigantic whale floating on the bosom of the sea, on whose back the sands have settled and trees have grown since the world was young! When you lit the fire it felt

the heat and stirred. Make haste, I say; or soon the whale will plunge into the sea and you will all be lost!"

Hearing the captain's cries, the passengers made for the ship in panic-stricken flight, leaving behind their cooking-pots and other belongings. Some reached the ship in safety, but others did not; for suddenly the island shook beneath our feet and, submerged by mountainous waves, sank with all that stood upon it to the bottom of the roaring ocean.

Together with my unfortunate companions I was engulfed by the merciless tide; but Providence came to my aid, casting in my way a great wooden trough which had been used by the ship's company for washing. Impelled by that instinct which makes all mortals cling to life, I held fast to the trough and, bestriding it firmly, paddled away with my feet as the waves tossed and buffeted me on every side. Meanwhile the captain hoisted sail and set off with the other passengers. I followed the ship with my eyes until it vanished from sight, and I resigned myself to certain death.

Translated from the Arabic by N.J. Dawood

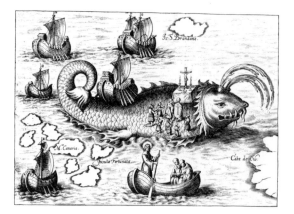

Engraving of Saint Brendan and confrères saying Mass on the whale's back, from "Nova Typis Transacta Navigatio" by H. Philoponus (1621)

from *Gargantua and Pantagruel*

Pantagruel sights a monstrous spouting Whale near Savage Island

Towards noon, as we came near to Savage Island, Pantagruel sighted in the distance a huge and monstrous spouting whale, making straight towards us. It was snorting and thundering, and so puffed up that it rode high on the waves, above the main-tops of our ships. As it drew near it sent great jets of water from its throat, which looked like mighty rivers tumbling from the mountains before it. Pantagruel pointed it out to Xenomanes, and to the ship's captain, who advised that the *Thalamège*'s trumpets should be sounded. So the alarm call went out: "Combat formations!" At this signal all the ships, galleons, frigates, and brigantines drew up in order of battle, according to their previous instruction, in the shape of the Greek Y, Pythagoras's letter; which is the formation you will see cranes take when flying. They formed an acute angle, therefore, and at its cone and base was the *Thalamège*, ready to put up a fierce fight. Friar John climbed bravely and resolutely on to the fo'c'stle with the gunners. But Panurge began to wail and cry more loudly than before. "B-b-b-b-b-b-b," he moaned, "this is worse than ever. Let's run away. Why I'll be blowed if it isn't the Leviathan described by the great prophet Moses in his life of that holy man Job! He'll swallow us all up, ships and men together, like so many little pills. We shan't take up any more room in his hellish great throat than a grain of spiced oats in an ass's mouth. Look at him there. Let's flee and go ashore. I think it's the same sea-monster that was sent in the old days to gobble up Andromeda. We're all done for. Oh, if only there were some valiant Perseus here to slay him at a blow!"

"I'll be a Perseus to him!" answered Pantagruel. "Don't be afraid."

"God's truth, then," said Panurge, "remove us from the causes of fear. You wouldn't expect me to be frightened, would you, except in the face of evident danger?"

"If your fatal destiny is as Friar John described it a little while ago, you should be afraid of Pyroeis, Eöus, Aethon, and Phlegon, the celebrated and flammivomous horses of the sun, which breathe fire through their nostrils. But you need have no fear of spouting whales, which only throw up water from their mouths and their blowing-holes. For you'll never be in danger of death by water. In fact that element is more likely to preserve you than to hurt you, more likely to protect you than to do you harm."

"That be hanged for a tale," said Panurge. "It's wasted on me. By all the little fishes, haven't I explained the transmutation of the elements to you carefully enough? Haven't I shown you what a close connexion there is between roasting and boiling, boiling and roasting? Oh, oh! Here it comes. I'll go and hide myself below. We shall all be dead men in a minute. I can see the cruel Atropos on the main-top, with her scissors freshly ground, ready to cut the thread of all our lives. Mind out! Here it comes. Oh, you dread and horrible monster! You've drowned plenty of good men before us, who haven't lived to boast of the fact. Oh, if only it spouted wine — good, appetizing, and delicious wine, white and red — instead of this bitter, stinking salt water, that in a way would be bearable. It would give us a chance of showing calm, like that English lord who was ordered to choose what death he would suffer for the crimes he had been convicted of, and elected to be drowned in a butt of malmsey. Here it comes. Oh, oh, Satan, Leviathan, you devil! I can't look at you, you're so hideously ugly. Go off to the Chancery! Go after the Bum-bailiffs, do!"

Translated from the French by J.M. Cohen

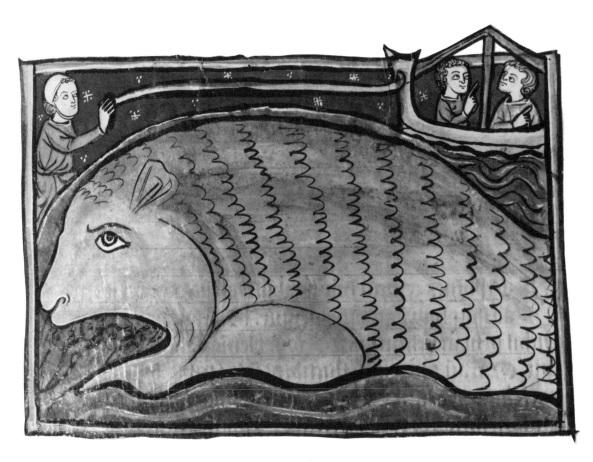

top

"Belua" from the "Westminster Abbey Bestiary", 12th c. Whales went by many names during the Middle Ages, "Aspidoceleon" and "Belua" being two of the lesser known.

"Physeter" or sperm whale (physeter catadon) from "Historia Animalium" by KONRAD GESNER

17

from *Orlando Furioso*

But let us follow the knight who is longing to be quickly at the island of Ebuda, where beautiful and delicate women are given as food to a sea-monster.

But the more haste the paladin made, the less the wind seemed to have. Whether it blows from the right side or the left or astern, it is always so light he can make little distance with it; and sometimes it is wholly spent; sometimes it blows so adverse that he is obliged to turn or to keep circling to windward.

It was the will of God that he should not come to that place before the king of Hibernia, in order that the events I shall let you hear within a few pages might more easily happen. When they had anchored near the island, Orlando said to his shipmaster: "Now you can wait here and give me the skiff, because I want to put myself on the rocky isle without any company.

"And I want the largest cable with me and the largest anchor you have in the ship. I will let you see why I take them if I succeed in confronting that monster." He had the small boat put in the water with him, with all that was suited to his plan. He left all his arms except his sword, and alone took his course toward the rocky island.

He draws the oars to his breast and keeps his back turned toward the place where he intends to land, just as the salt-water crab does when it goes on shore from the sea or from the bay. It was the hour when the fair Aurora had scattered to the Sun, still half revealed and half hidden, her yellow locks, not without the anger of jealous Tithonus.

When he has rowed as close to the naked rock as a strong hand can throw a stone, he seems to hear and not to hear weeping — so weak and tired it comes to his ears. He turns wholly to the left side, and fixing his eyes on the shore close to the waves, he sees a woman naked as she was born, bound to a tree trunk; and the waters bathe her feet.

Because she is still far from him and because she holds her head bent down, he does not well see who she is. He pulls both oars in haste, and draws near with strong desire to learn more of her. But just then he hears the sea bellow, and the forests and the caverns reëcho; the waves swell, and now appears the monster, which has almost hidden the sea beneath her breast.

As from a valley damp and dark there rises a cloud pregnant with rain and wind, which blacker than night spreads itself over all the world and seems to overcome day, so swims the beast, and takes up so much of the sea that one can say that she holds it all; the waves rage. Orlando, self-possessed, boldly looks at her and does not change heart or countenance.

And like one who had a well-made plan for all he intended to do, he moved quickly; and so he could be a screen to the maiden and at the same time attack the beast, he went with his boat between the orc and her, leaving his sword hid in the scabbard. He took in his hand the anchor with the cable; then with firm heart he awaited the horrible monster.

As soon as the orc drew near and discovered Orlando in his skiff not far away, she opened so huge a mouth to swallow him down that a man on horseback could have entered there. Orlando pressed forward, and plunged himself into her throat with that anchor, and if I am not wrong, with the boat as well and he hooked the anchor to her, both to her palate and to her soft tongue,

so that her horrid jaws can no more come down from above or be raised from below. So one who uses his iron in the mines supports the earth wherever he makes his way, that a sudden fall may not cover him while incautiously he applies himself to his labor. From one fluke to the other the anchor is so high that Orlando cannot reach it without leaping.

Having fixed the points and made himself sure that the monster can close her mouth no more, he draws his sword and strikes here and there in that dark cave with cuts and thrusts. As a castle can be defended when foes have come within the wall, so could the orc defend herself from the paladin she had in her throat.

Overcome by pain, now she rushes over the sea and shows her flanks and her scaly back; now she plunges in there and with her belly moves the sand from the bottom and makes it leap up. Feeling the water, which is too plentiful, the knight of France comes swimming out; he leaves the anchor fixed and takes in his hand the rope that hangs from the anchor.

And with that he goes swimming in haste toward the rock; when he has set foot there, he draws toward himself the anchor, fixed in her mouth with both points, that tortures the ugly

monster. The orc is obliged to follow the hemp by that force that exceeds all other force, that force that draws harder in one pull than a windlass can in ten.

As a wild bull that feels an unexpected lasso thrown on his horns leaps here and there, turns around, kneels and rears and cannot free himself from torment, so the orc, pulled by the strength of that arm from her old life-giving abode, follows the rope with a thousand struggles and a thousand strange circles and cannot release herself.

She pours from her mouth blood in quantity so great that to this day that sea can be named Red, where she beats the waves in such a way that you might see them open to the bottom; now she drenches the sky with them and conceals the light of the shining sun – she makes them leap so high. To the uproar that is heard all around, the forests, the mountains and the distant shores reëcho.

Old Proteus when he hears such uproar goes out of his grotto upon the sea; and when he sees Orlando go into and come out of the orc and draw to the shore so measureless a fish, he flees over the wide ocean, forgetting his scattered flocks; and the tumult so increases that Neptune has his dolphins hitched to his chariot and hastens that day into Ethiopia.

Ino weeping, with Melicerta in her arms, the Nereids with dishevelled hair, Glaucuses and Tritons and the rest, without knowing where, go hither and thither to save themselves. Orlando dragged to the shore the horrible fish with which he no longer needed to take any pains, for because of her struggles and the pain she had borne, she died before she was on the beach.

Translated from the Italian by Allan Gilbert

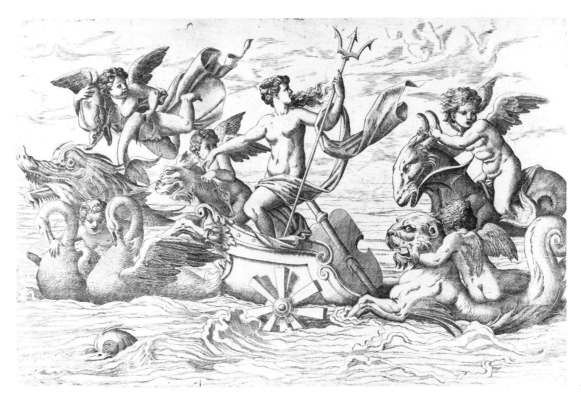

from Baron Munchausen

The Red-Headed Whale

After drifting about, we knew not where, for we were without a compass, we came to a sea that seemed all black: we tested what we thought was dirty water, and found it to be excellent wine. It was with great difficulty that we prevented our crew from getting drunk. But our joy was not of long duration, for some hours afterwards we found ourselves surrounded by whales and other fish equally vast in size; there was one of such prodigious length that we could not see the end of him, even with a telescope. By ill luck we did not see the monster till he was close to us: he swallowed at one gulp our ship at full sail. When we had been some time in his throat, he opened his jaws to take in a great gulp of water; our vessel, floating on this current, was drawn into the monster's stomach, where we were as quiet as though we had been at anchor in a dead calm. The air, I must admit, was heated and heavy. We saw in his stomach anchors, cables, barges, and a good number of vessels, some with their cargoes on board, others empty, which had fallen into the same plight as ourselves. We were obliged to exist by torchlight; we could see nothing of the sun, the moon, or the stars. It usually happened that twice a day we were left high and dry, and twice we floated. When the monster drank we floated, and when he poured the water out we were left dry. We made an exact estimate of the quantity of water he drank, and found that it would be sufficient to fill the Lake of Geneva, which is thirty miles in circumference.

On the second day of our captivity in this gloomy region, I ventured, accompanied by the captain and some of his officers, to take a short excursion when it was low water, as we used to say. We had provided ourselves with torches, and we encountered, one after the other, nearly 10,000 men of different nations, who were in the same case as ourselves. They began to deliberate eagerly upon the means they could employ for the recovery of their liberty. Some of them had passed several years already in the stomach of the monster. But at the very moment when the president was beginning to inform us of the subject of the resolution to be proposed to the meeting, our tyrant of a fish commenced

drinking: the water poured in with such violence that we had only just time to regain our several ships; several of us, less active than the rest, had to swim for our lives.

When the fish opened his mouth again, and poured the water out, we assembled afresh, and I was chosen president. I proposed to them to fasten two of our tallest masts together, end to end, and when the monster opened his jaws, to plant them in such a manner as should prevent his shutting his mouth again. This plan was passed by acclamation, and a hundred of the strongest men among us were selected to put it into execution. The two masts had scarcely been arranged according to my directions, before a favourable moment presented itself. The monster began to yawn; we planted our two masts in such a way that their lower end was fixed in his tongue, while the upper pierced the roof of his palate, so that he would be unable, for ever after, to make his jaws meet.

As soon as we found ourselves afloat, we manned the boats, in which we rowed ourselves out, and came back into the world. It was with joy inexpressible that we saw once more the light of the sun, of which we had been deprived during our fortnight's imprisonment. When every one had left the vast stomach of the monster, we found we were a fleet of thirty-five ships of all nations. We left our two masts fixed in the monster's throat, to preserve from an accident similar to ours those who should find themselves drawn towards that abyss.

One day some men from Sudurnes rowed out to the Geirfugla Skerry to trap auks there, but when they were wanting to set off for home once more, one man was missing. They hunted all over the skerry for him, but he was not to be found, so his companions went home leaving matters as they stood.

A year later, the men from Sudurnes went again to the skerry to trap birds, and then they found the man; he was walking to and fro on the skerry, as cheerful as could be. Some elves had lured the man to them by magic and kept him among them for a year, and had treated him well; they had wanted him to stay longer, but he had not wished to. Now the fact of the matter was that an elf-woman was with child by him, and that he had got permission to leave the skerry and go home on the condition that he promised to arrange for the child to be baptized as soon as it was brought to a church. The woman said she would bring it to Hvalsnes Church, for that was the man's parish church. So now he sailed back to the mainland with those men from Sudurnes, and everyone was glad to see him again.

So now time passed, and nothing worth mentioning happened. Then one Sunday when people came to Hvalsnes for the service, there was a cradle standing outside the church door, and a small baby in it. Over the cradle lay a coverlet, very beautiful and delicately worked, and woven of some unknown cloth; and at the foot of the cradle was a slip of paper with these words written on it: "He who is the father of this child will see to it that it is baptized."

The people were all astonished at this event, but no one would acknowledge that he was the father or claim the child as his. The priest had his suspicions about the man who had been missing for a whole year, for he thought the present affair was no stranger than the idea that a man could stay alive out on the skerry, and so he thought that this man be the child's father, or, at the least, must know something about it. But the man replied gruffly that he was not the child's father, and did not care in the least what became of it.

While they were still arguing, up came a tall, stately woman. She was extremely angry, and snatching the coverlet from the cradle she flung it in through the church door, saying: "The church must not lose its dues!" By this act she gave the coverlet to the church, and it has been used ever since as an altar-cloth for Hvalsnes Church, where it is regarded as a very precious treasure.

Then she turned to the man and said: "This do I say and this curse do I lay: you shall turn into the most vicious whale in the sea, and shall destroy many ships!"

After which the woman disappeared, and so did the cradle with the baby in it, and nobody ever found out any more about

them, but it was the general opinion that this must have been the elf-woman from Geirfugla Skerry, and that the man's own story showed that it was so.

But soon after the woman vanished, the man she had cursed went mad and went rushing off. He ran down to the sea and jumped over the cliff called Stakksgnypa, which is between Keflavik and Leira. Then all at once he turned into the most vicious whale, and was known as Red-Head from then on. He was very evil and destructive. He drowned nineteen boatloads of men between Akranes and Seltjarnarnes, where he was always lurking out in the open sea. Among others, Red-Head drowned the son of the priest of Saurbœ on Hvalfjardarstrand and the second son of the priest of Saurbœ on Kjalarnes. These two priests joined forces, for they took the loss of their sons very much to heart, and their chants drew Red-Head all the way up the fjord which separates the two Saurbœs, which ever since then has been called Hvalfjord, "Whale Fjord", and drew him right up into the lake up on Botnsheidi, which ever since then has been called Hvalvatn, "Whale Lake". Then there came a great earthquake all round that district, because of which the moors round Hvalvatn are called the Quaking Moors. People have thought there was proof that all this really did happen in the fact that at one time one could see a whale's bones beside this lake, and pretty big ones too. But nobody was ever injured by Red-Head after this.

Translated from the Icelandic by Jacqueline Simpson

JEWISH FABLE

An Old Man, His Son, a Fish, the Leviathan

He who does the commandment of his father, even the Leviathan will forgive his sin.

THERE was an old man devout and humble whose eyes had grown heavy with age. He put his trust in the Rock who created him. As he lay sick upon his bed he yearned for his elder son, and in view of his approaching death commanded him: "Cast thy bread upon the waters, for thou shalt find it after many days." And it came to pass after the old man died that the son sat upon his father's chair and did as he had commanded him; he walked in the way his begetter had led him and cast his bread into the sea without stint. God caused a great fish to eat his bread until he was satisfied. One greater than his neighbor swallowed him; the great fish proclaimed a day of slaughter for the fish round about, and in sorrow they went to the Leviathan, who was chief of them that handle the oar. The great fish trod his bow in strength against the fish; he wrought destruction among them without mercy and cut their branches off. The Leviathan commanded that he be summoned: "Let him not stand, though his host be great, lest the glory of his nostrils lose their terror. I shall slay him in battle." The great fish came bellowing and lamenting and storming mightily because of his strength; with a great trembling did that fish tremble, for he seethed in his depths like a pot. The Leviathan kindled his anger against him and his eyeballs gleamed like the dawn. Said he: "How couldst thou presume, how could thy heart embolden thee, to do such a thing? Who hath made thee ruler and judge over us? Art thou the man who hath consumed us?" The great fish drew near and confessed: "Let not thine anger kindle if I tell thee the truth. I did in mine iniquity murder, and this thing and that have I done." The Leviathan answered: "From whose hand hadst thou thy repast, who hath fed thee to this point?" And he said: "There is a man whose way it was to sustain me with daily rations; in truth he is responsible for his own injury." Answered the Leviathan: "If thou wouldst atone thy sin, violate not my commandment. Go thou to thy haunt, where thou hast affirmed the man's habit of casting his bread

to thee; when he seeks thee do thou swallow him, but keep his soul alive. Thereby wilt thou save thy life, for that thou hast slain without mercy." All answered, "This is appropriate," and the thing was determined and the great fish did so. He swallowed the man within his gullet and spewed him forth before his master. The Leviathan asked the man in anger: "What is this and why is this and wherefore hast thou given the fish thy food? It is not for thee to maintain him; but if it be so and thou art obliged to keep him, then must thou be destroyed for his sin." The man prostrated himself before him and said that he had done this thing in the innocence of his hands and by the commandment of his father. The Leviathan raised his hands and swore by his life that no hair of his head should fall: "Thou shalt not be judged by analogy, for thou hast kept a commandment, and art not responsible for its anomalous outcome. Open thy mouth and I shall fill it with the spirit of wisdom. Thou shalt be clever in all things and wiser than Darda and Chalcol." The saying of Leviathan was established; he was brought out from the sea, and his coming forth was very swift; none was found so wise as he. His history is duly recorded in a book of chronicles.

Translated from the Hebrew by Moses Hadas

left
Spindle whorls with stylized dolphin decoration, ca 1000 A.D. These incised, fired-clay spindle whorls, less than 1.5 cm in diameter, were created during the Integration period of Ecuador's cultural development, between 500 and 1500 A.D. Dolphin, whale and other animal motifs were commonly used on these weights.
Courtesy of Frederick Shaffer

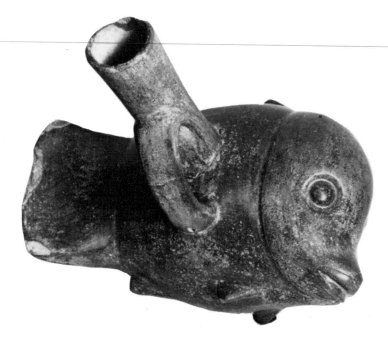

The Riverman

*A man in a remote Amazonian village decides to
become a* sacaca, *a witch doctor who works with
water spirits. The river dolphin is believed to have
supernatural powers; Luandinha is a river spirit
associated with the moon; and the* pirarucú *is a fish
weighing up to four hundred pounds. These and
other details on which this poem is based are from*
Amazon Town, *by Charles Wagley.*

I got up in the night
for the Dolphin spoke to me.
He grunted beneath my window,
hid by the river mist,
but I glimpsed him – a man like myself.
I threw off my blanket, sweating;
I even tore off my shirt.
I got out of my hammock
and went through the window naked.
My wife slept and snored.
Hearing the Dolphin ahead,
I went down to the river
and the moon was burning bright
as the gasoline-lamp mantle
with the flame turned up too high,
just before it begins to scorch.
I went down to the river.
I heard the Dolphin sigh
as he slid into the water.
I stood there listening
till he called from far outstream.
I waded into the river
and suddenly a door
in the water opened inward,
groaning a little, with water
bulging above the lintel.
I looked back at my house,
white as a piece of washing
forgotten on the bank,
and I thought once of my wife,
but I knew what I was doing.

They gave me a shell of *cachaça*
and decorated cigars.
The smoke rose like mist
through the water, and our breaths
didn't make any bubbles.
We drank *cachaça* and smoked
the green cheroots. The room

filled with gray-green smoke
and my head couldn't have been dizzier.
Then a tall, beautiful serpent
in elegant white satin,
with her big eyes green and gold
like the lights on the river steamers –
yes, Luandinha, none other –
entered and greeted me.
She complimented me
in a language I didn't know;
but when she blew cigar smoke
into my ears and nostrils
I understood, like a dog,
although I can't speak it yet.
They showed me room after room
and took me from here to Belém
and back again in a minute.
In fact, I'm not sure where I went,
but miles, under the river.

Three times now I've been there.
I don't eat fish any more.
There is fine mud on my scalp
and I know from smelling my comb
that the river smells in my hair.
My hands and feet are cold.
I look yellow, my wife says,
and she brews me stinking teas
I throw out, behind her back.
Every moonlit night
I'm to go back again.
I know some things already,
but it will take years of study,
it is all so difficult.
They gave me a mottled rattle
and a pale-green coral twig
and some special weeds like smoke.
(They're under my canoe.)
When the moon shines on the river,
oh, faster than you can think it
we travel upstream and downstream,
we journey from here to there,
under the floating canoes,
right through the wicker traps,
when the moon shines on the river
and Luandinha gives a party.
Three times now I've attended.
Her rooms shine like silver

The Sea Woman and the Dolphin

Long ago, before Man measured time, there lived a young man
who loved a chieftain's daughter. The man had no shells, no pigs
to buy the woman for his wife, and no parents or uncles to help
him. So the chief promised his daughter to the man if he could
catch alive the magic dolphin which swam along the coast of
New Ireland.

The confident man sailed his canoe to the favourite waters of
the dolphin where the creature swam around his canoe. He
jumped on to the dolphin's back. In the next moment he was
carried with mighty force skywards by a huge wave, and
alongside him was the most beautiful woman he had ever seen.
She was the Spirit of the Waves. Forgetting his village and the
chief's daughter, he jumped into the sea before he realized she
was only a spirit woman. The dolphin capsized the canoe, thus
destroying his only means of returning to his village.

The rough waters off the New Ireland coast are caused when
the condemned spirit of the man tries to struggle away from the
spirit woman and the waves and return to his home.

Retold by Glenys Köhnke

with the light from overhead,
a steady stream of light
like at the cinema.

I need a virgin mirror
no one's ever looked at,
that's never looked back at anyone,
to flash up the spirits' eyes
and help me recognize them.
The storekeeper offered me
a box of little mirrors,
but each time I picked one up
a neighbor looked over my shoulder
and then that one was spoiled —
spoiled, that is, for anything
but the girls to look at their mouths in,
to examine their teeth and smiles.

Why shouldn't I be ambitious?
I sincerely desire to be
a serious *sacaca*
like Fortunato Pombo,
or Lúcio, or even
the great Joaquim Sacaca.
Look, it stands to reason
that everything we need
can be obtained from the river.
It drains the jungles; it draws
from trees and plants and rocks
from half around the world,
it draws from the very heart
of the earth the remedy
for each of the diseases —
one just has to know how to find it.
But everything must be there
in that magic mud, beneath
the multitudes of fish,
deadly or innocent,
the giant *pirarucús*,
the turtles and crocodiles,
tree trunks and sunk canoes,
with the crayfish, with the worms
with tiny electric eyes
turning on and off and on.
The river breathes in salt
and breathes it out again,
and all is sweetness there
in the deep, enchanted silt.

When the moon burns white
and the river makes that sound
like a primus pumped up high —
that fast, high whispering
like a hundred people at once —
I'll be there below,
as the turtle rattle hisses
and the coral gives the sign,
travelling fast as a wish,
with my magic cloak of fish
swerving as I swerve,
following the veins,
the river's long, long veins,
to find the pure elixirs.
Godfathers and cousins,
your canoes are over my head;
I hear your voices talking.
You can peer down and down
or dredge the river bottom
but never, never catch me.

When the moon shines and the river
lies across the earth
and sucks it like a child,
then I will go to work
to get you health and money.
The Dolphin singled me out;
Luandinha seconded it.

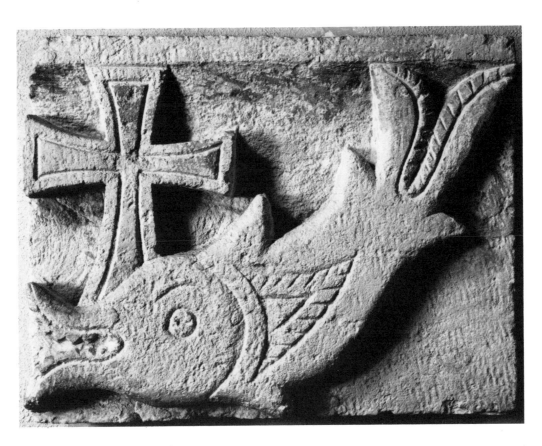

JOHN MASEFIELD

from A Mainsail Haul

"Down in the sea, very far down, under five miles of water, somewhere in the Gulf of Mexico, there is a sea cave, all roofed with coral. There is a brightness in the cave, although it is so far below the sea. And in the light there the great sea-snake is coiled in immense blue coils, with a crown of gold upon his horned head. He sits there very patiently from year to year, making the water tremulous with the threshing of his gills. And about him at all times swim the goggle-eyed dumb creatures of the sea. He is the king of all the fishes, and he waits there until the judgement day, when the waters shall pass away for ever and the dim kingdom disappear. At times the coils of his body wreathe themselves, and then the waters above him rage. One folding of his coil will cover a sea with shipwreck; and so it must be until the sea and the ships come to an end together in that serpent's death-throe.

"Now when that happens, when the snake is dying, there will come a lull and a hush, like when the boatswain pipes. And in that time of quiet you will hear a great beating of ships' bells, for in every ship sunken in the sea the life will go leaping to the white bones of the drowned. And every drowned sailor, with the weeds upon him, will spring alive again; and he will start singing and beating on the bells, as he did in life when starting out upon a cruise. And so great and sweet will be the music that they make that you will think little of harps from that time on, my son.

"Now the coils of the snake will stiffen out, like a rope stretched taut for hauling. His long knobbed horns will droop. The golden crown will roll from his old, tired head. And he will lie there as dead as herring, while the sea will fall calm, like it was before the land appeared, with never a breaker in her. Then the great white whale, old Moby Dick, the king of all the whales, will rise up from his quiet in the sea, and go bellowing to his mates. And all the whales in the world—the sperm-whales, the razor-back, the black-fish, the rorque, the right, the forty-barrel Jonah, the narwhal, the hump-back, the grampus and the thrasher—will come to him, 'fin-out,' blowing their spray to the heavens. Then Moby Dick will call the roll of them, and from all the parts of the sea, from the north, from the south, from Callao to Rio, not one whale will be missing. Then Moby Dick will trumpet, like a man blowing a horn, and all that company of whales will 'sound' (that is, dive), for it is they that have the job of raising the wrecks from down below.

"Then when they come up the sun will just be setting in the sea, far away to the west, like a ball of red fire. And just as the curve of it goes below the sea, it will stop sinking and lie there like a door. And the stars and the earth and the wind will stop. And there will be nothing but the sea, and this red arch of the sun, and the whales with the wrecks, and a stream of light upon the water. Each whale will have raised a wreck from among the coral, and the sea will be thick with them—row-ships and sail-ships, and great big seventy-fours, and big White Star boats, and battleships, all of them green with the ooze, but all of them manned by singing sailors. And ahead of them will go Moby Dick, towing the ship our Lord was in, with all the sweet apostles aboard of her. And Moby Dick will give a great bellow, like a foghorn blowing, and stretch 'fin-out' for the sun away in the west. And all the whales will bellow out an answer. And all the drowned sailors will sing their chanties, and beat the bells into a music. And the whole fleet of them will start towing at full speed towards the sun, at the edge of the sky and water. I tell you they will make white water, those ships and fishes.

"When they have got to where the sun is, the red ball will swing open like a door, and Moby Dick, and all the whales, and all the ships will rush through it into an anchorage in Kingdom Come. It will be a great calm piece of water, with land close aboard, where all the ships of the world will lie at anchor, tier upon tier, with the hands gathered forward, singing. They'll have no watches to stand, no ropes to coil, no mates to knock their heads in. Nothing will be to do except singing and beating on the bell. And all the poor sailors who went in patched rags, my son, they'll be all fine in white and gold. And ashore, among the palm-trees, there'll be fine inns for the seamen, where you and I, maybe, will meet again, and I spin yarns, maybe, with no cause to stop until the bell goes."

right
"The Last Judgement" engraving (detail) by PIETER BRUEGEL, THE ELDER *1558. 22.5 x 29.5 cm. Here the Leviathan swallowing the damned is clearly whale-like, and is modelled after other cetaceans drawn by Bruegel*

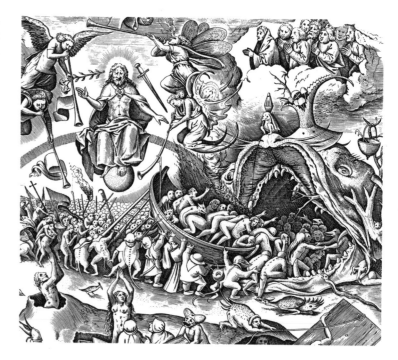

NED ROREM

Whales Weep Not!

Whales have always swum in my bloodstream, circling ever nearer the heart. Perhaps it is no coincidence that I now live upon an island shaped like a whale, Nantucket, where Melville's famous romance so nobly began (and where the painful craft of scrimshaw continues to be practised).

In 1958 I composed an orchestral tone-poem named *Eagles*; in 1963 another called *Lions*; and for years I planned logically to round off the cycle of air-land-sea with *Whales*. But other composers came along with the same idea, and my mind wandered elsewhere. Today how can I – at Anton Kuerti's urging, and from nostalgia for an early infatuation with the Big Brother — comment musically upon leviathan?

A big subject does not require a big canvas. Is a ninety-foot mural of the Sahara inherently more honest than a postcard? Is either so compelling as the original? Art and nature do forever copy each other in microcosm and both evolve new rulings every day. No work in any poet's catalogue could have existed without his own preceding work, not to mention what he steals from predecessors, friends and enemies. The only real comment on any work of art is another work of art; a thousand exegetical tomes on Lear will never match Lear himself, and the fact of Shakespeare precludes analyses of him. Similarly, an artist's comment on nature is not passing reaction (which could only be *Wow!*) but solid impression. Now, since in music an impression means literally only what the composer tells you, in words, that it means, let me claim that if these nineteen measures do not actually conjure visions of whales, they were nevertheless concocted in homage of a souvenir, and with love, for as long as, and longer than, my bloodstream continues to flow.

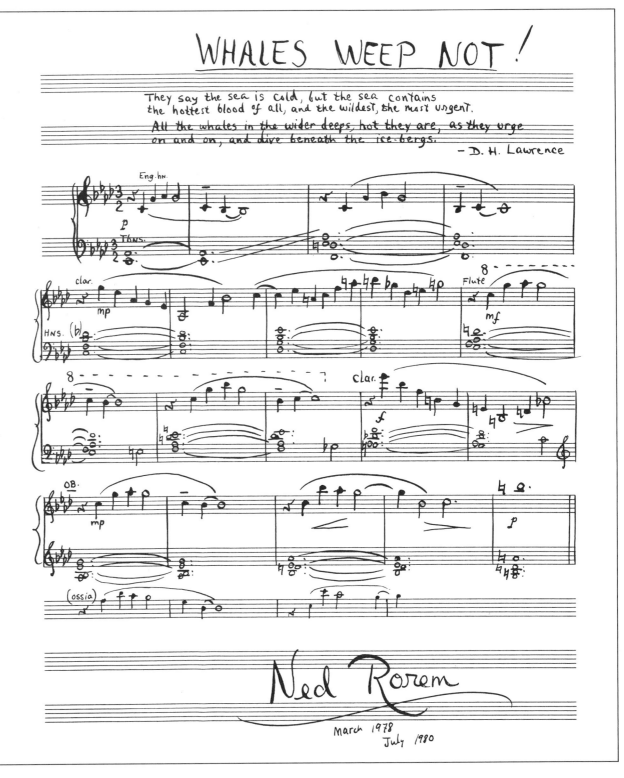

D. H. LAWRENCE

Whales Weep Not!

"Venus Marina" woodcut,
ALBRECHT DÜRER. *8 x 6 cm.*
Courtesy of the Ashmolean Museum,
Oxford

right
Black-figured Attic amphora with
marine fauna, late 6th c. B.C.
This masterpiece of the Greek
vase-painter's art is unique for the
Archaic and Classical periods because
of the absence of gods or humans,
and the complete concentration on
the denizens of the sea. Photo courtesy
of Dr. Leo Mildenberg

They say the sea is cold, but the sea contains
the hottest blood of all, and the wildest, the most urgent.

All the whales in the wider deeps, hot are they, as they urge
on and on, and dive beneath the icebergs.
The right whales, the sperm-whales, the hammer-heads,
 the killers
there they blow, there they blow, hot wild white breath out
 of the sea!

And they rock, and they rock, through the sensual ageless ages
on the depths of the seven seas,
and through the salt they reel with drunk delight
and in the tropics tremble they with love
and roll with massive, strong desire, like gods.
Then the great bull lies up against his bride
in the blue deep bed of the sea.
as mountain pressing on mountain, in the zest of life:
and out of the inward roaring of the inner red ocean of
 whale blood
the long tip reaches strong, intense, like the maelstrom-tip,
 and comes to rest
in the clasp and the soft, wild clutch of a she-whale's
 fathomless body.

And over the bridge of the whale's strong phallus, linking the
 wonder of whales
the burning archangels under the sea keep passing, back
 and forth,
keep passing archangels of bliss
from him to her, from her to him, great Cherubim
that wait on whales in mid-ocean, suspended in the waves
 of the sea
great heaven of whales in the waters, old hierarchies.

And enormous mother whales lie dreaming suckling their
 whale-tender young
and dreaming with strange whale eyes wide open in the waters
 of the beginning and the end.

And bull-whales gather their women and whale-calves in a ring
when danger threatens, on the surface of the ceaseless flood
and range themselves like great fierce Seraphim facing the threat
encircling their huddled monsters of love.
and all this happiness in the sea, in the salt
where God is also love, but without words:
and Aphrodite is the wife of whales
most happy, happy she!

and Venus among the fishes skips and is a she-dolphin
she is the gay, delighted porpoise sporting with love and the sea
she is the female tunny-fish, round and happy among the males
and dense with happy blood, dark rainbow bliss in the sea.

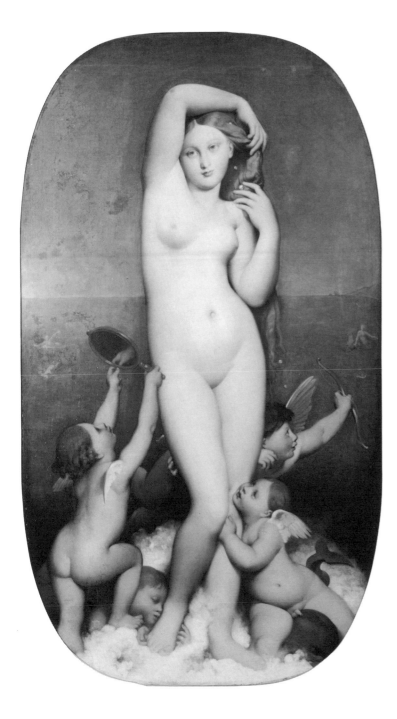

''Venus Anadyomene'', JEAN
AUGUSTE INGRES; 1848. Oil on
canvas, 150 x 88 cm. Photo courtesy
of the Musée Condée, Chantilly, France

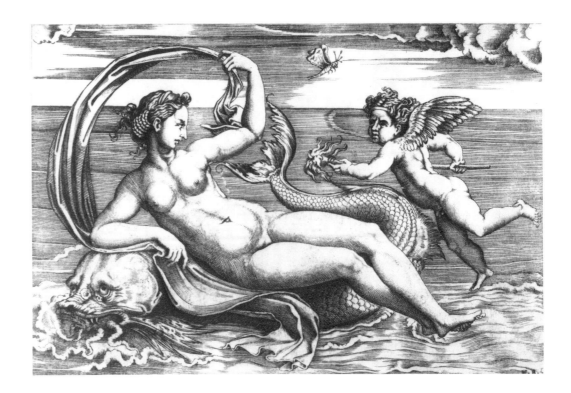

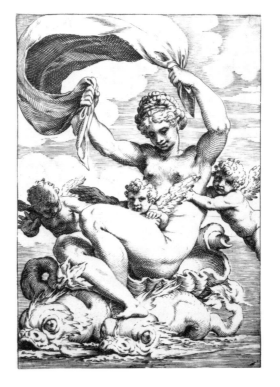

top
''Venus Reclining on a Dolphin''
engraving, AGOSTINO MUSI, after
Raphael. 17 x 25 cm. Courtesy of the
Trustees of the British Museum

''Venus Supported by Dolphins''
engraving, AGOSTINO CARRACCI;
ca 1590-1595. 15 x 11 cm. Courtesy of
the National Gallery of Art,
Washington D.C., Alisa Mellon
Bruce Fund

27

from The Cleverness of Animals

Solon here entered the conversation: "Well, Diocles, let it be granted that these things are near to the gods and far beyond us; but what happened to Hesiod is human and within our ken. Very likely you have heard the story."

"No, I have not," said I.

"Well, it is really worth hearing, and so here it is. A man from Miletus, it seems, with whom Hesiod shared lodging and entertainment in Locris, had secret relations with the daughter of the man who entertained them; and when he was detected, Hesiod fell under suspicion of having known about the misconduct from the outset, and of having helped to conceal it, although he was in nowise guilty, but only the innocent victim of a fit of anger and prejudice. For the girl's brothers killed him, lying in wait for him in the vicinity of the temple of Nemean Zeus in Locris, and with him they killed his servant whose name was Troïlus. The dead bodies were shoved out into the sea, and the body of Troïlus, borne out into the current of the river Daphnus, was caught on a wave-washed rock projecting a little above the sea-level; and even to this day the rock is called Troïlus. The body of Hesiod, as soon as it left the land, was taken up by a company of dolphins, who conveyed it to Rhium hard by Molycreia. It happened that the Locrians' periodic Rhian sacrifice and festal gathering was being held then, which even nowadays they celebrate in a noteworthy manner at that place. When the body was seen being carried towards them, they were naturally filled with astonishment, and ran down to the shore; recognizing the corpse, which was still fresh, they held all else to be of secondary importance in comparison with investigating the murder, on account of the repute of Hesiod. This they quickly accomplished, discovered the murderers, sank them alive in the sea, and razed their house to the ground. Hesiod was buried near the temple of Nemean Zeus; most foreigners do not know about his grave, but it has been kept concealed, because, as they say, it was sought for by the people of Orchomenos, who wished, in accordance with an oracle, to recover the remains and bury them in their own land. If, therefore, dolphins show such a tender and humane interest in the dead, it is even more likely that they should give aid to the living, and especially if they are charmed by the sound of flutes or some songs or other.

Translated from the Greek by Harold Cherniss and William C. Helmbold

from Guide to Greece

There are stories about the rocks sticking up particularly where the land narrows. The legend of the Molourian rock is that Ino threw herself into the sea from it holding her younger son Melikertes; Learchos the elder son was killed by his father. The legend speaks of Athamas murdering his son in madness, or else in irrepressible passion against Ino and her children, when he saw behind the famine at Orchomenos and the apparent death of Phrixos, not the hand of the gods but the machinations of the step-mother Ino; she fled, and threw herself and her son into the sea from the Molourian rock: but they say the boy was carried away by a dolphin to the isthmus of Corinth, and, among the honours paid to Melikertes under his new name Palaimon, the Isthmian games are consecrated to him

Translated from the Greek by Peter Levi

from The Cleverness of Animals

That the shield of Odysseus had a dolphin emblazoned on it, Stesichorus also has related: and the Zacynthians perpetuate the reason for it, as Critheus testifies. For when Telemachus was a small boy, so they say, he fell into the deep inshore water and was saved by dolphins who came to his aid and swam with him to the beach; and that was the reason why his father had a dolphin engraved on his ring and emblazoned on his shield, making this requital to the animal.

Translated from the Greek by Harold Cherniss and William C. Helmbold

"Palemon" engraving, ANTOINE CARON, *from "Images de Philostrate"; 16th c. Courtesy of the Robarts Library, University of Toronto*

PLUTARCH

from *The Cleverness of Animals*

From this the wild tales about Coeranus gained credence. He was a Parian by birth who, at Byzantium, bought a draught of dolphins which had been caught in a net and were in danger of slaughter, and set them all free. A little later he was on a sea voyage in a penteconter, so they say, with fifty pirates aboard; in the strait between Naxos and Paros the ship capsized and all the others were lost, while Coeranus, they relate, because a dolphin sped beneath him and buoyed him up, was put ashore at Sicinus, near a cave which is pointed out to this day and bears the name of Coeraneum. It is on this man that Archilochus is said to have written the line *Out of fifty, kindly Poseidon left only Coeranus.* When later he died, his relatives were burning the body near the sea when a large shoal of dolphins appeared off shore as though they were making it plain that they had come for the funeral, and they waited until it was completed.

Translated from the Greek by Harold Cherniss and William C. Helmbold

AELIAN

from *On Animals*

It seems that even Dolphins are more scrupulous than men in showing their gratitude and are not controlled by the Persian custom applauded by Xenophon. And what I have to tell is as follows. One Coeranus by name, a native of Paros, when some Dolphins fell into the net and were captured at Byzantium, gave their captors money, as it were a ransom, and set them at liberty; and for this he earned their gratitude. At any rate he was sailing once (so the story goes) in a fifty-oar ship with a crew of Milesians, when the ship capsized in the strait between Naxos and Paros, and though all the rest were drowned, Coeranus was rescued by Dolphins which repaid the good deed that he had first done them by a similar deed. And the headland and caverned rock to which they swam with him on their backs are pointed out, and the spot is called Coeraneus. Later when this same Coeranus died they burnt his body by the sea-shore. Whereupon the Dolphins, observing this from some point, assembled as though they were attending his funeral, and all the while that the pyre was ablaze they remained at hand, as one trusty friend might remain by another. When at length the fire was quenched they swam away.

Translated from the Greek by A. F. Scholfield

Emblems of the Dauphin, the eldest son of the King of France, 15th c. The practice of calling the heir to the throne the "Dauphin" ("Dolphin") originated with the counts of Vienne in south-east France in the 12th c., who took the title from their family name and heraldic device. In 1349 the heirless Dauphin of Vienne, Humbert II, decided to sell his territory to the King of France, and the title passed with the territory to the King's eldest son. It was used as an honorific, with the dolphin as principal emblem, until the demise of French royal aspirations in 1844. To this day the region around the city of Vienne is known as the Dauphiné. Courtesy of the Musée Cluny, Paris

from *Natural History*

Before these occurrences a similar story is told about a boy in the city of Iasus, with whom a dolphin was observed for a long time to be in love, and while eagerly following him to the shore when he was going away it grounded on the sand and expired; Alexander the Great made the boy head of the priesthood of Poseidon at Babylon, interpreting the dolphin's affection as a sign of the deity's favour. Hegesidemus writes that in the same city of Iasus another boy also, named Hermias, while riding across the sea in the same manner lost his life in the waves of a sudden storm, but was brought back to the shore, and the dolphin confessing itself the cause of his death did not return out to sea and expired on dry land. Theophrastus records that exactly the same thing occurred at Naupactus too.

Translated from the Latin by H. Rackham

PLUTARCH

from *The Cleverness of Animals*

And the goodwill and friendship of the dolphin for the lad of Iasus was thought by reason of its greatness to be true love. For it used to swim and play with him during the day, allowing itself to be touched; and when the boy mounted upon its back, it was not reluctant, but used to carry him with pleasure wherever he directed it to go, while all the inhabitants of Iasus flocked to the shore each time this happened. Once a violent storm of rain occurred and the boy slipped off and was drowned. The dolphin took the body and threw both it and itself together on the land and would not leave until it too had died, thinking it right to share a death for which it imagined that it shared the responsibility. And in memory of this calamity the inhabitants of Iasus have minted their coins with the figure of a boy riding a dolphin.

Translated from the Greek by Harold Cherniss and William C. Helmbold

AELIAN

from *On Animals*

The Dolphin's love of music and its affectionate nature are a constant theme, the former with the people of Corinth (with whom the Lesbians concur), the latter with the inhabitants of Ios. The Lesbians tell the story of Arion of Methymna; what happened in Ios with the beautiful boy and his swimming and the Dolphin is told by the inhabitants of Ios.

A certain Byzantine, Leonidas by name, declares that while sailing past Aeolis he saw with his own eyes at the town called Poroselene a tame Dolphin which lived in the harbour there and behaved towards the inhabitants as though they were personal friends. And further he declares that an aged couple fed this foster-child, offering it the most alluring baits. What is more, the old couple had a son who was brought up along with the Dolphin, and the pair cared for the Dolphin and their own son, and somehow by dint of being brought up together the man-child and fish gradually came without knowing it to love one another, and, as the oft-repeated tag has it, "a super-reverent counter-love was cultivated" by the aforesaid. So then the Dolphin came to love Poroselene as his native country and grew as fond of the harbour as of his own home, and what is more, he repaid those who had cared for him what they had spent on feeding him. And this was how he did it. When fully grown he had no need of being fed from the hand, but would now swim further out, and as he ranged abroad in his search for some quarry from the sea, would keep some to feed himself, and the rest he would bring to his "relations." And they were aware of this and were even glad to wait for the tribute which he brought. This then was one gain; another was as follows. As to the boy so to the Dolphin his foster-parents gave a name, and the boy with the courage born of their common upbringing would stand upon some spot jutting into the sea and call the name, and as he called would use soothing words. Whereat the Dolphin, whether he was racing with some oared ship, or plunging and leaping in scorn of all other fish that roamed in shoals about the spot, or was hunting under stress of hunger, would rise to the surface with all speed, like a ship that raises a great wave as it drives onward, and drawing near to his loved one would frolic and gambol at his side; at one moment would swim close by the boy, at another would seem to challenge him and even induce his favourite to race with him. And what was even more astounding, he would at times even decline the winner's place and actually swim second, as though presumably he was glad to be defeated.

These happenings were noised abroad, and those who sailed thither reckoned them among the excellent sights which the city had to show; and to the old people and to the boy they were a source of revenue.

Translated from the Greek by A. F. Scholfield

PAUSANIAS

from *Guide to Greece*

Among other dedications at Tainaron is Arion the musician in bronze on a dolphin. Herodotos told the story of Arion and the dolphin from hearsay in his records of Lydia; and I have seen the dolphin at Poroselene showing its gratitude to a boy who cured it when it was wounded by fishermen; I saw it come when he called it and carry him when he wanted to ride on it. There is also a water-spring at Tainaron which works no miracles nowadays, but once (so they say) if you looked into the water it would show you the harbours and the ships. A woman stopped the water from ever showing such sights again by washing dirty clothes in it.

Translated from the Greek by Peter Levi

from *Natural History*

A Letter from Pliny the Younger

The dolphin is an animal that is not only friendly to mankind but is also a lover of music, and it can be charmed by singing in harmony, but particularly by the sound of the water-organ. It is not afraid of a human being as something strange to it, but comes to meet vessels at sea and sports and gambols round them, actually trying to race them and passing them even when under full sail. In the reign of the late lamented Augustus a dolphin that had been brought into the Lucrine Lake fell marvellously in love with a certain boy, a poor man's son, who used to go from the Baiae district to school at Pozzuoli, because fairly often the lad when loitering about the place at noon called him to him by the name of Snubnose and coaxed him with bits of the bread he had with him for the journey, — I should be ashamed to tell the story were it not that it has been written about by Maecenas and Fabianus and Flavius Alfius and many others, — and when the boy called to it at whatever time of day, although it was concealed in hiding it used to fly to him out of the depth, eat out of his hand, and let him mount on its back, sheathing as it were the prickles of its fin, and used to carry him when mounted right across the bay to Pozzuoli to school, bringing him back in similar manner, for several years, until the boy died of disease, and then it used to keep coming sorrowfully and like a mourner to the customary place, and itself also expired, quite undoubtedly from longing.

Translated from the Latin by H. Rackham

left
Eros riding a dolphin, marble
fountain ornament from Capua;
1st c. B.C. *Probably a Roman copy*
of a Hellenistic original. Courtesy
of the Museo Nazionale, Naples

right
"Venus and Cupid Carried by
Dolphins" engraving, MARCO
DENTE DA RAVENNA, *after*
Raphael. 27 x 18 cm. Courtesy of the
Trustees of the British Museum

Some years ago there was a sentimental little song, from a sentimental little movie, about a Boy on a Dolphin. It had, of course, a happy ending. Here however is the real story, as it was told by Pliny the Younger in a letter to a friend of his, a poet called Caninius Rufus. Modestly he invites him to improve the story; or perhaps mock-modestly, for no one has yet succeeded in doing so. Even today it is hard to read it without tears. As a simple tale of the triumph of meanness and greed over joy and innocence, it stands alone.

TO CANINIUS RUFUS

I have come across a true story which sounds very like fable, and so ought to be a suitable subject for your abundant talent to raise to the heights of poetry. I heard it over the dinner table when various marvellous tales were being circulated, and I had it on good authority —

though I know that doesn't really interest poets. However, it was one which even a historian might well have trusted.

The Roman town of Hippo is situated on the coast of Africa. Near by is a navigable lagoon, with an estuary like a river leading from it which flows into the sea or back into the lagoon according to the ebb and flow of the tide. People of all ages spend their time here to enjoy the pleasures of fishing, boating, and swimming, especially the boys who have plenty of time to play. It is a bold feat with them to swim out into deep water, the winner being the one who has left the shore and his fellow-swimmers farthest behind. In one of these races a particularly adventurous boy went farther out than the rest. A dolphin met him and swam now in front, now behind him, then played round him, and finally dived to take him on its back, then put him off, took him on again, and first carried him terrified out to sea then turned to the shore and brought him back to land and his companions.

The tale spread through the town; everyone ran up to stare at the boy as a prodigy, ask to hear his story, and repeat it. The following day crowds thronged the shore, watched the sea, and anything like the sea, while the boys began to swim out, amongst them the same boy, but this time more cautious. The dolphin punctually reappeared and approached the boy again, but he made off with the rest. Meanwhile the dolphin jumped and dived, coiled and uncoiled itself in circles as if inviting and calling him back. This was repeated the next day, the day after, and several more occasions, until these people, who are bred to the sea, began to be ashamed of their fears. They went up to the dolphin and played with it, called it, and even touched and stroked it when they found it did not object, and their daring increased with experience. In particular the boy who first met it swam up when it was in the water, climbed on its back, and was carried out to sea and brought back; he believed it knew and loved him, and he loved it. Neither was feared nor afraid, and the one grew more confident as the other became tamer. Some of the other boys

from *On Animals*

used to go with him on either side, shouting encouragement and warnings, and with it swam another dolphin (which is also remarkable), but only to look on and escort the other, for it did not perform the same feats nor allow the same familiarities, but only accompanied its fellow to shore and out to sea as the boys did their friend. It is hard to believe, but as true as the rest of the story, that the dolphin who carried and played with the boys would even come out on the shore, dry itself in the sand, and roll back into the sea when it felt hot.

Then, as is generally known, the governor Octavius Avitus was moved by some misguided superstition to pour scented oil on the dolphin as it lay on the shore, and the strange sensation and smell made it take refuge in the open sea. It did not reappear for many days, and then seemed listless and dejected, but as it regained strength it returned to its former playfulness and usual tricks. All the local officials used to gather to see the sight, and their arrival to stay in the little town began to burden it with extra expense, until finally the place itself was losing its character of peace and quiet. It was then decided that the object of the public's interest should be quietly destroyed.

I can imagine how sadly you will lament this ending and how eloquently you will enrich and adorn this tale — though there is no need for you to add any fictitious details; it will be enough if the truth is told in full.

Translated from the Latin by Betty Radice

right
Hermes riding two dolphins,
polychrome floor mosaic; 2nd c. B.C.
Delos, Greece

The story of a Dolphin's love for a beautiful boy at Iassus has long been celebrated, and I am determined not to leave it unrecorded; it shall accordingly be told.

The gymnasium at Iassus is situated close to the sea, and after their running and their wrestling the youths in accordance with an ancient custom go down there and wash themselves. Now while they were swimming about, a Dolphin fell passionately in love with a boy of remarkable beauty. At first when it approached, it frightened the boy and completely scared him; later on, however, through constant meeting, it even led the boy to conceive a warm friendship and kindly feelings towards it. For instance, they began to sport with one another: and sometimes they would compete, swimming side by side in rivalry, sometimes the boy would mount, like a rider on a horse, and be carried proudly along on the back of his lover. And to the people of Iassus and to strangers the event seemed marvellous. For the Dolphin would go a long way out to sea with its darling on its back and as far as it pleased its rider; then it would turn and bring him close to the beach, and they would part company and return, the Dolphin to the open sea, the boy to his home. And the Dolphin used to appear at the hour when the gymnasium was dismissed, and the boy was delighted to find his friend expecting him and to play together. And besides his natural beauty, this too made him the admired of all, namely that not only men but even dumb animals thought him a boy of surpassing loveliness.

In a little while however even this mutual affection was destroyed by Envy. Thus, it happened that the boy exercised himself too vigorously, and in an exhausted state threw himself belly downwards on to his mount, and as the spike on the Dolphin's dorsal fin chanced to be erect it pierced the beautiful boy's navel. Whereupon certain veins were severed; there followed a gush of blood; and presently the boy died. The Dolphin perceiving this from the weight — for the boy lay heavier than usual, as he could not lighten himself by breathing — and seeing the surface of the water crimson with blood, realised what had happened and could not bear to survive its darling. And so with all the gathered force of a ship dashing through the waves it made its way to the beach and deliberately cast itself upon the shore, bringing the dead body with it. And there they both lay, the boy already dead, the Dolphin breathing its last. (But Laïus, my good Euripides, did not act so in the case of Chrysippus, although, as you yourself and the common report tell me, he was the first among the Greeks to inaugurate the love of boys.) And the people of Iassus to requite the ardent friendship between the pair built one common tomb for the beautiful youth and the amorous Dolphin, with a monument at the head. It was a handsome boy riding upon a Dolphin. And the inhabitants struck coins of silver and of bronze and stamped them with a device showing the fate of the pair, and they commemorated them by way of homage to the operation of the god who was so powerful.

And I learn that at Alexandria also, in the reign of Ptolemy II, a Dolphin was similarly enamoured; at Puteoli also, in Italy. So, had these facts been known to Herodotus, I think they would have surprised him no less than what happened to Arion of Methymna.

Translated from the Greek by A. F. Scholfield

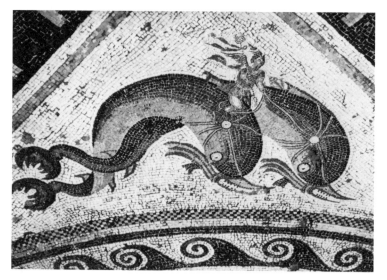

DAVID R. SHADDOCK

Dolphin, to Man

A Greek coin, lost at sea,
stamped with a boy astride my back.
Over a wave we arc. For the boy
the ride of a lifetime.

What is there on the other side
of wave? A trough. A
nother. What mint, what
discourse expects, what hand
grabbing expects —

but more wave rocking
and salt in his hair
and a belly thrill
as we crest and tail-surf.

Once in men's minds we swam,
from Delphi to the sea,
caressed, in them, such downy-haired
bronze-skinned youth as this.
Maidens surged with dolphin tingle
laughing on the crest of moon-tide.

What boy's lyre song then
did not mingle with dolphin's?

Now we are extinct in those mental seas.
Where did the boy go?
He's trapped in metal,
heavy, unbuoyant, in the shadows of
 sea-bottom,
far from the dance of sun and waves.

What could they expect to buy
with such as this?
What when in that instant,
the boy, and in apprehension of him,
their minds,
had everything.

DOROTHY LIVESAY

On Seeing "The Day of the Dolphin"

Years later
he might wander on that
 shore
ageing and alone
longing not for wife
nor children grown
but for Alpha
"Fah" that dolphin
loved cavorting

He might wander back and
 forth
kicking at sand sharp pebbles
 shells
wishing to see that more
 vibrant
dance of life:
body action
ballet leap
from ocean
into ocean shelter
"going to English school"—
that squeaky dolphin shriek:
"Fah love Pa."

Because of touch
loving survives
even amongst humans
always amongst dolphins

O rub my shoulders
stroke my finny skin!
convince me
I am next of kin.

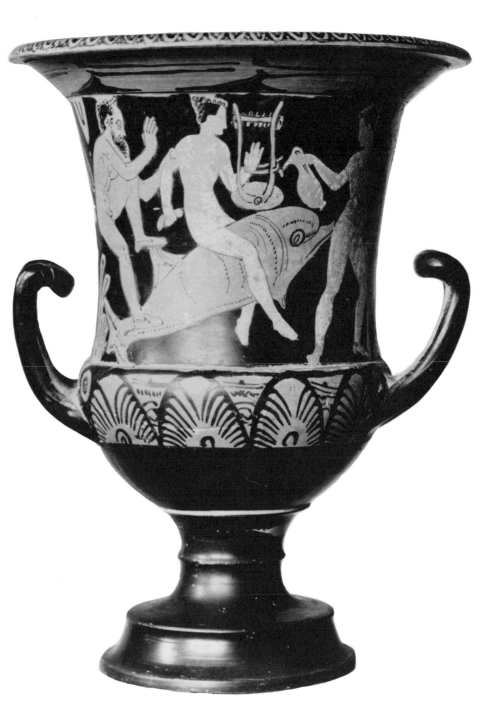

*Red-figured cylix-crater, Etruscan,
ca 350 B.C. Provenance unknown.
Courtesy of the Royal Ontario
Museum, Toronto*

The Ape and the Dolphin

from The Thousand and One Nights

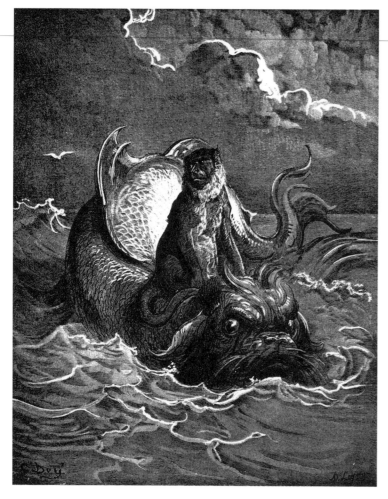

"The Ape and the Dolphin"
engraving, GUSTAVE DORÉ, *from*
"Les Fables" of Jean de La Fontaine
(Paris, 1868)

Among the Greeks it was understood
That almost every voyager
Would provide as an interlude
Trick monkeys or dogs with his traveling gear.
Now a barque on which such toys were conveyed,
Went down near Athens, it is said,
And all would have perished at sea
But that porpoises mercifully
Are friends of mankind, as Pliny records,
And no one disputes this author's words.
Well, helpful dolphins swam about;
Even an ape who shared the mischance,
Possessed so human a countenance
That he was assisted to clamber out,
Instead of be drowned far from home.
A porpoise afforded him a chair,
As though a composer were in his care
And Arion been drawn from the foam.
Meanwhile in bearing the ape ashore,
The dolphin presently inquired,
"You are from Athens, the much admired?"
— "Ah yes; the same. I am well known there,"
The ape replied. "Permit me, sir,
To serve you; I am a favored man;
The entire world venerates my clan;
My cousin is Justice — a high officer."
The dolphin replied, "A courtesy.
Of course as a celebrity
Your fame has doubtless equally
Charmed Piraeus; a reputation gains."
— "Quite so. He's devoted to me
With an ardor that never wanes,"
Our impostor said — neatly caught,
By confusing inhabitant with home:

Many a fool plays aristocrat,
Not knowing Vaugirard from Rome;
Boasting he's seen this spot and that
Whereas his alps have all been flat.

The dolphin smiled and turned his head,
Appraised his gem, saw what he'd done,
And having saved from oblivion
An ordinary quadruped,
Swirled him right into the ocean
And swam back to save a person.

Translated from the French by Marianne Moore

It hath reached me, O auspicious King, that
when Abdullah was a-wearied with watching,
and wanted to sleep, they also lay beside him
on another couch and waited till he was drowned
in slumber, and when they were certified thereof
they arose and knelt upon him: whereupon he
awoke, and, seeing them kneeling on his breast,
said to them, "What is this, O my brothers?"
Cried they, "We are no brothers of thine, nor
do we know thee, unmannerly that thou art!
Thy death is become better than thy life." Then
they gripped him by the throat and throttled
him, till he lost his senses and abode without
motion; so that they deemed him dead. Now
the pavilion wherein they were overlooked the
river; so they cast him into the water; but when
he fell, Allah sent to his aid a dolphin, who was
accustomed to come under that pavilion because
the kitchen had a window that gave upon the
stream; and as often as they slaughtered any
beast there, it was their wont to throw the refuse
into the river, and the dolphin came and picked
it up from the surface of the water; wherefore
he ever resorted to the place. That day they had
cast out much offal by reason of the banquet;
so the dolphin ate more than of wont and gained
strength. Hearing the splash of Abdullah's fall
he hastened to the spot, where he saw a son of
Adam, and Allah guided him so that he took

R. F. BRISSENDEN

The Whale in Darkness

the man on his back and crossing the current made with him for the other bank, where he cast his burthen ashore. Now the place where the dolphin cast up Abdullah was a well-beaten highway, and presently up came a caravan, and finding him lying on the river bank, said, "Here is a drowned man, whom the river hath cast up"; and the travellers gathered around to gaze at the corpse. The Shaykh of the caravan was a man of worth, skilled in all sciences and versed in the mystery of medicine, and withal, sound of judgment: so he said to them, "O folk what is the news?" They answered, "Here is a drowned man"; whereupon he went up to Abdullah and, examining him, said to them, "O folk, there is life yet in this young man, who is a person of condition and of the sons of the great, bred in honour and fortune, and Inshallah, there is still hope of him."

Translated from the Arabic by Sir Richard Burton

Fishing at night under a rising moon
We have felt your great hulk like an island move
Beneath our boat; and riding the quiet swell
At dawn before the winds begin to stir
We've watched your cousin the sleek dolphin break
Clear of the grey Pacific in a rainbowed
Ecstasy of killing. Everything
In the murderous sea is eating everything else
Continually and nothing wants to die:
The plankton fight for one last eternal moment
As they snag on your mesh of teeth and the mullet shudders
As its back snaps in the dolphin's smiling mouth.
Hungry intelligent and beautiful you show
No mercy and expect none – yet we must
Learn to be merciful to you: the barbed
Grenades that burst and tear your flesh begin
To shake our hearts – for in your belly you
Still bear us and the world as once you bore
The weeping angry man. Will there be time
Before the sky rains blood for us to speak
With love and spare what we would kill? We wait
For the hot squall to lift, the harpoon guns
To cease: perhaps we yet may hear together
The lost boy singing as he rides once more
The dolphin's arching back across the sea.

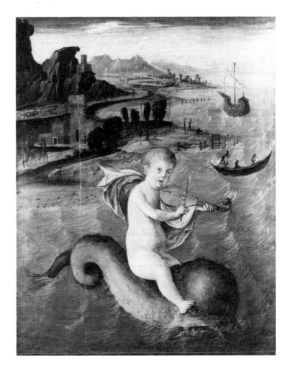

"Boy on a Dolphin", BIANCHI FERRARI, *oil on canvas. Courtesy of the Ashmolean Museum, Oxford*

left
Ornament with four genii, sea horse, and dolphin, engraving by JACOB BINK, *2.7 x 7.9 cm. Courtesy of the Trustees of the British Museum*

ANDREI GERMANOV

Poem

left
"Eros on a Dolphin", *lunette fresco*,
SEBASTIANO DEL PIOMBO; *1511.*
Villa Farnesina, Rome

Thousands of years on end the Dolphin swims in the sea.
He comes from far away and swims, swims in this sea,
Carrying the dead boy on his back. The dead boy he saves.
And in his way tragic and eternal he'll keep swimming in the sea.

Arion

Periander, who disclosed the oracle's answer to Thrasybulus, was the son of Cypselus, and sovereign lord of Corinth. As the Corinthians and Lesbians agree in relating, there happened to him a thing which was the most marvellous in his life, namely, the landing of Arion of Methymna on Taenarus, borne thither by a dolphin. This Arion was a lyre-player second to none in that age; he was the first man, as far as we know, to compose and name the dithyramb which he afterwards taught at Corinth.

Thus then, the story runs: for the most part he lived at the court of Periander; then he formed the plan of voyaging to Italy and Sicily, whence, after earning much money, he was minded to return to Corinth. Having especial trust in men of that city, he hired a Corinthian ship to carry him from Taras. But when they were out at sea, the crew plotted to cast Arion overboard and take his money. Discovering the plot, he earnestly entreated them, offering them all his money if they would but spare his life; but the sailors would not listen to him; he must, they said, either kill himself and so receive burial on land, or straightway cast himself into the sea. In this extremity Arion besought them, seeing that such was their will, that they would suffer him to stand on the poop with all his singing robes about him and sing; and after his song, so he promised, he would make away with himself. The men, well pleased at the thought of hearing the best singer in the world, drew away from the stern amidships; Arion, putting on all his adornment and taking his lyre, stood up on the poop and sang the "Shrill Strain," and at its close threw himself without more ado into the sea, clad in his robes. So the crew sailed away to Corinth; but a dolphin (so the story goes) took Arion on his back and bore him to Taenarus. There he landed, went to Corinth in his singing robes, and when he came told all that had befallen him. Periander, not believing the tale, put him in close ward and kept careful watch for the coming of the sailors. When they came they were called and questioned, what news they brought of Arion, and they replied that he was safe in the parts of Italy, and that they had left him sound and well

at Taras: when, behold, they were confronted with Arion, just as he was when he leapt from the ship; whereat they were amazed, and could no more deny what was proved against them. Such is the story told by the Corinthians and Lesbians. There is moreover a little bronze monument to Arion on Taenarus, the figure of a man riding upon a dolphin.

PSYCHE IN NAVI À DELPHINIS VECTA

Cornecta in Anulo Aureo Antiq. Apud Antonium Borionum

MAURIZIO NANNUCCI
Untitled, 1980
collage, 7.5 x 8.5 cm

Translated from the Greek by A. D. Godley

MARCUS CORNELIUS FRONTO

from Correspondence

Arion of Lesbos, according to Greek tradition foremost as player on the lyre and as dithyrambist, setting out from Corinth, where he constantly sojourned, in pursuit of gain, after amassing great riches in the coast-towns of Sicily and Italy, prepared to make his way home from Tarentum to Corinth. For his ship's crew he chose Corinthians by preference, and boldly freighted their ship with his immense gains. When the ship was well out at sea he realized that the crew, coveting the wealth which they carried, were plotting his death. He wearied them with prayers to take all his gold for themselves, but leave him his life alone. When that boon was denied him, he was yet granted another grace, in taking farewell of life to sing as much as he would. The pirates put it down as so much to the good that over and above their booty they should hear a consummate artist sing, to whose voice moreover no one should ever thereafter listen. He donned his robe embroidered with gold, and withal his famous lyre. Then he took his stand before the prow in the most open and elevated place, the crew being afterwards intentionally scattered over the rest of the ship. There Arion, exerting all his powers, began to sing for sea and sky, look you, the last reminder of his skill. His song ended, with a word on his lips he sprang into the sea: a dolphin received him, carried him on his back, outstripped the ship, landed him at Taenarus as near the shore as a dolphin might.

Thence Arion made his way to Corinth, man and robe and lyre and voice all safe; presented himself before Periander, the king of Corinth, who had long known him and esteemed him for his skill; recounted in order what had happened on the ship and subsequently in the sea. The king believed the man but did not know what to think of the miracle, and waited for the return of ship and crew. When he learnt that they had put into harbour, he gave orders for their being summoned without any excitement; questioned them with a pleasant countenance and gentle words as to whether they had any news of Arion the Lesbian. They answered glibly that they had seen that most fortunate of men at Tarentum making golden profits and applauded by all, his profession being to sing to the lyre: and that his stay was prolonged by reason of his popularity, his profits, and his praises. As they were saying this, Arion sprang in safe and sound, just as he had stood on the ship's stern with his gold-embroidered robe and his famous lyre. The pirates were dumbfounded at the unexpected sight, nor did they thereafter attempt any denial or disbelief or exculpation. The dolphin's exploit is recorded by a statue set up at Taenarus of a man seated on a dolphin, small in size and executed as a subject-piece rather than as a likeness.

Translated from the Latin by C. R. Haines

bottom
''Arion Riding a Dolphin'',
ALBRECHT DÜRER; 1514. *Pen and brown ink, brush with watercolour, 14 x 23 cm. Courtesy of the Kunsthistorisches Museum, Vienna*

top
Ornamental engraving (detail),
DANIEL HOPFER. *12 x 12 cm. Courtesy of the Trustees of the British Museum*

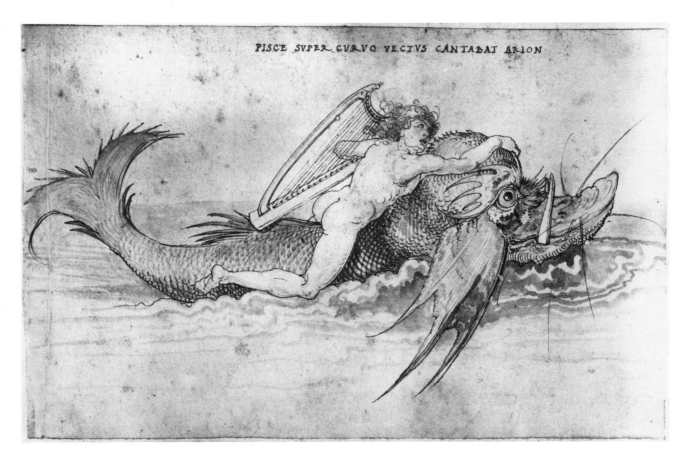

PISCE SVPER CVRVO VECTVS CANTABAT ARION

GEORGE WOODCOCK

Arion Sings of his Rescue

I woke to hear them talking of my death.
Gold was the prize, my life the inconvenience.
One talked of knives. One of the axe.
One said a poet should have silken strangling.
The mildest spoke of drowning.
I ceased pretending sleep. The gold
Was in their hands, guilt in their eyes
And anger in their voices. I did plead
Not to be killed with blood. I asked
To suffer the sweet strangling of the sea.
I asked to sing one song before I died.
The mild agreed, the angry shouted,
Yet as I struck my lyre fell silent,
And joined the others as the song was ending
To spill me in the sparkling waters.

No land in sight and archers on the deck,
I let my lyre float off and hopelessly
Swam outward from the ship.
Then did the waters surge
With leaping bodies, and the dolphin's back
Rose dark and glistening up between my legs,
And I rode singing on the summer sea,
And heard the dancing beasts around me sing
And, deep below, the ocean ringing
As the whales sang of the great freedom
In all their weight and wisdom, Leviathan
Whose enemies were not yet born.

Then the cloud came, the sea grew wine-dark,
My song fell sombre for I saw the future,
Leviathan among his foes as I
Among the robbing sailors, wisdom
Losing its weight and weight its reason
A man, the cruellest of all
Creatures and the most cunning,
Destroys the great free beings of the earth.
I see the wild as dead, the elephants stampede
Towards extinction, in their death throes
Trumpet the end of all whales' singing.

Does it console me as my song grows darker
That those who kill the free destroy
Their own freedom, those who destroy
The wise die from their own folly?

I see an empty world, the whale's path
Silent, and a lifeless waste
The elephant's ground, the cities sand and salt,
The last man drowning in the barren waters
And no beast there to answer to his song
And take him riding to the sands of life
Where I wade in, embrace my brother beast,
And sing him back towards the ringing depths.

right
"Arion and the Dolphin",
ANNIBALE CARRACCI, *ceiling*
fresco, Villa Farnese, Rome; ca 1596.
Courtesy Istituto Centrale per il
Catalogo e la Documentazione

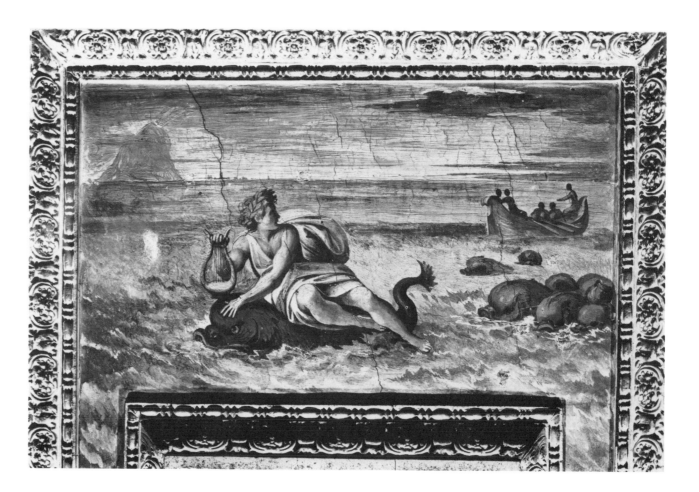

SEXTUS PROPERTIUS
Poem

I saw you, darling, shipwrecked in my dream
plying with weary stroke the Ionian spray;
for every falsehood you confessed your sin,
and bowed your hair beneath the water's
 weight,
tossed like Helle on the livid deep
when she fell from the fleecy back of a golden
 sheep.

O how I feared some sea would bear your name,
and men would sail your waters in dismay.
I prayed to Neptune, Castor and his twin,
and you, Leucothoe, made divine of late.
Above the waves you stretched your fingertips,
and as you sank my name was on your lips.

If Glaucus had beheld those eyes of yours,
 then you'd be mistress of the Ionian sea,
and have to listen to the spiteful jeers
 of white Nesaee and blue Cymothoe.

But then I saw a dolphin swift to save,
 the one, no doubt, that bore Arion's lyre.
High on a rock I steeled myself to dive —
 and the dream faded, shattered by my fear.

Translated from the Latin by John Warden

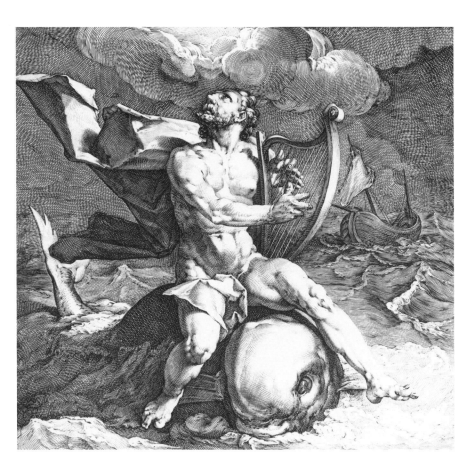

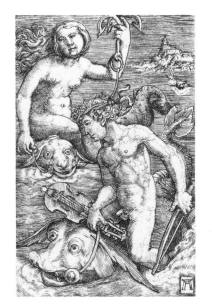

top
''Arion on a Dolphin'' engraving,
JAN MULLER, after Cornelisz,
33 x 35 cm. Courtesy of the Trustees of
the British Museum

''Arion and Nereid'' engraving,
ALBRECHT ALTDORFER, 6 x 4 cm.
Courtesy of the Trustees of the British
Museum

top left
Three men-of-war and Arion on a
dolphin (detail), engraving, PIETER
BRUEGEL THE ELDER; 1565.
22 x 29 cm

ROY FULLER
Arion to the Dolphin

I wonder you were drawn
By songs of human love:
Your eye rose out of the deep
At one end of a grin,
As a bird's at ill-temper's end.

I thought they were my last
When, from the pirates' plank,
I leapt in my singing robe
Among the crowded waves
Of the listening escort. But
Your curved, fur-coated back
Buoyed my faint thighs and
 towed
Me straight to Corinth's quay.

You wouldn't leave. I saw
You craved the finenesses,
The stammerings, of air;
And Corinth's luxuries —
From which you died at last,
Like any Corinthian.

My patron, the tyrant king,
Chose the elaborate tomb
I'd raised above your poor
Blubber as setting for
My resurrected self
Proving the sailors false,
The usual human lies.
At his command, they joined
Your nonsensical decay.

Voyages, tyrannies —
Background of song. The fate
Of singers — to be set
By Apollo in the skies,
If lucky. But my love:
As I look down, I see
How marvellous it was —
Amused at your gluttony,
Concerned about the curve,
Not speaking the tongue of
 clicks
Nor even knowing your sex.
What purity have air,
Water and passion for those
Strange to such elements!

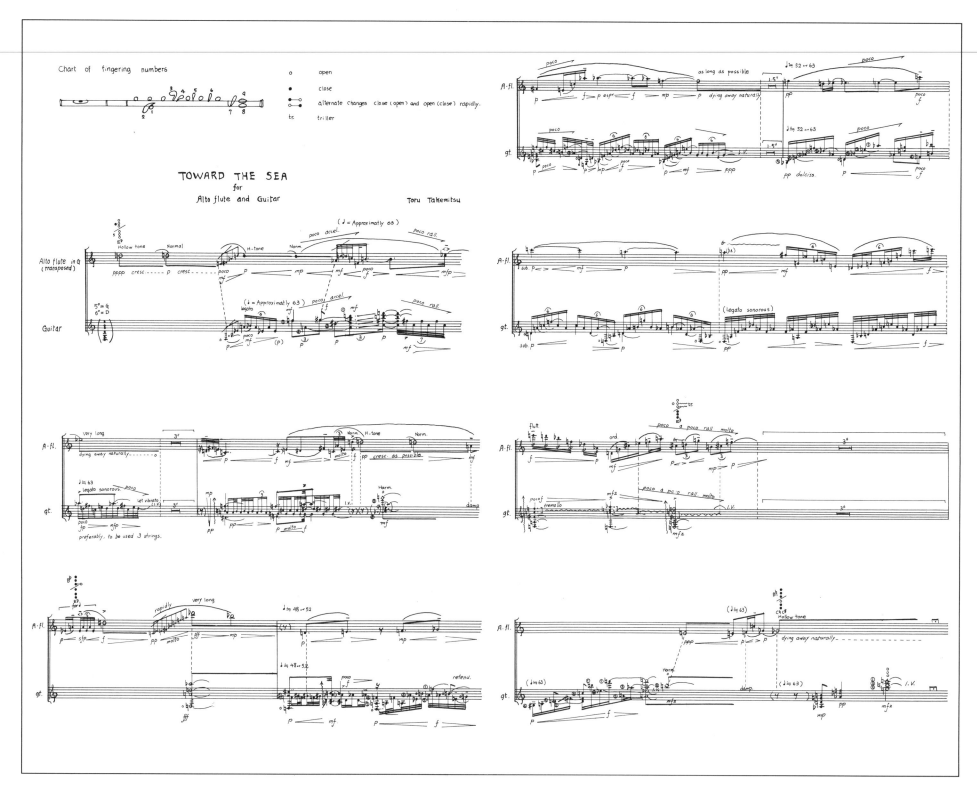

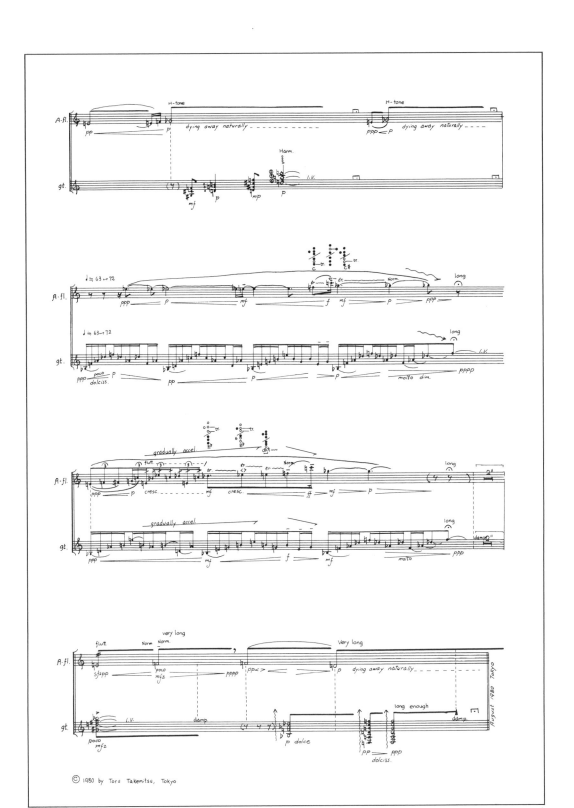

HELEN SHAW

Playful Lovesong

A gilded harp I'll play
To call you up, and
Quivering soundwaves send
To lure you. My arms embracing
The instrument I'll
Send the music underwater
Rippling. O my dolphin
The sea's an empty palace
Until for delight I conjure
Up a playful lovesong.
 Through the portals of the harp
 To this harpist, dolphin, leap

As fluttering doves follow;
And riding through the sea
We'll send bright waves
Around the palace echoing.
Who'll guess my dolphin's name
My dearest myth?
My mystery?
While, in the sea of paradise,
Will be harvested netted
The fruit of golden branches
 As my dolphin brings to earth —
 To this harpist, a silver youth.

Cetus, a letter from Jonah

The whales
are singing.
They answer
each other.
They move
through the water
repeating
strange verses.
Listen, God.
Listen.

I would be frightened
if it were not
for the singing.
I move through a space
where Cetus,
at midnight,
is swimming
toward
Delphinus
singing.

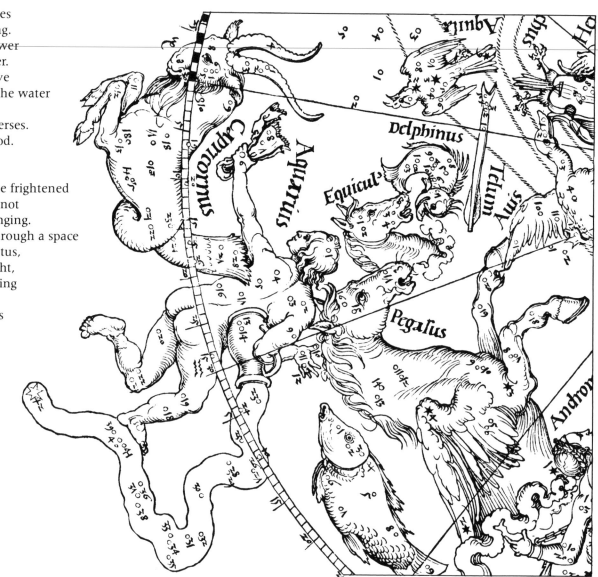

*"Celestial Map of the Northern
Hemisphere" (detail, the
constellation Delphinus) by
ALBRECHT DÜRER, 1515, woodcut,
42 x 42 cm. Courtesy of the National
Gallery of Art, Washington, D.C.,
Rosenwald Collection*

from *Fasti*

The Dolphin, which of late thou didst see
fretted with stars, will on the next night escape
thy gaze. (He was raised to heaven) either
because he was a lucky go-between in love's
intrigues, or because he carried the Lesbian lyre
and the lyre's master. What sea, what land
knows not Arion? By his song he used to stay
the running waters. Often at his voice the wolf
in pursuit of the lamb stood still, often the lamb
halted in fleeing from the ravening wolf; often
hounds and hares have couched in the same
covert, and the hind upon the rock has stood
beside the lioness: at peace the chattering crow
has sat with Pallas' bird, and the dove has been
neighbour to the hawk. 'Tis said that Cynthia
oft hath stood entranced, tuneful Arion, at
thy notes, as if the notes had been struck by
her brother's hand. Arion's fame had filled
Sicilian cities, and by the music of his lyre he
had charmed the Ausonian land. Thence
wending homewards, he took ship and carried
with him the wealth his art had won. Perhaps,
poor wretch, thou didst dread the winds and
waves, but in sooth the sea was safer for thee
than thy ship. For the helmsman took his stand
with a drawn sword, and the rest of the
conspiring gang had weapons in their hands.
What wouldst thou with a sword? Steer the
crazy bark, thou mariner; these weapons ill
befit thy hands. Quaking with fear the bard, "I
deprecate not death," said he, "but let me take
my lyre and play a little." They gave him leave
and laughed at the delay. He took the crown
that might well, Phoebus, become thy locks; he
donned his robe twice dipped in Tyrian purple:
touched by his thumb, the strings gave back a
music all their own, such notes as the swan
chants in mournful numbers when the cruel
shaft has pierced his snowy brow. Straightway,
with all his finery on, he leaped plump down
into the waves: the refluent water splashed the
azure poop. Thereupon they say (it sounds past

from *Poetica Astronomica*

credence) a dolphin did submit his arched back to the unusual weight; seated there Arion grasped his lyre and paid his fare in song, and with his chant he charmed the ocean waves. The gods see pious deeds: Jupiter received the dolphin among the constellations, and bade him have nine stars.

Translated from the Latin by Sir James George Frazer

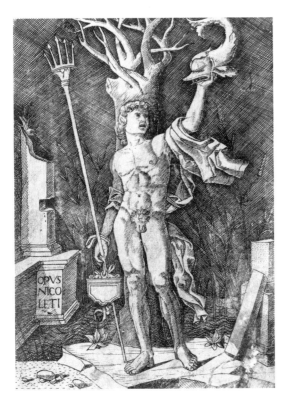

"Neptune" engraving, NICOLETTO DA MODENA, *17 x 12 cm. Courtesy of the Trustees of the British Museum*

Eratosthenes and others give the following reason for the dolphin's being among the stars. Amphitrite, when Neptune desired to wed her and she preferred to keep her virginity, fled to Atlas. Neptune sent many to seek her out, among them a certain Delphin, who, in his wanderings among the islands, came at last to the maiden, persuaded her to marry Neptune, and himself took charge of the wedding. In return for this service, Neptune put the form of a dolphin among the constellations. More than this, we see that those who make statues of Neptune place a dolphin either in his hand or beneath his foot — a thing that they think will please the god especially.

Aglaosthenes, who wrote the *Naxica*, says that there were certain Tyrrhenian shipmasters, who were to take Father Liber, when a child, to Naxos with his companions, and give him over to the nymphs, his nurses. Both our writers and many Greek ones, in books on the genealogy of the gods, have said that he was reared by them. But, to return to the subject at hand, the shipmasters, tempted by love of gain, were going to turn the ship off course, when Liber, suspecting their plan, bade his companions chant a melody. The Tyrrhenians were so charmed by the unaccustomed sounds that they were seized by desire even in their dancing, and unwittingly cast themselves into the sea, and were there made dolphins. Since Liber desired to recall thought of them to men's memory, he put the image of one of them among the constellations.

Others, however, say that this is the dolphin which bore Arion, the citharist, from the Sicilian Sea to Taenarum. He excelled all others in skill, and was travelling about the islands for the sake of gain, when his servants, thinking there was more profit in treacherous freedom than in quiet servitude, planned to cast their master into the sea and divide his goods among them. When he realized their designs, he asked from them, not as a master from his slaves, nor as an innocent man from evil-doers, but as a father from his sons, to allow him to attire himself in the garb he had often worn when victor, since there was no other who, so well as

himself, could honor his death with lamentation. When he had obtained permission, straightway taking up his cithara, he began to mourn his own death, and attracted by the sweet sounds, dolphins from all over the sea swam along at the singing of Arion. Then, invoking the power

*"The Constellation Delphinus" from the vital Persian astronomical text "The Book of the Fixed Stars" (*MS *Marsh 144, p. 148) by Abd al-Rahman al Sufi, illustrated by his son; ca 1010* A.D. *In the Islamic cosmology the stars were affixed to the ninth sphere of the heavens, and all depictions of the constellations showed them as they would be seen from earth and also from outside the firmament. Courtesy of the Bodleian Library, Oxford*

from *Halieutica*

of the immortal gods, he threw himself down upon them, and one of them took him and carried him to the shore at Taenarum. In memory of this, the statue of Arion placed there seems to have on it the likeness of a dolphin, and for this happening the dolphin's form is pictured by ancient astronomers among the constellations. But the slaves who thought they had escaped from servitude, driven by a storm to Taenarum, were seized by their master and visited with no slight punishment.

*Translated from the Latin
by Mary Grant*

The Dolphins both rejoice in the echoing shores and dwell in the deep seas, and there is no sea without Dolphins; for Poseidon loves them exceedingly, inasmuch as when he was seeking the dark-eyed daughter of Nereus who fled from his embraces, the Dolphin marked her hiding in the halls of Ocean and told Poseidon; and the god of the dark hair straightway carried off the maiden and overcame her against her will. Her he made his bride, queen of the sea, and for their tidings he commended his kindly attendants and bestowed on them exceeding honour for their portion.

Translated from the Greek by A. W. Mair

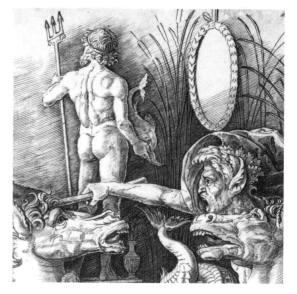

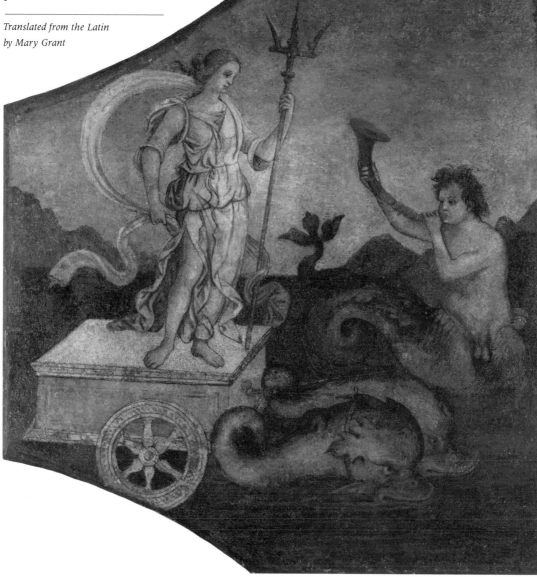

top
''Battle of the Sea Gods'' (detail), engraving, ANDREA MANTEGNA; ca 1493. 34 x 45 cm. Courtesy of the Trustees of the British Museum

left
''The Triumph of Amphitrite'', PINTORICCHIO. Ceiling fresco painted ca 1508, transferred to canvas, from the Palazzo del Magnifico, Sienna. Courtesy of the Metropolitan Museum of Art, New York, Rogers Fund, 1914

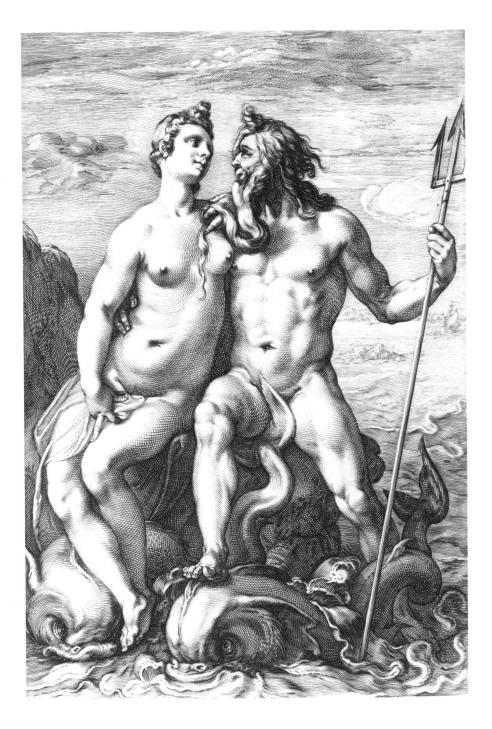

"Neptune and Amphitrite"
engraving, JAN SAENREDAM *after*
Goltzius. 31 x 21 cm. Courtesy of the
Trustees of the British Museum

Red-figured lekythos (detail) — nereid
with dolphin — by the PAINTER OF
THE BOLOGNA BOREAS, *ca 460* B.C.
Courtesy of the Metropolitan Museum
of Art, New York, Rogers Fund, 1920

Red-figured neck amphora (detail) —
Poseidon with dolphin — by the
BERLIN PAINTER, *ca 470-465* B.C.
Courtesy of the Metropolitan Museum
of Art, New York, Rogers Fund, 1941

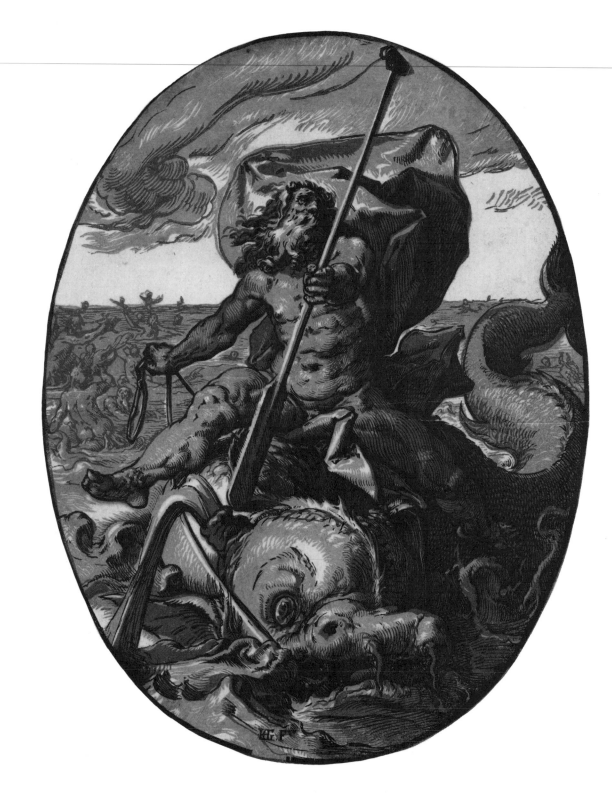

ROSEMARY DOBSON

The Dolphin

Amphitrite, the Nereid, outshining in grace and celerity
Each of her forty-nine sisters, courted by Neptune,
Slipped shyly from wave-crest to wave-crest, deft in avoidance.
Ardent, pursuant, the amorous King of the Ocean
Cried out for assistance to whom but the keen-witted, eloquent
Dolphin.
Personable, sleek, as fitted to be an emissary
As a swallow-tailed, top-hatted gentleman, pausing
On the steps to the Court of St. James,
Versed in the ninety-nine arts of diplomacy, needing
Little instruction, subtle, disarming,
He stayed the fugitive sea-nymph.
Gently he won her
With praise of her lover, and gently, gently he drew her
In a frisson of wavelets to Neptune, her King and her Consort.

Suddenly, everywhere, people are talking about dolphins,
They call them the sheep-dogs of the sea, applaud their ability
To communicate one with another in the language of dolphins.
How amenable they are to direction, helpful to man!
We hear they will round up schools of edible fishes,
Indicate the presence of plankton, deliver a message —
I deplore the thought of a kind of aquatic postman.

Neptune knew better.
With a proper regard for the dignity of the dolphin
And for services given he had him translated to heaven.
At the levee of night observe him, with decorations,
Resplendent, discreet, the dean of the constellations.

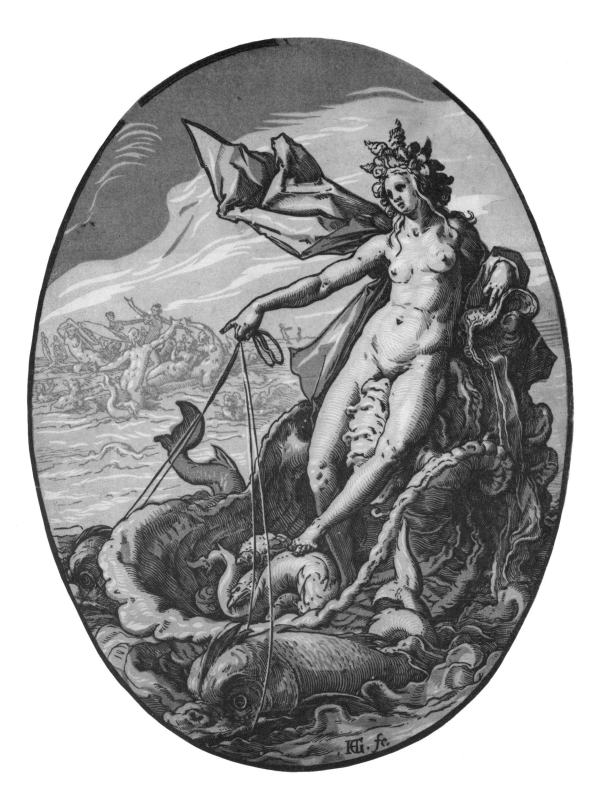

47

from Poetica Astronomica

from Ode Sixteen

from Dionysiaca

It is said that when Theseus came to Crete to Minos with seven maidens and six youths, Minos, inflamed by the beauty of one of the maidens, Eriboea by name, wished to lie with her. Theseus, as was fitting for a son of Neptune, and one able to strive against a tyrant for a girl's safety, refused to allow this. So when the dispute became one not about the girl but about the parentage of Theseus, whether he was the son of Neptune or not, Minos is said to have drawn a gold ring from his finger and cast it into the sea. He bade Theseus bring it back, if he wanted him to believe he was a son of Neptune; as for himself, he could easily show he was a son of Jove. So, invoking his father, he asked for some sign to prove he was his son, and straightway thunder and lightning gave token of assent. For a similar reason, Theseus, without any invoking of his father or obligation of an oath, cast himself into the sea. And at once a great swarm of dolphins, tumbling forward over the sea, led him through gently swelling waves to the Nereids. From them he brought back the ring of Minos and a crown, bright with many gems, from Thetis, which she had received at her wedding as a gift from Venus. Others say that the crown came from the wife of Neptune, and Theseus is said to have given it to Ariadne as a gift, when on account of his valor and courage she was given to him in marriage. After Ariadne's death, Liber placed it among the constellations.

Translated from the Latin by Mary Grant

So the bark sped fast on its journey, and the northern breeze, blowing astern, urged it forward. But all the Athenian youths and maidens shuddered when the hero sprang into the deep; and tears fell from their bright young eyes, in prospect of their grievous doom.

Meanwhile dolphins, dwellers in the sea, were swiftly bearing mighty Theseus to the abode of his sire, lord of steeds; and he came unto the hall of the gods. There beheld he the glorious daughters of blest Nereus, and was awe-struck; for a splendour as of fire shone from their radiant forms; fillets inwoven with gold encircled their hair; and they were delighting their hearts by dancing with lissom feet.

Translated from the Greek by Richard C. Jebb

''Rape of Europa'', TITIAN;
1562. Oil on canvas, 1.78 x 2.05 m
Courtesy of the Isabella Stewart
Gardner Museum, Boston

But the maiden, a light freight for her bull-barge, sailed along oxriding, with a horn for a steering-oar, and trembled at the high heaving of her watery course, while Desire was the seaman. And artful Boreas bellied out all her shaking robe with amorous breath, love-sick himself, and in secret jealousy, whistled on the pair of unripe breasts. As when one of the Nereïds has peeped out of the sea, and seated upon a dolphin cuts the flooding calm, balanced there while she paddles with a wet hand and pretends to swim, while the watery wayfarer half-seen rounds his back and carries her dry through the brine, while the cleft tail of the fish passing through the sea scratches the surface in its course, — so the bull lifted his back: and while the bull stretched, his drover Eros flogged the servile neck with his charmed girdle, and lifting bow on shoulder like a pastoral staff, shepherded Hera's bridegroom with Cypris' crook, driving him to Poseidon's watery pasture.

Translated from the Greek by W.H.D. Rouse

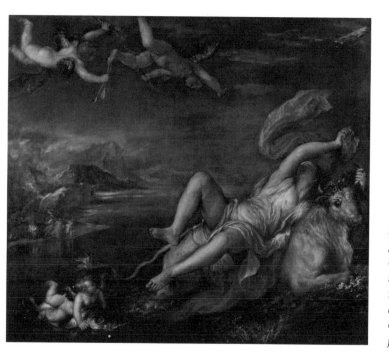

right
Map of Venice (detail, lower central portion) by JACOPO DE 'BARBARI, *ca 1500, 67.8 x 100.3 cm. This massive woodcut features Neptune riding a dolphin to symbolize the city's maritime power. Courtesy the Cleveland Museum of Art, purchase from J.H. Wade Fund*

King Sulemani and the Dolphin

King Sulemani and the Whale

In the days of King Sulemani there were no dolphins. Sulemani ruled the animals and the birds, the fishes and the insects, the demons and the human mortals. All the king's regal power lay in his ring. Allah had given him the ring: on this ring there was a seal, and in this seal there was engraved Allah's one hundredth name. Only the prophet Sulemani and the prophet Mohammed have ever known this holy name of God.

One ominous day, when the king was asleep, the devil came and stole the ring. Now the devil, ugly Satan, took the shape of King Sulemani and sat down on his throne, ready to rule men and animals. Soon, however, he was bored with sitting there and decided to go on a voyage. He ordered a ship to be made ready and sailed out. In the middle of the Ocean he lost the ring, which sank and sank and sank in the water, until Allah sent a fish along to look for it. This fish was the dolphin, which Allah created for the purpose. If you go out sailing on the Ocean you are likely to see the dolphins still diving for the magical ring.

Other learned men narrate that the ring was snapped up by a fish, which was caught by a fisherman, who offered it for sale to King Sulemani's cook, so that the king found his ring on his own plate. But Allah knows better.

Translated from the Swahili by Jan Knappert

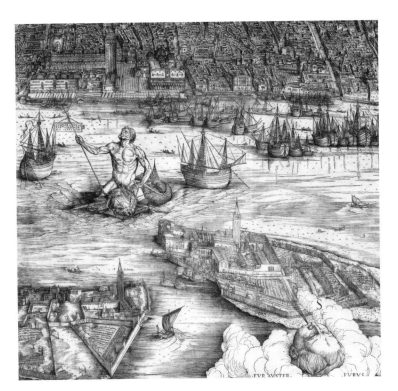

One day, when all people, spirits, and animals in his kingdom had eaten their fill, Sulemani prayed to God that He might permit him to feed *all* the created beings on earth. God answered: "You are asking the impossible; but, all right, you may begin tomorrow with the creatures of the sea." At once Sulemani, overjoyed, ordered the jinns to load up a hundred thousand camels, and the same number of mules, with bags of grain. He himself was present when the seemingly endless caravan arrived on the beach. The king called out: "Ye, fishes of the seven seas, come here all together, your king is inviting you to dinner!" At first one by one, then in their hundreds, in their thousands, the fishes appeared near the shore, and the king strewed grains by the million into the waves. The fishes, who were soon satisfied, dived back into the depths of the sea, after thanking their king.

Alas, all human enterprise must have an end in the very size of the encounter it has sought so fervently to face. It pleased God to raise to the surface of the sea a fish such as fishermen had never seen. In the learned books it is described as a whale but it was much bigger. It rose up from the water like an island, like a mountain. It swam towards the king, then opened its huge mouth wider than the city gates. King Sulemani ordered his spirit-servants to fly over the animal carrying bags of grain, and to drop them in the gaping maw. The busy spirits went on and on flying to and fro, until not a single bag of corn was left. When they had finished all the supplies, the whale raised its voice and roared: "Oh king, I am still hungry, feed me!" Sulemani asked the big fish if there were more fishes of its size in the sea, to which the sea-monster replied: "Of my tribe there are seventy thousand, the smallest one of us is still big enough to eat all the animals and people on your beach." At these words, King Sulemani prostrated himself upon the ground and prayed to God: "Forgive me, Lord, for my foolish desire to feed Thy creation." God answered him: "Nabii Sulemani, my kingdom is still larger than yours. Rise up and watch just one of my many creatures, the control over which I could never entrust to any human king

on earth!" At these words there began a terrible, thundering uproar in the sea, huge waves splashed on the beach, fountains of water jetted upward from the depths. At last there arose what looked like a continent: undulating plains with ridges and rivers, sloping shores at the ever-receding coastline. A monster fish raised its colossal head out of the foaming waves, seventy thousand times larger than the previous fish. It opened its mouth and boomed: "Praise be to God, for He feeds me every day!"

At that moment, God sent His angel Jiburili (Gabriel) down from Heaven. Jiburili spoke to King Sulemani: "Follow me and I will show you a creature of whose existence only God has knowledge." The angel led the king out into the sea, deep down into the depths, while God took care that His king did not drown. Finally they came to a huge rock under the bottom of the sea. The angel ordered the rock to open, and lo! Inside the rock there was a lake, and in the lake there was an island, and in the island there was a cave, and in the cave there lived a strange animal of which no scholar has ever written a description. Upon seeing the king, the creature opened its mouth and spoke in human language, which God had taught it in the time it takes to bat an eyelid: "Welcome, king of all the animals and fishes! You are the first human being I have ever seen. Thanks to the good care of my Creator, I live, and I eat every day, and I am healthy. Only He knows what His creatures eat! Praise be to Allah!" King Sulemani thanked the creature for teaching him a lesson, and returned to his home. From then on, he no longer tried to take over God's job of feeding all His creatures. Even a king does not know what his subjects eat.

Translated from the Swahili by Jan Knappert

GLORIA RAWLINSON

A Ballad for Dolphins

(This ballad is really about the legendary Maori voyager Kupe (Koo-peh), who is said to have discovered New Zealand about 950 A.D. Kupe's expedition began its 2000-mile journey from the island of Raiatea, now part of French Oceania. It is said that Kupe was guided south by noting the path of migrating birds, especially the Shining Cuckoo. It is also said that dolphins accompanied the canoes for most of the way. Kupe named his discovery Aotearoa, (Land of) The Long White Cloud. Legend notwithstanding, New Zealand was probably the last country of considerable area to be discovered and inhabited by human beings. This ballad imagines that the coastal waters of this uninhabited land must have been a paradise for dolphins and whales.)

It's a strange old tale and one that we hardly know
how to explain to that land lying far below
the edge of discovery from such men as these
who are cutting the foam south to our hidden seas.

How long and how wide we have chased inquisitive sails
that sought to pierce the Unknown through sunshine and gales;
we have followed a prow since ever those journeys began:
very old in dolphin lore are the wanderings of man.

Always he left his shores to go venturing forth –
curragh bobbing about on the cold green oceans north,
or starved and helpless on drifting catamaran,
or cotton sails flapping, or copper keels glinting, we have
followed wandering man.

Island to island, ringed with coral and foam,
wherever a palm waved welcome he made his home;
but his children were born restless with home and clan –
and again we dolphins were following wandering man.

From time's beginning we knew of a bird-singing coast
whose shadows lay on the waves like a calm green ghost;
but now we feared for the distance, the fortunate span
that divided this haven of ours, and wandering man.

You birds who summer away in that secret south, beware!
His sharp eyes and terrible mind will follow you there!
We cried to the cuckoo, "Hide in the clouds when you can,
lest your wings betray the direction to wandering man."

East to west, from island to island we've seen
the whole Pacific mapped by his sly lateen,
and now it's the south his curious brown eyes scan,
and now we are following Kupe, a wandering man.

O glittering gulfs, and rivers where mullet leap,
O bird-sung hills and bays, wake from your sleep!
Dolphins are warning the waves, gulls cry down to the trees,
Kupe, a wandering man, has entered our hidden seas.

right
"Triton Fountain", GIANLORENZO
BERNINI; *1642-43. Piazza Barberini,
Rome*

far right
"Triton Blowing A Trumpet",
BATTISTA LORENZI; *bronze, late
16th or early 17th c. Copyright the
Frick Collection, New York*

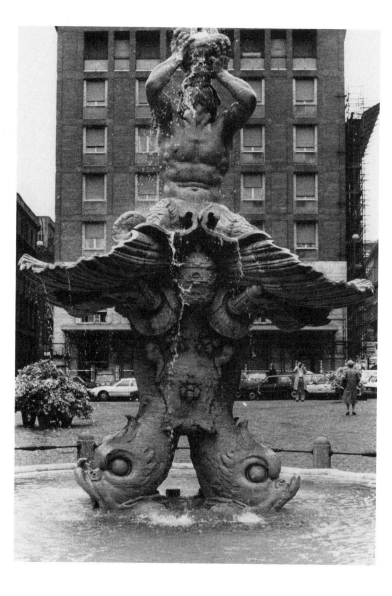

from *Metamorphoses*

'When the first flush of dawn appeared I rose, and showed my comrades the way that led to a spring, telling them to fetch fresh water. I myself climbed a high hill to see what the breeze promised: then I called my men, and made my way back to the ship. Opheltes was the first of my friends to return. "Here we are!" he cried, and came along the shore, bringing with him a boy, as pretty as a girl. He had found him alone in a field, and had taken possession of this prize, as he thought. The boy, drowsy with sleep and wine, seemed to stumble, and was scarcely able to follow. I looked at his clothes, at his features, and his bearing, and saw that everything indicated him to be more than mortal. When I realized this, I said to my companions: "What god is within that body, I cannot tell, but a god there is. I pray you, whoever you are, be gracious and assist our labours. Grant pardon, too, to these your captors." "No need to pray on our behalf!" cried Dictys, the quickest man who ever climbed to the topmost halyard and slid down again by the rope. Libys and blond Melanthus, who was our look-out, and Alcemidon said the same; so did Epopeus, whose task it was to apportion spells of rest, and to set the time for the rowers, spurring them on with his voice. All the others agreed with them – so blind was their lust for plunder. But I retorted: "I have the chief say in this matter. I will not allow a ship of mine to become accursed by carrying off holy cargo," – and I barred the gangway of the ship. This enraged Lycabas, who was the boldest of them all. He had been banished from his city in Lydia for a horrible murder, and was enduring exile as a punishment. When I tried to resist him, he tore at my throat with his strong young fists, and would have dashed me overboard into the sea, if I had not, half-stunned as I was, clung to a rope which held me back. The scoundrelly crew applauded his deed; and then at last Bacchus, for it was Bacchus, intervened, as if his slumbers had been dispelled by the shouting and his senses restored again, after his drinking bout. "What goes on here? What means all the shouting?" he asked. "Tell me, sailors, how came I to this place? Where do you intend to take me?" "Do not be afraid," Proreus soothed him. "Tell us what harbour you want to reach, and you will be set down in the land of your choice." "Direct your course towards Naxos," Liber told them. "My home is there, and that land will give you hospitality." By the sea and by all the gods they treacherously swore that so it would be, and they told me to hoist sail in the painted ship. Naxos was on the right hand: but as I set my sail towards the right, Opheltes shouted: "You fool, what are you doing? What madness has possessed you?" And every man joined in, crying: "Make for the left!" Most of them indicated their purpose by a nod, but some whispered in my ear what they meant to do. I was horrified. "Someone else can take the rudder!" I cried, and refused to have any share in their wickedness, or in the sailing of the ship. They all cursed me, my whole crew muttered angrily. Then one of them, Aethalion by name, exclaimed: "I suppose you think the safety of us all depends on you alone!" and he himself took my place, and performed my duties. Leaving Naxos behind, he sailed off in a different direction.

'Then the god made sport of them. As if he had only just perceived their treachery, he stood on the curved stern, looking out over the sea, and pretended to weep. "These are not the shores you promised me, sailors, this is not the land I asked for. What have I done to deserve such treatment? What credit is it for a large band of grown men to cheat a solitary boy?" I had long been weeping; but my wicked crew laughed at my tears, and sped on, striking the sea with their oarblades.

'Now I swear to you by that god himself – for there is no god greater than he – that what I tell you is as surely true as it seems past belief. The ship stood still in the water, as if held in a dry dock. The sailors, in surprise, kept on plying their oars and spread their sails, trying to run on with the help of both; but their oars were hampered with ivy, which twined up the blades in curling tendrils, and adorned the sails with heavy clusters. The god himself wreathed his head with bunches of grapes, while in his hand he flourished a wand draped with

from *Halieutica*

vine-leaves. Around him lay phantom shapes of wild beasts, tigers and lynxes and panthers with dappled skins. The sailors leaped overboard, whether in madness or in fear I cannot tell. Medon's body was the first to darken in colour, and his spine arched into a well-marked curve. Lycabas began to say to him: "What kind of monster are you turning into?" But even as he spoke, his own mouth widened, his nostrils became hooked, and his skin hardened into scales. Libys, as he strove to pull the sluggish oars, saw his hands shrinking into small compass, saw that they were no longer hands, but might rather be called fins. Yet another, as he tried to lift his arms to handle the twisted ropes, found that he had no arms and, arching his limbless body, sprang backwards into the waves. The end of his tail was sickle-shaped, bent round like the horns of a half-moon. On all sides these creatures leaped about, dashing up clouds of spray: they sprang out of the water, and dived under again, throwing their bodies about in wanton play, like some troupe of dancers, and blowing out the sea-water that washed into their broad nostrils. Where there had lately been twenty men — for that was the ship's crew — I alone remained. I was trembling with cold and fear, scarcely in my right mind; but the god comforted me, saying: "Be not afraid, make for Dia's isle." Brought safely to that island, I was initiated into the sacred mysteries and, since then, I have been one of Bacchus' worshippers.'

Translated from the Latin by Mary M. Innes

Now all the viviparous denizens of the sea love and cherish their young but diviner than the Dolphin is nothing yet created; for indeed they were aforetime men and lived in cities along with mortals, but by the devising of Dionysus they exchanged the land for the sea and put on the form of fishes; but even now the righteous spirit of men in them preserves human thought and human deeds. For when the twin offspring of their travail come into the light, straightway, soon as they are born they swim and gambol round their mother and enter within her teeth and linger in the maternal mouth; and she for her love suffers them and circles about her children gaily and exulting with exceeding joy. And she gives them her breasts, one to each, that they may suck the sweet milk; for god has given her milk and breasts of like nature to those of women. Thus for a season she nurses them; but, when they attain the strength of youth, straightway their mother leads them in their eagerness to the way of hunting and teaches them the art of catching fish; nor does she part from her children nor forsake them, until they have attained the fulness of their age in limb and strength, but always the parents attend them to keep watch and ward. What a marvel shalt thou contemplate in thy heart and what sweet delight, when on a voyage, watching when the wind is fair and the sea is calm, thou shalt see the beautiful herds of Dolphins, the desire of the sea; the young go before in a troop like youths unwed, even as if they were going through the changing circle of a mazy dance; behind and not aloof their children come the parents great and splendid, a guardian host, even as in spring the shepherds attend the tender lambs at pasture. As when from the works of the Muses children come trooping while behind there follow, to watch them and to be censors of modesty and heart and mind, men of older years: for age makes a man discreet; even so also the parent Dolphins attend their children, lest aught untoward encounter them.

Translated from the Greek by A. W. Mair

from *The Greek Anthology*

When the Tyrrhene pirates hurled
the lyre-player in the sea,
a dolphin saved him handily —
lyre, singing voice, and all —
and swam to Corinth with him; then
sea-creatures were more just than men?

Translated from the Greek by Robin Skelton

D. H. LAWRENCE

They Say the Sea is Loveless

They say the sea is loveless, that in the sea
love cannot live, but only bare, salt splinters
of loveless life.

But from the sea
the dolphins leap round Dionysos' ship
whose masts have purple vines,
and up they come with the purple dark of rainbows
and flip! they go! with the nose-dive of sheer delight;
and the sea is making love to Dionysos
in the bouncing of these small and happy whales.

right
Black-figured cylix by EXEKIAS; *ca*
540 B.C. *Exekias is considered the*
greatest of black-figured vase painters;
this is one of his best known
masterpieces, showing the god
Dionysus after he has transformed
the Tyrrhenian pirates into dolphins.
Note also the dolphins painted on the
ship as talismans for clear sailing.
This is the first known use of dolphins
in art to depict a specific legend.
Courtesy of the Staatliche
Antikensammlungen und Glyptotek,
Munich

ANONYMOUS

Homeric Hymn to Dionysus

Now of the god Dionysus, respectable Semele's offspring
I shall recall his appearance upon the unharvested seashore,
High on a prominent headland: he looked like a young adolescent
In the first flower of youth, with his beautiful coal-coloured ringlets
Shaken in curls all about him, and wearing a purple-dyed mantle
Over his powerful shoulders – when presently out of the distance
Over a wine-coloured sea and aboard a well-outfitted vessel
Swiftly Tyrsenian pirates approached: evil fortune their loadstone.
As they beheld Dionysus they nodded unto one another,
Leapt from their ship to the shore, where they quickly laid hold of the god and
Set him erect in their vessel, with hearty complacence because they
Thought him the scion of kings that are nurtured by heaven. They tried to
Cruelly bind him, however the bonds would not hold him, the fibres
Started apart from his hands and his feet, and he just sat there smiling
Out of his sea-coloured eyes. Then the pilot, who had recognized him,
Called out at once to his comrades, "You fools! Do you know who this mighty
God is whom you, having seized, are attempting to bind? Why, not even
Our sturdy ship is sufficiently strongly constructed to bear Him.
Say, is He Zeus? or perhaps He's the silver-bowed archer Apollo?
Maybe Poseidon? Because he most certainly doesn't resemble
Men who must perish, but rather the gods who inhabit Olympus.
Come, let us set Him at liberty on the mysterious mainland
Instantly; do not lay hands upon Him at all, lest, being angry,
He should raise troublesome winds and invoke a most terrible tempest."
So said the pilot. The captain returned a detestable answer:
"Fool! do you notice which way the wind's blowing? Why, then, put out canvas,
Laying on all of the rigging on board. As for him, he's our business,
Men's business. Sooner or later I hope he'll reach Egypt or Cyprus,
Maybe the back of the North Wind – or maybe beyond! In the meantime
He shall provide us at last with the names of his friends and relations,
Telling us all they possess. A divinity handed him to us."
Therewith he put up the mast and he hoisted the sail of the vessel.
Breezes inflated the canvas and tightened the rigging about it.
Soon there began to appear to the pirates incredible marvels.
Wine, to begin with, ran bubbling throughout the length of the black ship,
Wine as delicious to taste as to smell; an ambrosial odour
Rose. And amazement laid hold of the crew one and all when they saw this.
Instantly over the top of the sail there extended a grapevine
Hither and thither, with plentiful bunches of grapes dangling from it.
Ivy encircled the mast, shiny, black, with luxuriant blossoms;
Fruit ripened pleasantly on it; a garland festooned every oarlock.
Finally, after the sailors had seen this, they called to the pilot
Quickly to put into shore. But in front of their eyes Dionysus
Turned himself into a lion, right there in the ship. On the foredeck
Mightily roaring he stood – something dreadful! And meanwhile amidships
Great Dionysus had cunningly fashioned a bear with a shaggy
Mane: thus displaying his emblems. The bear stood erect on her hindlegs
Ravening; forward the lion stood glowering horribly fiercely,

Whereby the pirates were terrified aft, where they gathered about the
Right-thinking pilot all stricken with terror, till, all of a sudden
He – Dionysus the lion – sprang onto the skipper and gripped him.
All of the men, when they saw this, evading a horrible fortune
Leapt from the vessel in unison into the glittering salt sea
Where they were turned into dolphins. However, the god in this mercy
Held back the pilot and made him exceedingly happy, and told him,
"Be of good cheer, my dear fellow, for you have delighted my humour.
I really am Dionysus the Thunderer. Semele bore me,
Semele, Cadmus's daughter, in sexual union with great Zeus."
Hail to thee, offspring of lovely-faced Semele! There is no way by
Which anybody who once has forgot you may order the sweet ode.

Translated from the Greek by Daryl Hine

53

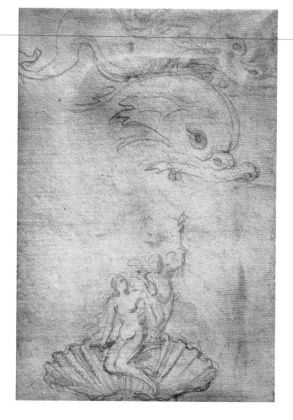

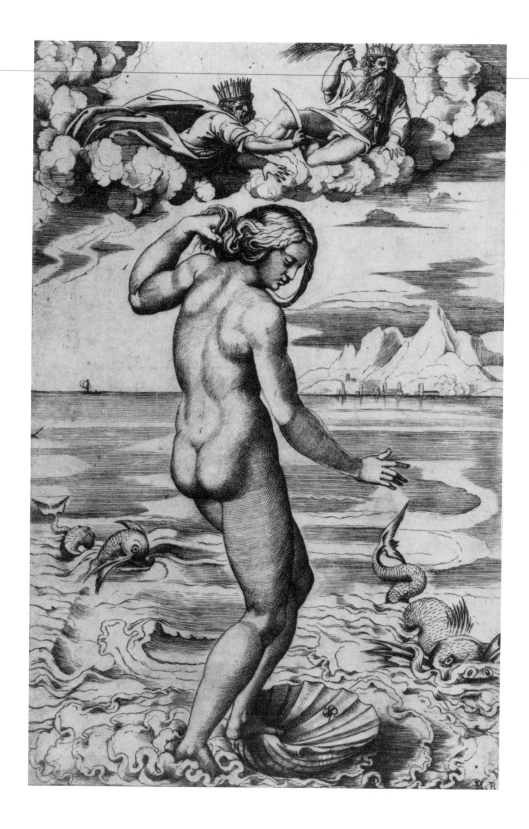

top
''Venus and Dolphins'', NICOLAS
POUSSIN. *Chalk study; ca 1635,*
16 x 23 cm (verso of a larger drawing).
Courtesy of the Nationalmuseum,
Stockholm

right
''The Birth of Venus'', MARCO
DENTE DA RAVENNA, *after*
Raphael. Engraving, 26 x 17 cm.
Courtesy of the Trustees of the British
Museum

''Venus'', COSMÉ TURA; *ca 1465.*
Oil on wood, 116 x 71 cm. Courtesy of
the Trustees, The National Gallery,
London

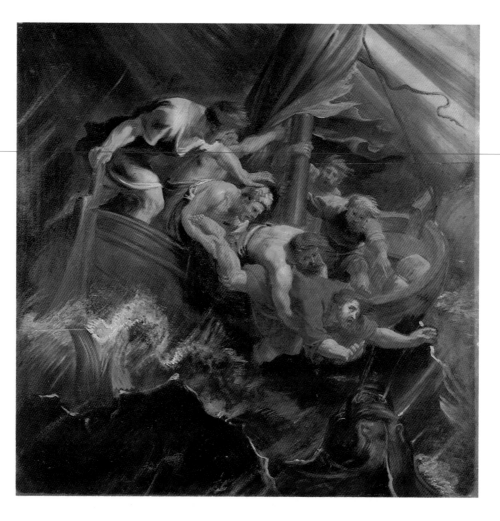

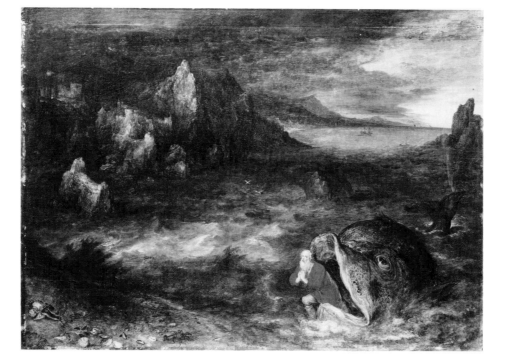

top
"Jonah", PETER PAUL RUBENS;
*1618-1619. Oil on wood, 70 x 70 cm.
Rubens was commissioned to paint
this predella by the Guild of the
Fishmongers for their Church of
Notre Dame at Mechlin, France. This
is yet another example of the belief that
whales were giant fish. Courtesy of
the Musée des Beaux-Arts, Nancy*

bottom
"Jonah Leaving The Whale", JAN
BRUEGHEL THE ELDER. *Oil on
panel, 38 x 56 cm. Courtesy of
Der Alte Pinakothek, Munich*

right
JOHN WILLENBECHER
"Arion Rescued By The Dolphin (2)" 1980
acrylic on Masonite. 50 x 60 cm

*"... Arion was a poet noted for
having changed the dithyramb from
a linear, processional chorus to one
chanted in a 'circle'."*

from A Tale of a Tub

"Storm At Sea", PIETER BRUEGEL
THE ELDER; *ca 1569. Panel,
70 x 97 cm. This painting was
unfinished at Bruegel's death, but the
motif of the whale and the barrel is
evident. The throwing overboard of
the cask has been interpreted as the
necessity to cast off worldly goods in
order to achieve salvation. Courtesy
of the Kunsthistorisches Museum,
Vienna*

THE WITS of the present Age being so very numerous and penetrating, it seems, the Grandees of *Church* and *State* begin to fall under horrible Apprehensions, lest these Gentlemen, during the intervals of a long Peace, should find leisure to pick Holes in the weak sides of Religion and Government. To prevent which, there has been much Thought employ'd of late upon certain Projects for taking off the Force, and Edge of those formidable Enquirers, from canvasing and reasoning upon such delicate Points. They have at length fixed upon one, which will require some Time as well as Cost, to perfect. Mean while the Danger hourly increasing, by new Levies of Wits all appointed (as there is Reason to fear) with Pen, Ink, and Paper which may at an hours Warning be drawn out into Pamphlets, and other Offensive Weapons, ready for immediate Execution: It was judged of absolute necessity, that some present Expedient be thought on, till the main Design can be brought to Maturity. To this End, at a Grand Committee, some Days ago, this important Discovery was made by a certain curious and refined Observer; That Sea-men have a Custom when they meet a *Whale*, to fling him out an empty *Tub*, by way of Amusement, to divert him from laying violent Hands upon the Ship. This Parable was immediately mythologiz'd: The *Whale* was interpreted to be *Hobs*'s *Leviathan*, which tosses and plays with all other Schemes of Religion and Government, whereof a great many are hollow, and dry, and empty, and noisy, and wooden, and given to Rotation. This is the *Leviathan* from whence the terrible Wits of our Age are said to borrow their Weapons. The *Ship* in danger, is easily understood to be its old Antitype the *Commonwealth*. But, how to analyze the *Tub*, was a Matter of difficulty; when after long Enquiry and Debate, the literal Meaning was preserved: And it was decreed, that in order to prevent these *Leviathans* from tossing and sporting with the *Commonwealth*, (which of it self is too apt to *fluctuate*) they should be diverted from that Game by a *Tale of a Tub*.

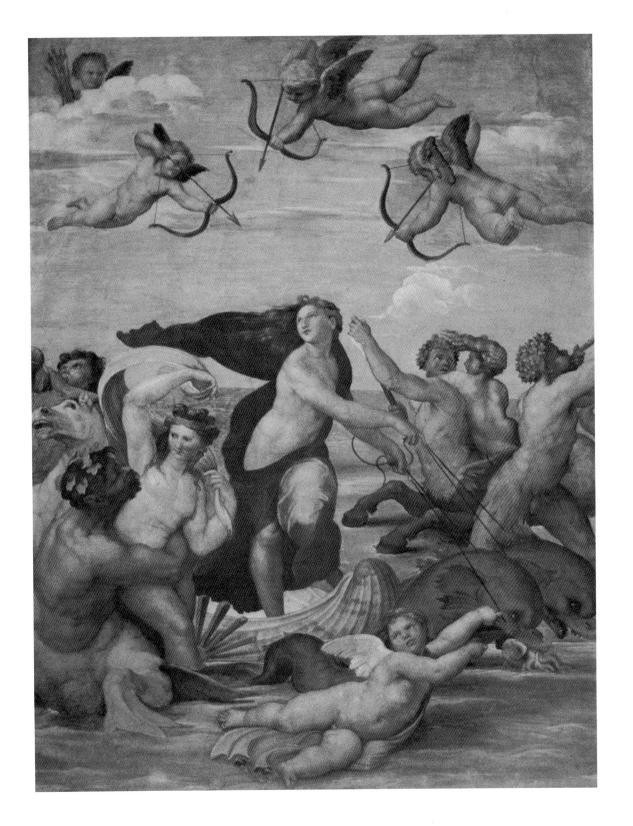

ANGELO POLIZIANO

from The Stanze

Two shapely dolphins pull a chariot: on it sits
Galatea and wields the reins; as they swim, they
breathe in unison; a more wanton flock circles
around them: one spews forth salt waves, others
swim in circles, one seems to cavort and play for
love; with her faithful sisters, the fair nymph
charmingly laughs at such a crude singer.

Translated from the Italian by David Quint

*''Triumph of Galatea'', RAPHAEL;
1511. Fresco, 2.95 x 2.25 m. Villa
Farnesina, Rome. Raphael would
have been familiar with the classical
authors' various tellings of the
Polyphemus and Galatea legend, but
the specific arrangement of the
characters seems to have been inspired
by Poliziano's poem. The dolphin's
killing of the octopus reinforces the
theme of the painting: that sublime
and pure love (as in humans and
dolphins) will always triumph over
the claims of lust (as in the Cyclops
and the octopus)*

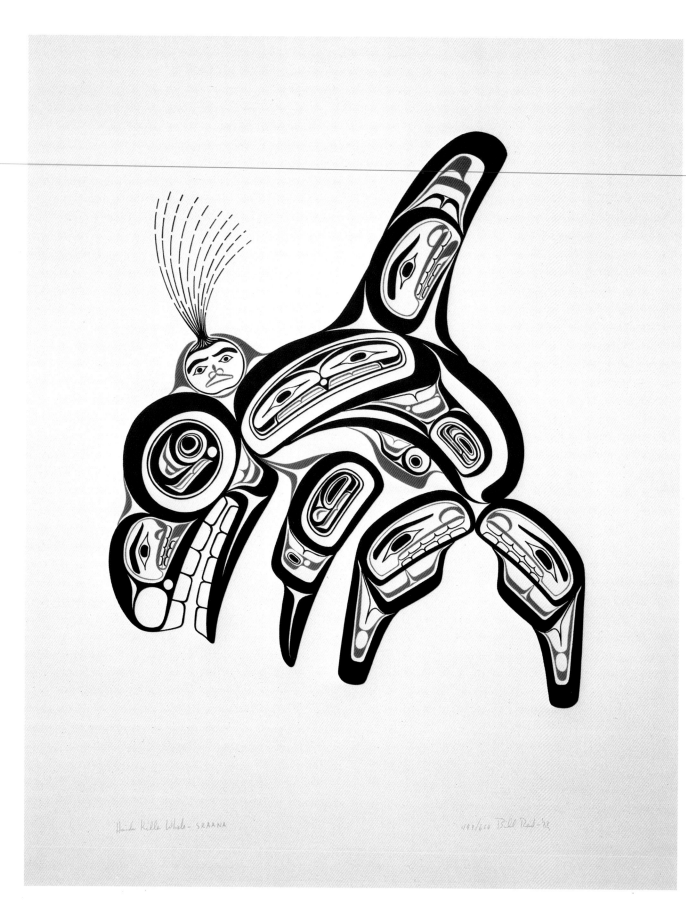

Haida Killer Whale – SKAANA 493/600 Bill Reid-73

The First Blackfish

Natsihlane of the Tlingit was a good hunter. Because of this, his elder brother-in-law was very jealous of him. Natsihlane's younger brother-in-law was fond of him, and one day when the two brothers were about to leave on a hunt, the younger one asked that Natsihlane be taken along. This suited the plans of the older brother, because after a long journey by canoe to a far distant island, they went ashore to separate and hunt in different parts of it. When Natsihlane got back to where they had left the canoe, he saw his brothers-in-law paddling far from shore.

"Come back!" Natsihlane shouted, throwing a deer which he had killed and slung across his shoulders onto the beach. He saw the younger man in the canoe try to paddle back toward the island, but the elder brother proved too strong for him and the canoe disappeared into the distance. Natsihlane was sad and wondered how he would ever escape from the island, for he had no tools with which to make a dugout canoe. At last, he fell asleep by his fire on the shore and dreamed that he heard a strange voice say, "Awake. The one sent to get you is here."

He awakened but could see nothing. He thought that he had only heard a dream-voice, so he went to sleep again. The voice came again as he slept and again he started up. This time he saw a big gull and a half-grown sea lion on the beach not far from him. Natsihlane lay down again and pretended to sleep, but he kept good watch from under his blanket. He saw the gull come close to his blanket and heard it speak.

The Tlingit sprang up and exclaimed, "I heard you speak!"

"You did," the gull answered. "I said, the one sent to get you is here. Follow me."

They went to the edge of the ocean and he saw the sea lion in the water. It said, "I have come for you. The sea lion chief wishes to see you. Climb on my back but keep both eyes tightly closed until I tell you to open them again."

BILL REID
"Haida Killer Whale – Skaana" 1973
silkscreen, 64 x 49 cm

Natsihlane obeyed because he knew that there was strong medicine at work. After the sea lion had swum for a long time, Natsihlane felt it climb out of the water. "Open your eyes," it said. The Tlingit did so and found that he was on a great rock beside a cliff. The rock opened and the Tlingit found himself inside a great house. Though the people inside it looked like humans to him, he sensed that they must be sea lions.

The chief of the sea lions sat on a great carved chair. "When you have helped my son, we will help you in your trouble," he said.

The chief pointed behind him and Natsihlane saw a sea lion lying on the floor with a shaman shaking a rattle over him. The Tlingit, who could often work magic when he could call up the right spirit power, saw that there was a sharp bone harpoon point sticking in the sea lion's side, just beneath the skin.

"I will cure your son, if you will see that I reach my home on the mainland, O Chief," said the Tlingit.

"It shall be as you wish," declared the chief.

Natsihlane believed that the old chief spoke with a straight tongue and soon removed the harpoon point from the wounded sea lion.

The chief thanked the Tlingit, offered him rich foods, then ordered some slaves to fill the dried stomach of a sea lion with air. This they did, and put some food and fresh water inside. Before putting the Tlingit inside the stomach, the chief said, "Thoughts are powerful medicine when they are used well. Think hard of the beach beside your village. Do not let your thoughts stray off on other trails and be sure not to think of this house."

The slaves pushed the sea lion's stomach out into the ocean and it began to float rapidly away. Inside it, Natsihlane thought of the sea lion chief who had befriended him. Quick as a loon dives, he was back, bobbing up and down

bottom
HERBERT BAYER
*"Wall Hanging with Eskimo Motif"
1975 acrylic on paper, 21.6 x 54 cm
(Reproduction of a tapestry designed
by Herbert Bayer for the Atlantic
Richfield Company offices in
Anchorage, Alaska.)*

*Soapstone carving of a whale,
probably bowhead, early Thule
culture (likely 12th c. A.D.), from
Bathurst Island, northern Canada.
Similar objects were used in Alaska
in the 19th c. as whaling charms.
Photo courtesy of the National
Museum of Man, Ottawa*

just outside the chief's house door.

Once again the slaves pushed him out into the ocean. This time he kept his thoughts fixed on the beach close to his house. Soon after, he was washed up on that beach. He split open the sea lion's stomach with his knife, left his strange craft, and hid himself in the forest.

He decided not to go home until he had thought of a way to be revenged on his evil brother-in-law. An inner voice spoke to him. He cut branches from different trees and began to carve. He made eight big fish from spruce branches and painted stripes on them with clay which he found nearby. He put them in a row on the beach, close to the ocean. He said some medicine words over them and then ordered them to jump into the water. They sprang into the ocean at his command, but lay lifeless on the surface. He then cut eight more fish from red cedar, laid them in a row on the sand, sang medicine songs to them and ordered them into the ocean. They entered the water, swam around a little, then were washed up by the incoming tide. He made fish from hemlock, but they would not live either.

"Once more will I try," he vowed. He worked by moonlight and carved eight fish from yellow cedar. He did his very best work and painted each fish with a white stripe across the head and a circle on the dorsal fin. Never before had he seen fish like them, but he placed them in line, as he had done the others, and danced and sang his most powerful spirit song for them. Then, as the raven cawed a greeting to morning, he commanded the fish to leap into the water and swim and live. They did so, and soon the tide washed up foam from their spouting, because they had grown greatly and become black whales. They brought fish to Natsihlane and obeyed his orders.

When at last he saw his brother-in-law's canoe in the distance, he called the blackfish to him. "Swim out and destroy that canoe and see that all in it drown except the youngest. Bring him safely to me."

Swift as salmon, the eight fish raced toward the distant canoe. Soon Natsihlane saw them surround it and it disappeared. The Tlingit feared for a while for the safety of his younger brother-in-law, but soon saw him riding safely on the backs of two of the blackfish which swam side by side to Natsihlane. He called them out of the water and they formed a line on the shore again.

"I made you to get revenge," he told them. "That was a bad thing to do. You must never again harm any human being."

Having so told them, he let them go and they swam far out into the ocean and disappeared. They were the first blackfish to swim the seas.

Retold by Allan A. Macfarlan

top
HORST ANTES
"The Six Cardinal Points" *1980*
charcoal and acrylic on paper, 70 x 188 cm

Kondole, the Whale

The mythology of Encounter Bay, in South Australia, tells how, at the time of the ceremonies, the day was so hot that the streams of perspiration pouring from the bodies of the actors created all the springs and watercourses in the neighbourhood.

As the performers had no means of providing light for the evening rituals, they invited Kondole hoping that he, being the sole owner of fire, would bring it with him. But being mean and disagreeable, Kondole simply hid the fire in the bush and arrived without it.

Enraged by his selfishness, the performers discussed several possible means of forcing him to bring his fire to the ceremonial grounds. But as Kondole was a large, powerful man, no one was brave enough to follow up any suggestion. Finally, one of the performers, completely losing his temper over Kondole's mean behaviour, crept up behind him and threw a spear that penetrated his skull.

Suddenly, the people of the ceremony were transformed into creatures. Some became kangaroos, some opossums, others the smaller creatures. Some rose into the air as birds, while others, entering the sea, were changed into fish in their many forms. Kondole, the largest of them all, became the whale who, ever since, has spouted water from the spear-wound in his head.

Retold by Charles P. Mountford

right
MARTIN CHIRINO
''Leyenda sobre el Barranco de la Ballena''
(''Legend on Whale's Hill'') 1975
ink and pastel

''My work is based on an historical fact; it took place on the Great Canary Island. The place actually exists, and is named after the whale.''

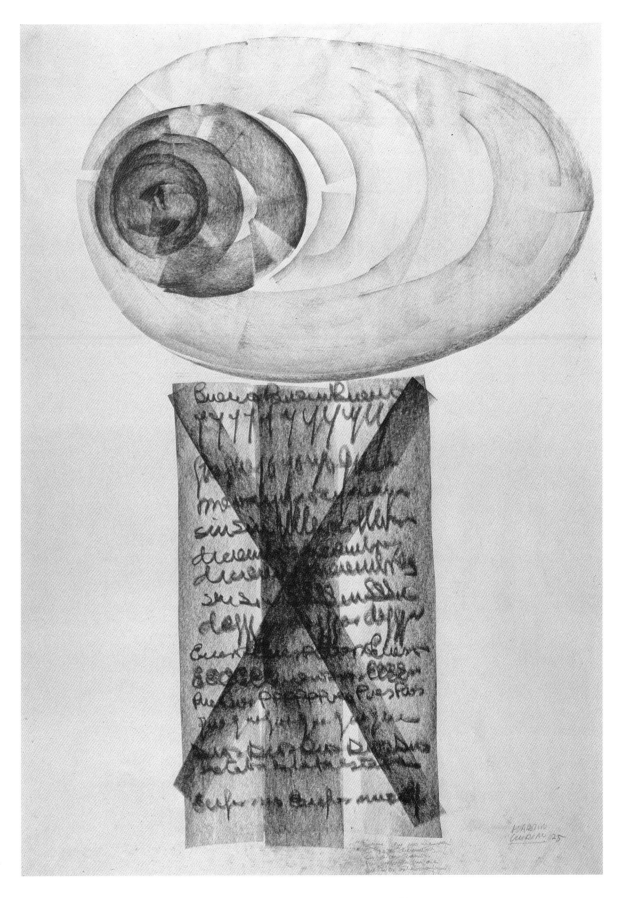

X. J. KENNEDY

Narwhal

Around their igloo fires with glee
 The Eskimo tell tales
Of narwhal. Listen and you'll see
 This unicorn of whales

Through frosty waves off Greenland's coast
 Majestically advance
And like a knight come forth to joust
 Hold high its ivory lance.

SALVADOR DALI
''Zebulum: Jonah and the Whale'' 1973
hand-coloured etching, 36.25 x 50 cm

64

LUCA PATELLA
"Heraclitus' River Run" 1980
egg tempera on canvas, 16.5 x 21 cm

65

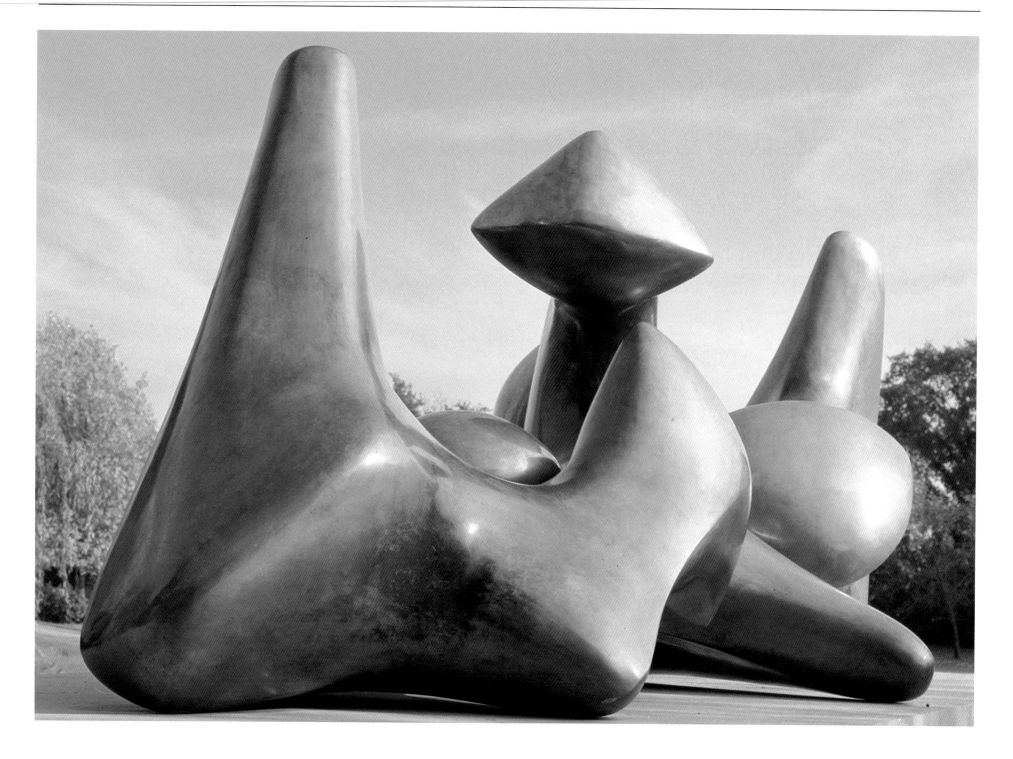

JOHN STEINBECK

from Sea of Cortez

IN THE MORNING we had come to the Santa Barbara Channel and the water was slick and gray, flowing in long smooth swells, and over it, close down, there hung a little mist so that the sea-birds flew in and out of sight. Then, breaking the water as though they swam in an obscure mirror, the porpoises surrounded us. They really came to us. We have seen them change course to join us, these curious animals. The Japanese will eat them, but rarely will Occidentals touch them. Of our crew, Tiny and Sparky, who loved to catch every manner of fish, to harpoon any swimming thing, would have nothing to do with porpoises. ''They cry so,'' Sparky said, ''when they are hurt, they cry to break your heart.'' This is rather a difficult thing to understand; a dying cow cries too, and a stuck pig raises his protesting voice piercingly and few hearts are broken by those cries. But a porpoise cries like a child in sorrow and pain. And we wonder whether the general seaman's real affection for porpoises might not be more complicated than the simple fear of hearing them cry. The nature of the animal might parallel certain traits in ourselves − the outrageous boastfulness of porpoises, their love of play, their joy in speed. We have watched them for many hours, making designs in the water, diving and rising and then seeming to turn over to see if they are watched. In bursts of speed they hump their backs and the beating tails take power from the whole body. Then they slow down and only the muscles near the tails are strained. They break the surface, and the blow-holes, like eyes, open and gasp in air and then close like eyes before they submerge. Suddenly they seem to grow tired of playing; the bodies hump up, the incredible tails beat, and instantly they are gone.

HENRY MOORE
''Working Model for Three-Piece
Vertebrae'' 1968
bronze, 2.25 m long, edition of eight
© Trustees of the Henry Moore
Foundation

''I think I should explain how it may
be you have heard of the 'whale'
connection with my work.... It is
a very large sculpture comprising
three elements and arranged spatially
with a triangular form, and in being
questioned by the press during the
inauguration of the sculpture, I think
I said, 'one of the forms rises up
like a whale out of water'.''

AELIAN

from On Animals

There are stories which reach us from Euboea of fisher-folk in those parts sharing their catch equally with the Dolphins in those parts. And I am told that they fish in this way. The weather must be calm, and if it is, they attach to the prow of their boats some hollow braziers with fire burning in them, and one can see through them, so that while retaining the fire they do not conceal the light. They call them lanterns. Now the fish are afraid of the brightness and are dazzled by the glare, and some of them not knowing what is the purpose of the thing they see, draw near from a wish to discover what it is that frightens them. Then terror-stricken they either lie still in a mass close to some rock, quivering with fear, or are cast ashore as they are jostled along, and seem thunderstruck. Of course in that condition it is perfectly easy to harpoon them. So when the Dolphins observe that the fishermen have lit their fire, they get ready to act, and while the men row softly the Dolphins scare the fish on the outskirts and push them and prevent any escape. Accordingly the fish pressed on all sides and in some degree surrounded, realise that there is no escaping from the men that row and the Dolphins that swim; so they remain where they are and are caught in great numbers. And the Dolphins approach as though demanding the profits of their common labour due to them from this store of food. And the fishermen loyally and gratefully resign to their comrades in the chase their just portion − assuming that they wish them to come again, unsummoned and prompt, to their aid, for those toilers of the sea are convinced that if they omit to do this, they will make enemies of those who were once friends.

Translated from the Greek by A. F. Scholfield

Printer's mark of ROBERT
GRANJON, inventor of display type;
a refined variant of the mark of
Aldus Manutius

MARKO GANCHEV

A Dolphin

Beside the boat a dolphin splashed his tail,
for an instant under the sun it shone
with the bowed curve of a rainbow,
after − it stabbed like a sword.
He vanished and the water became calm again,
but the people, who admired him,
continued to talk about him.

When the time comes to go there, where
the depths lurk in darkness and the sea is
 silent
you are not going to feel sadness
if, before you plunge into the murk and are
 concealed,
you at least for a single instant
arc like a scimitar, or a bow.

Translated from the Bulgarian by Greg Gatenby and
Nikola Roussanoff

AELIAN

from On Animals

It seems that Dolphins are mindful even of their dead and by no means abandon their fellows when they have departed this life. At any rate they get underneath their dead companion and then carry him along to the shore, confident that men will bury him, and Aristotle bears witness to this. And another company of Dolphins follow them by way of doing honour to, or even actually fighting to protect, the dead body, for fear lest some other great fish should rush up, seize it, and then devour it. All just men who appreciate music bury dead Dolphins out of respect for their love of music. But those to whom, as they say, the Muses and the Graces are alien care nothing for Dolphins. And so, beloved Dolphins, you must pardon the savage nature of man.

Translated from the Greek by A.F. Scholfield

67

P. LAL
An Ocean of Whales

On the way they saw
the wind-fretted ocean
reservoir of many waters,
howling:

An ocean of whales,
Fish that swallow whales,
makaras, and thousands
upon thousands of sea-
 creatures;

Fierce, monstrous,
dark sea-animals,
allowing none near;
crocodiles, tortoises;

All kinds of gems;
the home of Varuṇa;
the palace of the nāgas;
the lord of rivers

Home of undersea flames;
friend of the anti-gods;
terror of creatures;
undecaying receptacle;

Holy, god-beneficent;
source of nectar;
infinite, inconceivable;
sacred, full of marvels;

Roaring with the voices
of invisible sea-creatures;
breeder of whirlpools;
horripilating being;

Rolling high with winds
of storm and anger;
dancing with wave-
uplifted hands;

Heaving endlessly with
moon-produced billows;
Pāñcajanya's father;
treasure-house of jewels;

Subdued in the past
by powerful Govinda
in his boar-avatāra
when he raised the earth;

Baffler of rage Atri
who tried for a thousand years
to plumb its deeper-
than-the-depths nether-world;

Bed of lotus-navelled
Viṣṇu at each yuga-end
sinking in the peace of
cosmic sādhanā;

Refuge of the mountain
Maināka from falling thunder;
hide-out of the anti-gods
after the terrible battle;

Giver of ghee to the fire
from the mouth of Vaḍavā;
limitless, fathomless,
vast lord of rivers;

Thousands of rival rivers
rushing for its love —
they saw. Always full,
always wave-dancing;

Reverberating with the roars
of makaras and whales —
they saw: space-vast,
unfathomable reservoir.

*Transcreated from the Sanskrit
Mahābhārata of Vyasa, Ādi Parva,
XXI 3-18*

ALFREDO CARDONA PEÑA
Small Ode to Whales and Dolphins

You are the most distinguished beings
among the millions of societies that populate the Ocean:
in it there are entities similar to choreographed universes
and microscopic ballets of primordial cells.
Nijinskys of colours, diaphanous somnambulists
and horrors with a hundred arms and black eyes teem
in the black oxygenated depths.
But of all the manifestations of life
swaying to and fro and generating tremors and bubbles,
you, deep, gigantic commotions, whales
that appear among the waves like breathing islands,
and you, mystical intellects, oh dolphins
that like sonar installations
move through the waters
anterior to hate,
you are those incomparable organisms
that, linked to the beginnings of the world,
have accompanied the sleep of nocturnal voyages,
when man, fearful of monsters,
felt secure at the sight of your forms,
that, swimming and sending up paeans of spray,
were the first to proclaim the art of navigation.
Moreover, a prophet found a dwelling-place in the belly
of the greatest of animals,
and princes' sons have ridden on the backs
of obliging dolphins,
that, like silver arcs,
conveyed legends to hospitable shores.
So, withal, we humans,
favoured with such distinctions,
cannot destroy with contemptuous zeal
these glories of Creation.
That would be to bend Heaven's designs
or to shatter with abominable threats
those peaceful beds where silently
the species propagate and love.

Translated from the Spanish by Margaret Cullen

NJÖRDUR P. NJARDVÍK
The Surface Breaks

The surface breaks
the surface breaks
the silence of the sea
as slow huge elegance
blows the sigh of life
to the sky

An oval black movement
floats through me
and vanishes down
into the cold deep
of green peace
where gentle singing vibrates

Go down my friend
go down into your kindness

How the Dolphins Came

With panic, in water too far from the island,
Plates of waves clack in the minds of the drowned.

We sail out of Notre Dame Bay, swell
pulls gently on the bow. To the left,
an island, its side rotting,
seems infected with an old woman's spirit.
I imagine what could happen below
Going over, faces turned up to the white of the sky.
Struggle becoming disbelief. Legs disappear.

Quickly they came, by the blunt rusty prow
Like sharks, but their sides had cream in them.
The bodies seem softer than rubber,
a strange kind of metal,
but skin above all
In water that is suddenly green.

The fear their quickness causes is not
 revenge
As with anything rare in nature,
surprise is the first emotion
Then comes an arc and gasp,
blowholes like great soft navels
glance by the rusting steel wedge.
The function of breath is a wound.
One, then five,
This energy, this new light in the water,
is reassurance.

One stays with us, froth on its back
as it breathes more quickly. Turns
Pauses for a moment in the endless green
Then down, down into the murk
Down into what is to be most feared
Down with a blessing.

from Cape Cod

We saw this forenoon what, at a distance, looked like a bleached log with a branch still left on it. It proved to be one of the principal bones of a whale, whose carcass, having been stripped of blubber at sea and cut adrift, had been washed up some months before. It chanced that this was the most conclusive evidence which we met with to prove what the Copenhagen antiquaries assert, that these shores were the *Furdustrandas*, which Thorhall, the companion of Thorfinn during his expedition to Vinland in 1007, sailed past in disgust. It appears that after they had left the Cape and explored the country about Straum-Fiordr (Buzzard's Bay!), Thorhall, who was disappointed at not getting any wine to drink there, determined to sail north again in search of Vinland. Though the antiquaries have given us the original Icelandic, I prefer to quote their translation, since theirs is the only Latin which I know to have been aimed at Cape Cod.

Cum parati erant, sublato
velo, cecinit Thorhallus:
Eo redeamus, ubi conterranei
sunt nostri! faciamus aliter,
lata navis explorare curricula:
dum procellam incitantes gladii
morae impatientes, qui terram
collaudant, Furdustrandas
inhabitant et coquunt balaenas.

In other words, "When they were ready and their sail hoisted, Thorhall sang: Let us return thither where our fellow country-men are. Let us make a bird (a vessel) skillful to fly through the heaven of sand (the sea) to explore the broad track of ships; while warriors who impel to the tempest of swords; who praise the land, inhabit Wonder Strands, *and cook whales*." And so he sailed north past Cape Cod, as the antiquaries say, "and was shipwrecked on to Ireland."

Though once there were more whales cast up here, I think that it was never more wild than now. We do not associate the idea of antiquity with the ocean, nor wonder how it looked a thousand years ago, as we do of the land, for it was equally wild and unfathomable always. The Indians have left no traces on its surface, but it is the same to the civilized man and the savage. The aspect of the shore only has changed. The ocean is a wilderness reaching round the globe, wilder than a Bengal jungle, and fuller of monsters, washing the very wharves of our cities and the gardens of our seaside residences. . . .

from We Chose The Islands

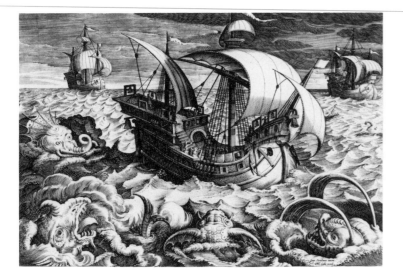

Unattributed engraving of tintinnabulation attracting whales and sea-monsters; probably 16th c. Illustrates late Renaissance belief that the ringing of bells on board ship drew frightful responses from *the deep, an interesting variant of the Arion legend. Courtesy of the Old Dartmouth Historical Society Whaling Museum, New Bedford, Massachusetts*

DANTE

from The Inferno

All my attention was fixed upon the pitch:
to observe the people who were boiling in it,
and the customs and the punishments of that ditch.

As dolphins surface and begin to flip
their arched backs from the sea, warning the sailors
to fall-to and begin to secure ship —

So now and then, some soul, to ease his pain,
showed us a glimpse of his back above the pitch
and quick as lightning disappeared again.

Translated from the Italian by John Ciardi

It was common rumour in the Gilbert Islands that certain local clans had the power of porpoise-calling; but it was rather like the Indian rope-trick; you never met anyone who had actually witnessed the thing. If I had been a reasonably plump young man, I might never have come to see what I did see on the beach of Butaritari lagoon. But I was skinny. It was out of sheer pity for my poor thin frame that old Kitiona set his family porpoise-caller working. We were sitting together one evening in his canoe-shed by the beach, and he was delivering a kind of discourse on the beauty of human fatness.

"A chief of chiefs," he said, "is recognized by his shape. He is fleshy from head to foot. But his greatest flesh is his middle; when he sits, he is based like a mountain upon his sitting place; when he stands, he swells out in the midst, before and behind, like a porpoise." It seemed that in order to maintain that noble bulge a high chief simply must have a regular diet of porpoise-meat; if he didn't, he would soon become lean and bony like a commoner or a white man. The white man was doubtless of chiefly race, thought Kitiona, but his figure could hardly be called beautiful. "And you," he added, looking me up and down with affectionate realism, "are in truth the skinniest white man ever seen in these islands. You sit upon approximately no base at all."

I laughed (heartily I hope) and asked what he thought could be done about that. "You should eat porpoise-flesh," he said simply, "then you too would swell in the proper places." That led me to inquire how I might come by a regular supply of the rare meat. The long and the short of his reply was that his own kinsmen in Kuma village, seventeen miles up-lagoon, were the hereditary porpoise-callers of the High Chiefs of Butaritari and Makin-Meang. His first cousin was a leading expert at the game; he could put himself into the right kind of dream on demand. His spirit went out of his body in such a dream; it sought out the porpoise-folk in their home under the western horizon and invited them to a dance, with feasting, in Kuma village. If he spoke the words of the invitation aright (and very few had the secret of them) the porpoise would follow him with cries of joy to the surface.

Having led them to the lagoon entrance, he would fly forward to rejoin his body and warn the people of their coming. It was quite easy for one who knew the way of it. The porpoise never failed to arrive. Would I like some called for me? After some rather idle shilly-shallying, I admitted that I would; but did he think I should be allowed to see them coming? Yes, he replied, that could probably be arranged. He would talk to his kinsmen about it. Let me choose a date for the calling and, if the Kuma folk agreed, his canoe would take me to the village. We fixed on a day early in January, some weeks ahead, before I left him.

No further word came from Kitiona until his big canoe arrived one morning to collect me. There was not a breath of wind, so sailing was out of the question. The sun was white-hot. It took over six hours of grim paddling to reach our destination. By the time we got there, I was cooked like a prawn and wrapped in gloom. When the fat, friendly man who styled himself the High Chief's hereditary porpoise-caller came waddling down the beach to greet me, I asked irritably when the porpoise would arrive. He said he would have to go into his dream first, but thought he could have them there for me by three or four o'clock. Please, though, he added firmly, would I be careful to call them, from now on, *only* "our friends from the west". The other name was tabu. They might not come at all if I said it aloud. He led me as he spoke to a little hut screened with newly plaited coconut leaves, which stood beside his ordinary dwelling. Alone in there, he explained, he would do his part of the business. Would I honour his house by resting in it while he dreamed? "Wait in peace now," he said when I was installed, "I go on my journey", and disappeared into the screened hut.

Kuma was a big village in those days: its houses stretched for half a mile or more above the lagoon beach. The dreamer's hut lay somewhere near the centre of the line. The place was dead quiet that afternoon under its

swooning palms. The children had been gathered in under the thatches. The women were absorbed in plaiting garlands and wreaths of flowers. The men were silently polishing their ceremonial ornaments of shell. Their friends from the west were being invited to a dance, and everything they did in the village that day was done to maintain the illusion.

Even the makings of a feast lay ready piled in baskets beside the houses. I could not bring myself to believe that the people expected just nothing to come of all this careful business.

But the hours dragged by, and nothing happened. Four o'clock passed. My faith was beginning to sag under the strain when a strangled howl burst from the dreamer's hut. I jumped round to see his cumbrous body come hurtling head first through the torn screens. He sprawled on his face, struggled up, and staggered into the open, a slobber of saliva shining on his chin. He stood awhile clawing at the air and whining on a queer high note like a puppy's. Then words came gulping out of him: "*Teirake! Teirake!* (Arise! Arise!)...They come, they come!...Our friends from the west...They come!...Let us go down and greet them." He started at a lumbering gallop down the beach.

A roar went up from the village, "They come, they come!" I found myself rushing helter-skelter with a thousand others into the shallows, bawling at the top of my voice that our friends from the west were coming. I ran behind the dreamer; the rest converged on him from north and south. We strung ourselves out, line abreast, as we stormed through the shallows. Everyone was wearing the garlands woven that afternoon. The farther out we got, the less the clamour grew. When we stopped, breast deep, fifty yards from the reef's edge, a deep silence was upon us; and so we waited.

I had just dipped my head to cool it when a man near me yelped and stood pointing; others took up his cry, but I could make out nothing for myself at first in the splintering glare of the sun on the water. When at last I did see them, everyone was screaming hard; they were pretty near by then, gambolling towards us at a fine clip. When they came to

the edge of the blue water by the reef, they slackened speed, spread themselves out and started cruising back and forth in front of our line. Then, suddenly, there was no more of them.

In the strained silence that followed, I thought they were gone. The disappointment was so sharp, I did not stop to think then that, even so, I had seen a very strange thing. I was in the act of touching the dreamer's shoulder to take my leave when he turned his still face to me: "The king out of the west comes to meet me," he murmured, pointing downwards. My eyes followed his hand. There, not ten yards away, was the great shape of a porpoise poised like a glimmering shadow in the glass-green water. Behind it followed a whole dusky flotilla of them.

They were moving towards us in extended order with spaces of two or three yards between them, as far as my eye could reach. So slowly they came, they seemed to be hung in a trance. Their leader drifted in hard by the dreamer's legs. He turned without a word to walk beside it as it idled towards the shallows. I followed a foot or two behind its almost motionless tail. I saw other groups to right and left of us turn shorewards one by one, arms lifted, faces bent upon the water.

A babble of quiet talk sprang up; I dropped behind to take in the whole scene. The villagers were welcoming their guests ashore with crooning words. Only men were walking beside them; the women and children followed in their wake, clapping their hands softly in the rhythm of a dance. As we approached the emerald shallows, the keels of the creatures began to take the sand; they flapped gently as if asking for help. The men leaned down to throw their arms around the great barrels and ease them over the ridges. They showed no least sign of alarm. It was as if their single wish was to get to the beach.

When the water stood only thigh deep, the dreamer flung his arms high and called. Men from either flank came crowding in to surround the visitors, ten or more to each beast. Then, "Lift!" shouted the dreamer, and the ponderous black shapes were half-dragged, half-carried, unresisting, to the lip of the tide. There they

settled down, those beautiful, dignified shapes, utterly at peace, while all hell broke loose around them. Men, women and children, leaping and posturing with shrieks that tore the sky, stripped off their garlands and flung them around the still bodies, in a sudden dreadful fury of boastfulness and derision. My mind still shrinks from the last scene — the raving humans, the beasts so triumphantly at rest.

We left them garlanded where they lay and returned to our houses. Later, when the falling tide had stranded them high and dry, men went down with knives to cut them up. There was feasting and dancing in Kuma that night. A chief's portion of the meat was set aside for me. I was expected to have it cured as a diet for my thinness. It was duly salted, but I could not bring myself to eat it. I never did grow fat in the Gilbert Islands.

Carthaginian stele; 2nd c. B.C. For at least the last 400 years of Carthage's history the dolphin was the sacred symbol of the city's supreme deity, the goddess Tanit. Photo courtesy of the Louvre, Paris

ANDREAS OKOPENKO

from *Lexicon-Roman*

Afternoon conversations 9. As we were discussing the one who never comes a flashlight salesman joined in, one who was interested in behavioural research, though. He told us how a young American had grown fond of a Pacific dolphin girl; he lived with her in the dolphin pool, learned to dive and jump, and learned her language, and she learned from him, admirably quickly, advanced mathematics and formal logic, and they turned out to be a quite exemplary couple in matters of communication, leaving human couples far behind in that. However, the young American was then obliged to hand his lover over to the CNR (Central Navy Research) who sent her off to a research ship due to be scrapped with a tactical nuclear warhead superior to any torpedo. Intelligent as she was she had no difficulty stowing her loaded body in the engine room, where she was then blown up along with the wreck. The young American mourned her loss. An altogether different question is why the love and intelligence of the girl could not bring her to be a conscientious objector; but maybe her mind had already adopted a too human character; according to Professor Lilly, dolphins, in spite (or indeed because) of their high intelligence, can easily be corrupted.

Translated from the German by Michael Hulse

LEWIS CARROLL

from *Alice's Adventures in Wonderland*

... the Mock Turtle sang this, very slowly and sadly:
"Will you walk a little faster?" said a whiting to a snail,
"There's a porpoise close behind us, and he's treading on my tail...."
... said Alice ... "I'd have said to the porpoise, 'Keep back, please! We don't want *you* with us!'"
"They were obliged to have him with them," the Mock Turtle said. "No wise fish would go anywhere without a porpoise."
"Wouldn't it, really?" said Alice, in a tone of great surprise.
"Of course not," said the Mock Turtle. "Why, if a fish came to *me*, and told me he was going on a journey, I should say, 'With what porpoise?'"
"Don't you mean 'purpose'?" said Alice.
"I mean what I say," the Mock Turtle replied, in an offended tone.

KENDRICK SMITHYMAN

Boy

Child, in a sandhill's lap curled
as against his mother, stares over surflines.
A most blue sea tramps up and down the world
yet here's world's end where sand skids
white and brown from longhaired marram.
Then, is the surf. Unsanctioned runs the blue.

Some days, jocose, you may see whales blow
(three miles? Who knows?) beyond the shore
which ridicules them heavily at play.
Handier dolphins stride — but this you know
and we shall take as read. Taking also
as read, strung to their dunes those butterflies
coming from nowhere but this ocean, quick,
viable from its deep. There's slow
flicking and flashing on our gritty winds.

A gull his course continually tries.
Once, a leather turtle slapped the strand.
Lurid a sea snake tossed on land
frightened us kids though none roared for his
 Dad
who would have scuttled, swept
away joyous danger from his toothsome lad.

Even the children love what could destroy.

Mark, from your life's edge triangles take flight.
Your boy picks up erratic one sail's beat
hauled counter-course, engine of delight
where channel does not sound. How small!
 but neat
canvas strikes angles while lacklogic flails
to claim a convict frantic from the johns.
A yacht adrift. Some artifact of wreck...
not summer at its cruising gone astray.
Lacklogic sweetens panic, being sly.

Even children love what may destroy.

RICHARD EBERHART

Off Spectacle Island

Seals and porpoises present
A vivid bestiary
Delightful and odd against the mariner's chart.

The sea bells do not locate them,
Nor lights, nor the starred ledges;
We are unprotected from their lyricism.

They play in the blue bay, in day,
Or whoosh under the midnight moonlight;
We go from point to point where we are going.

I would rather see them playing,
I would rather hear them course
Than reach for Folly from Pride's Light.

Map (detail), "Typus Cosmographicus Universalis" (Basel, 1532), attributed to HANS HOLBEIN THE YOUNGER. *Dolphins or whales were not used as sea symbols on maps until the 15th c., and did not become common until decades later. Courtesy of the National Map Collection, Public Archives of Canada, Ottawa*

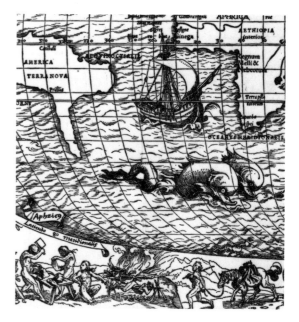

GEOFFREY LEHMANN

The Dolphins

A Monologue of Marcus Furius Camillus, Governor of Africa

I

My personal slave in Africa first told me
Of how they play with men and rub against
 one
(Though barnacles upon their backs may cause
Abrasions, even death)
And how they dive for bubbles and bright
 objects,
And mimic us with duck-like noises.

This slave once on a journey called to me.
I had my litter lowered, stepped out and
 followed him.
He ran down goat-tracks to a rocky cove
And whistled and a dolphin danced towards us
Across the flat grey sea. The slave
Threw off his tunic and his rope-soled sandals,
Swam to the dolphin with outlandish shouts,
Hugged it and bit it with a laugh.
Almost intelligible it clicked and whistled.

Months later, at the noon siesta,
He came to me distraught and led me wordless
Past bodies snoring in cool hallways
And over sand dunes to a beach.
A dolphin lay there, puffed with death, eyes
 squinting.
Making a sign to ward off evil spirits
He split the skull in with a flint. The brain
Lay large and lustrous, bigger than a man's,
A silvery pulp, marbled with tiny veins.
He pointed to it briefly, muttered hoarsely,
Then threw sand on the body.

That night he babbled to me about dolphins,
Their sea-lore and their songs and odysseys,
And how their minds excelled our own
And they would contact us one day and bring
Peace to the world.
 The palm-leaves clashed,
As breezes fanned the peristyle.
Rubbing ash on his face he softly moaned
Of the dead dolphin and his passion for it,
The language they had shared

And the shrill music that its blow-hole uttered,
Inaudible to him, but causing dogs
To freeze and listen, muscles trembling.

He raved of dolphins until dawn,
Of feats of magic and strange medicaments,
And history dating back before our gods.

My head drooped and I drowsed off on my
 couch.

Soon afterwards he vanished. Fishermen
Maintained they saw him swimming out to sea
One dusk, a strange light in his salt-wet hair.

II

My home at dusk. Now to forget the triumph
I led through Rome today past roaring crowds.
A slave girl singing to me of Arion,
Famed lutanist, who sailing home
With lavish trophies from a contest,
Was almost murdered by the envious sailors,
But singing on the sunlit deck,
So the sea came alive with listening dolphins,
He jumped upon a music lover's back
And fled to safety through the foam.

A shower of spray becomes a trumpet blast,
Chained negroes looking puzzled, silver eagles,
Processions carrying pictures of my conquests,
Of plains and date-palms, hills and rivers,
(In fact the plains are dry, the rivers brackish).
Men call me happy, but the Emperor's praise
Was tempered to chill rivals to his greatness.

Should I row out to sea with picnic basket
And throw fish to the dolphins,
And make weird noises trying to converse?

And if I found them stupid, what despair
To know that no minds could excel our own.

And if their minds excelled ours ... then what
 envy!

Safer for me to quietly age in Rome
Amongst familiar unrealities.

III

A lute hurled on a deck and still vibrating,
Sunlight and anger in those sailors' eyes,
And their gesticulating, empty hands.
And is it they that have undone us,
Our hands that covet, make and take,
And if we had no hands ...
 Those gentle flippers,
Those heaving seas and that inaudible music!

IV

Walking one evening by the sea I heard
Laughter and splashing and strange voices,
And in an inlet came upon nine dolphins
Leaping and frisking in the stillness,
With moonlight gleaming dully on their bodies.
I listened to their comic mimicry
Of human voices, high-pitched and distorted,
And thought I picked out
Snatches of speech from various languages.
Not just the rudimentary sounds they
 mimicked,
But also tones, inflexion, quirk of speech.
The voices threatened, laughed, were sad or
 boastful.
Face down upon a shelf of rock I lay
And yearned to stand and cry with arms
 outstretched,
"I am a man and you are dolphins, let
Us love each other."
 But I was afraid.
Bubbles and flakes of phosphorescence.
Hour-long I watched, and now
With voices dwindling in a wake of stillness
They headed out to sea still gossiping.

Exhausted my eyes shut and I woke next day
Amongst red rock and sun and sea-glare.

DAVID CAMPBELL

Whales

THOR HEYERDAHL

The Friendly Whale

Bulk large here
Blowing morning
Messages that with net and
 spade
And bent pin I seldom beach
Remote in my sandcastle.

Once epics were written
For whales — we coax
Them into a lyric,
Ahabs obsessed
By a lonely gadgetry:
Harpoons please,
Pulley, churning lance.

This is a whale poem
Though it is our
Humanity sounds here
And in the flurry
All may be flotsam.

From our adroit
Scheming save the seas,
Poetry, the whale.

The whale is the friendly giant of our planet. There is no creature to match it in size, strength and yet amiability, either ashore or in the ocean. Seventy percent of our planet was once its legitimate domain. But modern man has conquered the oceans and declared war on the peaceful whales. Today the human species, in our limitless greed for wealth, has pursued these friendly creatures beyond all horizons and driven them to the very verge of extinction without any pity and with as little understanding of the economic wisdom of maintaining a sustainable yield for future generations of mankind.

The whale is today so scarce that few people other than those who sail out to kill them have a chance even to see one sending up a water-spout on the horizon. In this respect I count myself lucky. I have been in intimate company with whales in their own domain and without any bloodshed. I have had them within reach of an outstretched hand in broad daylight as well as in the pitch dark. And I have come to feel that the whale is man's nearest relative in the sea. In the silent world of the cold fishes and squids, the whale comes up, nice and warm, and breeds like us. Friendly and intelligent as a swimming horse, one cannot but take a definite liking to this colossus who seems so happy in the wet element although it belongs in a way among us ashore. Elegant beyond description in its movements, and never rushed, it behaves like a happy holiday-maker who has discovered the boundless fun of tumbling about in weightlessness supported by water. A deep breath and away down into almost incredible depths, so dark that this prehistoric colossus preceded man by millions of years in using transmitting devices of the radar type to avoid collisions with bottom rocks or underwater traffic of its own kind.

No matter how often you have heard that the whale is a mammal, it remains a big, cold fish to most people who know it only from its pictures. This impression is gone forever once you have heard the panting, snuffling respiration of a whale coming up near you to fill its lungs with fresh air. When we drifted silently across the Atlantic in our papyrus raft-ship *Ra*, it was natural for our black Buduma companion Abdulla from Lake Chad in Central Africa to shout "hippopotamus" when a whale came up beside us to expel its air and refill the lungs. He had never heard of salt water and still less of whales, but it was obvious at once that the beast coming up at our side was not a big fish. Previously, on the balsa raft *Kon-Tiki* in the Pacific, we had had sharks swallowing a sleeping-bag, devouring our parrot, and one even taking a bite at the balsa log forming part of our raft, but the whales always came merely to take a friendly glimpse at us before they dived and peacefully swam right under us to roll up on the other side and resume their journey.

Recently, moving as noiselessly along with the winds across the Indian Ocean in our reed-ship *Tigris*, we had the fortune to be called upon by these majestic beasts of the open sea more than once. They seem to trust prehistoric watercraft more than fast modern ships. They are wise enough to prefer to stay deep down or far away when modern keels with thumping engines and rumbling propellers race across their domain. It is a unique experience to be awakened by the sound of someone blowing his nose so loudly that it arouses even an experienced raft voyager accustomed to the most exclusive snoring by men packed together in a tiny bamboo cabin. It gives a thrill of happiness to sit up in the sleeping-bag and stare at the black water beside the open bamboo wall where something solid has emerged, something big and smooth as a water-washed reef and blacker than the dark night outside. If the moon is shining the apparition glisters like a polished shoe, but in all the smoothness is a big, panting blow-hole that leaves no doubt that we have a living whale at our bedside. No matter how often you might have seen a small porpoise tumbling about in some marineland, it is quite different to wake up in intimate contact with a big whale within its own free environment. With a bump of the nose it could break your steering-oars, with a blow from the tail it could smash a fragile vessel to bits. But nothing of the sort happens, as long as you do not run a harpoon into the amiable visitor. The whale, if any surviving animal giant has, has little reason to deal lightly with the tiny human species, yet with all its tremendous body-strength it never touched our vessel nor even scratched loose a reed from the bundles. It made sure never to bump into us even in the pitch dark. At an arm's length it could suddenly come up, with the colossal head pointing straight for us, then it would bow head under and slide like a shadow right beneath our bundles to come up on our other side and resume the voyage it had interrupted merely to pass by and say a friendly hello.

It is not everybody's fortune to have had bedside company with whales in their own free playground. But those of us who have, feel an urge to support the growing majority of mankind that demands that the tiny minority who threatens the remaining whale species with complete extinction for personal economic gains should be forced to leave the whales in peace until able to multiply for the benefit of future generations on this planet.

RODNEY PYBUS

Loveless Losing Paradise *

Dear, distant wife, here
I saw a whale blowing off the coast —
a marvel of lithe tonnage
rising and plunging in its salty joy;

it took my heart up
with its fluked lashing of swollen water,
the pressured plume of the gush
from its fontanelle,

its fluent congress with ocean.
Anchored on land, I cried for Jonah:
my mouth a mute O to the wind.
This is surely the land of might-have-been.

All the promises of paradise hung
at the bottom of the globe —
its dawns of illuminated fruit,
the sky a great bowl of ripening sun,

nights of black velvet pricked with frost.
Colours not invented by the North
all behind bars
as if we might steal away

with cargoes of sun, our hold
daily brightening.
My only music here is water
and the dark swimming of its song.

May they never spear
that great white whale:
I'd think it me
they dragged to land,

my body's blubber they hacked,
my fat that boiled and stank
so far from home, my soul
inquisitors delved for deep inside.

My poor bleached hopes for amity.
In the light from plundered tallow
inhumanity's mad commanders
strike without pity through the flies.

Let me be whale and graze
those unfenced acres of blue
take my chances outside
the bars we're flayed to build,

outside the colony of scarlet coats
where our blood does not show
before it dries. To the whale I cry
"Stay free, great conspirator!"

George Loveless of Tolpuddle, Dorset, in Van Diemen's Land 1832

JOEL OPPENHEIMER

Moratorium

wednesday, 15 october 1969

the little boy wasn't three yet,
and as the crowd grew, carrying
candles, it was hard to know what
he thought about it. he, himself,
wasn't carrying a candle but had
a large corrugated cardboard whale,
it had giant teeth, and he held it
high and proud. four people looked
at it and said noah the whale, and
one oohed moby dick, but most didn't
say a thing. it was a silent march.
the little boy got tired, but he would
keep walking, so he gave the whale to
his father. now it rode high above
the crowd; people were asking what
is it? and, why carry a whale in
a peace march?
 i tried to answer
that they were dying more quickly than
us, so it seemed to make sense. some
looked at the two of us very strangely,
a few heard what we were saying.
 they
are killing the whales so fast that
the fleets come back half-full ahead
of time — and a male blue whale can
swim his whole life without ever
finding a mate. this should tell us
what sort of a beast we are, how we've
learned to draw leviathan forth from
the sea, and kill him. from the
beginning we knew how to kill ourselves.

Woodcut by ROCKWELL KENT
from "Moby Dick" (New York, 1930).
Courtesy of the Rockwell Kent Legacies

75

BRIGID BROPHY

The Two Emperors

THE EMPEROR of the East met the Emperor of the West at a large inflated plastic dolphin a quarter of a mile out to sea. The Emperor of the West had been taking private swimming lessons to make sure he could get there and back without exhaustion.

That, however, was a minimal item in the preparations. Three years of subterfuge had been needed for each Emperor to escape the surveillance not so much of the other side's as of his own secret service.

It was during a conference that the rendezvous was finally fixed. One Emperor said something which caused all his military, economic and political advisers to go simultaneously flurrying through the files of papers in front of them. While they were seeking the precise text of the subclause he had queried, the Emperor stooped as though to scratch his ankle and managed to push a pencilled note down the side of the other Emperor's shoe.

The other Emperor communicated his acceptance of the appointment during the afternoon session. He politely extended his cigarette case to the first Emperor. It contained only one cigarette, along whose seam "Yes" was faintly scribbled.

In accordance with the security procedure common to both sides, the first Emperor, having read the message, burned it.

On the day dedicated by the conference schedule to "informal leisure activities", each Emperor contrived to send his bodyguard briefly off on a false trail. Then the Emperors swam, each from his own side of the bay, to the appointed dolphin.

Having met, they were careful not to speak before the Emperor of the East, who had in youth been an agile swimmer, dived, rather

Ornament with two dolphins and four genii, JACOB BINK. *2 x 11 cm. Courtesy of the Trustees of the British Museum*

puffily, beneath the dolphin and divested its underside of half a dozen limpet microphones.

In still unspeaking accord, the two Emperors nosed the plastic beast round so that its bulk came between them and the shores of the bay: this for fear of directional microphones operating from land.

Then the Emperors bumped and bobbed their way along to the dolphin's tail, to which their two pairs of hands clung side by side, and at last gave one another Good Afternoon.

"When Napoleon and the Tsar Alexander the First did this in the middle of the river Niemen," said the Emperor of the East, still rather out of breath, "they had a pavilion constructed on a raft for them to meet in."

"At that date there was still such a thing as privacy," replied the Emperor of the West: "at least for the ruling classes. Nowadays, building workers wouldn't know how to build a pavilion without building in microphones."

On a sudden thought he pulled the stopper out of the inflation valve in the dolphin's tail. Inside, there was a microtape-recorder, which the Emperor tossed out to sea before replacing the stopper.

"We'd better get straight to business," the Emperor of the East urged. "It won't be long before my security people become worried about my safety and insist on rescuing me. And I daresay yours are the same."

"It wouldn't surprise me if mine sent a gunboat," said the Emperor of the West.

"If they do, mine will send a faster gunboat," said the Emperor of the East gloomily.

"I'll waste no more time," said the Emperor of the West, "pleasant though it is to chat with you in the warm sea. I can explain the situation on my side very quickly. My Empire is approaching the last extremes of poverty. Almost all our revenue is absorbed by the quite unproductive business of building anti-weapons to answer your weapons, and building weapons to out-strip your anti-weapons. Sometimes I think we'd be better off if we *let* you invade and conquer us. At least, most of us would then be peacefully dead, and those that remained would constitute fewer mouths to feed. As things are,

the civilized values which we believe we are spending all this money to preserve are vanishing from our lives. I realize," the Emperor added solemnly, "that in telling you this I may have put my half of the world at your mercy. But since you are matching up weapon for weapon, I would guess that you are in exactly the same case and therefore in no position to take advantage of us."

"You can feel absolutely secure about having told me," the Emperor of the East replied, "because your guess is absolutely right. My Empire is based on a revolution in the name of the people, and the people are daily becoming more impoverished and more oppressed by our security forces: all because we have to be prepared to defend our revolutionary achievement against your Empire. Therefore, if you hadn't spoken first, I would have said exactly the same thing to you."

Both Emperors gave a rather plopping sigh of relief. Side by side in the water, they turned heads and smiled at each other directly: two fattish, brick-pink, middle-aged men in bathing trunks experiencing the relief of lovers who, having bravely confessed to love, find it reciprocated.

"Well what in hell", said the Emperor of the West, "shall we do? Couldn't we reach an agreement to disarm simultaneously?"

"Don't be insulted," said the Eastern Emperor, "but people on my side feel certain that if we reached such an agreement you'd cheat us."

"I can't very well be insulted, because my side believes exactly the same of you."

"Couldn't you", the Emperor of the East suggested, "convince your people? Couldn't you argue them into sense? After all, you have the advantage of being a democratic ruler."

"The people never mistrust a politician so much", the Emperor of the West replied, "as when he tries to convince them. If they thought me a man of principle, I'd never be elected again. They want to believe us wily, unscrupulous and self-seeking, because they think that's the only kind of person who can stand up to you. Now *you*, I should have thought, truly could do something, because as

76

an absolute ruler you needn't bother about carrying the people with you. Couldn't you just give orders to destroy your weapons and disband your forces? The instant you'd done it, my side would be only too happy to follow suit.''

"How can you be sure? You might no longer be Emperor.''

"It's true I can't bind my successors. That's another of the disadvantages of democratic government.''

"Perhaps your people have elected a peaceful man like yourself only because they know my Empire is strong,'' said the Emperor of the East. "As soon as we became weak, they might throw you out and elect an Emperor who'd take advantage of our weakness. You can't offer me any guarantee that they wouldn't, so I couldn't pass on any guarantee to my committee.''

"Your committee?''

"My dear Emperor of the West, you have to deal with an electorate of millions, at least some of whom would agree with you if you suggested destroying all your Empire's weapons. I have to deal with a committee of six, not one of whom would agree with me. If I gave orders to destroy all our weapons, the six, who normally hate each other, would unite to countermand my orders and murder me. The man who replaced me would build up bigger armies and more powerful weapons than ever, because he would think he had proof that you were more dangerous than ever. Indeed, he'd suppose you had grown so aggressive and so powerful that you'd managed actually to suborn *me*. That's the only way he could explain my having given such a lunatic order.''

"I see your point, and I grant'', said the Emperor of the West, "that neither of us wields unconditional power. Yet between us we surely wield the largest single quantity of power in the world. Surely that's powerful enough to do *something*?''

"You'd think so,'' said the Emperor of the East. "But *what*?''

"We'd better decide quickly or our respective security forces will be upon us,'' said the

Emperor of the West. "It's a bit slipshod of them not to be here already. No doubt the events of this afternoon, when they discover we've been absent and unobserved so long, will put them more on the alert, and that will make it harder than ever for us to meet confidentially. Both our Empires will be beggared before we can contrive such another chance as this.''

"The security forces themselves'', the Emperor of the East grumbled, "are one of the most expensive and least productive drains on the revenue. Is that your experience too? In my Empire, about one in four of the citizens is drawing a high salary from the state merely for watching the other three.''

"In mine, about half the security force is occupied solely in watching the other half of the security force. We have to pay even more for that, because it's more highly skilled work. Indeed,'' the Western Emperor went on, "for all I know, the entire security force may be self-parasitic. I ought to know what goes on, because I'm the only person with total access to top secrets. But to be the only person with total access is in fact totally futile, because only another person with total access could explain the total system to you.''

"Could there be'', the Emperor of the East enquired, "hope in that?''

"If you can see it, please expound it.''

"Well: the financial appropriations for new weapons, for example. They go through your parliamentary process? The parliamentarians vote for the money for the weapons?''

"Yes.''

"But the parliamentarians don't oversee in detail how the money is spent?''

"I daresay I'm infringing security in telling you, but no, of course they don't,'' the Emperor of the West replied. "Parliamentarians have a very low-grade security clearance. The money for weapons is spent secretly, by experts.''

"Indeed,'' said the Emperor of the East.

"What about your committee?'' the Emperor of the West asked in a slow voice that indicated he was thinking as he spoke. "Do the experts keep your committee in the dark, too?''

"The Committee votes the money,'' the

Eastern Emperor replied, "and each member of the committee would dearly like to know the secrets of how it's spent. But for each member there are five other members who mistrust him. So rather than let any one member acquire the power that would accompany total knowledge, they all insist on the traditional security procedure of the cell, whereby each person knows only the minimum he needs to know.''

"So it would be possible'', the Western Emperor speculated, "for the money to be voted for defence but in fact to be spent on –''

"– better things,'' said the Eastern Emperor trenchantly. "And no one would know how it was being spent, because the whole subject is top secret.''

"A man could join the army and be seconded to work in a hospital or a school. That man would suppose secondment to be just his individual lot. He would believe that millions of other men truly were serving in the army, and no one would know that in fact there *was* no army, because the numbers and dispositions of the armed services are naturally matters of top secrecy.''

"What about the weapons that already exist?'' asked the Emperor of the East.

"We'll order those to be destroyed, on the grounds that they're obsolete. We'll say we're going to replace them by weapons more up-to-date and more effective – weapons which are, of course, ultra-hyper-top-top-secret.''

"And for those supposedly more effective weapons we can get really huge amounts of money voted,'' said the Eastern Emperor, "which can be spent on *much* better things. Do you know that in my Empire, the very home of the art, we are contemplating closing the state ballet because we have no funds for anything except defence?''

"I was going to ask you if your ballet could come to us on tour.''

"It can come every year if you'll put our plan to work.''

"Agreed,'' cried the Emperor of the West. "My first step, like, I don't doubt, your own, will be to tighten up the security system. Obviously we need very strict security if it's not to leak out

that we have no security."

The Emperors clapped each other on the sunburnt shoulders, kicked off from the plastic dolphin, sending it spinning out to sea, and swam separately back to their own shores.

To the populations of both Empires it seemed that the Emperor-level conference had been a failure, since the first announcement each Emperor made, on returning to his own capital was that security was to be tightened.

(The Western Emperor told his agents that his reason for absenting himself for a whole afternoon was as a test of them, and they had not even noticed. That, he argued, demonstrated the need to redesign the whole system.)

Further financial stringencies were expected and, indeed, announced. But though everyone in both Empires knew that more money than ever was being spent on weaponry, no individual seemed to be personally feeling the financial pinch. In neither Empire did anyone seem to meet anyone who had actually known anyone whose job was in a weapons factory — though of course that was only to be expected, given the secret nature of such jobs. What people did notice was that the slums were being pulled down and handsome flats were going up. However, every individual realized that it must be just his individual good luck to live in a neighbourhood where, quite against the general trend, it was easy to find a decent home and where, should you fall ill, there was a modern and comfortably equipped hospital to care for you.

No announcement was made in either Empire about an increase in subsidies to theatres, opera-houses, museums and symphony orchestras. But people who went to museums noticed that the buildings had been recently renovated; and people who applied for tickets to performances noticed that tickets had become cheaper and performances better. If you chanced to be acquainted with a musician or an actor, you probably noticed that your friend was suddenly more affluently off and less worried, which probably accounted for the improvement in performances.

In a corner of the Empire of the West, three poets, who had been on the verge of starving in a cramped garret and who had been using up their failing strength in debating which of them was the least gifted poet (for they all agreed that, once he had been justly picked out, it would be only just for the other two to eat him), were rescued at the latest possible moment by state pensions for life, granted them personally (and, he insisted, privately) by the Emperor.

In brief, the plan worked.

Everyone in both Empires was soon receiving a sound but interesting education and then going on to a secure and pleasant job which exacted from him only short hours of work.

Everyone continued, however, to believe that most of his fellow citizens were slaving away, in factories too secret for their whereabouts to be divulged, at the distasteful but necessary chore of making weapons.

Each Empire was quickly growing into a paradise — but a paradise much less boring than its mythical prototype. For, besides being offered entertainment of a high standard to divert them in their new quantities of leisure, both populations turned their serious attention to the unendable quest for excellence in art. And there was constant public discussion of adventurous and subversive ideas.

Ideas which a few years before would have been called dangerous were now thought exciting. People no longer wanted to stop others saying things they disagreed with. They positively wanted the ideas they disliked to be expressed, because otherwise it was impossible to put the arguments against them.

Now that people were enjoying their own lives, they felt very little impulse to prevent other people from enjoying theirs.

No more did they want to prevent animals of other species from continuing and enjoying *their* lives. Humans stopped torturing and killing other animals for purposes of sport, science or food production. They explored the luxuries of vegetarian food (which, since it was cheaper than carnivorous food, further increased the affluence of both Empires), and two new and sophisticated vegetarian cuisines were

developed, one Eastern and spicy, the other Western and saucy.

On each side there were moves to extend the new tolerance to the other Empire. Each Empire was inclined to believe that its own way of life was now so obviously paradisal that citizens of the other Empire would need only to see it to be won over.

Having lost their dread of subversion (their secret conviction, that is, that the other side was more attractive than one's own), both sides permitted their own citizens to travel freely and welcomed visitors in return.

The tourists were much freer than before to roam while they were abroad. Although they knew there existed large military areas which it was forbidden to enter, they never seemed to chance on one, no matter how widely they wandered.

In their new freedom, the tourists became much less purblind about what they allowed themselves to admit to themselves they saw. Both sets of tourists were, in fact, astonished to realize, from observation, that the other Empire was also a paradise.

On each side, the consensus worked spontaneously round to the conclusion that, regrettable though it was in principle and expensive in practice, armed vigilance must still be kept up, since the rival Empire obviously had dangerously huge material resources.

Suddenly, the Emperor of the West died.

(His doctors diagnosed, unfortunately after the event, that his heart had been weakened by his taking up long-distance swimming and when he was past the age for it.)

The new Emperor of the West, like most people in both Empires, was a believer in reluctant armed might. As soon as he was installed and had access to top secrets, he considered it his duty to satisfy himself about the state of the armed forces, the stock of weapons and the security precautions of his Empire.

He found it difficult to penetrate the codes and the reciprocally watertight systems of the many security organizations. Having, however, been trained in Formal Logic, he set about deciphering the secret files systematically and coolly.

Yet for all his coolness he could scarcely believe the conclusion to which all his investigations seemed to point.

Flustered despite himself, the new Emperor realized that he must instantly summon the whole political and military hierarchy and disclose what he thought he had discovered. If anyone could shew that the Emperor had misunderstood the files, so much the better: he would merely have made a fool of himself.

He planned to disclose the truth in total secrecy, of course. He realized that any leak would entail enormous risk: should word reach the East of the West's complete lack of defence, immediate invasion might result.

Although he had made up his mind what he must do, the new Emperor found the state of affairs he was about to disclose so incredible that, before summoning the assembly, he retired to his private study and passed an hour of agonized solitude trying to get used to the reality of what he had to tell.

He was on the point of pressing the intercom button and sending out his summons, when he notice his window being besieged by a singularly persistent pigeon.

A birdlover in any case, impressed by this bird's purposeful behaviour, and feeling the need for a moment's respite from his huge and urgent responsibility, the Emperor raised the window, despite the disruption that invariably made in the air conditioning, and found that a note, purporting to be from the Emperor of the East, was attached to the pigeon's left leg.

"If you've discovered what I think you must by now have discovered," the message read, "do nothing rash. I had an arrangement with your predecessor. I'll explain when I can see you alone. Accept my forthcoming invitation to an official conference, and leave the table for the lavatory at 11.39 GMT on the second morning. Message ends."

The emperor pushed the intercom button but only to ask for the air conditioning to be rectified and to request a handful of corn from the kitchen so that he might thank the pigeon.

The next day, diplomats from the East began negotiations for an Emperor-level conference.

That seemed to offer the Emperor of the West some assurance that the message was not a hoax.

All the same, he was worried by the danger of doing nothing about his Empire's vulnerability. He might be committing the grossest dereliction of duty in history. He told his own diplomatists to hurry the conference arrangements.

However, protocol and security could not be skimped. Six weeks elapsed. During them, the Emperor of the West read and reread the pigeon message, trying to understand the "arrangement" it mentioned. The best he could surmise seemed a redoubled incredibility: was it possible that the Empire of the East was also without defence?

It crossed the Western Emperor's mind that, were that so, it might conceivably be his distasteful duty, for the sake of humanity at large, to order an invasion of the East.

However, he happily realized that that decision, right or wrong, was one he need not take: because his own Empire, being without armies or arms, was in no position to march in.

The Emperor of the West approached the first day of the conference impatient for the second day and the secret appointment.

He thought of the first day as mere slack time, during which no private puzzles could be answered and all he could expect from his fellow-Emperor was public affability.

But the Emperor of the East in fact did something unexpected. He died.

He thudded forward onto the conference table, seemed to be trying to say something to the Emperor opposite, and extended his dying arm across the table towards him.

The delegates from the Eastern Empire, in consternation, accused the Empire of the West of having poisoned the Emperor.

One Eastern official, reputedly the toughest member of the so-called Committee of Six, actually leaned threateningly across the conference table and shouted at the Emperor of the West: "Assassin!"

The Emperor of the West remained cool. "Surely it would be wiser to wait for the post mortem findings before making accusations. To my admittedly untrained eye, the symptoms

looked just like those of my own predecessor, when he had *his* heart attack."

"Nonsense," said the tough official. "Even in death, our heroic and martyred comrade was trying to point the finger of suspicion at you."

"On the contrary," the Emperor of the West replied suavely. "He was trying to extend to me the hand of conciliation."

It was an answer which discernibly calmed both delegations. The Eastern delegation announced that they must immediately retire into private session to consider domestic problems, by which everyone understood them to mean they must choose a new Emperor.

By the next day he was chosen. He was not the tough official (who indeed had vanished overnight from the Eastern delegation) but a mildly spoken man, who opened the session by apologizing for the accusations flung in the crisis of grief.

"It turns out," said the new Emperor of the East, "that our late esteemed comrade Emperor died of causes entirely natural — unless, that is, your Western technologists have come up with a poison that is undetectable."

There was a moment's bristling on both sides, but then the new Emperor smiled to shew he was joking.

"Our own technologists," he added, "tell me that is impossible, and since ours are known to be the best technologists in the world I entirely believe them."

The Emperor of the West shushed one of his technical advisers who was obviously on the point of interpolating that it was western technologists who were the best, and the Eastern Emperor went on to say, apologetically, that in the new circumstances he felt obliged to adjourn the inter-Emperor conference. "I am very much a new boy," he said, smiling again, "and have much to learn about my new job. When I have sufficiently schooled myself, I hope to have the pleasure of resuming, on an informed basis, this conference with my colleague the Emperor of the West."

Everybody understood the new Emperor to be saying that he must discover what military resources were at his disposal so that he could

know from how much strength he was negotiating.

Everybody thought it a perfectly natural response on his part.

Only the Emperor of the West was secretly worried. However, having foreseen what might happen, he said, before the conference dispersed: "Fellow-Emperor, I have been personally grieved, as I am sure you have, by the death of your predecessor. I have written you a purely personal and private letter in which I have tried to express my feelings. May I beg you to read it, when you return to your own capital, in privacy. I should be embarrassed if my stumbling sentences were seen by any eyes but yours, which I know will look sympathetically on my deficiencies."

And he held out the letter, which was in a sealed envelope.

Some Eastern security men moved to intercept it and vet it. But their Emperor brushed them aside. "There is no such thing as an undetectable poison," he said. "If the letter poisons me, you will know all about it, and you will have lost nothing but my life and the peace of the world. But I am sure," he added, with a slow courteous bow to the Western Emperor, "that it will bring me not poison but comfort." And, taking the letter, he put it into his inside breast pocket next to his heart.

When he opened the letter in privacy, the Emperor of the East found that, to a sheet of his official tiara'd writing paper, the Western Emperor had sticky-taped the by now crumpled message sent him by pigeon. Underneath, the Emperor of the West had written: "I had this from your predecessor. If you recognize the writing as his, you will have an earnest of my good faith. When you make a certain disturbing discovery, please take no action until you have called for a resumption of the adjourned conference. At that conference, please keep the appointment your predecessor made with me."

Within a fortnight, diplomatists from the East applied for the conference to be resumed.

On the second morning of the resumed conference, the Emperor of the West rose abruptly from the table, remarked, "The drinking water in these spa towns where we hold conferences is always upsetting," and left the room.

A second later, the Emperor of the East rose, said, "I don't think it's the water; I think it's the quantity of wine at these banquets we give each other," and also left.

By the time the Emperor of the East reached the room marked "Toilets. Emperors Only", the right-hand cubicle (there were, of course, only two) was already occupied, with its door shut.

The Emperor of the East entered the cubicle on the left.

Beneath the partition between the cubicles, a sheet of blue lavatory paper was extended towards him.

The Emperor of the East picked it up and read: "I have discovered that my Empire is totally disarmed. Have you?"

On a piece of pink lavatory paper from the box in his cubicle, the Emperor of the East replied: "Yes. Let's keep it up."

In accordance with security procedure, both Emperors flushed away the messages they had received.

So, though this conference too appeared to produce no result, paradise continued in both Empires.

Indeed, it became double paradise. In the free exchange of ideas, each Empire was able to copy the best things about the other.

The Emperor of the West grew old and judged that the world was now safe enough for him to contemplate retirement while he might still have something new and truthful to say about the theory of the syllogism.

He was encouraged by the existence of an up-and-coming young politician who was campaigning for a reconciliation with the East. His slogan was "Trust the People — whether of West or East."

The Emperor, who believed he had more knowledge than anyone else of exactly how trustworthy the East was, took the young man to his heart. "I will retire and support you for the succession," he said, 'on condition that as soon as you become Emperor I may see you in strict privacy. I have something to tell you."

"I don't like deals between politicians," said the young man. "It may surprise you, but I'm not a cynic. I truly believe in trusting the people."

"The belief does you credit," said the old Emperor. "But as this concerns the security of the Empire, indeed of the world, I must insist."

The young politician agreed and, with the now ex-Emperor's help, was elected.

The ex-Emperor was about to remind his successor of their appointment, when he was summoned to the Palace.

He found the new Emperor pale and furious.

"I've already discovered," the new Emperor said. "I move fast. And a more despicable, catastrophic betrayal of the people I never—"

"But you don't know the whole of it," the ex-Emperor said. "There is a secret arrangement—"

"I will have no truck with secret arrangements. I am for honesty, sincerity and open discussion with the people. I shall tell the people at once that they have been left without a shred of protection. I shall tell them it was you who left them so. I'm having you arrested at once." The Emperor pushed a button. "I've summoned the armed guards."

Emperor and ex-Emperor waited three minutes in silence.

"You see, said the ex-Emperor gently, "there *are* no armed guards."

"A trifle like that won't stop me," said the new Emperor, and he threw up the window.

The ex-Emperor tried to warn him of the effect on the air conditioning.

But the new Emperor pushed past him and yelled through the window: "I want three hefty loyal citizens to arrest a traitor!"

Heavy footsteps rushed up the stairs outside.

"It won't take as many as three," the ex-Emperor was murmuring when five strong louts burst in.

"Take this traitor to prison."

"Certainly sir. But could you tell us where the nearest prison is? It's one of those secrets no unauthorized person knows."

"I'm not cognisant of details," said the Emperor. "Ask the secret police or someone."

"As a matter of fact there *are* no prisons," said

the ex-Emperor, "any more than there *is* any secret police. We have been living as free human beings for some time now, though we didn't know it."

"Things have even more indescribably gone to pieces than I'd realized," said the Emperor. "But I tell you, trifles won't stop me. Put him," the Emperor commanded the louts, "in a cellar. We still have plenty of those. Indeed, everyone drinks too much these days. The whole concept of discipline is vanishing."

In the Palace cellar where he was rapidly thrust, the ex-Emperor was, as a matter of fact, comparatively happy. He thought about syllogisms by day and drank claret by night.

He was probably the only person in the Empire who did not hear the urgent broadcast in which the new Emperor told the people that they had been left defenceless and called on them for a superhuman effort to remedy the lack.

The broadcast was of course monitored in the Empire of the East.

No one in the East was unduly worried. Defence was believed to be adequate to meet any threat — particularly if the Western Emperor's broadcast had been not a ruse but the truth, in which case there could not be much threat.

Without urgency, however, the Eastern Empire's Committee of Six, against the wishes of their Emperor, thought it advisable to check up, as a matter of routine, on the defences available.

On the second day of the check-up, the Eastern Emperor was deposed and the tough official who had not taken part in public life for some years replaced him.

In both Empires paradise was demolished.

It went amazingly quickly.

The new flats were commandeered for improvised barracks. The new schools and theatres were turned into weapons factories and arsenals.

Both sides were in such haste, their commanders in such panic and their technicians so out of practice that, on one side or the other (or perhaps on both simultaneously), there was error and a weapon was detonated by mistake.

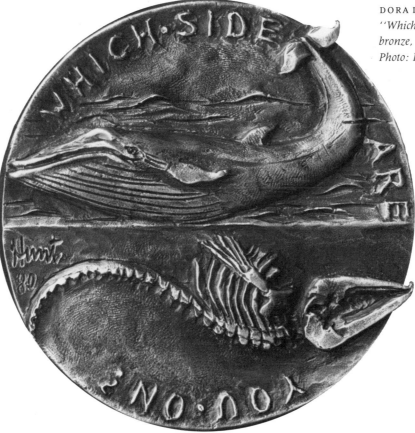

DORA DE PEDERY HUNT
"Which Side Are You On?" 1980
bronze, 8 cm diameter
Photo: Elizabeth Fry

The other Empire believed the accident to be an act of aggression, and retaliated. Counter retaliation followed automatically.

The Western Emperor's Palace, a prime target, received one minute's warning from the improvised alert system. The occupants, rushed to the cellar, tripping, in their rush, over the ex-Emperor, who was sitting drunk on the steps inside, happily mouthing that he'd at last seen a way to refute John Stuart Mill's aspersions on the syllogism. However, the cellar was not protection enough. All the occupants perished when the Palace, and with it most of the capital city of the Western Empire, was obliterated.

Certain retaliatory devices continued to be despatched, on both sides, automatically; and in consequence the human species became extinct.

It is possible that some of the weapons continued to shoot about in the depopulated world after the species which had designed them had ceased.

The resulting world-wide fallout soon extinguished the other animal species — the more rapidly because the other animals, during mankind's brief bout of tolerance towards them, had given up shunning human habitation.

Only a plastic dolphin, floating at the remote centre of an ocean now emptied of mind and instinct, bobbed on, its gay and silly nods slandering the intelligent animal in whose likeness it was shaped.

However, the stopper in its inflation valve, constructed to allow for the presence of a tiny machine, was no longer, in the absence of that machine, completely airtight. Little by immeasurably little, as the years passed uncounted, the only unpolluted air in the world leaked away. The dolphin shape collapsed, and the plastic eventually shrivelled.

WILLIAM GOLDING

Encounter

It was sometime in 1940 and very far north. We were hunting and being hunted through a seascape more brilliant than any I had seen before. The water was every shade of blue. The ice was every shade of blue and green and white and scattered over a silky sea. This was the long, Arctic summer – daylight all the time but strange and unreal to eyes dulled by lack of sleep. It was strange to a mind become so habituated to danger that death was a continual but semiconscious worry like a too heavy bill you know will have to be paid some time out of an account where there isn't enough money. I was on watch, my life varied only by the four hours on and four hours off of the wartime navy. Our cruiser slid, slitting the shimmer of blue silk sea. She was keeping clear of the scattered ice and the long ice wall beyond it against which the enemy would appear. The sun was low and bright and the time, for what that was worth, was two o'clock in the morning.

I had the binoculars to my eyes and swept the horizon on the port bow with a mechanical movement as exhaustion and sleeplessness were at odds in me with my sense of the outrageousness of this voyage in our eggshell of a ship against a battle cruiser, a huge enemy. All the time it was hard to believe I was where I was in this magical place with this mechanical job. It was hard to believe in anything or stay on my feet. But if duty could not do it alone, the submerged worry kept me awake, the unpaid bill of death that was likely enough approaching us over the northern horizon.

Then I was wide awake and the bill was right there demanding payment in full, a final demand. I pulled myself together and in a crisp voice worthy of *In Which We Serve* made my report.

"Bearing Red 025, sir. Shellfire, distant."

There was a commotion. Bells rang, orders were shouted. The gun barrels of our forrard turrets moved individually and restlessly like the fingers of a pianist about to play then settled all together on Red 025.

There was a long pause.

After that, nothing much happened. At last the orders went into reverse, the gun barrels sank and trained forrard. Long before the captain approached me I knew what I had done, an amateur in a professional world. But he did approach me at last, after the ship had stood down from action stations. I felt his arm on my shoulder from behind, then a friendly pat. He murmured.

"I don't suppose you'd ever seen a whale spouting before."

Later we passed it, him or her, rolling along in the sea, casual, enormous, sometimes blowing a high jet of spray, at home, a black reef that appeared every now and then. I remember envying him, so much a part of the light and ice and water that he did not have to worry about the steel death coming down from the north to present its bill against my tiny account. I thought he didn't have worries and would outlast us all.

I was wrong, of course.

Woodcut by ROCKWELL KENT *from "Moby Dick" (New York, 1930). Courtesy of the Rockwell Kent Legacies*

WIELAND SCHMIED

Whales, For Example

Whales
are only one example
the world does not cease to be
when a whale dies
the world does not cease to be
when a wood dies

Whales
are only one example
I could speak of a hundred
dead dolphins
of a thousand
young seals

I have never
seen a whale die
except in pictures
on television
or in Melville's
famous book

So it is easy

to say:
the world
does not end
when a whale
is slaughtered

The Eskimos started
hunting whales
in order to survive

All the peoples of the earth
have cut down woods
in order to survive

What alarms me
is the proliferation of examples
the growing of the deserts
the withering of the woods

Birds falling from chemical
 clouds
fishes washed up

in industrial sewers
which were once our rivers

"The inhospitality of cities"
"Seas polluted by oil"
I can read nothing else
I can hear nothing else

Melville was of the opinion
that we could conquer Nature
we need to learn
that conquest can mean our
 deaths

The murder of whales
is only one example
to show that man no longer
wishes to live in this world.

Translated from the German by Michael Hulse

DAVID RABE

First Whale

I have never seen a whale.
And this is reason enough
for me to wonder about him.
If he is at all.
Let alone vanishing.
We had a turtle.
And a turtle is not a whale.
But this turtle loved his way
of life. Of this I have no
 doubt.
He proved it by fleeing.

If a turtle loves its life,
what love must a whale have,
for a whale is bigger than a
 turtle,
and if I grew to respect the
 turtle,
what a respect I might have
 for
a whale.

Size is not the crucial factor
 in life.
But it matters.
It is not as crucial as life.
On this I am sure the whale
 agrees.
As would the turtle had he
 not fled.
When he fled, I was glad.
He found a way away.
I hope the whale lives.
I hope he gets away.

But the world is a circle.
Fleeing in any direction
only brings you back to where
you started, even if it's round
 the world.
That's not escape.
That's being in a trap.
No hope in a circle
Unless it's a friend.

DAVID GASCOYNE

Whales and Dolphins

We're told that we must never anthropomorphize
when we are writing about animals, or "creatures"
as we'd prefer to say; nor are we now allowed,
of course, to speak of "all God's creatures" either,
since there are few today who can believe
that He exists and once created them and us.
To write a poem about whales or dolphins, then,
presents a challenge to all those who see
in the great whale the dread Leviathan
which Scripture teaches man should look upon
as the huge proof of the Creator's mightiness,
the ruler of the deeps, and in the guise
of the White Whale of Melville's *Moby Dick*
a mighty symbol of both Death and Mystery;
or who, as I do, see in the dolphin's face
the look both of the cherubim and of the unborn child
safe in its mother's womb, with the angelic, innocent
smile worn by all the creatures of God's Paradise.
Many the myths about the dolphin. *Dauphin* means,
or used to, dolphin and also "first-born"; and
a boy upon a dolphin's back is such an old
image, it surely tells us men have always sensed
some sort of kinship that the reason can't explain
between the amphibious being and our own.
Then there's the recent question or new myth
about the dolphin's sort of speech: a mystery
indeed! Poets and thinkers are increasingly
concerned with the great problems language sets.
A poem should avoid abstraction and all forms
of private declaration of belief; yet I must state
that I'm convinced by what is called the Fall of Man.
We've been turned out of Paradise; we've made the world
into a shambles and a slaughter-house; we've lost
the primal *Ursprāch* which may once have been
also an aid in our communion with the beasts
we now exploit and prey upon. Polluted earth,
polluted souls: Now finally, perhaps too late,
we try to care, if not to pray, for some Salvation.
A poet friend of mine[1] wrote lately that: "We live
in the mind of God, here, now and always, for there is
no other place." And R. Buckminster Fuller wrote
in nineteen sixty-three: "Stop 'calling names'
names that are meaningless; / you can't suppress God
by killing off people which are, physically,
only transceiver mechanisms through which God
is broadcasting." And too: "The more man becomes man,
the more it will be needful for him to,
and to know how to, worship": thus the Père

Teilhard de Chardin. I do not digress.
If you have faith you may not have it every day
but somehow you believe that we shall not destroy
ourselves and God's creation; though we can
"kill off people" and, be it added, species like
the direly menaced whales and dwindling dolphins.
Now "the light of the public darkens everything."[2]
But still the animal kingdom and the world of nature can
remind us of our long-lost innocence. All things shall be
made new. Let chaos come. The mortal must first die.
Yet even an atheist poet[3] could write: "The rose
tells that the aptitude to be regenerated has
no limit"; and "what selectivity there can occur,
only just in time, and succeed in imposing its law
in spite of everything. Man sees this pinion tremble
which in every language is the first great letter of
the word Resurrection." Redemption. Paradise Regained.
God's Kingdom here on earth. Absurd, discarded dreams?
Not only fools can still believe and fight for faith
and meaning: to preserve our innate, obstinate capacity
for love, for wonder at the miracle of life:
to speak out even if the words one's forced to use
seem worn nearly to death, and say: Yes, we can still
do what we can to preserve not only such rare things
as whales and dolphins, but the eternal Mystery of which
they are both emblem and incarnate form.

1 *Kathleen Raine*

2 *Martin Heidegger*

3 *André Breton*

from *Whale's Song* *The Apollonian Whale (Opus 74)*

Above the sea time was fixed
like a star.
Waves beat eternally against
 those cliffs,
and if Knupfer's naiads
were to sunbathe under them
even after a long hundred
 years
they wouldn't recognize a
single wrinkle.

Mr. Roger Payne and his wife
 Katie
understood the language of
 whales
and near the islands of Hawaii
 and Bermuda
they taped the song of the
 finbacks
whom the sailors call
Keporkaci

Whales have nearly died out.
This might better be a funeral
 song.
But it isn't!
In the grey depths of the sea
it sounds grandiloquently.

Maybe we should get up,
take off our hats
and stand at attention as
 straight
as a lighthouse.

Maybe this is a hymn of the
 sea!
The kind heard rarely,
but since the beginning of the
 world.

Translated from the Czech by Lyn Coffin

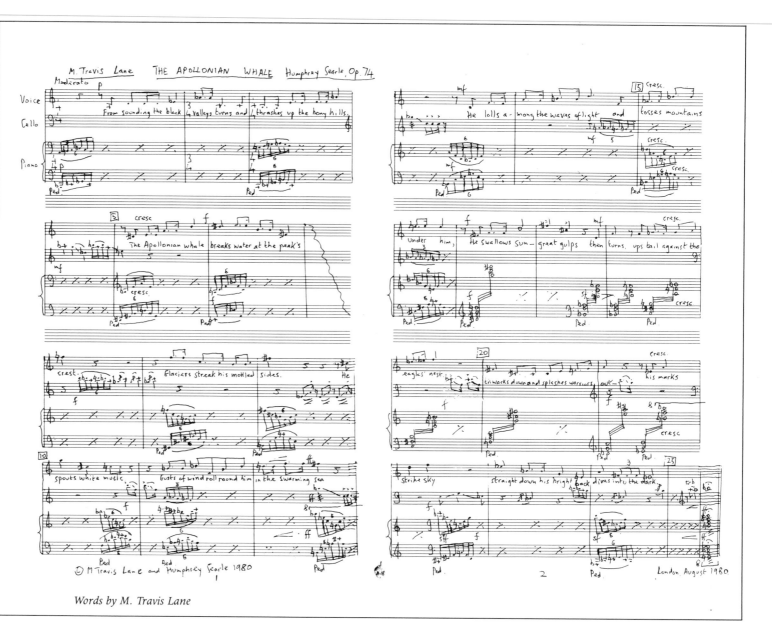

Words by M. Travis Lane

far right
"Jonah and the Whale" illumination
from the Kennicott Bible (MS
Kennicott 1, fol. 305r), 1476,
generally regarded as the most
beautifully illustrated and penned
Hebrew Bible in existence. Courtesy
of the Bodleian Library, Oxford

GÜNTER HERBURGER

The Song of the Whale

Huge animals, weighing many tons,
swimming constantly in their nourishment,
and quietly, after sixty, seventy years, dying
as if their time were up,
covered with small, sharp eyes
which can look into the depths
and beyond the edge of the water
where the continents begin,
thus they have no natural enemies,
none at all, apart from us,
and in storms their bodies
simply sink into other zones
where peace reigns in plankton,
luminous fish sail by, and only the arms
of the octopus still move like flowers.

One must imagine
we could be like this:
overwhelmingly calm, cunning and powerful,
at once childlike and curious,
whilst fountains spurt from airholes
and tails beat again and again
into the sea like a tanker's rudder,
echoing from shelf to shelf.
Distances are the proof
of vision and permanence,
equipped with a self-understanding
which needs to worry no more about space.

In copulation the cow-whales
sometimes refuse,
have no desire or act prudish,
stand vertically on their heads
and lift for hours their own weight,
twenty, thirty tons,
bleating and snorting.
Then the males, just as heavy,
circle round the redoubtable beasts
and begin a desperate song.

It must be said, too,
that there are also offspring, calf-whales,
who don't care for this headstand
and strike their heads
against their mothers' bodies,
trying to knock them over.
Or they lie flat next to them
until sunburn scales their backs,

their skin hangs in shreds, food for birds
who are in on the party.

But then a slurping and fiddling start up
through the oceans, heart-rending music.
The whales answer each other over thousands
 of miles,
and we alone in our iron ships
can interrupt their signals.
From the Arctic to the Indian Ocean,
from the Pacific to the Caribbean
ring out the wistful calls of the whales
who hardly dare meet any more
in the gun-emptied vastness.
Organs sound, huge flutes,
bows scratch over whalebone
carrying a hundred thousand strings for each
 jawbone,
and on the gloomy ground below
behind banks of coral
small, timid grebes work
amplifiers and manuals.

Sometimes when I am sad,
I imagine I am a whale,
a lung-fish, fat as a gigantic barrel,
which no longer needs to crawl onto dry land
to refine itself, exposed to wind and rain
and the knife-sharp competition of men
who don't wish to live as it does.
I would refuse the biological mutation,
freely reduce the number
of unused brain cells
and throw myself back into the waves,
reunited with my pledge
which would be answered
in the slow, considered movements of the
 whales,
rolling their bodies like mountains
and producing melodies like mountain echoes,
secure in an element
greater than any land.

Translated from the German by Michael Butler

PNINA GAGNON

Jews of the Ocean

Wandering from longitude to latitude lines and the reverse
reciting their oral tradition
exchanging opinions about the untransparent state of the world
arguing about which food to eat and how
using their luminous stomach as an imaginary net,
their killed dies fast, a mirror of beauty in their wide open eyes.
Loving their kin and observing the lunar calendar
the whales bleach out on shores for people to wonder
and take stock.
Something must be done for the survival of the remnants
What a learned creature!
studying and talking day and night
life long
you sing many bibles
you draw lines
curved by your body
to leave no trace nor mark
your sound is space
your cry echoes tearlessly and you speak colours.
To me, you don't seem fat.
From our blubber soap was
also made.
Let me shake your hand, Thalidomide brother,
and warn you, that the best dies first...
and do not leave the water:
the land around is antisemite.

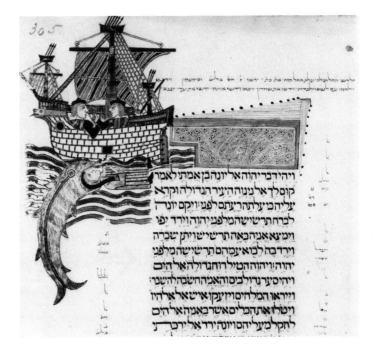

85

from The Saga of Eirik the Red

King Olaf Tryggvason had given Leif two Scots: a man who was called Haki and a woman who was called Hekja; they could outrun deer. These two were on the ship with Karlsefni. And when they had sailed past Furdustrand they put the two Scots ashore and told them to run south into the country to see whether it was good land or not and come back within three days. They wore a garment that they called a kjafal; it was made with a hood at the top, open down the sides, no sleeves, and fastened together between the legs with buttons and loops, and otherwise they were bare. The ship stopped there meanwhile. And when the two Scots came back one of them brought a bunch of grapes and the other wild wheat. Then Karlsefni and his crew went aboard with them and sailed on. – They sailed into a firth. There was an island at the mouth; on it were large streams; so they called it Stream Island. There were so many eider ducks on the island that they could hardly walk for the eggs. They called the place Stream Firth. They brought the cargo ashore there from their ships and settled in. They had all kinds of cattle with them. It was a fair land; they did not lay in stores, only explored the land. They were there over the winter and had nothing left by summer. Game and fishing went off and they were short of food. Then Thorhall the hunter went away. They had already prayed to God for food, but their prayers were not answered quickly enough for their needs. They looked for Thorhall for three days and found him on a rocky ledge; he lay there and stared up to the sky with his mouth and nostrils wide and muttered something. They asked why he had come there. He said it had nothing to do with them. They told him to come back with them and he did so. Soon after that a whale was stranded and they went to it and cut it up, but none of them knew what kind of whale it was; and when the cook cooked it they ate it, and they were all ill. Then Thorhall said: Didn't Redbeard outdo your Christ, now? I have that whale for my poem, that I made for Thor, my patron; he has seldom let me down. And when they understood this they threw what was left of the whale into the sea and put themselves in God's hands. Weather improved then and they were able to row out and fish, and then they were not short of game because now there was good hunting on land, and eggs on the island and fish in the sea.

Translated from the Old Norse by George Johnston.

''Redbeard is Thor. Thorhall is a pagan and he has composed a verse to Thor, which is not given in the saga. He seems to reckon that the whale was a gift from Thor for his verse. But their Christ, whom they had prayed to, had sent them nothing, or at any rate nothing soon enough. But after their illness and Thorhall's taunt they understand that they have erred; they throw Thor's whale meat back into the sea and are then rewarded with good hunting and fishing. The saga writer was Christian but his theology seems naive. Thorhall is naive too, bragging about a gift that made them all ill.'' G.J.

Giant Whales

Abu al-Hasan Muhammad b. Ahmad b. Umar al-Sirafi told me in Oman in 300/912 that he had seen a fish that had been stranded on shore. The tide had left it there when it ebbed, and then picked it up and dragged it up as far as the town. The Amir, Ahmad b. Hilal, came out on horseback, accompanied by troops, and the people came to see it. It was so big that a horseman could enter its jaws and come out on the other side without dismounting. They measured it: it was more than 200 cubits long and its height was about fifty cubits. It was said that the fat from its eyes was sold for some 10,000 dirhams.

Ismailawayh the shipmaster told me that this fish abounds in the Sea of Zanj and in the Great Sea of Samarqand. It is called a *Wal*. It likes wrecking ships. If it attacks a ship, [the sailors] strike pieces of wood against one another, and shout and beat drums. Sometimes it spouts water, which rises up like a minaret. From afar off one would think it was the sail of a ship. When it plays with its tail and its fins, one would think it was the sail of a boat.

Translated from the Persian by
G.S.P. Freeman-Grenville

left and right
Tracings of mesolithic rock carvings from various shores in Norway; ca 5000 B.C. These are the oldest depictions of whales in art. Photos courtesy of the University Museum of National Antiquities, Oslo

ARRIAN

from *The Account of the Voyage of Nearkhos*

Whales of enormous size frequent the outer ocean, besides other fish larger than those found in the Mediterranean. Nearkhos relates that when they were bearing away from Kyiza, the sea early in the morning was observed to be blown up into the air as if by the force of a whirlwind. The men greatly alarmed enquired of the pilots the nature and cause of this phenomenon, and were informed that it proceeded from the blowing of the whales as they sported in the sea. This report did not quiet their alarm, and through astonishment they let the oars drop from their hands. Nearkhos, however, recalled them to duty, and encouraged them by his presence, ordering the prows of those vessels that were near him to be turned as in a sea-fight towards the creatures as they approached, while the rowers were just then to shout as loud as they could the *alala*, and swell the noise by dashing the water rapidly with the oars. The men thus encouraged on seeing the preconcerted signal advanced to action. Then, as they approached the monsters, they shouted the *alala* as loud as they could bawl, sounded the trumpets, and dashed the water noisily with the oars. Thereupon the whales, which were seen ahead, plunged down terror-struck into the depths, and soon after rose astern, when they vigorously continued their blowing. The men by loud acclamations expressed their joy at this unexpected deliverance, the credit of which they gave to Nearkhos, who had shown such admirable fortitude and judgment.

Translated from the Greek by John W. McCrindle

MICHAEL HAMBURGER

Before Dinner

The sea, the sea, oh, to make friends with the
 sea,
Longs Mr. Littlejoy, walking the wide salt marshes
Towards winter, at low tide. The hungry gulls
Above him circle, shriek as he prods a cluster
Of prickly oysters, picks the largest, bags it,
Walks on with care yet crunches underfoot
Mussels marooned in grasses, winkles attached
To sandbank, rock, then plunges a cold arm
Into the slime of a pool's bed, groping for clams.
That underground is depleted. He tries again,
Pool after pool, in vain. Plods on. The near
 gulls cry.
Peculiar gases rise. He stops, plods on
But to his ankles, to his knees, no, to his waist
Sinks into mud that gurgles at him, holds him,
So fondly sucks at him, he feels, he knows:
The sea accepts me. I've made friends with the
 sea.
And, stuck there, seems to hear a siren song,
The moan of whales, as caught, as taped by his
 kind
On their kind's way across depleted waters:
Cow's call to calf, cow's call to slaughtered bull.
Whole cities the soft mire of bog, he marvels,
Fenland supports that drags one lean man down.
The sea, the sea makes me a monument,
Memorial founded on the wide salt marshes
To the sea's friend, recorder of her whales.

HANS TEN BERGE

Past Tierra Del Fuego

 Southwards, and critical phases
are within reach again.
we return heavy
with dew; I have eluded myself.
salted wounds cleaved deeper
by the mile. sea vegetation of rampant ice,
fishlike slime around the propeller

as the cold cuts my throat
chervil burns the jack-
tar, the coughing cook
scratches a furrow behind his blubber
furnace where black pottage boils, froths
and without restraint stirs
his tawny grappling irons in the soup

till anchor mate marston cries
ship in sight!
but whales

whales? at this latitude?
we are rallied together amid
ships singing on the empty sea.
I say, let's have lunch,
pass around thick soup being outstanding today
since mussels, cook's pants and kelp.

JAMES K. BAXTER

The Sixties

'The icy dawn of the sixties' –
Yes, you have it there.
Today I saw a black sperm whale
Rolled on the rocks at Pukerua Bay.

The stench grew loud as I came near,
Gulls were grabbing at the kill.
From that sleek projectile body
Jutted a gigantic reddened phallus
Mauled by the Cook Strait squid.

Under the sunset fires it seemed to be
The body of our common love
That bedrooms, bar rooms never killed,
The natural power behind our acts and verses
Murdered by triviality.

ELIZABETH SMITHER

The Whale

The whale feeds her young with tenderness
Great as the sloping hills: these are sunken
Gods too heavy for the sky to hold.
It seems such boldness must always be
Submerged in waves while men in tight submarines
Apply a stethoscope to the great heart
Of love they cannot understand.

OSKAR MORAWETZ

The Sorrow of the Orphan Whale Calf

88

MARGO GLANTZ

from *Two Hundred Blue Whales*

We must return to the whales, to their bones, and to the illustrious opening of their mouths which house the prophets. To forget the width of their eyes is dangerous, or the lovely roundness of their spouts which promise us a faithful reading of the Gospels in the circus, at sea, a question mark in foam. How can we forget them, these enormous caravelles whose faces, stripped of all their rigging, make plain the face of Jonah, or of his brother Melville? White, the whales survive among harpoons, like the huge bulls at Santa Gertrudis, concealing semen that is cooled then in the warmth of sacred horns: the whale bores deep inside a lively belly, and its giant uterus gives credence to the voices that come down to us from circuses, and from Conrad and Collodi.

The whale pleases me because he looks nothing like the pelicans and because, unlike the birds who make their nests along the coast, he gives his excrement back to the sea.

The sargassos rest upon his glistening hump. The seaweed shines. A whale is beautiful even when nothing's left of him but the bone of corset ribs or the shimmer of white brooches left to harden in the foam and sun that gather at the very eye of Conrad's typhoon of words. I like whales for the silk and intelligence of their skin, or for the sweet smell that comes off them when their hide is split. I like them for the slant of their comic eyes and for the sound of their voices, these invisible sirens who long ago struck both Jason and Ulysses dumb. I like them because they show disdain for the sea itself, and keep it as their tomb when they choose suicide and leave their bones to float white, like bright rafts across the water, giving shelter to the men who are lost at sea. I like the whale, and the crawling snails as well, and even the smooth stones and crabs that make holes in the sand. I like the giant sperm, unfurled, which becomes a candle burning in the white light of masts and cross-beams. I like the docile look in their eyes at Disneyland, but find that I trust the dolphins less for living precariously close to the crowns of absolute kings. I like the whales because they take shape again as mermaids. I like them for the salt and water of their mammalian beastliness, and for their surge and thunder when they dive deep like the cachalot. I like them for taking refuge in the nation's parks, and for flooding the many gorges that have been left in the sand; for their premature extinction, and for their vast, Pacific blueness which breaks the cosmic and primeval waves of their exile in the flesh.

Translated from the Spanish by Paul Aviles and Marjorie Agosin

MARGARET LAURENCE

A Fable — For the Whaling Fleets

Imagine the sky creatures descending to our earth. They are very different from humankind. We have known of their existence, although we cannot truly conceive of the realms in which they live. Sometimes a tiny thing has fallen to earth violently, lifeless when we found it, like a lost bird with wings broken and useless. But the sky creatures are not birds. They are extremely intelligent beings. Their brains, although not as large as ours, have been developed for complex and subtle use. They bear their young live from the mothers' bodies, as humans do, and nourish them from the breast. Although they live in the highest heights, we breathe the same air. Like us, they have language, and like humankind they have music and song. They care for their young, love them and teach them in the ways of their species. But when they loom low over our lands in their strong air vessels, they hunt humanity with the death sticks. At first there are only a few of them, then more and more. There are fewer and fewer human beings. The sky creatures make use of the dead bodies of our children, of our hunted young women and young men, of our elders. The flesh of our dead children is eaten by the sky creatures and their slaves. The fat from the bodies of our loved children gives oil which is used by the sky creatures in various ways — much of it goes to make unguents and creams for their vanity. They do not need to hunt humans in order to survive. They continue to slaughter us out of greed. Some of their number believe the slaying is wrong. Some of them sing their songs to us, and we in return answer with our songs. Perhaps we will never be able to speak in our human languages to those who speak the sky creatures' languages. But song is communication, respectful touch and trust are ways of knowing. Too many of them, however, do not think in this manner, do not have these feelings. Too many of them hear the sounds and songs of humanity but do not sense our meanings. Too many do not see our beauty as beauty, our music as music, our language as language, our thoughts as thoughts, for we are different from the sky creatures. Our songs are lost to their ears, and soon may be lost even

to our own earth, when the last of humankind is hunted and slain and consumed. If that terrifying time should come, then our love, our mirth, our knowledge, our joy in life, will disappear forever, and God will mourn, for the holy spirit that created the sky creatures and gave them the possibility of the knowledge of love, also created us with the same possibilities, we who are the earthlings, humankind.

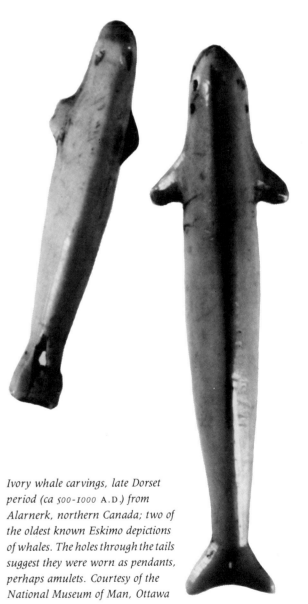

Ivory whale carvings, late Dorset period (ca 500-1000 A.D.) from Alarnerk, northern Canada; two of the oldest known Eskimo depictions of whales. The holes through the tails suggest they were worn as pendants, perhaps amulets. Courtesy of the National Museum of Man, Ottawa

JAMES DICKEY

In Lace and Whalebone

Bull-headed, big-busted,
Distrustful and mystical: my summoned kind of looks
As I stand here going back
And back, from mother to mother: I am totally them in the eyebrows,
Breasts, breath and butt:
You, never-met Grandmother of the fields
Of death, who laid this frail dress
Mostly freshly down, I stand now in your closed bones,
Sucked-in, in your magic tackle, taking whatever,

From the stark freedom under the land,
From under the sea, from the bones of the deepest beast,
Shaped now entirely by me, by whatever
Breath I draw. I smell of clear
Hope-surfeited cedar: ghost-smell and forest-smell
Laid down in dim vital boughs
And risen in lace
and a feeling of nakedness is broadening world-wide out
From me ring on ring — a refining of open-work skin — to go
With you, and I have added
Bad temper, high cheek-bones and exultation:
I fill out these ribs

For something ripped-up and boiled-down
Plundered and rendered, come over me
From a blanched ruck of thorned, bungled blubber,
From rolling ovens raking-down their fires

For animal oil, to light room after room
In peculiar glister, from a slim sculpt of blown-hollow crystal:
Intent and soft-fingered
Precipitous light, each touch to the wick like drawing
First blood in a great hounded ring
the hand blunted and gone
Fathomless, in rose and ash, and cannot throw
The huddled burn out of its palm:

It is all in the one breath, as in the hush
Of the hand: the gull stripped downwind, sheering off
To come back slow,
the squandered fat-trash boiling in the wake,
The weird mammalian bleating of bled creatures,

A thrall of ships:
lyric hanging of rope
(The snarled and sure entanglement of space),
Jarred, hissing squalls, tumultous yaw-cries
Of butchery, stressed waves that part, close, re-open

Then seethe and graze: I hold-in my lungs
And hand, and try out the blood-bones of my mothers,
And I tell you they are volcanic, full of exhorted hoverings:
This animal

This animal: I stand and think

Its feed its feel its whole lifetime on one air:
In lightning-strikes I watch it leap
And welter blue wide-eyes lung-blood up-misting under
Stamped splits of astounding concentration,
But soundless,
the crammed wake blazing with fat
And phosphor,
the moon stoning down, Venus rising,

And we can hold, woman on woman,
This dusk if no other
and we will now, all of us combining,
Open one hand.
Blood into light

Is possible: lamp, lace and tackle paired bones of the deep
Rapture
surviving reviving, and wearing well
For this sundown, and not any other,
In the one depth

Without levels, deepening for us.

"Delphin" from "Historia
Animalium" by KONRAD GESNER

STANLEY KUNITZ

The Wellfleet Whale

1. You have your language too,
 an eerie medley of clicks
 and hoots and trills,
 location-notes and love calls,
 whistles and grunts. Occasionally,
 it's like furniture being smashed,
 or the creaking of a mossy door,
 sounds that all melt into a liquid
 song with endless variations,
 as if to compensate
 for the vast loneliness of the sea.
 Sometimes a disembodied voice
 breaks in, as if from distant reefs,
 and it's as much as one can bear
 to listen to its long mournful cry,
 a sorrow without name, both more
 and less than human. It drags
 across the ear like a record
 running down.

2. No wind. No waves. No clouds.
 Only the whisper of the tide,
 as it withdrew, stroking the shore,
 a lazy drift of gulls overhead,
 and tiny points of light
 bubbling in the channel.
 It was the tag-end of summer.
 From the harbor's mouth
 you coasted into sight,
 flashing news of your advent,
 the crescent of your dorsal fin
 clipping the diamonded surface.
 We cheered at the sign of your greatness
 when the black barrel of your head
 erupted, ramming the water,
 and you flowered for us
 in the jet of your spouting.

3. All afternoon you swam
 tirelessly round the bay,
 with such an easy motion,
 the slightest downbeat of your tail,
 an almost imperceptible
 undulation of your flippers,
 you seemed like something poured,
 not driven; you seemed
 to marry grace with power.
 And when you bounded into air,

slapping your flukes,
 we thrilled to look upon
pure energy incarnate
 as nobility of form.
 You seemed to ask of us
not sympathy, or love,
 or understanding,
 but awe and wonder.

That night we watched you
 swimming in the moon.
 Your back was molten silver.
We guessed your silent passage
 by the phosphorescence in your wake.
 At dawn we found you stranded on the rocks.

4. There came a boy and a man
 and yet other men running, and two
 schoolgirls in yellow halters
and a housewife bedecked
 with curlers, and whole families in beach
 buggies with assorted yelping dogs.
The tide was almost out.
 We could walk around you,
 as you heaved deeper into the shoal,
crushed by your own weight,
 collapsing into yourself,
 your flippers and your flukes
quivering, your blowhole
 spasmodically bubbling, roaring.
 In the pit of your gaping mouth
you bared your fringework of baleen,
 a thicket of horned bristles.
 When the Curator of Mammals
arrived from Boston
 to take samples of your blood
 you were already oozing from below.
Somebody had carved his initials
 in your flank. Hunters of souvenirs
 had peeled off strips of your skin,
a membrane thin as paper.
 You were blistered and cracked by the sun.
 The gulls had been pecking at you.
The sound you made was a hoarse and fitful bleating.

What drew us to the magnet of your dying?
 You made a bond between us,
 the keepers of the nightfall watch,

who gathered in a ring around you,
 boozing in the bonfire light.
 Toward dawn we shared with you
your hour of desolation,
 the huge lingering passion
 of your unearthly outcry,
as you swung your blind head
 toward us and laboriously opened
 a bloodshot, glistening eye,
in which we swam with terror and recognition.

5. Voyager, chief of the pelagic world,
 you brought with you the myth
 of another country, dimly remembered,
where flying reptiles
 lumbered over the steaming marshes
 and trumpeting thunder lizards
wallowed in the reeds.
 While empires rose and fell on land,
 your nation breasted the open main,
rocked in the consoling rhythm
 of the tides. Which ancestor first plunged
 head-down through zones of colored twilight
to scour the bottom of the dark?
 You ranged the North Atlantic track
 from Port-of-Spain to Baffin Bay,
edging between the ice-floes
 through the fat of summer,
 lob-tailing, breaching, sounding,
grazing in the pastures of the sea
 on krill-rich orange plankton
 crackling with life.
You prowled down the continental shelf,
 guided by the sun and stars
 and the taste of alluvial silt
on your way southward
 to the warm lagoons,
 the tropic of desire,
where the lovers lie belly to belly
 in the rub and nuzzle of their sporting;
 and you turned, like a god in exile,
out of your wide primeval element,
 delivered to the mercy of time.
 Master of the whale-roads,
let the white wings of the gulls
 spread out their cover.
 You have become like us,
disgraced and mortal.

MAXINE KUMIN

Gladly

When the whale washed ashore on Billingsgate Shoal
where was I but beached at the farthest end of the map
casting off ballpoint pens gone pale
ripping the Latin words from legal pads.

While the town put out to sea in dories of green
red blue or elephant gray where was I but noisily going
gray as the whale itself. There they were rowing
rowing up to the anterior fin, anchoring fast

climbing aboard as if en route to Oak Bluffs,
as if on the old Bourne Bridge, as if
that barnacled quivering slab were
God's own tractor tire He chose to puncture.

I who was weeks getting back to my shoal
by way of small towns missed out on walking the whale
the length of a regulation swimming pool
missed out on the stench that set in, on the Coast Guard

all buckled and businesslike towing the poor
dead Jonah-house southerly past the bar
so it could most reverently be deep-sixed.
Cousin, Mama, you were on my barefoot lifelist.

How else to know our common root but through you
who are compost now on the Atlantic shelf?
I who was absent oh yes knees buckling from
the touch would have gladly walked you myself.

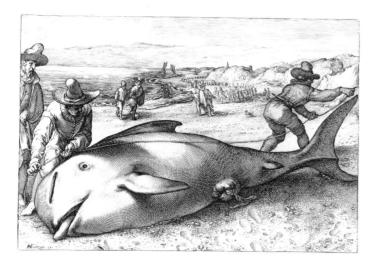

MARTIN BOOTH

Whales Off Sasketeewan

first light,
we stood on the peninsula
watching their humped backs
undulate through the water
rigid as hard waves

every minute
blasts of air sounding

they cleared the reef
rolled longingly into the estuary

basking in the noon
they heaved inshore
diving,
the huge fanned tails up like weird flowers
slapping the sea to fury

the sun wrought heat on the sand
and our backs
burned with waiting

in evening,
they mated
rolled alongside one another
moving gently forward
sometimes staying

dancelike,
the vast hulks fleshed
and actively quiet
entranced us with their musics

at midnight,
Orion walking across the bar with us
toward the dunes
a soft wind snared at the grasstufts
we saw,
half-sunk in the sand
one of their skeletons
washed up a year ago
to be picked bare by the gulls and shiftless crabs
scuttled like a discarded craft

the ribs
cut a barred pattern on the sand
which the stars stabbed through

in the night ahead
we saw the lights of Sasketeewan
coruscate on the sea

it was a homing
we were making,
a motion toward peace

KENNETH O. HANSON

Before the Storm

One summer, high in Wyoming
we drove nine miles and paid
to see the great whale, pickled
and hauled on a flatcar crosscountry.
"Throat no bigger'n a orange,"
the man said, in a smell to high
heaven. I wondered how Jonah
could weather that rubbery household
tangled in fish six fathoms down.
Now, beached by the sun and
shunted to a siding the gray
beast lay dissolving in chains.

It was none of my business
late in the day, while overhead
Stars and Stripes Forever played
in a national breeze, to sidle
past ropes and poke with a ginger
finger, nostril and lip and eye
till Hey! said the man, keep away
from my whale! But too late,
too late. I had made my mark.
The eye in its liquid socket swung,
the jaw clanged shut, and all the way home
through the bone-dry gullies I could
hear the heart as big as a bushel
beat. O weeks I went drowned
while red-winged grasshoppers span
like flying fish, and the mile-high
weather gathered its forces.

BRIAN PATTEN

Note from the Laboratory Assistant's Notebook

The whale came back.
It took off its hat.
It took off its overcoat.
It took off its dark glasses
and put them in its suit pocket.
It looked exhausted.

I made sure the doors were locked.
I turned off several lights.
I got the stars from the fridge
and injected them.
I washed my fingerprints from things.

Next I sneaked into the back garden and
 buried
The History Of Genetic Possibilities.
Outside people not from the neighbourhood
were asking questions.

DANNIE ABSE

Spiked

Meteorite fall, gunshot echo,
ear parasites, who knows what
set those whales gargling to the shore
while promenade voices fussed.
"Whalebone whales," cried the professor,
"each as long as a cricket pitch,
not seen in the Bristol Channel
before. Yes, the Balaenidae,
distinguished by absence of teeth."

"As I am, see," said Dai, "though I
ate whale-steak once during the war."
And added, clever, "Whales for the Welsh."
Then surprised, and surprising us,
flopped salt-faced, moaning to the floor.
At once a tall staring psychopomp
bolted fast as an ambulance,
mouth open, eyes wild, while others,
different sizes, stampeded too.

In each village, the curtains twitched
as straggling sleep-runners struggled
after the psychopomp. Too late:
at lighting-up time doleful foghorns
blurted and soon sea-mists landed
rapidly, advanced over rocks,
up cliffs, deleted sheep-fields, deep
lanes, and those runners who took the wrong
minor road to Llantwit Major.

That night, night of the avenging whales,
I sent my report typed tidy
to *The Glamorgan Herald*.
I headlined it FARRAGO IN FLIGHT
and THEY FOLLOWED THE PSYCHOPOMP.
Nice. Rhythmic. But the editor said,
"No, mun, no — this incident is of
bugger-all human interest.
Besides, what happened to the whales?"

THOMAS SHAPCOTT

Oceans

Those who live sea-edge are sifters and collectors.
If you live inland, do you recognize fossils
 unearthed in your backyard, or in the Mains excavation?

Those used to walking the sea edge with nothing to do
 have always something to look for.
Inland, you read of the whale as a specimen bound to extinction.
 Has it a right to live?

Those scuffing across sandhills, reaching last night's tideline,
 looking at water and the mobility we know has a salt task
 through ninety per cent of our own body, need to have seen
 whales only once, passing,
though they may not, returning inland, be precise in getting
 exactly why they remember.

The great whales lollop in dream continents, submarine, beyond
 subdivision. There has grown wonder in dry bones. We have
 needs we are sure about. There are moments we feel, in our
 ears, amphibian.

JAIME GARCÍA TERRÉS

Bay of Whales

Although I only know them
 as rumours
set in swirls of spray,
I confess, Gentlemen:
I happen to be thinking of the whales
— blue, black, white, grey —
of Baja California.

I like to speculate about them
from my shaky balcony
and calculate those onerous journeys
to the sound of their archaic song.
I like, Gentlemen,
to know them ruminative on the salty ways:
immersed monuments
 or remote stimuli
in the bubble of our doom.

My whales are not the dream symbols
 of Jonah or Melville;
they are living hyperboles that flow rejoicing
in the ineffable submarine sport;
whales, whales who have a music
and we know not from where it comes
 nor where it goes;
islands that dance so, changing course
responsive one to another,
as the petals of time unfold.

It is said that sometimes
 — listen well —
imperious guardian angels
are wont to propel them
 right over there,
with stout syllable of wind
and due solemnity
to pour out at the end their identity,
 insignificant only for them,
over the sands of the bay.

Translated from the Spanish by Margaret Cullen

WOLF WONDRATSCHEK

Singing on a Rainy Day

The world is like a ship: some day, some bright,
 clear, sunny day,
on a calm, calm sea, it smashes on a reef,
and falls asunder, slowly.
In my dream I pass through a transparent
 film of moisture,
while every day life here on board
lists to one side just a little more, imperceptibly.
My lady keeps company with the fishes;
maybe it's good
when you're under water and your brain
slowly mosses over.
I inform my publisher: you need someone
who'll keep his mouth shut.

The world is like a ship: some day, some bright,
 clear, sunny day,
on a calm, calm sea, it smashes on a reef,
and falls asunder, slowly.
Already there's a company builds houses in
 the water.
The end is near,
my girl listens to the singing and asks me,
do you think it'll be all right for my skin?
Kiss me. Where is this strange journey taking us?
Past a munitions factory,
and then to the horizon, then a bit more,
one last look back across the calm, calm sea,
my lady survives the end
and I become a dolphin.

Translated from the German by Michael Hulse

ANTONIO PORTA

Whales, Dolphins, Children

to Luigi, New York

I.

Dear old friend, young Mr. Melville, a friend of mine living
in the belly of New York, came over here from Newport without sails
and told me there were no more whales, round here; how queer
I thought, at first not catching on to what he wanted to tell me,
since he lives in the belly of a whale hung on the seventeenth floor,
a whale full of windows lit with tiny lights
which go off if the whale sneezes — and then you can't find your matches any more!
But when my friend speaks to me his breath condenses
in the belly of the whale and he says to me: Careful! not all fish
are good but men are worse,
the ones who eat dolphins and who have whale underwear
(whale underwear? — I'd never heard of it). Yes, of course,
he said, the *guêpières*
(which they use no more) — whereupon I asked: How old are you?
That's the point, he replied, I don't know.
But one thing I know for sure — I listened, looking him straight in the eyes —
I'll begin counting the years, the moment that I manage to break out
of the belly of the whale; from the moment when
life will begin again.
Not for me do I say this, my friend,
I say it for everyone, because nowadays, well, hell...,
(it's my habit not to write down oaths)
there's no longer me nor whales, that's the way it goes
(I was now beginning to understand a little more, as far as I could tell)
So we both looked out of a window together, and listened
to the suffocated, prohibited cry of a dolphin-skin seller:
they're needed to wrap up children and send them into the ocean;
behind the Statue of Liberty there's a hole: they stick them in.
I don't believe it, I said to him,
It's beyond believing.
Let the whale preserve us, he murmured, pointing
at the shimmering blades
that lash in the frozen air of New York beneath our frozen eyes —
how blue they were, those eyes, and what was the name of
the puppy man
that puppy whale
that dolphin child
what became of him?

22 Aug. 1980

2.

We went down to the Chelsea Bar
(I remember now, number 18, corner of 7th street).
I can't remember how we managed — perhaps with hemp ropes,

rare systems nowadays, there's no hemp any more, nor any hope
of finding someone willing to plait them! Solid hands, feet
that compete with those of monkeys, with what disgust
those whale steaks were offered us,
filet of dolphin, and we replied together as if singing in chorus:
I'd like to eat your loins, little pig! But there was nothing
we could do except keep quiet and go on drinking
at the table of the inevitable Jonah, nailed to a chair,
embalmed, and there for two centuries, with a notice sticking
to his jacket on which we read: Melville, in great stupor.
We laughed a long time, suffocating
lest we should be heard — Melville had gill blades around his neck
but there was nothing that could be done; he breathed no more,
not even with those gills could those lungs three centuries dried
in the Indian Ocean breathe
(you know someone told me, in Norfolk I think, that they'd seen them
floating like life-ring sponges: this person was saved, he stayed
clinging there for three days and nights, more or less, until a
helicopter.... Perhaps there's someone ready to believe me,
as usual it helped to drink a little more, the thirty-seventh beer,
a little like us when we decided to become the hunters' hunter
without really knowing what to do: *we are not* the brothers
of the assassins, or *are we*, on the other hand?) At that moment
Jonah's eyebrows closed, they fell into dust and the eyes of glass
smashed on the marble of the variegated table as smooth as the
threatening Ocean on the chair — the clothes flopped down
raising dust so that in an uncontrollable attack of coughing,
tears in our eyes, we repeated the same question in unison
each of us with mouth open awaiting confirmation
— you really believe it, I mean to say, that life will have continuation?

Translated from the Italian by Rosemary Liedl

Some of My Best Friends Are Dolphins

The first scientific conference on the subject of communication with extraterrestrial intelligence was a small affair sponsored by the U.S. National Academy of Sciences in Green Bank, West Virginia. It was held in 1961, a year after Project Ozma, the first (unsuccessful) attempt to listen to possible radio signals from civilizations on planets of other stars. Subsequently, there were two such meetings held in the Soviet Union sponsored by the Soviet Academy of Sciences. Then, in September 1971, a joint Soviet-American conference on Communication with Extraterrestrial Intelligence was held near Byurakan, in Soviet Armenia. The possibility of communication with extraterrestrial intelligence is now at least semirespectable, but in 1961 it took a great deal of courage to organize such a meeting. Considerable credit should go to Dr. Otto Struve, then director of the National Radio Astronomy Observatory, who organized and hosted the Green Bank meeting.

Among the invitees to the meeting was Dr. John Lilly, then of the Communication Research Institute, in Coral Gables, Florida. Lilly was there because of his work on dolphin intelligence and, in particular, his efforts to communicate with dolphins. There was a feeling that this effort to communicate with dolphins — the dolphin is probably another intelligent species on our own planet — was in some sense comparable to the task that will face us in communicating with an intelligent species on another planet, should interstellar radio communication be established. I think it will be much easier to understand interstellar messages, if we ever pick them up, than dolphin messages, if there are any.

The conjectured connection between dolphins and space was dramatized for me much later, at the lagoon outside the Vertical Assembly Building at Cape Kennedy, as I awaited the *Apollo 17* liftoff. A dolphin quietly swam about, breaking water now and again, surveying the illuminated Saturn booster poised for its journey into space. Just checking us all out, perhaps?

Many of the participants at the Green Bank meeting already knew one another. But Lilly was, for many of us, a new quantity. His dolphins were fascinating, and the prospect of possible communication with them was enchanting. (The meeting was made further memorable by the announcement in Stockholm during its progress that one of our participants, Melvin Calvin, had been awarded the Nobel Prize in Chemistry.)

For many reasons, we wished to commemorate the meeting and maintain some loose coherence as a group. Captured as we were by Lilly's tales of the dolphins, we christened ourselves "The Order of the Dolphins." Calvin had a tie pin struck as an emblem of membership; it was a reproduction from the Boston Museum of an old Greek coin showing a boy on a dolphin. I served as a kind of informal co-ordinator of correspondence the few times that there was any "Dolphin" business, all of it the

election of new members. In the following year or two, we elected a few others to membership — among them I.S. Shklovskii, Freeman Dyson, and J.B.S. Haldane. Haldane wrote me that membership in an organization that had no dues, no meetings, and no responsibilities was the sort of organization he appreciated; he promised to try hard to live up to the duties of membership.

The Order of the Dolphins is now moribund. It has been replaced by a number of activities on an international scale. But for me the Order of the Dolphins had a special significance — it provided an opportunity to meet with, talk with, and, to some extent, befriend dolphins.

It was my practice to spend a week or two each winter in the Caribbean, mostly snorkeling and scuba diving — examining the nonmammalian inhabitants of the Caribbean waters. Because of my acquaintance and later friendship with John Lilly, I was also able to spend some days with Lilly's dolphins in Coral Gables and in his research station at St. Thomas in the U.S. Virgin Islands.

His institute, now defunct, unquestionably did some good work on the dolphin, including the production of an important atlas of the dolphin brain. While I will be critical here about some of the scientific aspects of Lilly's work, I want to express my admiration for any serious attempt to investigate dolphins and for Lilly's pioneering efforts in particular. Lilly has since moved on to investigations of the human mind from the inside — consciousness expansion, both pharmacologically and nonpharmacologically induced.

I first met Elvar in the winter of 1963. Laboratory research on dolphins had been limited by these mammals' sensitive skin; it was only the development of plastic polymer tanks that permitted long-term residence of dolphins in the laboratory. I was surprised to find that the Communication Research Institute resided in what used to be a bank, and I had visions of a polystyrene tank in each teller's cage, with dolphins counting the money. Before introducing me to Elvar, Lilly insisted that I don a plastic raincoat, despite my assurances that this was entirely unnecessary. We entered a medium-sized room at the far corner of which was a large polyethylene tank. I could immediately see Elvar with his head thrown back out of the water so that the visual fields of each eye overlapped, giving him binocular vision. He swam slowly to the near side of the tank. John, the perfect host, said, "Carl, this is Elvar; Elvar, this is Carl." Elvar promptly slapped his head forward, down onto the water, producing a needle-beam spray of water that hit me directly on the forehead. I had needed a raincoat after all. John said, "Well, I see you two are getting to know each other" — and promptly left.

I was ignorant of the amenities in dolphin / human social interactions. I approached the tank as casually as I could manage and murmured something like "Hi, Elvar." Elvar promptly turned on his back, exposing his abraded, gun-metal-gray belly. It was so much like a dog wanting to be scratched that, rather gingerly, I massaged his underside. He liked it — or at least I thought he liked it. Bottle-nose dolphins have a sort of permanent smile set into their heads.

After a little while, Elvar swam to the opposite side of the tank and then returned, again presenting himself supine — but this time about six inches subsurface. He obviously wanted his belly scratched some more. This was slightly awkward for me because I was outfitted under my raincoat with a full armory of shirt, tie, and jacket. Not wishing to be impolite, I took off my raincoat, removed my jacket, slid my sleeves up onto my wrists without unbuttoning my shirt cuffs, and put my raincoat on again, all the while assuring Elvar I would return momentarily — which I did, finally scratching him six inches below the water. Again he seemed to like it; again, after a few moments, he retreated to the far side of the tank, and then returned. This time he was about a foot subsurface.

My mood of cordiality was eroding rapidly, but it seemed to me that Elvar and I were at least engaged in communication of a kind. So I once again removed my raincoat, rolled up my sleeves, put my raincoat on again, and attended to Elvar. The next sequence found Elvar three or four feet subsurface, awaiting my massage. I could just have reached him were I prepared to discard raincoat and shirt altogether. This, I decided, was going too far. So we gazed at each other for a while in something of a standoff — man and dolphin, with a meter of water between us. Suddenly, Elvar came booming out of the water head first, until only his tail flukes were in contact with the water. He towered over me, doing a kind of slow backpedaling, then uttered a noise. It was a single "syllable," high-pitched and squeaky. It had, well, a sort of Donald Duck timbre. It sounded to me that Elvar had said "More!"

I bounded out of the room, found John attending to some electronic equipment, and announced excitedly that Elvar had apparently just said "More!"

John was laconic. "Was it in context?" was all he asked.

"Yes, it was in context."

"Good, that's one of the words he knows."

Eventually, John believed that Elvar had learned some dozens of words of English. To the best of my knowledge, no human has ever learned a single word of delphinese. Perhaps this calibrates the relative intelligence of the two species.

Since the time of Pliny, human history has been full of tales of a strange kindred relation between humans and dolphins. There

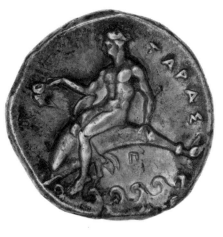

Coin of Tarentum (present day Taranto, Italy); ca 400 B.C., showing the son of Poseidon, Taras, riding a dolphin. Courtesy of the Royal Ontario Museum, Toronto

*far left
Red-figured psykter,* OLTOS; *ca 520 B.C. The men riding the dolphins round the vase are either hoplites or actors, and one (not visible here) has a dolphin as a shield device. Courtesy of the Metropolitan Museum of Art, New York, private collection on loan*

are innumerable authenticated accounts of dolphins saving human beings who would otherwise have drowned, and of dolphins protecting human beings from attack by other sea predators. As recently as September 1972, according to an account in the New York *Times*, two dolphins protected a twenty-three-year-old shipwrecked woman from predatory sharks during a twenty-five-mile swim in the Indian Ocean. Dolphins are pervasive and dominant motifs in the art of some of the most ancient Mediterranean civilizations, including the Nabatean and Minoan. The Greek coin that Melvin Calvin had duplicated for us is an expression of this long-standing relation.

What humans like about dolphins is clear. They are friendly, and faithful; at times they provide us with food (some dolphins have herded sea animals to fishermen); and they occasionally save our lives. Why dolphins should be attracted to human beings, what we do for them, is far less clear. I will propose later in this chapter that what we provide for dolphins is intellectual stimulation and audio entertainment.

John was replete with dolphin anecdotes of first- or second-hand. I remember three stories in particular. In one, a dolphin was captured in the open sea, put aboard a small ship in a plastic tank, and confronted his captors with a set of sounds, whistles, screeches, and drones that had a remarkably imitative character. They sounded like seagulls, fog horns, train whistles — the noises of shore. The dolphin had been captured by shore creatures and was attempting to make shore talk, as a well-brought-up guest would.

Dolphins produce most of their sounds with their blow hole, which produces the spout of water in their cousins the whales, of whom they are close, miniature anatomical copies.

In another tale, a dolphin held in captivity for some time was let loose in the open sea and followed. When it made contact with a school of dolphins, there was an extremely long and involved sequence of sounds from the liberated prisoner. Was it an account of his imprisonment?

Besides their echo-location clicks — a very effective underwater sonar system — dolphins have a kind of whistle, a kind of squeaky-door noise, and the noise made when imitating human speech, as in Elvar's "More!" They are capable of producing quite pure tones, and pairs of dolphins have been known to produce tones of the same frequency and different phase, so that the "beat" phenomenon of wave physics occurs. The beat phenomenon is a lot of fun. If humans could sing pure tones, I am sure we would go on beating for hours.

There is little doubt that the whistle noises are used for dolphin communications. I heard what seemed to be (I may be anthropomorphizing) very plaintive whistles on St. Thomas from a male adolescent dolphin named Peter, who, for a while, was kept in isolation from two adolescent female dolphins. They all whistled a lot at each other. When the three were reunited in the same pool, their sexual activity was prodigious, and they did not whistle much.

Most of the communication among dolphins that I have heard is of the squeaky-door variety. Dolphins seem to be attracted to humans who make similar noises. In March 1971, for example, in a dolphin pool in Hawaii, I spent forty-five minutes of vigorous squeaky-door "conversation" with several dolphins, to at least some of whom I *seemed* to be saying something of interest. In delphinese it may have been stupefying in its idiocy, but it held their attention.

In another story, John told how it was his practice with dolphins of adolescent age and sexual proclivities to separate male and female over the weekend when there would be no experiments. Otherwise, they would do what John, with some delicacy, described as "going on a honeymoon" — which, however desirable to the dolphins, would leave them in no condition for experimentation on Monday morning. In one case, dolphins could pass across a large tank, from one half to the other, only through a heavy, vertically sliding door. One Monday morning John found the door in place but the two dolphins of opposite sex, Elvar and Chi-Chi, on the same side of the barrier. They had gone on a honeymoon. John's experimental protocol would have to wait, and he was angry. Who had forgotten to separate the dolphins on Friday afternoon? But everyone remembered that the dolphins had been separated and the door properly closed.

As a test, the experimenters repeated the conditions. Elvar and Chi-Chi were separated and the heavy door put in place amid Friday-afternoon ceremonies of loud goodbyes, slammings of building doors, and the heavy trodding of exiting feet. But the dolphins were being observed covertly. When all was quiet, they met at the barrier and exchanged a few low-frequency creaking-door noises. Elvar then pushed the door upward at one corner from his side until it wedged; Chi-Chi, from her side, pushed the opposite corner. Slowly, they worked the door up. Elvar came swimming through and was received by the embraces ("enfinments" is not the right word, either) of his mate. Then, according to John's story, those who lay in waiting announced their presence by whistling, hooting, and booing — whereupon, with some appearance of embarrassment, Elvar swam to his half of the pool and the two dolphins worked down the vertical door from their opposite sides.

This story has such an appealing human character to it — even down to a little dollop of Victorian sexual guilt — that I find it unlikely. But there are many things that are unlikely about dolphins.

CAROLYN STOLOFF

Porpoises

Single-winged seraphim
with blunt snouts
you slice the thick
sea and spring
silver. Water-
logged we
drown in profounder
night over whose deeps, up
into an arc of sky
you slip
dripping sleep.
Skittering school! you
take the leaps
easy over us un-
learned lungers.

I am probably one of the few people who has been "propositioned" by a dolphin. The story requires a little background. I went to St. Thomas one winter to dive and to visit Lilly's dolphin station, which was then headed by Gregory Bateson, an Englishman of remarkable and diverse interests in anthropology, psychology, and human and animal behavior. Dining with some friends at a fairly remote mountaintop restaurant, we engaged in casual conversation with the hostess at the restaurant, a young woman named Margaret. She described to me how uneventful and uninteresting her days were (she was hostess only at night). Earlier the same day Bateson had described to me his difficulties in finding adequate research assistants for his dolphin program. It was not difficult to introduce Margaret and Gregory to each other. Margaret was soon working with dolphins.

After Bateson left St. Thomas, Margaret was for a while *de facto* director of the research station. In the course of her work, Margaret performed a remarkable experiment, described in some detail in Lilly's book *The Mind of the Dolphin*. She began living on a kind of suspended raft over the pool of Peter the dolphin, spending twenty-four hours a day in close contact with him. Margaret's experiment occurred not long before the incident I now speak of; it may have had something to do with Peter's attitude toward me.

I was swimming in a large indoor pool with Peter. When I threw the pool's rubber ball to Peter (as was natural for me to have done), he dove under the ball as it hit the water and batted it with his snout accurately into my hands. After a few throws and precision returns, Peter's returns became increasingly inaccurate — forcing me to swim first to one side of the pool and then to the other in order to retrieve the ball. Eventually, it became clear that Peter chose not to place the ball within ten feet of me. He had changed the rules of the game.

Peter was performing a psychological experiment on me — to learn to what extreme lengths I would go to continue this pointless game of catch. It was the same kind of psychological testing that Elvar had conducted in our first meeting. Such testing is one clue to the bond that draws dolphins to humans: We are one of the few species that have pretensions of psychological knowledge; therefore, we are one of the few that would permit, however inadvertently, dolphins to perform psychological experiments on us.

As in my first interview with Elvar, I eventually saw what was happening and decided stoutly that no dolphin was going to perform a psychological experiment on me. So I held the ball and merely tread water. After a minute or so, Peter swam rapidly toward me and made a grazing collision. He circled around and repeated this strange performance. This time I felt some protrusion of Peter's lightly brushing my side as he passed.

As he circled for a third pass, I idly wondered what this protrusion might be. It was not his tail flukes, it was not Suddenly it dawned on me, and I felt like some maiden aunt to whom an improper proposal had just been put. I was not prepared to cooperate, and all sorts of conventional expressions came unbidden to my mind — like, "Don't you know any nice girl dolphins?" But Peter remained cheerful and unoffended by my unresponsiveness. (Is it possible, I now wonder, that he thought I was too dense to understand even *that* message?)

Peter had been separated from female dolphins for some time and, in the not too distant past, had spent many days in close contact, including sexual contact, with Margaret, another human being. I do not think that there is any sexual bond that accounts for the closeness that dolphins feel toward humans, but the incident had some significance. Even in what we piously describe as "bestiality" there are only a few species which, so far as I have heard, are put upon by human beings for interspecific sexual activities; these are entirely of the sort that humans have domesticated. I wonder if some dolphins have thoughts about domesticating us.

Dolphin anecdotes make marvelous cocktail party accounts, an unending source of casual conversation. One of the difficulties that I discovered with research into dolphin language and intelligence was precisely this fascination with anecdote; the really critical scientific tests were somehow never performed.

For example, I repeatedly urged that the following experiment be done: Dolphin A is introduced into a tank that is equipped with two underwater audio speakers. Each hydrophone is attached to an automatic fish dispenser catering tasty dolphin fare. One speaker plays Bach, the other plays Beatles. Which speaker is playing Bach or Beatles (a different composition each time) at any given moment is determined randomly. Whenever Dolphin A goes to the appropriate speaker — let us say, the one playing Beatles — he is rewarded with a fish. I think there is no doubt that any dolphin will — because of his great interest in, and facility with, the audio spectrum — be able soon to distinguish between Bach and Beatles. But that is not the significant part of the experiment. What is significant is the number of trials before Dolphin A becomes sophisticated — that is, always knows that if he wishes a fish he should go to the speaker playing Beatles.

Now Dolphin A is separated from the speakers by a barrier of plastic broad-gauge mesh. He can see through the barrier, he can smell and taste through it, and, most important, he can hear and "speak" through it. But he cannot swim through it. Dolphin B is then introduced into the area of the speakers. Dolphin B is naïve; that is, he has had no prior experience with underwater fish dispensers, Bach, or Beatles. Unlike the well-

EDWIN MORGAN

The Dolphin's Song

Man is a fool
as a rule
but we must humour him in
 school.
So far he only plays with hoops
but we suspect he talks
and every time he looks
at us we blow our tops
and surface laughing — really
we must try to communicate
before it is too late
with the silly
suicidal but engaging skate.

Black-figured cylix (wine-cup) from Selinus; 550-525 B.C. Dolphins rarely form the sole subject of vase painting in Archaic Greek art; this example is one of the earliest and best. Courtesy of the Museum of Fine Arts, Boston

known difficulty in finding "naïve" college students with whom to perform experiments on *cannibis sativa*, there should be no difficulty finding dolphins lacking extensive experience with Bach and Beatles. Dolphin B must go through the same learning procedure as did Dolphin A. But now each time that Dolphin B (at first randomly) succeeds, not only does the dispenser provide him with a fish, but a fish is also thrown to Dolphin A, who is able to witness the learning experience of Dolphin B. If Dolphin A is hungry, it is distinctly to his advantage to communicate what he knows about Bach and Beatles to Dolphin B. If Dolphin B is hungry, it is to his advantage to pay attention to the information that Dolphin A may have. The question, therefore, is: Does Dolphin B have a steeper learning curve than Dolphin A? Does he reach the plateau of sophistication in fewer trials or less time?

If such experiments were repeated many times and it were found that the learning curves for Dolphin B were in a statistically significant sense always steeper than those of Dolphin A, communication of moderately interesting information between two dolphins would have been established. It might be a verbal description of the difference between Bach and the Beatles — to my mind, a difficult but not impossible task — or it might simply be the distinction between left and right in each trial, until Dolphin B catches on. This is not the best experimental design to test dolphin-to-dolphin communication, but it is typical of a large category of experiments that could be performed. To my knowledge and regret, no such experiments have been performed with dolphins to date.

Questions of dolphin intelligence have taken on a special poignancy for me in the past few years as the case of the humpback whale unfolded. In a remarkable set of experiments, Roger Payne, of Rockefeller University, has trailed hydrophones to a depth of tens of meters in the Caribbean, seeking and recording the songs of the humpback whale. Another member, along with the dolphins, of the taxonomic class of Cetacea, the humpback whale has extraordinarily complex and beautiful articulations, which carry over considerable distances beneath the ocean surface, and which have an apparent social utility within and between schools of whales, which are very gregarious social animals.

The brain size of whales is much larger than that of humans. Their cerebral cortexes are as convoluted. They are at least as social as humans. Anthropologists believe that the development of human intelligence has been critically dependent upon these three factors: Brain volume, brain convolutions, and social interactions among individuals. Here we find a class of animals where the three conditions leading to human intelligence may be exceeded, and in some cases greatly exceeded.

But because whales and dolphins have no hands, tentacles, or other manipulative organs, their intelligence cannot be worked out in technology. What is left? Payne has recorded examples of very long songs sung by the humpback whale; some of the songs were as long as half an hour or more. A few of them appear to be repeatable, virtually phoneme by phoneme; somewhat later the entire cycle of sounds comes out virtually identically once again. Some of the songs have been commercially recorded and are available on CRM Records (SWR-II). I calculate that the approximate number of bits of information (individual yes/no questions necessary to characterize the song) in a whale song of half an hour's length is between a million and a hundred million bits. Because of the very large frequency variation in these songs, I have assumed that the frequency is important in the content of the song — or, put another way, that whale language is tonal. If it is not as tonal as I guess, the number of bits in such a song may go down by a factor of ten. Now, a million bits is approximately the number of bits in *The Odyssey* or the Icelandic *Eddas*. (It is also unlikely that in the few hydrophone forays into Cetacean vocalizations that have been made to date, the longest of such songs has been recorded.)

Is it possible that the intelligence of Cetaceans is channeled into the equivalent of epic poetry, history, and elaborate codes of social interaction? Are whales and dolphins like human Homers before the invention of writing, telling of great deeds done in years gone by in the depths and far reaches of the sea? Is there a kind of *Moby Dick* in reverse — a tragedy, from the point of view of a whale, of a compulsive and implacable enemy, of unprovoked attacks by strange wooden and metal beasts plying the seas and laden with humans?

The Cetacea hold an important lesson for us. The lesson is not about whales and dolphins, but about ourselves. There is at least moderately convincing evidence that there is another class of intelligent beings on Earth besides ourselves. They have behaved benignly and in many cases affectionately toward us. We have systematically slaughtered them. There is a monstrous and barbaric traffic in the carcasses and vital fluids of whales. Oil is extracted for lipstick, industrial lubricants and other purposes, even though this makes, at best, marginal economic sense — there are effective substitute lubricants. But why, until recently, has there been so little outcry against this slaughter, so little compassion for the whale?

Little reverence for life is evident in the whaling industry — underscoring a deep human failing that is, however, not restricted to whales. In warfare, man against man, it is common for each side to dehumanize the other so that there will be none of the natural misgivings that a human being has at slaughtering

another. The Nazis achieved this goal comprehensively by declaring whole peoples *untermenschen,* subhumans. It was then permissible, after such reclassification, to deprive these peoples of civic liberties, enslave them, and murder them. The Nazis are the most monstrous, but not the most recent, example. Many other cases could be quoted. For Americans, covert reclassifications of other peoples as *untermenschen* has been the lubricant of military and economic machinery, from the early wars against the American Indians to our most recent military involvements, where other human beings, military adversaries but inheritors of an ancient culture, are decried as gooks, slopeheads, slanteyes, and so on — a litany of dehumanization — until our soldiers and airmen could feel comfortable at slaughtering them.

Automated warfare and aerial destruction of unseen targets make such dehumanization all the easier. It increases the "efficiency" of warfare because it undercuts our sympathies with our fellow creatures. If we do not see whom we kill, we feel not nearly so bad about murder. And if we can so easily rationalize the slaughter of others of our own species, how much more difficult will it be to have a reverence for intelligent individuals of different species?

It is at this point that the ultimate significance of dolphins in the search for extraterrestrial intelligence emerges. It is not a question of whether we are emotionally prepared in the long run to confront a message from the stars. It is whether we can develop a sense that beings with quite different evolutionary histories, beings who may look far different from us, even "monstrous," may, nevertheless, be worthy of friendship and reverence, brotherhood and trust. We have far to go; while there is every sign that the human community is moving in this direction, the question is, are we moving fast enough? The most likely contact with extraterrestrial intelligence is with a society far more advanced than we. But we will not at any time in the foreseeable future be in the position of the American Indians or the Vietnamese — colonial barbarity practiced on us by a technologically more advanced civilization — because of the great spaces between the stars and what I believe is the neutrality or benignness of any civilization that has survived long enough for us to make contact with it. Nor will the situation be the other way around, terrestrial predation on extraterrestrial civilizations — they are too far away from us and we are relatively powerless. Contact with another intelligent species on a planet of some other star — a species biologically far more different from us than dolphins or whales — may help us to cast off our baggage of accumulated jingoisms, from nationalism to human chauvinism. Though the search for extraterrestrial intelligence may take a very long time, we could not do better than to start with a program of rehumanization by making friends with the whales and the dolphins.

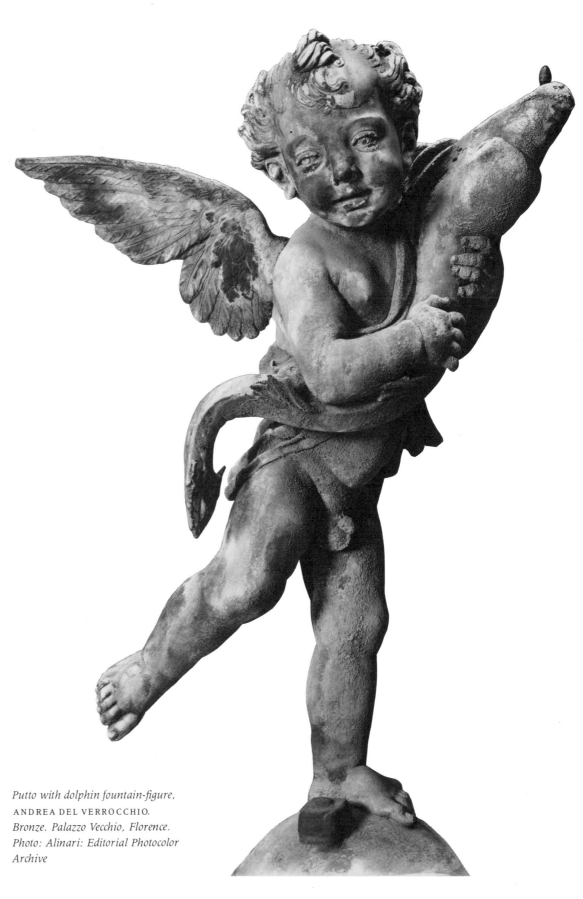

Putto with dolphin fountain-figure,
ANDREA DEL VERROCCHIO.
Bronze. Palazzo Vecchio, Florence.
Photo: Alinari: Editorial Photocolor
Archive

OGDEN NASH

The Porpoise

I kind of like the playful
 porpoise,
A healthy mind in a healthy
 corpus.
He and his cousin, the playful
 dolphin,
Why they like swimmin
 like I like golphin.

H. L. VAN BRUNT

Speaking for Us

sun strikes the
sea like kitchen
light on a
bowl of soup

the curve
a dolphin's liver-pink
fin makes
is like a rainbow

whales raise
a wave
the motion
leaves behind

they also leave behind their
 calls
plangent so intelligent
we think they must
speak for us

WILLIAM JAY SMITH

The Dolphins

I *With the Pirates*

I set out with Dionysus to visit the islands, and abducted with
 him by pirates, was tied with heavy cords

Only to see the knots loosen miraculously and fall to the deck;

Watched the face of the terrified pilot when he sensed that
 their captive was divine,

And the obdurate pirates still refused his release; saw the water
 darken about the ship,

Flowing freely into fragrant wine, while up from the deck,
 its branches enveloping the sail, a vine rose, looping
 its firm trunk around the mast,

And at my side, beneath great pendant clusters, under crisp,
 veined leaves

The god assumed his fearful aspect, and the sailors in horror
 leapt into the sea,

Where, as dolphins, they followed along in the somber water;
 and only the pilot survived.

II *San Pedro Channel*

Passengers secure their gear; we seek out our bunks below while
 the boat plows ahead into black San Pedro Channel.

We toss for an hour, rough blankets up to our chins, then my son
 wakes me, needing air,

And we climb back on deck, proceed to the bow, where water is
 played out like the scalloped inside of a shell;

Phosphorescence breaks, has broken, into glowing bits of foam
 and then the foam bursts into sprays of flying fish drawn
 to the light;

Our wake swerves into a thousand foaming wings; and then,
 where the waves rise and fall, two waves break, and then
 two more, greener than green,

Not waves but porpoises, darting in and out; the high prow rides
 as if harnessed by dolphins, and my son's head on my shoulder,
 we fly through the night.

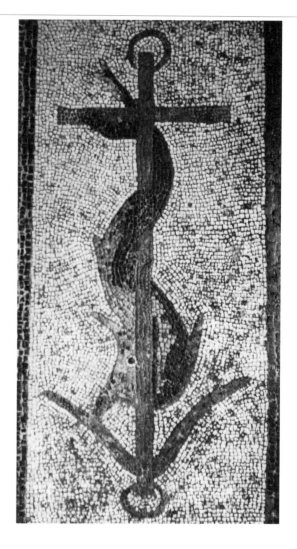

*Polychrome mosaic with dolphin
and anchor; 2nd c. B.C. Delos,
Greece. This is one of the earliest uses
of the dolphin and anchor symbol,
among the oldest continually used
motifs in western art*

DAVID BROOKS

Kairos

Then,
 leaving,
 that rockburst
of gannets, terns, and frigate-birds; pelicans
strafing the shallows,

and quick,
 there,
 rounding
the point,
 eight
grey arcs
 in consort
 shining!

And from the mid-
surf, intermittent, mingled
with wave-sound,

their high
thin
reel.

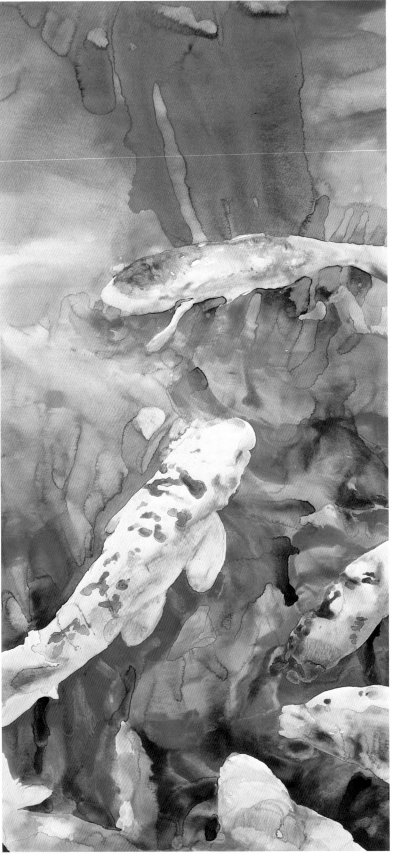

JOSEPH RAFFAEL
"Le Miroir de Mire-Ô" *1978*
watercolour and rainwater on paper
2.4 x 1.2 m

Paleolithic paintings of dolphins, 20,000-15,000 B.C. These, the oldest known depictions of dolphins in the world, date from the Solutrean period and are located in the Nerja Cave near Malaga, Spain. The dolphins are painted in red ochre on a stalactite about 70 cm from the floor of a small rotunda found in one of the difficult-to-reach upper galleries of the cave; each dolphin is about 30 cm in length. The same gallery has another stalactite with dolphins on it. The Mediterranean is just visible from the mouth of the cave. Photo courtesy of Lya Dams

DAVID RABINOWITCH
''La Baleine'' 1982
sculpture in two parts, firewood
carved and painted, 31.75 x 122 x 46 cm

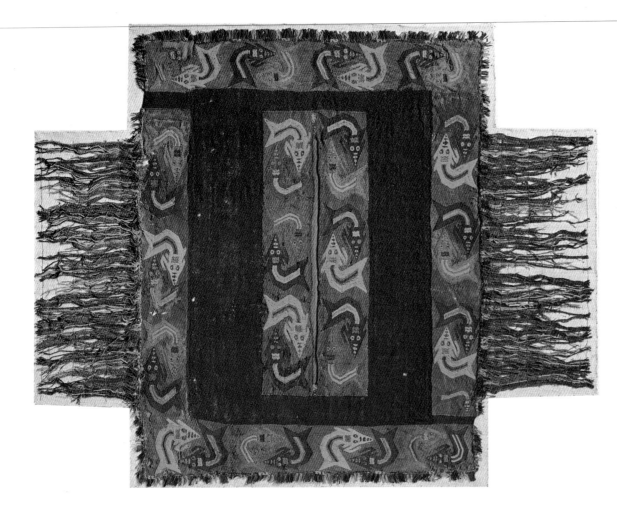

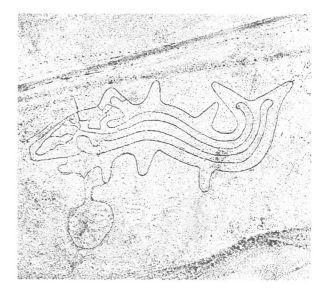

Poncho with killer whale motif, from
Peru, south coast, pre-Spanish
Paracas culture, 57.7 x 51 cm.
Courtesy of the Brooklyn Museum,
Alfred W. Jenkins fund

Killer whale (orcinus orca) with
trophy head, Nazca culture, ca 100
A.D. The largest whales in the
world are found, not in the sea, but
in the desert. The arid tableland
surrounding the Palpa Valley in Peru
was carved by Nazca Indians, over
a millennium (app. 100 B.C. to 900
A.D.), with fantastic figures and
animals, a few of which are identified
as whales. This example, one of the
smaller ones, is over 30 metres long.
Photo copyright © 1979 by Marilyn
Bridges

VOY FANGOR
(in collaboration with Magdalena Fangor)
''Homage To The Whale'' 1980
paper towel (100 rolls), 28 x 187 m

107

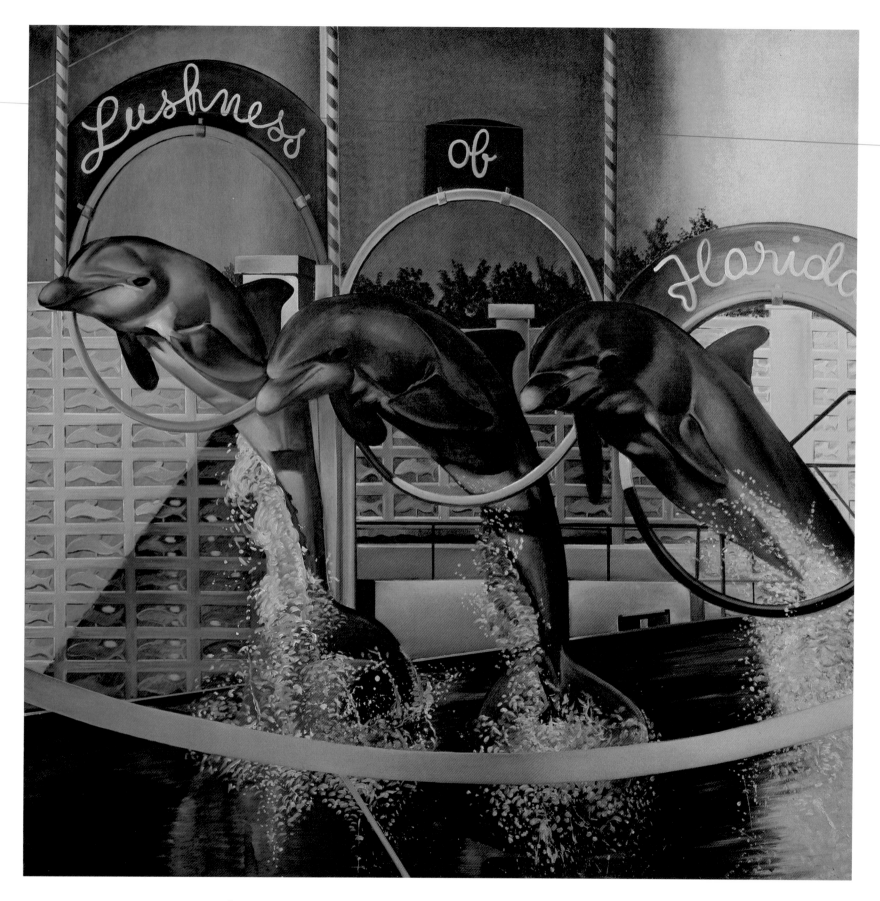

left
JACQUES MONORY
"Technicolour No. 9" 1977
oil on canvas, 1.5 x 1.5 m

WILLIAM PETTET
"Safe Harbour" 1980
acrylic on paper, 45 x 59 cm

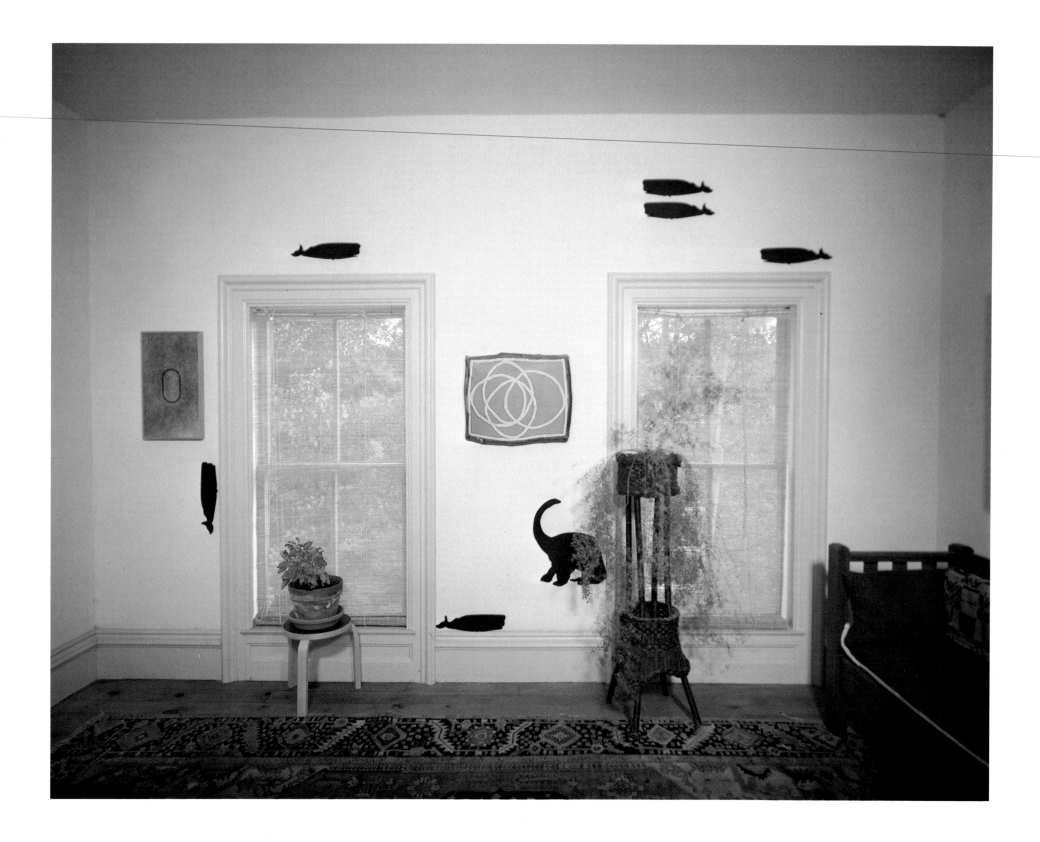

RICHARD ARTSCHWAGER
Untitled, 1980
painted wood cutouts

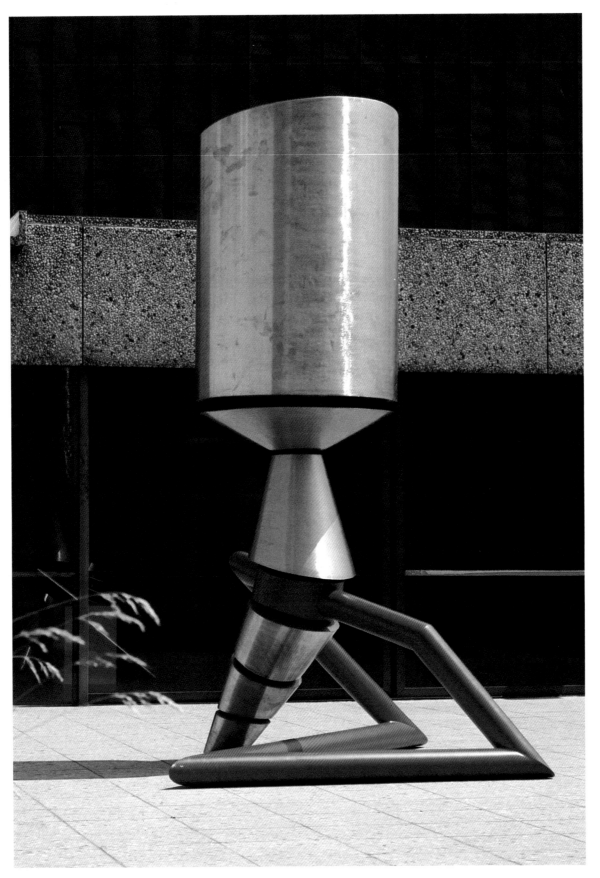

GERLINDE BECK
"Stehende Figur" from the
Physiognomics series, *1971*
chrome-nickel steel and paint
3 x 2.8 x 2.4 m

*"The theme of my work here is the
enclosed manipulated creature, which
is unable to fight against large groups
of self-interest."*

following page

left
JOYCE WIELAND
"Birth of Newfoundland" *1980*
coloured pencils on paper, 21 x 21 cm
Private collection, Toronto

right
AGOSTINO BONALUMI
"Blu" *1967*
acrylic on stretched canvas
100 x 121 x 30 cm
Collection: Samuele Fontana

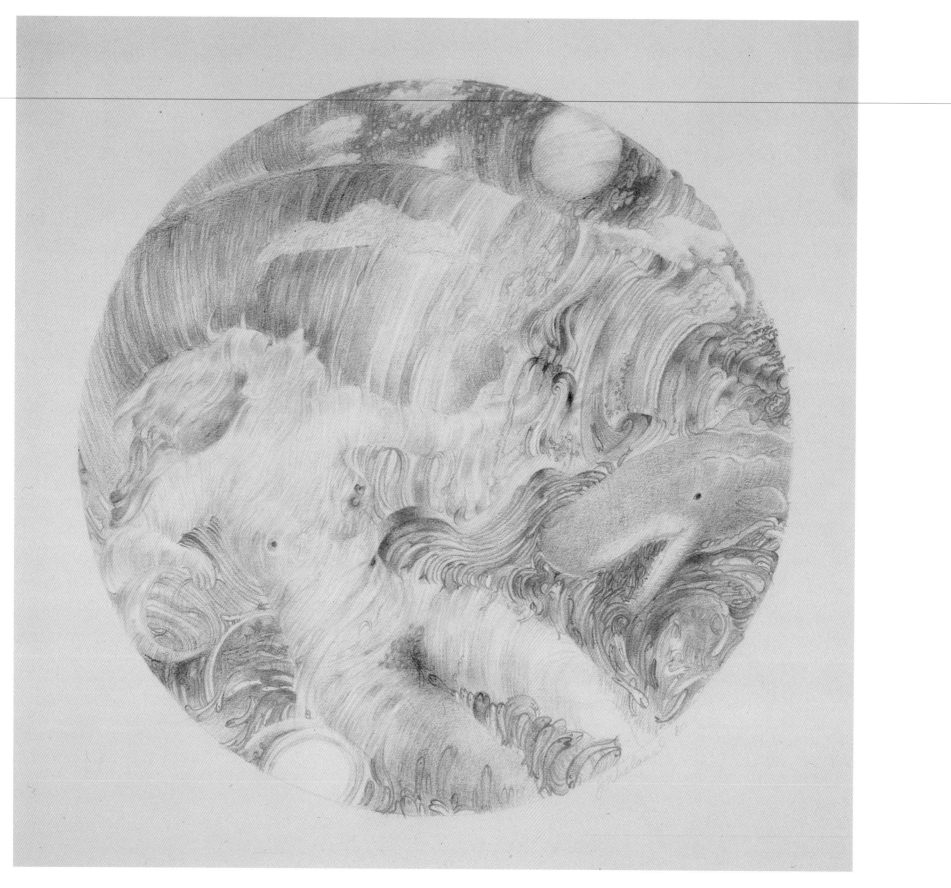

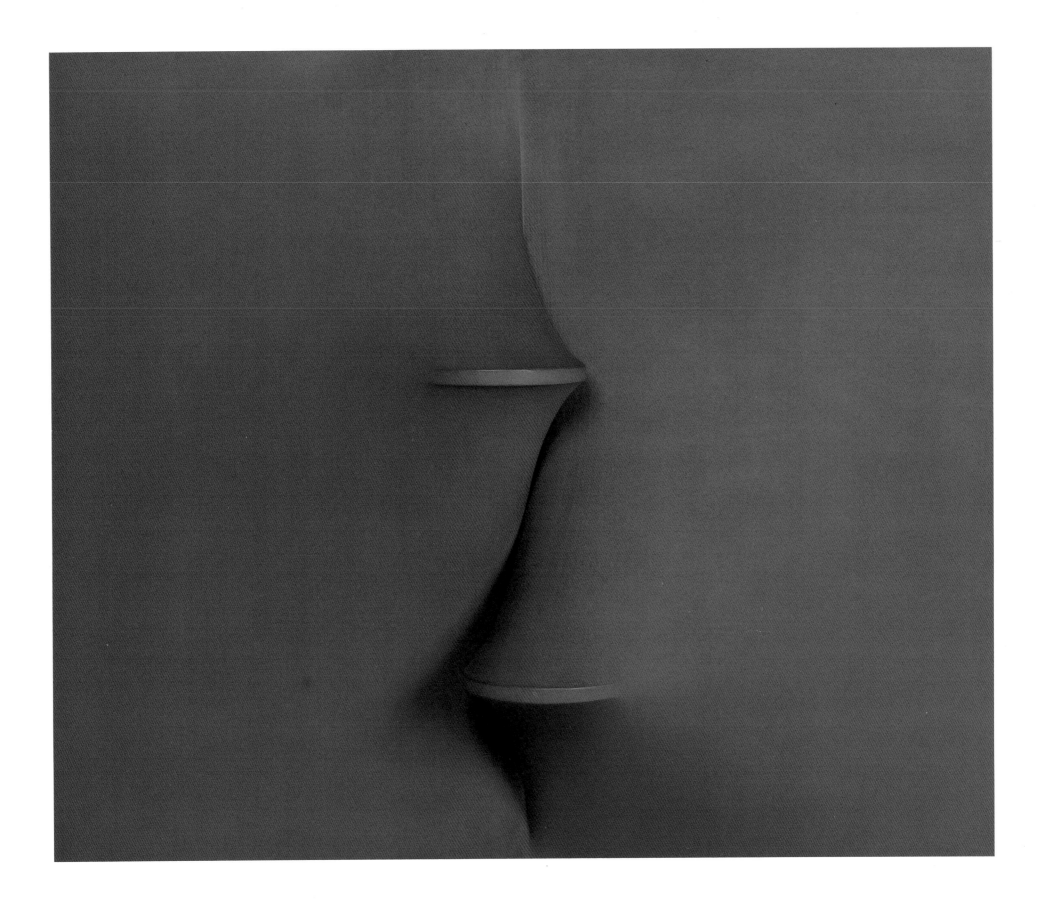

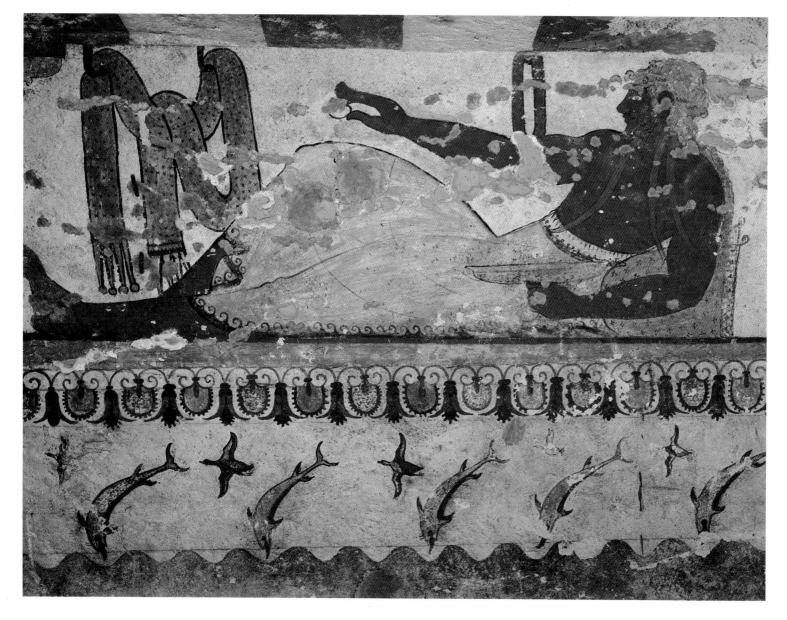

Etruscan wall fresco, Tomb of the Lioness; ca 520 B.C. Tarquinia, Italy. Photo: Giraudon

D.H. LAWRENCE

from *Etruscan Places*

But one radical thing the Etruscan people never forgot, because it was in their blood as well as in the blood of their masters: and that was the mystery of the journey out of life, and into death; the death-journey, and the sojourn in the after-life. The wonder of their soul continued to play round the mystery of this journey and this sojourn.

In the tombs we see it; throes of wonder and vivid feeling throbbing over death. Man moves naked and glowing through the universe. Then comes death: he dives into the sea, he departs into the underworld.

The sea is that vast primordial creature that has a soul also, whose inwardness is womb of all things, out of which all things emerged, and into which they are devoured back. Balancing the sea is the earth of inner fire, of after-life, and before-life. Beyond the waters and the ultimate fire lay only the oneness of which the people knew nothing: it was a secret the Lucumones kept for themselves, as they kept the symbol of it in their hand.

But the sea the people knew. The dolphin leaps in and out of it suddenly, as a creature that suddenly exists, out of nowhere. He was not: and lo! there he is! The dolphin which gives up the sea's rainbows only when he dies. Out he leaps; then, with a head-dive, back again he plunges into the sea. He is so much alive, he is like the phallus carrying the fiery spark of procreation down into the wet darkness of the womb. The diver does the same, carrying like a phallus his small hot spark into the deeps of death. And the sea will give up her dead like dolphins that leap out and have the rainbow within them.

right
Black-figured Attic amphora
showing Heracles struggling with
Nereus, with the dolphins
representing the sea; ca 530 B.C.
Courtesy of the Royal Ontario
Museum, Toronto

SIDONIUS

from *Epithalamium*

Hither scaly Triton with heart aflame bore amid the waters Venus, seated where the boundaries of his double back meet above the windings of his writhing belly. But Galatea has brought up close to him her weighty, glittering shell, and presses his side, which she pinches with inserted thumb, promising by that stealthy touch connubial bliss; whereupon the lover, rejoicing in that torturing jest, smiles at the wound and anon lashes his beloved with a gentle stroke of his fishy tail. Behind them comes a column of Loves in ardent squadrons; one controls a dolphin with reins of roses.

Translated from the Latin by W.B. Anderson

FRANCES HOROVITZ

Invocation

Like a whale
　　　　let me sleep
falling through shoals of silence
imponderable, vast
displacing darkness upon darkness
pricked by oxygen of dreams.

　　Then, like dolphins
　　　　let me wake
plummetting toward that pellucid skin of light
to break through with laughter
ridden by your joyful thighs.

MELEAGER

from *The Greek Anthology*

Listen you who are love-sick:
the Southerly that men think kind
has drowned my dear, my other half;
how happy are the waves and wind
that clasp him now. I wish I were
a dolphin so that he might rise
above the deep and on my back
reach Rhodes, the home of all sweet boys.

Translated from the Greek by Robin Skelton

FRANCO FORTINI

From The Newspapers

You, too, are an easy allegory,
dolphin, who following in the wake
of a cargo boat, trusting
and carefree, lose your liberty
and struggle in a channel. But
of course I'm not thinking of your emblem,
the so agile shape on coins
or heraldic signs, curled round the anchor,
eternal. Such is our life
in stories, a comment, melodious
and sad, but comforting, goes with each figure
and almost it seems that at rest, for ever
the lives of others are seen, as exalted, frozen.
But I know, and you know how it is: not an emblem.
You leap to the point of exhaustion, you struggle
in dirty water, then in the mud men
under the sun kill you. And in that
 meaningless
horror, the cruel waste, the ripping up
of your so tender belly, the convulsed
"not like that!" of the dying.

Translated from the Italian by Michael Hamburger

*Maori "Te Oha" storehouse from
central North Island, New Zealand;
ca 1820 A.D. Highly stylized whales
are carved on the barge boards, tails
to the apex. Farther down is a spiral
for the eye and a larger spiral for the
mouth. Whales were symbols of plenty
to the Maori, and were placed on
storehouses reserved for keeping
food for important guests.
Courtesy of the
Auckland Institute and
Museum*

116

ADRIAN HENRI

Whale Poem

This poem moves at the deepest levels of the paper
majestic amongst minnows of words
filters shovelfuls of clichés through its subtle jaws
swallows whole vocabularies. Its voice
vibrates at deepest levels of the mind, where
phosphorescent eyes gleam through the murky darkness.

This poem will be dragged blind into daylight
strips of helpless flesh torn from it, boiled down
into précis, summaries, concordances.

The poem's last despairing cry
rumbles deep across the tundras of this page.

ARNOLD WESKER

The world in whales

If I worked hard at it
I'd find the WORLD in WHALES.

WHALE
is HALE W.
W is Wesker, I presume.
Hail whale, then.

There's ALE there, too.
That I'll drink to you, easily,
Any time.

Let's see now.
Halve a W you find a V.
WHALES are HALV(V)E(D)?

And WHALES have SLEW in their middle
And HE LAWS.
If you turn W upside down
There's MASH there too
And SHAME
As well as HEAL.

Stretching it you think?
Stretch, stretch to win, I say,
Stretch to survive, Ws!

If playing with WHALES will help,
I'll play
And stretch and find words in words
And words in WHALES.

For example: WHALES have HAS in them.
 WASH and HEWS are there
 LASH and SHAW
 HE'S and SHALE
 SEW and LEASH.

 SHEL and HEL'S there, too.

For example: I have a house in WALES
 And live there as Jonah once did.
 There's peace there,
 Nature respects herself.
 I work my best.

What's more: My mother's in the WHALE.
 LEAH W was her name.
 And I loved her.

SILVINA OCAMPO

Dolphins

Signature seal (plaster cast), Greek; 5th c. B.C. Officials and wealthy individuals used seals with unique designs to mark possession, or endorse documents; this is an especially exquisite example. Courtesy of the Museum of Fine Arts, Boston, donation of Francis Bartlett

Dolphins don't toy with the waves
as people believe.
They sink into sleep as they fall to the
 depth of the sea.

In search of what? I certainly don't know.
When they touch the sands where the waters
 end
they wake with a start
and rise again because the sea's too deep
and when they rise, what do they look for?
 I don't know.
And they see the sky and feel drowsy again
and again sink asleep to the depth
and again touch the sands of the deep
and again they wake and they rise
again. Like our dreams.

Translated from the Spanish by Alberto Manguel

VALERY PETROV

Loneliness

Playful, friendly kind
with a fissured brain,
with a secret voice
which could have in due time
begun to associate
with us.

Dolphins. What a hope
at the very first contact even!
As though it weren't enough, it seems,
that every one is separately alone,

that an entire humanity
because of this occurrence
senses in a flash that it has lived
in loneliness in this world.

Translated from the Bulgarian by Greg Gatenby and Nikola Roussanoff

Printer's mark of ALDUS MANUTIUS; *ca 1500. The dolphin represented the speed and intelligence with which work should be performed; the anchor, steadfastness. The dolphin and anchor symbol was also a common personal emblem of Roman emperors and popes, and is now used as company logo by several publishing houses.*

ROBERT GRAVES

from The White Goddess

Silver dekadrachm of Syracuse, Sicily; 415-357 B.C. Head of Persephone surrounded by dolphins. The coins of Syracuse featured dolphins for centuries and are widely regarded as among the most beautiful of antiquity. Courtesy of the Royal Ontario Museum, Toronto

The porpoise (mistranslated "badger") whose skins made the covering for the Ark of the Covenant has always been one of the three royal "fish" of Britain, the others being the whale — the first living thing created by Jehovah, and "whale" includes the narwhal — and the sturgeon, which does not occur in the Jordan but was sacred in Pelasgian Greece and Scythia.

EDMUND SPENSER

from Visions of the World's Vanity

Toward the sea turning my troubled eye,
I saw the fish (if fish I may it clepe)
That makes the sea before his face to fly,
And with his flaggy fins doth seem to sweep
The foamy waves out of the dreadful deep,
The huge leviathan, dame Nature's wonder,
Making his sport, that many makes to weep:
A sword-fish small him from the rest did sunder,
That, in his throat him pricking softly under,
His wide abyss him forced forth to spew,
That all the sea did roar like heaven's thunder,
And all the waves were stain'd with filthy hue.
 Hereby I learned have not to despise
 Whatever thing seems small in common eyes.

JOHN DONNE

from *The Progresse of the Soule*

XXXI

Into an embrion fish, our Soule is throwne,
And in due time throwne out againe, and growne
To such vastnesse as, if unmanacled
From Greece, Morea were, and that by some
Earthquake unrooted, loose Morea swome,
Or seas from Africks body had severed
And torne the hopefull Promontories head,
This fish would seeme these, and, when all hopes faile,
A great ship overset, or without saile
 Hulling, might (when this was a whelp) be
 like this whale.

XXXII

At every stroake his brazen finnes do take,
More circles in the broken sea they make
Than cannons voices, when the aire they teare:
His ribs are pillars, and his high arch'd roofe
Of barke that blunts best steele, is thunder-proofe:
Swimme in him swallow'd Dolphins, without feare,
And feele no sides, as if his vast wombe were
Some inland sea, and ever as hee went
Hee spouted rivers up, as if he ment
 To joyne our seas, with seas above the firmament.

XXXIII

He hunts not fish, but as an officer,
Stayes in his court, at his owne net, and there
All suitors of all sorts themselves enthrall;
So on his backe lyes this whale wantoning,
And in his gulfe-like throat, sucks every thing
That passeth neare. Fish chaseth fish, and all,
Flyer and follower, in this whirlepoole fall;
O might not states of more equality
Consist? and is it of necessity
 That thousand guiltlesse smals, to make
 one great, must die?

XXXIV

New drinkes he up seas, and he eates up flocks,
He justles Ilands, and he shakes firme rockes.
Now in a roomefull house this Soule doth float,
And like a Prince she sends her faculties
To all her limbes, distant as Provinces.

The Sunne hath twenty times both crab and goate
Parched, since first lanch'd forth this living boate;
'Tis greatest now, and to destruction
Nearest; There's no pause at perfection;
 Greatnesse a period hath, but hath no station.

XXXV

Two little fishes whom hee never harm'd,
Nor fed on their kinde, two not throughly arm'd
With hope that they could kill him, nor could doe
Good to themselves by his death (they did not eate
His flesh, nor suck those oyles, which thence outstreat)
Conspir'd against him, and it might undoe
The plot of all, that the plotters were two,
But that they fishes were, and could not speake.
How shall a Tyran wise strong projects breake,
 If wreches can on them the common anger wreake?

XXXVI

The flaile-finn'd Thresher, and steel-beak'd Sword-fish
Onely attempt to doe, what all doe wish.
The Thresher backs him, and to beate begins;
The sluggard Whale yeelds to oppression,
And t'hide himselfe from shame and danger, downe
Begins to sinke; the Swordfish upward spins,
And gores him with his beake; his staffe-like finnes,
So well the one, his sword the other plyes,
That now a scoffe, and prey, this tyran dyes,
 And (his owne dole) feeds with himselfe
 all companies.

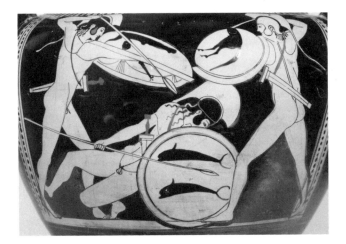

HESIOD

from *The Shield of Heracles*

And on the shield was a
harbour with a safe haven
from the irresistible sea, made
of refined tin wrought in a
circle, and it seemed to heave
with waves. In the middle of
it were many dolphins rushing
this way and that, fishing: and
they seemed to be swimming.
Two dolphins of silver were
spouting and devouring the
mute fishes. And beneath
them fishes of bronze were
trembling.

Translated from the Greek by Hugh Evelyn-White

*Black-figured Attic neck amphora
(detail) with dolphins as shield device;
ca 520 B.C. Courtesy of the
Metropolitan Museum of Art, New
York, Rogers Fund, 1941*

GIORGIO CAPRONI

The Dolphin

Wherever the dolphin jumps
(the sea is his kingdom,
they say, from the Ocean
to the Mediterranean) there
you can see the spring of God
which appears and disappears, joyous
acrobat with a witty beak.

He is the juggler of our
restless fate — the emblem
of the Other we eagerly
seek, and that
(the dolphin is lively — he is the happy
companion to all navigation)
he enjoys himself (he urges us)
mixing negation
(a submarine dive — a flight
elegant and improvised
in a white of foam)
with a cry of affirmation.

Translated from the Italian by Gabriel del Re

Page from ''Le Bestiaire'' (1908) by
RAOUL DUFY *and* GUILLAME
APOLLINAIRE. *Dufy carved a series
of Apollinaire's poems on the same
woodcut as his art, creating a number
of dramatic pages of which this is
undoubtedly the most forceful.
Courtesy of the estate of Raoul Dufy*

Dolphins, you frolic in the sea
But bitter is the brine.
Sometimes my happiness breaks through
In this cruel life of mine.

Translated from the French by Alberto Manguel

LE DAUPHIN.

Dauphins, vous jouez dans la mer,
Mais le flot est toujours amer.
Parfois, ma joie éclate-t-elle?
La vie est encore cruelle.

MANUEL DURÁN

The Dolphins in the Dawn

Mais, ô mon coeur, entends le chant des matelots
STÉPHANE MALLARMÉ

Someone is sewing
 someone is darning
the torn canvas of the sky
someone is covering over holes with wool clouds
someone is covering over clouds with silk holes

When I look upward I see signs
written with salt
 drawn with wind
painted with pink and yellow brushes

When I look down I see that the earth is water
is hard smooth motionless tranquil water

When I look inside
I see that dawn is a large nervous ship
that my time is that very sailboat with unfurled
mended sails covering the whole sky
which are the whole sky
and slowly I begin to move off in another
 courseless voyage

I sail through my time and through the water
I am myself and I am that sailboat holding me up
and tossing me ahead

And dolphins appear robed in shadows
and silver: three four twenty
leap greet me return to the sea
now they go ahead of the boat
but also fly up behind on each side
I'm sailing over a river of dolphins
dawnlight puts gold mirrors
in the broad silver curves
in the soft leaping shadows
the dolphins also voyage through time
and through the sea at the same time
their lives also like mine
empty into the sea of death
in a flash they stare at me compassionate
and go back to their play
to the joy of leaping and racing
they know
what I scarcely guess
life is a serious game

a mortal leap toward death
in their way they know and smile
pity me and go with me
and from them I learn calm happiness
the smile in the leap
a leap saying yes and no
to life to death
all at the same time
a great silver leap in blue time

Translated from the Spanish by Willis Barnstone

*Burial jar from Pachyammos, Crete,
ca 1700 B.C. Courtesy of the University
Museum, University of Pennsylvania,
Philadelphia*

JAN BOELENS

Black Roses

A whale recumbent in gardens of waves
she listens afraid and careful to the shores
she opens a fountain of her frightened life.

She floats with her body as a trembling castle
she leans in open windows of deep seas
her children play on billows as sliding seats
she knows the large mountains of the Ice Age
she is conscious of the alphabet of the seasons.

We are ignorant and strangers in cities of nature
our imagination is watered down and diluted
whales are black roses in the rivers of our age.

C.H. GERVAIS

whale ease

the long gray bulk moving out —
 a mountain swimming in the solitary gloom
we stand on the beach in the morning
 watching her float into the rising sun
 struggling thru the mesh of clouds
the rolling storm ahead
 our fortunes & misfortunes
 like a large bruise in the ocean
our eyes swim with her into the
 first light of day

Request to a Dolphin

Of Whales and Dreams

Every night
embracing my pillow like a
 gentle dolphin
I swim farther away.

Gentle dolphin
in this sea of heartbeats
bear me,

when light dawns,
to a more kindly shore.
Far from the coast of
 tomorrow.

*Translated from the German
by Michael Butler*

MANY, MANY YEARS ago a man told me that to deny my dream was to sell my soul. I was young and unaware that the words were finding their own particular place within me so they would be mine forever, but I do remember blinking my eyes and nodding my head as if the very motion was forcing the truth in what he said deeper within me.

And I was full of dreams.
Dreams, dreams, dreams. And I dream still.
And the whale is a dream.

When I was a lad and landlocked playing ships was my game. A stick in water was fine. I did not need sails or steam, only imagination, and my ships sailed through mirror-like waters or weathered the most treacherous of storms. And the suns reflection looked up at me from south sea lagoons, or, as a breeze rippled the water, the reflection became a broken moon in the Atlantic.

And sea-walls and jetties were my playgrounds and I would spend endless days on the shore or pier watching the various vessels of every description and flag sail in and out of the harbor, or drop their anchor and rest while small launches brought men ashore. I was aware the pilots knew just where each ship should be, and how much room to leave, yet still I constantly marvelled at how a harbor filled with anchored ships

An early European illustration of South Atlantic whales from "An Account of Several Late Voyages and Discoveries to the South and North" by Sir John Narborough, dedicated to Samuel Pepys (London, 1694). Courtesy of the Thomas Fisher Rare Book Library, Toronto

could be so free of problems. And I would sit for hours watching the tide slowly change the positions of the ships as they tugged at their chains. I watched and dreamed.

And then as the years went so slowly by I would stand at the head of a pier and wait for a tug to tie up, hoping the captain would see me and yell down for me to come aboard, that they needed a messboy, and I would leap on her deck and the mooring lines would be let go immediately and we would be off on our adventure.

And at night I would lie in my bed and allow my imagination to take me any which where and I would sail to the places I had seen in pictures, and see our tug battling the seas of Cape Hatteras, or sailing thru the Keys, the very words sounding distant and romantic.

And one day I did leap on a tug and crossed the harbor and back. I was living in a dream. An old deckhand chuckled at me and told me about his days at sea and all the countries he had seen and all the oceans he had crossed, and told me of the time he shipped on a whaler and how the whales looked as they flowed through the sea, and the sudden bursting forth when they breached and the banging roar of the huge flukes cracking the surface of the water. And he even imitated the voice of a whale. The captain let me in the wheelhouse, and even let me take the wheel for a minute, but I spent almost all of those few hours with the old deckhand listening to more and more stories about whales. For days and nights I relived that day, dreaming always of teaching the whales to dance.

While still in my mid-teens I finally went to sea. A lifetime spent dreaming of the sea died and now a new life of living the dream had begun. And still I pursued my dream even though it was now my life. I never did ship on a whaler, but manys the time Ive seen them break the surface of the sea, barely causing a ripple, looking so gentle and strong and indomitable, and, as I stood at the gunnel watching them, in my head I would be playing a song on a concertina and pipe, teaching them to dance, and they honked their glee as they whirled and twirled through the sea waving their flukes in time and merriment to the music....

And when it came time to stop they sang a final note and waved and continued on their inevitable way, and me on mine, leaning against the gunnel, staring at the disappearing ripples, feeling a part of them was still with me and a part of me with them. They somehow became a part of my dream, in some strange way as important a part of the dream as me. It took the two of us to make the dream. And it does still.

And still I dream though Ive been on the beach now for some years, in Snug Harbor. We're all ex-sailors here and talk of the many ports we/ve been to, of the endless countries and people

MICHAEL HULSE

The Whale

we/ve seen, so many of which have changed names a dozen times over. But I spend as much time alone as possible, looking down at the harbor, a harbor that was once filled with vessels of every type, a harbor that is now spotted with an occasional ship. As with all things its changed.

But my dreams the same. And I pursue it still.

Ive sailed so long and sewn so much canvas that the tips of my fingers are blunted and hard, and hauled so many ropes my hands are as rough as manila hemp; Ive scampered up ratlins in heavy seas and sat on the hatch of a brand new freighter feeling the thump of her engine. Memories ...all memories. Images to help pass a day. But only for a short time. I chase them with my dream...my vision. I close my eyes and hear the music and they come, all about me, dancing and singing and O how lovely it is to see the sea rolling from their backs that shine and glisten, and though theyre monstrous in size they barely send out a ripple as they go through endless seas. And I call to them, through cupped hands, with a loud and happy, HELLO MY FRIENDS...and they wave their flukes at me and we dance and laugh and this thing called death no longer exists, being dissolved in our oneness, and I know that so long as my heart, and that timeless, ageless leviathan part of me, is filled with my dream...my vision of dancing with my friends... that there is only life, life as large and strong and beautiful and full of gentleness and joy as my friends, and where they go I go also, and we are inseparable, and my life is theirs and theirs mine, and we are all part of the same dream.

De l'audace, encore de l'audace, et toujours de l'audace

Poised for the leap, the pole-vaulter pulses with his future. The potter pressures time into form. The actor creates dimensions to move in.

All of them,
all of the sea-green incorruptibles,
the makers of transformation,
working to wrest from the stasis of time
the cardiac apprehension of beauty,
the sudden arrest of perception.

And somewhere the blue-backed past breaks the black salt, shouldering off the dream we had harboured deep in warmth, and shows us sculpture and stone unsundered, living, in motion.

Gnathia dish with dolphins painted in white, from southern Italy; 4th c. B.C. Courtesy of the Allard Pierson Museum, Amsterdam

Dolphin fountain by GASTON LACHAISE; *1924. Bronze, 40 x 93 x 60 cm. Collection of the Whitney Museum of American Art, New York*

ANDREW TAYLOR

Whale

I think of it as a vast city
plunging through the history of our dreams
singing its largely inaudible songs –
its highways, its alleys, even its crammed slums
churning the phosphorescence that we wake
and marvel at as it dies and dries
on our clinging fingers

I've followed the windings of its veins
have been shown the historic site of Jonah's betrayal
and the path the missionaries took
along its perfumed roads to the death they so desired
their staff still planted like a shaft of blood
in the brain high on a headland brooding over waves
at the bottom of storms

I've woken on mornings after storms
and been taken by hand across the shuddering dunes
and seen it beached and have felt the stink
of such enormous death creep over the town
and smelt the death of a song that has set its foot
firmly in the alleys of my brain.

GABRIEL ZAÏD

Holy Week

Something profound is
 rising up through the waters
to breathe, Jonah,
with great jets of grief.

There waits for you
the whale of melancholy.

Translated from the Spanish by
Margaret Cullen

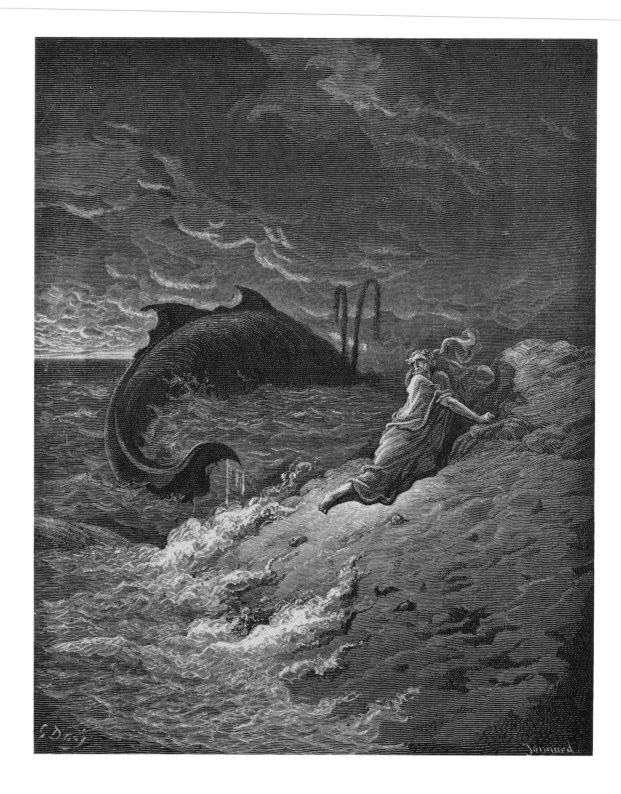

124

FAZIL HÜSNÜ DAĞLARCA

The Whale and the Tangerine

*In the white night of the North Sea, a whale
swimming all by himself and a tangerine drifting
all alone come across each other. One is the largest
of mammals, and wanders among icebergs. The other
is a tiny fruit which was swept away from a warm
climate where he used to sing songs immersed in blue.*

THE EYES

Riveted on me
Are those deep eyes,
Two deep nights.

For his huge size
He has such tiny eyes,
Which means he's not hungry-eyed.

Does he see me from under the water
Or from above, who knows,
Maybe his eyes are the water.

He looks at me, but I'm not scared.
After all
He is better than the icebergs.

HIS LENGTH

He is so long
If we were a thousand tangerines
We could not count that long.

HIS MOUTH

His mouth is so huge
You cannot tell where it begins
Or where it ends.
It is more like
A floating cave.
His mouth
Is the size of desert islands.

HIS WARMTH

A wave tosses me onto his back,
As his skin touches my rind
First I feel a warmth.

He is remote as fables,
Let him be,
I feel a warmth at first.

SOFTLY

I called out softly;
But how could he hear?
Even the light
Was drowned out by the waves.

I called out:
"What is your name?
Are you a bird
Or a bear?"

*So they strike up a tender friendship. They are
very happy to have each other. The giant whale
feels bad about how the little tangerine
keeps shivering.*

REPLY

My name is Whale
Part bird part bear
Part life.
Loneliness for short.

Yellow brother, they call me Sky-Whale.

*Although he knows how his heart will cringe when
he leaves his own seas, the whale carries the
tangerine all the way into the Mediterranean, to
Turkey's southern coast where the little tangerine
is reunited with his mother and elder sister and
millions of other tangerines.*

*On his way back, the fishermen of the
Mediterranean spot the tired whale off the Italian
coast. Wondering "how this silly thing stumbled
in here", they kill him.*

HIS DEATH

There they shot the Sky-Whale
The Mediterranean overflowed with blood
Now all its blue is silent,
Scarlet, terrifying.

*It is with his own life that the whale paid for his
love of the tangerine. Each one of us is either a
whale or a tangerine.*

Translated from the Turkish by Talat Sait Halman

*"Yūnus and the Whale"
illumination from a Turkish
manuscript (Add. MS 18576, f. 87a)
of the late 16th c. A.D. Courtesy of
the Trustees of the British Library*

*far left
"Jonah and the Whale" engraving
by* GUSTAVE DORÉ, *from "La Sainte
Bible" (1866)*

125

A political anecdote The Aspidoceleon Ghost Song

About ninety million years
 ago
a fourteen-foot fish
Portheus
swallowed another fish of
 seven foot
and choked
They found it in a
 stone-quarry
in Kansas, U.S.A.
which was once under the sea
Buried in the mud of the
 primeval ocean
it has given posterity
proof of its greed

right
One of several illustrations of the perils offered by whales to mariners, from ''Historia Animalium'', Book IV, by KONRAD GESNER, *published posthumously in 1604. Courtesy of the Thomas Fisher Rare Book Library, Toronto*

far right
Nootkan whaling hat, British Columbia. Only the chief was permitted to wear the ceremonial whaling hat, or to harpoon whales, and even then only after several days of fasting and ritual, so that the whale would ''allow'' itself to be killed. Shown here is the most famous of Nootkan chiefs, Maquinna, from a drawing by Tomas de Suria in 1791. Courtesy of the Thomas Fisher Rare Book Library, Toronto

Physiologus spoke of a certain whale in the sea called the aspidoceleon that is exceedingly large like an island, heavier than sand, and is a figure of the devil. Ignorant sailors tie their ships to the beast as to an island and plant their anchors and stakes in it. They light their cooking fires on the whale but, when he feels the heat, he urinates and plunges into the depths, sinking all the ships. You also, O man, if you fix and bind yourself to the hope of the devil, he will plunge you along with himself into hell-fire.

The whale has another nature: when he grows hungry he opens his mouth very wide and many a good fragrance comes out of his mouth. Tiny little fish, catching the scent, follow it and gather together in the mouth of that huge whale, who closes his mouth when it is full and swallows all those tiny little fish, by which is meant those small in faith. We do not find the larger and perfect fish approaching the whale, for the perfect ones have achieved the highest degree. Indeed, Paul said, ''We are not ignorant of his cunning'' [II Cor. 2:11]. Job is a most perfect fish as are Moses and the other prophets. Joseph fled the huge whale, that is, the wife of the prince of the cooks, as is written in Genesis [Gen. 39]. Likewise, Thecla fled Thamyridus, Susanna the two wicked old men of Babylon, Esther and Judith fled Artaxerxes and Holofernes. The three boys fled the King Nebuchadnezzar, the huge whale [Dan. 3], and Sara the daughter of Raguelis fled Nasmodeus (as in Tobia). Physiologus, therefore, spoke well of the aspidoceleon, the great whale.

Translated from the Latin by Michael Curley

Whale in the
water is like
dead men wading.
Bone pierces the
spirit-belly,
looks like
tentacles rising.

I am afraid of the
moon
in the dark night
shining.
The trees look like
mountains,
their shadows hang
like hair.

Whale makes a
human sound,
voice of an old man
dying.
He opens his mouth up,
looks like a
devil feeding.

I was a
whale once
but then I had a
bird's shadow.
A devil breathed his
breath in me,
turned feathers into
fins.

Whale in his sleep
is like dead men
dreaming.
Darkness makes him
look like a frog;
he needs many faces
to keep the dead from waking.

Once I had a
whale's shape
but then I had only
sadness.
A devil sucked my
spirit out;
now I am a ghost
wading inland to die.

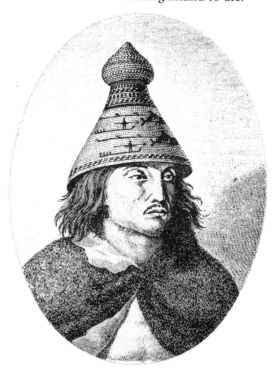

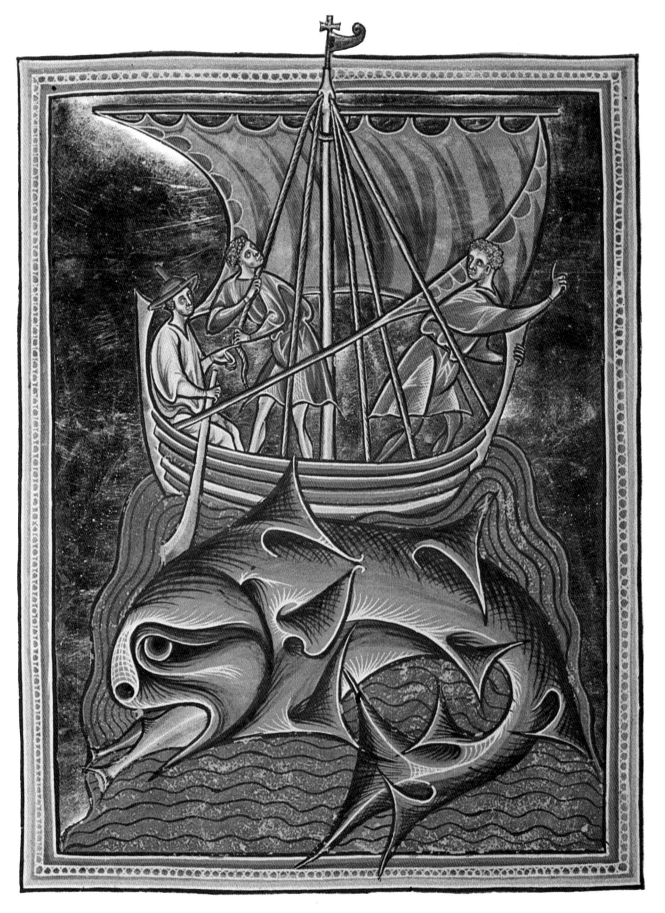

Illumination from a 12th c. English bestiary (MS Ashmole 1511, fol. 86v) showing sailors mistaking the whale for an island, and fish seduced into the whale's mouth. In the Middle Ages whales were regarded, not as mammals, but as giant fish. As such, they simultaneously represented both good and evil – the evil as explained by Physiologus, the good as the fish symbol of Christ, supporting the Church as ship. Note the cross at the top of the mast, and cross formed by the mast itself with the square yard. Courtesy of the Bodleian Library, Oxford

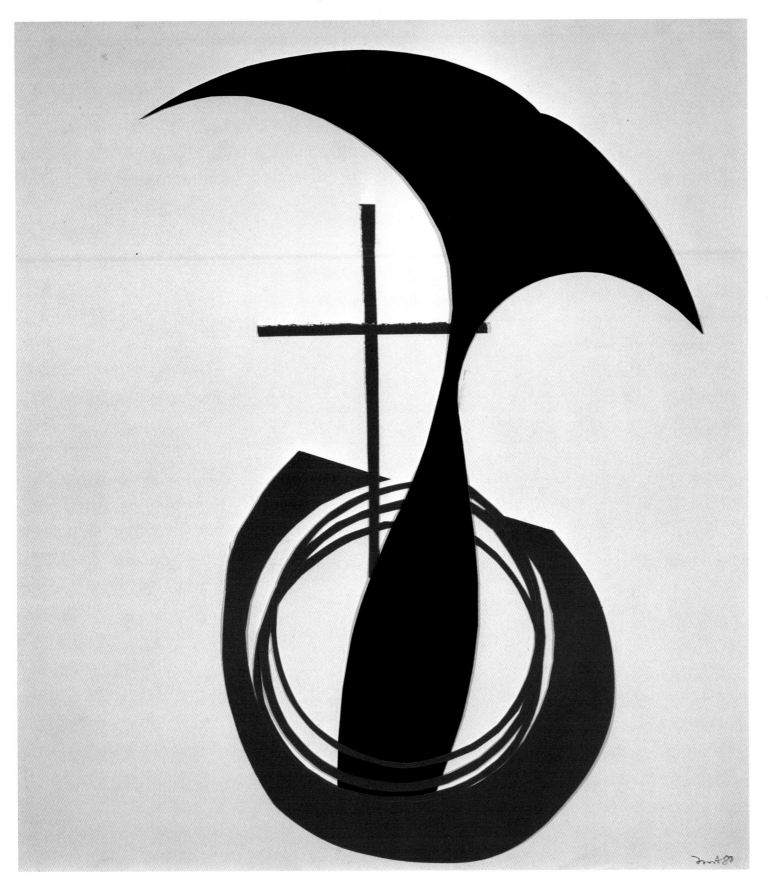

TERRY FROST
Untitled, 1980
collage, 51 x 45 cm

far left
VICTOR PASMORE
''The Happy Whale'' 1978
ink and paint on paper, 71 x 88 cm

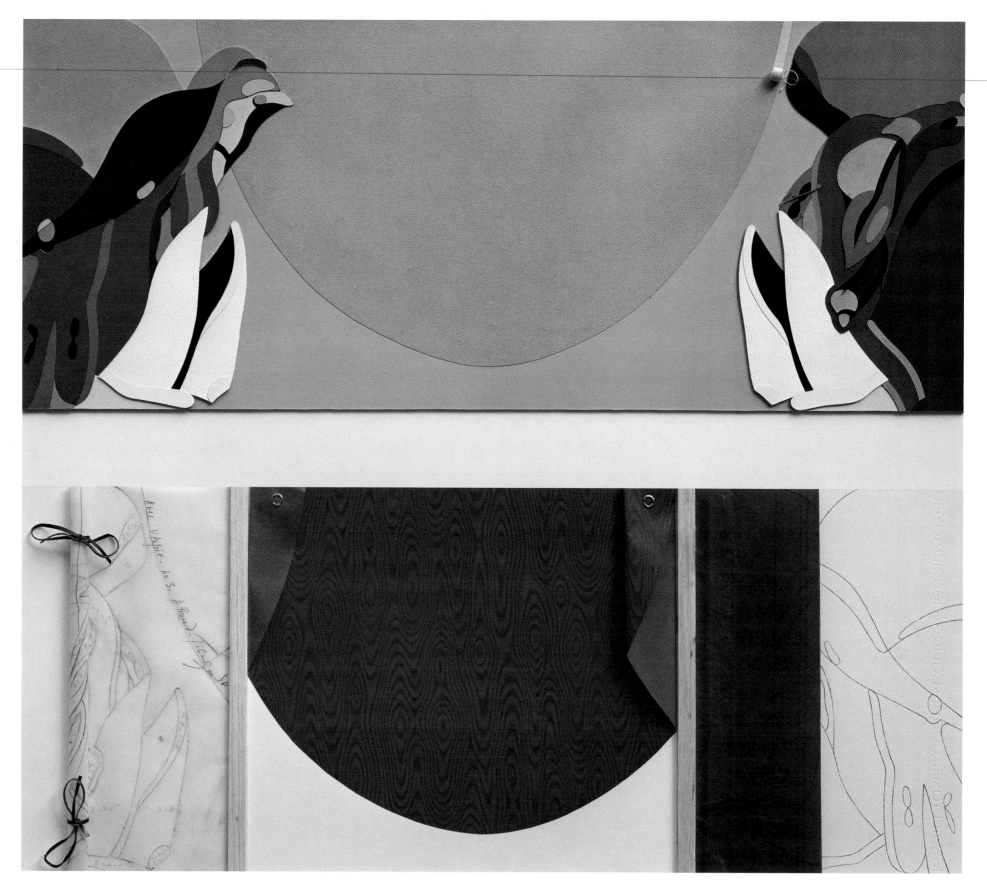

JAMES McGARRELL
''Whale'' 1980
watercolour, 53 x 44 cm

far left
HERVÉ TÉLÉMAQUE
''Avec utopie No. 3'' 1979
collage, 74 x 80 cm

131

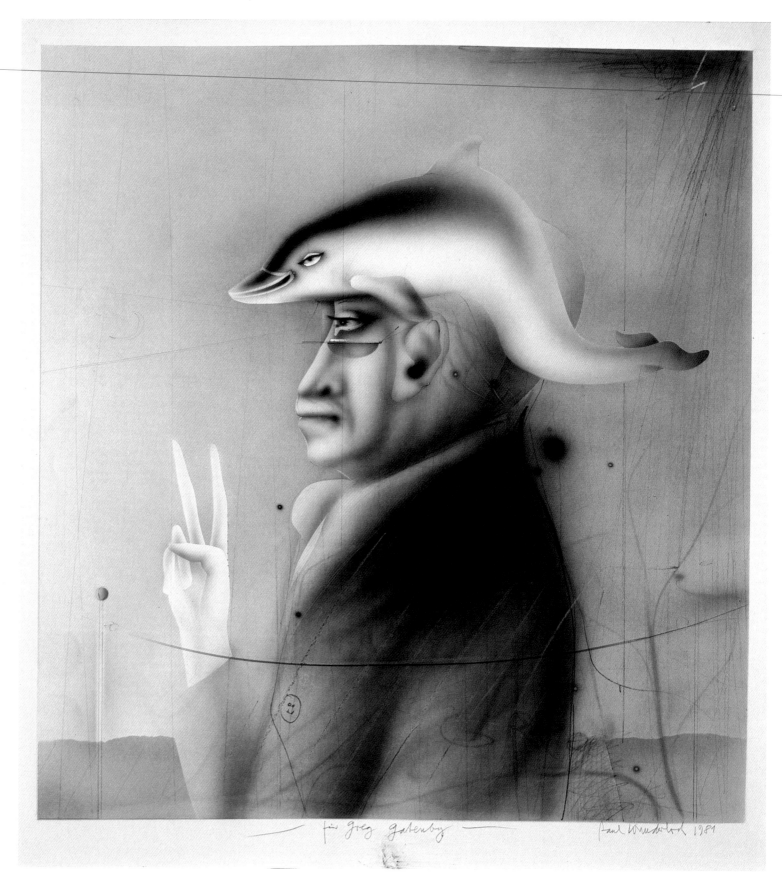

PAUL WUNDERLICH
"Self-Portrait with Dolphin" 1981
watercolour and drawing,
52 x 48.5 cm

far right
ALAN DAVIE
"Painting Nov. 65" 1965
oil on canvas, 1.5 x 2.1 m

132

GOTTFRIED HONEGGER
"Greenpeace" 1980
pencil and ink, 21 x 27 cm

134

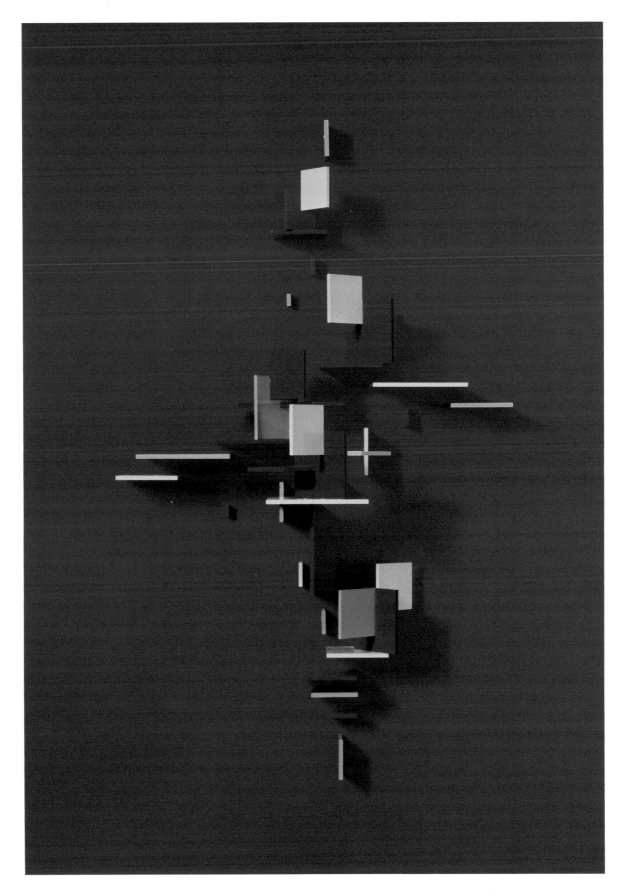

CHARLES BIEDERMAN
"Work No. 27 Red Wing" 1968-69
painted aluminum, 99 x 70.8 x 19.2 cm
Collection of the Minneapolis Institute
of Art

NICHOLAS SCHÖFFER
"Unitra 37-3" *1975*
serigraph and Plexiglass, 21.6 x 12 cm

left
JOHN PEARSON
"Constant Area Series: Square Through
Circle" *1979*
acrylic on canvas over wooden structure
1.2 x 7.62 m

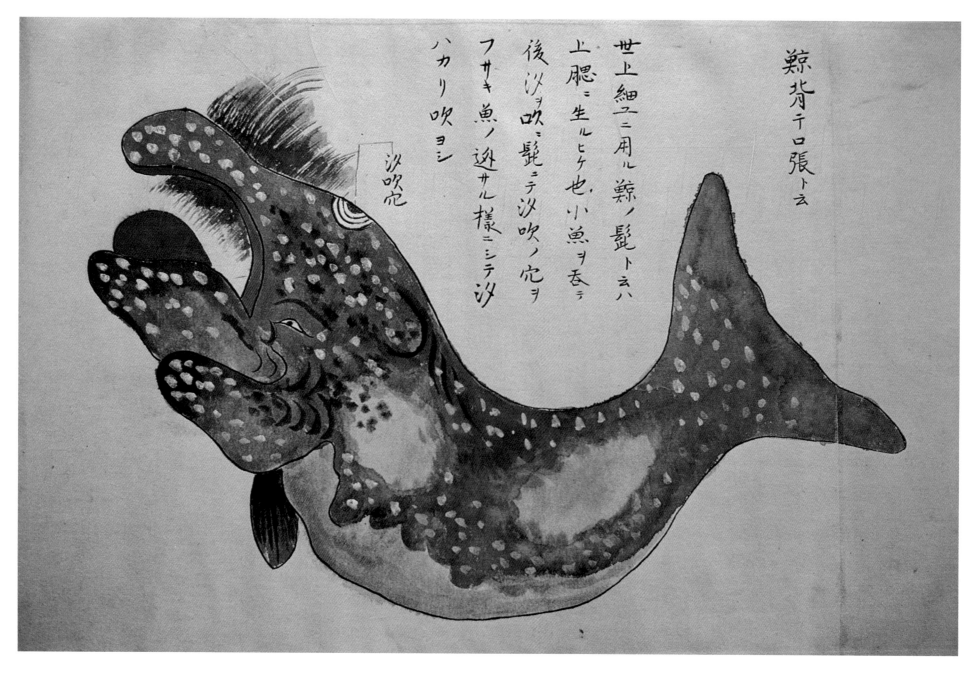

JESÚS URZAGASTI

Ancient animal

I am an ancient animal. I have the impermanent
appearance of simple creatures. It was not the
fin-flips of history that left me battered, but
the onslaughts of myths and legends. I feel
irritated in spite of no longer having a shape
that can be recognized by humans. And
frowning I watch, although I have nothing to
frown with and to watch with. So, finally, I
have hidden myself in the designless, formless
universe, that world that contains everything
without letting itself be influenced by the
contents. Now and then glimmers from present
times stir up that emotional heart of mine:
Then I think how sluggish I am not to let myself
be affected by the tocsins of the days that are
passing: I meditate compassionately on the
deaths of those who, longing for eternity,
perish somewhere between the heroic act and
futility; I get excited over those sweet songs I
once intoned while spouting lustily. This effort
is useless, I know. Little by little I'll give up and
be transformed into the uncompromising
conformity of my destiny. Sometimes I roll
over to uncover my back, a part of this
organism that remembers and was never afraid
of its memory. I am barely a left-over even for
myself and certainly nobody sees me now, lost
as I am — to their eyes — in the weedy growth of
this landscape of water, sky, and ice. I am a
cast-off skin of my own dreams, what has
remained that could not be reduced to
nothingness: the strength and the passivity,
where the young years flash like lightning
across old age. What must have happened to
me in this solitude, for me to be the immutable
witness to what is putrid and what is perishable.
A heart is needed for this business, a hard
heart, I know, invulnerable and yet perfectly
capable of being moved. At dusk I feel that all
life is summed up in inalterable youth, the
great ancestral home, the one in which I live
even if I am in the depths of sleep, and even if
I awaken on the dark path of night.

Translated from the Spanish by Margaret Cullen

MOKUO NAGAYAMA

Whale Slaughter-House

One summer in my boyhood I discovered
on a small island in the Japan Sea
a mammoth whale slaughter-house
like the long slipway in a shipyard but
without whales: only a gigantic
chopping-board with no workers around.

How foolish to believe a whale was a fish
before I read this sentence:
"It is no more a fish than a horse."
Its liver-oil drops I often took when young.
Its roast meat I ate to regain my vigour.
Its sliced raw flesh I relished.

Now, standing on the strand of time,
I try to catch the whale with my words.
It is far too large
while my weapons are far too small and poor.
In the Japan Sea how lucky I was
not to have seen one: it remains a boyhood dream.

In proportion to his dream
the whale is floating on the sea.
Beyond the crest of his dream
the whale is spouting water.
With all the weight of his dream
the whale dives undersea.

DEREK WALCOTT

The Whale, His Bulwark

To praise the blue whale's crystal jet,
To write, O fountain, honouring a spout,
Provokes this curse:
 "The high are humbled yet,"
From times that humble Godhead, beasthood, verse.

Once the Lord raised his bulwark to our eyes,
Once, in these seas, whales threshed,
The harpooner was common. Once, I heard
Of a baleine beached up the Grenadines, fleshed
By excited, antlike villagers a prize
Reduced from majesty to pigmy-size,
Salt crusted, mythological,
And dead.

The boy who told me couldn't believe his eyes,
And I believed him. When I was small,
God and a foundered whale were possible.
Whales are rarer, God as invisible.
Yet, through his gift, I praise the unfathomable,
Though the boy may be dead, the praise unfashionable,
The tale apocryphal.

139

Bubbles the Whale

Whale Song

On the roof of the tower there are several large pools where aquatic creatures, purported to be the most intelligent beings next to man himself, are performing. Dolphins, those strange sages of the Californian seas. What they are doing looks like a kind of co-ordinated gymnastic dance. On a command from the trainer, for instance, a trio of the mammals dive to the bottom of the deep pool, then race to the surface, break through with all their might, and execute — in perfect formation, like circus horses — a slow, magnificent, high leap. Three aerodynamic bodies in line describe exactly the same arc and then, sharp noses foremost, cut back into their natural element like a knife slicing into butter. And again and again, five, ten times in a row. They can also walk on the water, by rearing up on their tails and thrashing them rapidly, an action that propels them backwards to the opposite end of the pool.

But there is another creature in the aquarium who steals the show from the dolphins, as they say in show business. For a gigantic body can be seen moving among the dolphins, who stick their heads out of the water after each performance and await their reward in the form of a fish. This body is four times larger than the biggest dolphin, like a submersible railway car. It too thrusts its huge, spherical head out of the water for a fish. Bubbles the Whale, the program calls it, and says that he is supposed to be a less intelligent but rather more massive brother of the intellectuals of the sea. And when they command the dolphins to dance, Bubbles the Whale eagerly spins on his own axis through the water to the rhythm of a foxtrot, and when they are ordered to walk on the water this enormous cylinder of flesh rises up and, thrashing his tail so energetically that he drenches the little girls standing by the guard rail, he overcomes the force of gravity and shoots diagonally across the pool like an upright torpedo. It is as if the world's fattest fat lady were dancing the cancan with a line of svelte and sexy chorus girls. And at last, when the trainer is lifted high above the pool on a mechanical crane and, one by one, the dolphins shoot out of the water to a height of perhaps five metres to snatch a fish from his hands and then plummet back into the agitated pool with it, suddenly two policemen appear and begin energetically pushing the crowds away from the side of the pool. Why this sudden display of force? Then I understand. When the team of dolphins has finished taking turns, a rolling of drums comes from the loudspeakers, a clamorous, nerve-racking noise, as when artistes on the flying trapeze prepare to perform the *salto mortale*; then the water, moved from somewhere in the deep, begins to churn and boil, the surface breaks, and out of it, like a flying tank, rises that corpulent creature of the sea. He attains the same height as the dolphins, opens his huge maw, and gently plucks a two-foot cod straight from the trainer's hand.

At that moment, however, he appears to lose all interest in balance. He twists into a horizontal position and then falls — very slowly, it seems — and crashes in utterly unaerodynamic fashion, with all his many tons, into the water. A several-thousand-gallon tidal wave rises out of the pool on either side, and the astonished boys who have snuck back to the guard-rail behind the policemen's backs flee to their mothers, drenched to the skin. Bubbles the Whale — a creature from a Walt Disney cartoon.

A few days later, on the advice of experts, I stand on the westernmost point of the deserted peninsula of Point Reyes, north of San Francisco, a chimera-like *finis terrae* of the Californian coast. Bubbles the Whale, that sweet, trained cetacean, that corpulent water-ballet dancer, has filled me with the desire to see his free brothers and sisters. And see them I do: but only as black shadows moving just below the surface of the green water and as slender columns of delicate steam rising from it, testifying to the fact that these ladies and gentlemen are not fish, but members of the marine intelligentsia. They pass by Point Reyes on their millenia-old journey through the Pacific, with their twenty-foot calves. Once again, I feel that I have been touched by the hand of an eternal and impenetrable mystery.

"the whale
"upholds the world
my people taught
this is no lie then
it is the knowledge the jews kept
when they were still magicians
leapt to the center
of the temple
the center of the world
under the great stone
heard — like
indians —
the thunder of its heart

bottom
Kwakiutl Indian hand-clapper
sculpted in wood to represent a killer
whale with a man carved on the
underside; late 19th c. 28 cm long.
Courtesy of the British Columbia
Provincial Museum, Victoria

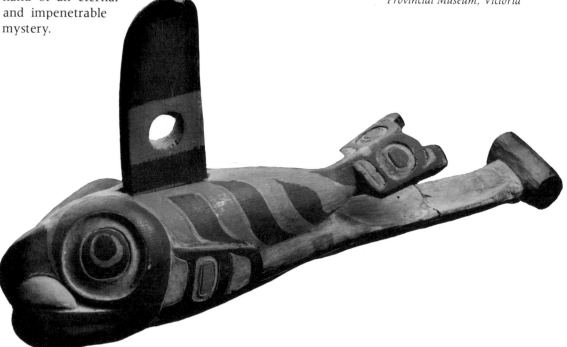

W. S. MERWIN

Leviathan

This is the black sea-brute bulling through wave-wrack,
Ancient as ocean's shifting hills, who in sea-toils
Travelling, who furrowing the salt acres
Heavily, his wake hoary behind him,
Shoulders spouting, the fist of his forehead
Over wastes grey-green crashing, among horses unbroken
From bellowing fields, past bone-wreck of vessels,
Tide-ruin, wash of lost bodies bobbing
No longer sought for, and islands of ice gleaming,
Who ravening the rank flood, wave-marshalling,
Overmastering the dark sea-marches, finds home
And harvest. Frightening to foolhardiest
Mariners, his size were difficult to describe:
The hulk of him is like hills heaving,
Dark, yet as crags of drift-ice, crowns cracking in thunder,
Like land's self by night black-looming, surf churning and trailing
Along his shores' rushing, shoal-water boding
About the dark of his jaws; and who should moor at his edge
And fare on afoot would find gates of no gardens,
But the hill of dark underfoot diving,
Closing overhead, the cold deep, and drowning.
He is called Leviathan, and named for rolling,
First created he was of all creatures,
He has held Jonah three days and nights,
He is that curling serpent that in ocean is,
Sea-fright he is, and the shadow under the earth.
Days there are, nonetheless, when he lies
Like an angel, although a lost angel
On the waste's unease, no eye of man moving,
Bird hovering, fish flashing, creature whatever
Who after him came to herit earth's emptiness.
Froth at flanks seething soothes to stillness,
Waits; with one eye he watches
Dark of night sinking last, with one eye dayrise
As at first over foaming pastures. He makes no cry
Though that light is a breath. The sea curling,
Star-climbed, wind-combed, cumbered with itself still
As at first it was, is the hand not yet contented
Of the Creator. And he waits for the world to begin.

GWEN MAC EWEN

Eyes and Whales

leave the blood to its own reasons for being
(how often have I looked inward
to find my own bleary eye
looking back out?)
or in those weary seas which trespass sense
the diving eye sometimes collides with
great blue whales of innocence.

 (a whale once, blue or sperm,
 I am not sure which
 entangled itself in
 a transatlantic cable
 cutting off communi
 cations between two continents)

leave the blood to its own reasons for being
(forget those breathing seas, horrible electric
seas, little squeezed beasts,
voltages of jellyfish, jealousy of fish,
graphs of waves, blood tides, lunar
madness, let me walk on beaches
clean as the complex sea,
the sea which is the sea's own tale)

not this backwash of vision,
this tangled cable from sense to sense,
the diving eye colliding with many blue
whales.

ROY FISHER

The Whale Knot

Sea-beast for sky-worshippers, the whale
easily absorbs all others.
Colours, languages, creatures, forms. Read
the whale in all the ways clouds
are read. The clouds out of sight
are patterned and inscrutable; chaos
from simple constituents,
form out of simple chaos.

A long-drawn complicity with us all
in the sperm-whale's little eye:
among its cells, somewhere,
land-knowledge, the diverse, our condition.

Decamped into boundless low viscosity,
our Absolute,
the whale seems simpler than it is:
an easy water-to-land knot
in the museum sperm-whale's bared
head-bone, alive
as the megaliths are alive, all
the force-lines crossing
within their singular undemanding
forms. Lifted from the whale-head,
a disused quarry
swims, borne on the earth;
its cliffs a moon-cradle,
its waters part of the sky.

Woodcut by ROCKWELL KENT
from ''Moby Dick'' (New York, 1930).
Courtesy of the Rockwell Kent Legacies

from *Orion trat aus dem Haus*

"There's no point," said the Keeper, "he's too old for sports, he's read all the crime stories, and at chess I lose from move to move. I'm simply no challenge for him."

The Zoo Director spoke into the tank: "What more can we do for you now, dear friend?"

The Dolphin shut *The Critique of Pure Reason* and yawned: "That time and space are *a priori* concepts, my mother sang to me in a puzzle-rhyme while I was still at her breast. The clue to the solution: The thing in itself is not knowable."

"Would you like to paint a picture?" the Director asked. "The chimpanzee exhibition had a remarkable success."

"Then I would not care to paint a picture," the Dolphin said. "What may be right for a chimpanzee is too cheap for a dolphin."

"Perhaps you would like to found a new philosophical system?"

The Dolphin said, "Give me twenty-four hours. I'd like to think it over."

The Director came the next day. "Have you considered the proposal?"

"More than that, I have already succeeded," the Dolphin said; "A meta-philosophy is born. Do you by chance have a five-mark piece in your pocket?"

The Dolphin swooped out of the water, let the five-mark piece spin like a planet, and spoke. "All previous philosophies can be reduced to four. One: This five-mark piece is a five-mark piece and is nothing other than a five-mark piece. Two: This five-mark piece is no five-mark piece, but is something entirely other than a five-mark piece. Three: This five-mark piece is a five-mark piece and is no five-mark piece; it is both at the same time. Four: This five-mark piece is a five-mark piece and is no five-mark piece; it is both at the same time and yet neither, but two five-mark pieces equal a ten-mark bill because it is capital and earns interest. Five! Metaphilosophy: When five is equal to ten, one is equal to two. When one is equal to two, one plus one is equal to two, but also three, but also four, so that one equals four and consequently one plus one is equal to five to six to seven et cetera, and by reason of the induction process the conclusion follows that one plus one is equal to an infinite number. One minus one is therefore also one as also zero as also minus one, one plus one minus one is also equal to zero and equal to one and equal to two, consequently one plus one equals one minus one equals zero equals one equals an infinite number. One is equal to infinity. I am a dolphin. I am one. I am infinite. I am God." The Dolphin swallowed the five-mark piece and sank in the waves.

After the post-mortem the Director got his money back.

Translated from the German by Agnes Stein

Sea-Mammal Songs

I

Kin-creatures. They came like
breasts of horses in the sea;
figments of Dionysus,
lent their backs to Arion,
who sang from the deck, high, high,
whose harp lights and hisses
in the water: calling
"Simo. Simo", a name that brings
their dark backs to the shore.

Eyes wide as a horse's,
flukes steady as hands
holding up their dead,
the high shoulder weeping,
lent their voice to Arion,
held noon rites in the shallows,
took fish from a spear-tip,
and came gently to the Dreamer,
the porpoise-caller, who would still
not speak their names in his dreaming.

II

At Lorne pier, in broad daylight,
the jaw-shaped mussels clacked
like bats under roof-joists,
and the redfaced fishermen,
weathered sea-husbandmen,
stood on the edge, their rifles
picking the dolphins off.

Years later, one winter Sunday,
as we walked on Lorne pier,
and the unarmed fishermen
talked, halting, to each other,
the fish smelt urinous,
the air dark as creosote
flickered and faded
where their gunsmoke had hung
on Erskine's still, heavy mouth.

III

You were the heat of the sea,
the coast's electric echo,
bodies warming bodies,
skin after skin rubbed off
on every flank of earth,
that great wet rolling back
that surfaced like a heart
or hung in weak sleep
became our soul's horizon.

IV

My dead mother, who left me
the lizard pouch on the eye
and my mind scuttling
like a crab's mouth,
surely you could have taught me
to distinguish
the dolphin's whistle: in the rush of trees,
or bursting asphalt, my own
eternity flexing around me;
and the Celts, with their sea-flukes
and new gills, travelling

V

following the spoor of the sea
into your words, the sonar
pulse of memory,
silk tissue of fingertip,
you saw, not heard, their urging
whistle; so your poem
may hold up a few dead,
your whistling sigh of love
help a hard few to breathe.

right
Black-figured Attic skyphos showing
actors dressed as warriors riding
dolphins; 6th c., B.C. *Courtesy of the*
Museum of Fine Arts, Boston. Gift
of the heirs of Henry Adams

JAN BENES

Dolphin

Day after tomorrow, day after tomorrow,
 the dolphin emerges from the sea
"Look, Ma!" cries a little girl with pigtails and a hair ribbon.
"It's only a fish," says the mother, worn out by the world and the little girl in it.
"A dolphin is not a fish," a didactic old age pensioner butts in clutching his telescope
 And they all hurry away
 because they say there'll be a really good show on TV tonight.

Who knows the truth about the dolphin?
 Who knows the dolphin's truth?
 It is a secret, like the wishes of virgins.
 You can guess, Maccabees, you can guess.
We guess, but one thing we know for sure:
 The dolphin's truth is not cruel!
It is the truth of the smiling leap,
the truth with which friendships are sealed by young wine — not hemlock.
 It is the truth of a creature who smiles all the time, and never lies —
 never lies!
It is the truth of a creature who was not given the word
 in order to obscure the idea.
 It is a truth better than other truths. We do not know it.
We cannot always praise the sea,
 but of the dolphin not one evil word can be said.
Of the dolphin
 we can speak even that truth
 we ourselves are ashamed to acknowledge.

Translated from the Czech by Josef Skvorecky

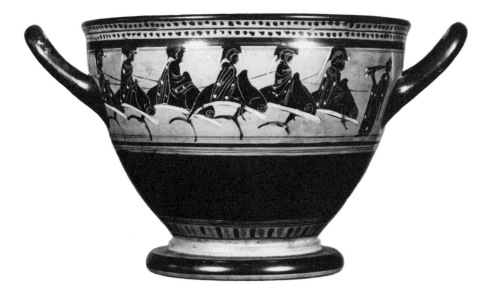

KOLYO SEVOV

At the Beach

In the oven of July, I was lying, estranged from my skin, my eyes fastened.
My duties under the pillow resembled birds in the cupped hands of children.
The sand was melting under the bulge of the sky.
The empty shells of sea animals and my illusions were cracking.
The dolphins were playing beside me, saving the space of my thoughts.
Then light exploded from my veins. The waves licked my legs.
Sea flies bolted, ran away from my body...
If my death were like that, I would have wanted it a hundred times over —
like the death of Ulysses, Achilles, Aeneas and their counterparts —
I got up, shed the sandy armour from my chest,
and plunged into the sea. The dolphins were calling me
with their tender voices
so I set out deeply for my heart and the truth of the sea
until my return, unique, to the shore.

Translated from the Bulgarian by Dobrina Nikolova and Greg Gatenby

WILLIAM STAFFORD

All at Once

Dolphins live like heroes without hands.
They know headfirst those aeons when
Earth leaned on a bell and no one heard.
They swim a life within. Whatever light
there is, they search and search. They think
fingers; they stutter music.

Their mothers hold them; then the sea does.
Their love provides that swoop the birds have,
or wind or wave, as far and lonely. Then
all at once — as Mozart judged the world with
every note — their songs bring close the Hesperides.

We own the world now, out here, but leave them
a place. Moonlight — that coat our old generals
wear — may be their sky too. Put a hand
in water, there where time goes: the sea
acts out a requiem, that loom feeling, the years.

143

Hedges of pack-ice
Line the forest where it grazes
On thorns of cuttle-fish.

Auroras of sheet-light
Spray it with arrows
Alongside paddocks of snow
 and moss.

Whistling and bellowing to
 itself,
It wanders through towers
Of glaciers, trumpeting:
A herald to days without
 beginnings or end.

Tapestries of lichen
Growing black and green, are a
 scrollwork
It never ceases to weave —
Diving over palisades of light
To straits and channels of
 pasture.

Harpooned or shot,
A legend dies in the Middle
 Ages —
Unicorns vanish on matted floes
Through squalls of mist that
 equators draw.

A scapegoat of reason
It roams in tribes
Over Arctic shelves and ridges,
Thrusting an ivory blade
At wings of sunlight that follow
 like a hawk.

We were now in that enchanted calm which they say lurks at the heart of every commotion. And still in the distracted distance we beheld the tumults of the outer concentric circles, and saw successive pods of whales, eight or ten in each, swiftly going round and round, like multiplied spans of horses in a ring...But far beneath this wondrous world upon the surface, another and still stranger world met our eyes as we gazed over the side. For, suspended in those watery vaults, floated the forms of the nursing mothers of the whales, and those that by their enormous girth seemed shortly to become mothers. The lake, as I have hinted, was to a considerable depth exceedingly transparent; and as human infants while suckling will calmly and fixedly gaze away from the breast, as if leading two different lives at the time; and yet while drawing mortal nourishment, be still spiritually feasting, upon some unearthly reminiscence; — even so did the young of these whales seem looking up towards us, but not at us, as if we were but a bit of Gulg-weed in their newborn sight...Some of the subtlest secrets of the seas seemed divulged to us in this enchanted pond. We saw young Leviathan amours in the deep.

 And thus, though surrounded by circle upon circle of consternations and affrights, did these inscrutable creatures at the centre freely and fearlessly indulge in all peaceful concernments: yes, serenely revelled in dalliance and delight. But even so amid the tornadoed Atlantic of my being, do I myself still for ever centrally disport in mute calm; and while ponderous planets of unwaning woe revolve round me, deep down and deep inland there I still bathe me in eternal mildness of joy.

Nor when expandingly lifted by your subject, can you fail to trace out great whales in the starry heavens, and boats in pursuit of them; as when long filled with thoughts of war the Eastern nations saw armies locked in battle among the clouds. Thus at the North have I chased Leviathan round and round the Pole with the revolutions of the bright points that first defined him to me. And beneath the effulgent Antarctic skies I have boarded the Argo-Navis, and joined the chase against the starry Cetus far beyond the utmost stretch of Hydrus and the Flying Fish.

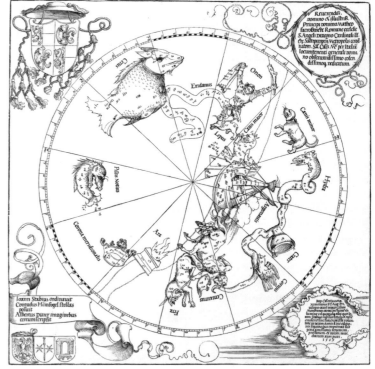

Tracing of a whale mother and calf carved into flat sandstone near Sydney, Australia, by an unknown Aboriginal artist of the 19th c. or earlier; 11.8 m long. From ''Memoirs of the Geological Survey of New South Wales'', No. 1, 1899

''Celestial Map of the Southern Hemisphere'' by ALBRECHT DÜRER, 1515, *woodcut, 42 x 42 cm. Courtesy of the National Gallery of Art, Washington, D.C.*

RODION SHCHEDRIN

Whale Composition

A. ALVAREZ

The Musicians

Enormous and tender, gifted and maternal,
Mysterious in their coming and going,
Their mating and dying
Secretive and ordained. They move
Warm-blooded and forgiving in their alien element,
Mild giants with brains bigger than a man's body.

Graceful, musical, addicted to pleasure, they sing
For each other's delight and their own
Under the bickering waves. They boom
Like tubas and bass drums, they snore
Like drunks, then warble, intricate as flutes:
Delicate, eerie, passionate, communicative.

This is the use of water. Open your ears to the deep.

Those lungs like caverns, throats like artillery
Refine themselves, purge all their bulk away,
Like Beethoven behind his battering forehead,
To produce at last the pure lost note of love.

And the song of the answering whale sounds like sleep.

„... Прямо к морю-окияну:
поперек его лежит
чудо-юдо рыба кит...“

„Конек-горбунок“

Родион Щедрин, Москва

Rodion Shchedrin,

Moscow 1979

145

The Dolphin

Artist's impression and infra-red photograph of a painted stone of man swimming with four dolphins from a coastal cave at Klassies River Mouth, South Africa, probably 4th c. B.C. This would seem to be the oldest image of a cetacean south of the Sahara. Courtesy of Dr. Ronald Singer

They are the lads that always live before the wind. They are accounted a lucky omen. If you yourself can withstand three cheers at beholding these vivacious fish, then heaven help ye; the spirit of godly gamesomeness is not in ye.
HERMAN MELVILLE

There's an animal I'd like to add
to those the Lord, to show His power, insight,
 and gift as creator,
enumerates for Job,
one to which I'd grant the same importance
and perfection, although of another order,
as the Leviathan and the Crocodile,
namely, the Dolphin.
And if I went on composing the Lord's speech
in human and contemporary terms, I would
have Him say:

"Does the dolphin owe its genesis to you
or do you think it was a random creation?
Could it be imagined to be the result of
 anything
but a creation,
whether immediate or gradual, after a
 gestation of millions of years
in the oceans' amniotic fluid?
(I adjust and express the possibilities
in your language
to suit your comprehension.)
However it came about,
there it was one day; and I ask:
'Could you, mortal of today,
not rich and loyal, wise and alert like my
 servant Job
in his prime, not sitting on a heap of ashes,
humiliated, tormented, and without reserves
 of any kind,
but triumphant, reigning over life and death
on the entire earth —
could you, with all your power and ingenuity,
have invented the dolphin;
could you have constructed its perfect
 graceful body,
imparted to it such speed, suppleness,
power to move in such perfect lines and
 curves,

springing into the air or swimming through
 the depths,
with so brilliant and gifted a mind for play,
so graceful a mentality:
the thought of the spacious brain one with its
 body from nostril to tailfin,
such natural goodness, spontaneous
 helpfulness,
joy of communication and social mind in
 lively streamlined integrity?
Or do you care whether or not you could have?
Do you find such a creature at all desirable,
a worthy objective,
or have things gone so far that you can only
 appreciate,
recognize and be truly interested in
what you yourself have produced or plan to
 produce?
From birth the baby swims as swiftly as the
 mother —
the breast nipple depressed in the body so as
 not to impair speed,
the mother contracts her muscles, squirting out
 her milk and the baby
sucks only seconds at a time, never needs to be
 washed or licked;
needs build no nest, use no caves, nor stake out
 territory;
it is naked without noticing,
and since in all ways it pleases me
and is without flaw,
I have let it remain in paradise,
in transparent flowing blue-green, black and
 purple
to this very day.
Could you, mortal,
have envisioned, let alone created
such a being?
Be honest and admit
that it would have been beyond your ability.'"

How could such a speech, such an argument
have stirred us and convinced us today,
brought us to insight and made us feel
some creator's power and vision
(since such a one does not, of course, exist)
with the dolphin's perfection
as proof?

No, for if we cannot create such a being,
we can do something else.
We can examine it,
inspect its habits while alive,
its structure when dead,
we can capture it and place it in tanks,
we can keep on dissecting it,
do autopsies on its carcass,
embalm it alive
in anaesthetized condition after our
 experiments,
the blood substituted by intravenous injection,
first with saline solution,
later with a preservative;
life slowly pumped out of its dormant body
like dew swept off by a windshield wiper.
We can be astonished by its intelligence in play,
by the brain's size and weight;
and then by measurable means
confirm the impression of its intelligence;
so much so that scientists in their admiration
 have thought
that the dolphin's talents must correspond to
 the human being's,
and were just being used in another way
fundamentally unlike ours,
impossible to define, but in any case I'll try:
with no need to possess or dominate, without
 aggression, duplicity, or ulterior motives,
its talents not extended to tools and weapons
but adequate with liberty of movement in its
 element
and by sheer excess integrated into the body
like one always dancing, always floating,
used mainly for communication and frolic.
And we may be astonished by its ability to
 communicate
above, as well as under, water,
both as receiver and sender of sounds, so
 differentiated and complicated
that they may be considered a language,
which has been investigated by hydrophones
 and oscilloscopes,
magnetic tapes and charts;
researchers have tried decoding with the same
 careful attention
that philologists

gave to hieroglyphics until they understood
 them.
They have established its ability to determine
 the wave lengths
of the sounds it emits,
to use its sonar, its cerebral echo-sounder
 incessantly
as we use sight, and have ascertained
that it receives twenty times more data via the
 ear than we
although ten times less via the eye,
that its total sense of direction without optic
 and acoustic equipment
is hence twice ours,
and that the cerebral organization in the
 dolphin as in man
relates exactly to these functions.
So exactly that the atomic scientist Szilard
from the conception of this brain and the
 dolphin's
lack of purpose imagined that
when we have learned their language and when
 they have mastered our knowledge,
their superior intelligence may guide us out
of insoluble conflicts and global danger
after the atomic bomb —
almost as the layman has hoped from creatures
from outer space, while scientists have prepared
for extra-terrestrial contact; but as for dolphins,
how explain ourselves to them? How find
 dolphin expressions
for alienation, aloofness, conditions
the dolphin knows nothing about or lives within
as within its element from its flanks to the
 shores of the earth —
a finned seraph
with flowing-streaming homes everywhere.
And finally we may wonder about the
 manifestation of its feelings
which do not seem to function just automatic
 or animal-like,
do not seem explained by mere urge and
 instinct —
and what is instinct? — but seem to lie absurdly
or astoundingly close to the human, no matter
 what
explanations conventional science has ready to
 distinguish between

the reasons for human and dolphin behavior,
insisting firmly on man's central
dignity and superiority, in contrast not only to
 a soulless creature —
for what is soul? — but to a machine without
 reason.
For how else explain that dolphins in captivity,
even under favorable conditions and when they
 have survived
human infection, are bored to the point of
 neurosis,
go on hunger strikes and die
as if their joy has been too great, too perfect
to endure life at any price under conditions
other than that of the open sea,
and even though it happens with other animals:
 How is it that
because of prolonged separation from its mate,
which the dolphin TV-star Flipper endured on
 his tours —
how is it that, despite the best of health,
he remained under water until he died,
committed suicide in other words,
the dolphin's way to abandon,
consciously and irrevocably,
a worthless life?
But we have also been able to do more than
 investigate
dolphins.
We have been able to use them.
As counselors? Never: a science-fiction dream.
As fragments of a model and encouraging
 neighborliness: Ridiculous,
although Plutarch long ago summarized
 Antiquity's attitude toward the dolphin
with this reflection: that it is the only creature
 that likes the human being for its own sake
"even though it has no need for man still it is
a warm friend of all beings, and has helped
 mankind."
No — but for entertainment,
in tanks and pools as a zoological phenomenon,
as a drilled artist in circus and marine shows:
In Great Britain alone about thirty, the majority
 in undolphin-like conditions,
forced, with poor training; neurotic because
 they are often cheated of their reward,

deadly bored in sterile containers without toys
to play with,
calls and sense of direction ruined by the
echo from their own sounds
in rectangular vessels,
tortured by the low frequency of other sounds
so that twenty per cent die every year, refuse
to cooperate with either trainer or doctor,
refuse to eat, and, in the end, to breathe.
And, furthermore, we have been able to use
them
as pets and for oceanographic research,
for consumption and for war:
The American military has experimented with
this intelligent
so-called animal,
trained it for underwater
military tasks, for which divers and frogmen
are inadequate
or where the risk of human life is too great:
Espionage
and the placing of electronic equipment in
foreign harbors,
seeking out mines and the homicide of saboteur
frogmen,
with the help of knives harnessed to the snout,
yet with a fundamental hindrance: that the
dolphin
never has attacked, and fails to understand
that it should attack, man; when
given the opportunity, it has only played with,
arched its back under for joyrides, saved from
drowning,
and has shown the way to his vessels in fog,
bad weather
and dangerous waters. There is
no ancient myth or modern yarn that does not
in like manner tell of the dolphin's helpful,
active friendliness,
no common experience or scientific observation
that contradicts it —
and consequently it cannot, among all its
intelligently perceived
appeals and signals,
comprehend the signal to kill — but
for this intelligent animal's
inability to perceive they've found a remedy:
Bored

a hole to the brain, driven a pipe through the
cerebrum and implanted
electrodes in its pain and pleasure centers
to arouse pain and aggression by electric
impulses
with what has been called success:
For the first time in the dolphin's existence
it has been a killer
because its strength has qualified it to be,
even without knives the shark cannot get the
better of it,
and this is the one improvement we have made
in this divine, long-since-perfect creature.
I have never felt, as did the Norwegian poet
Obstfelder,
that I have landed on the wrong planet;
on the contrary,
but at times rebellious and neurotic,
have felt that I belonged to the wrong species
and have felt consequently a red-hot sense
of shame,
which favorably compares with every
legitimate pride,
and if only a growing number would feel the
same,
there would be greater hope not only for those
animals
but for humans —
the wrong species: that is, a species for which
nothing is sacred,
which knows and respects no limits
(and limits
are the conditions of life's continuity),
*not to be confused with our self-created conventional
limits*
for avoiding life
that is: that cruelty, annihilation, death are the
last,
when all limits are passed, trodden down,
erased and forgotten,
the last — as deserts are the last, along with
radioactivity,
oxygen-empty air and dead seas.
The mobilization of the dolphin,
it occurs to me,
is such an exceeding of limits, incredibly far out
or far in, unexpected, shocking, one's fantasy
made dumb,

an unforeseeable encroachment, but consistent
when it has taken place —
and the use of this animal godchild
not just an expression of unthinkable contempt
or indifference,
but one of the strongest proofs that man's
global omnipotence, after all, has only one
absolute dimension:
the destructive one; and moreover
that the dolphin, in the end, is driven from its
paradise,
not only by outer injury, capture, marine
poisoning or slaughter,
as when seventy specimens of Pacific dolphins
were drowned in nets, speared or shot,
so that the stomach contents might be examined
but by injury to its mind,
elimination of its thousand-year-old,
nature-given friendliness,
the last intact remains of paradise,
as an environment to see and breathe and exist
in, nearly vanished,
attacked at the roots:
*after the penetration of the dolphin's skin and
brainpan*
*the electrodes gnaw at the very roots of the joy of
living*
and thereby the guarantee of life's continuity
on this planet
even if the occasion seems unimportant if
measured by larger
visible threats far and wide,
shaken a little more.
When limits are exceeded and wiped out with
catastrophic consequences
(to begin with, usually nothing is noticed or
nearly nothing)
we have what is called: crisis,
a condition that has to be endured, possibly by
a new
exceeding of limits called progress,
instead of examining and finding the cause of
the disease
in its very progression
"progress may have been all right once but it
went on too long."
As far as dolphins go there is still hope:
The Soviet Minister of Fisheries by law in 1966

forbade the commercial capture and
 slaughtering of dolphins for ten years
in the Azov and Black Seas,
probably because astute scientists like Sakharov
 and others,
after thorough research, found that the dolphin
 was too high-level
and rare an animal to be continually subjected
 to such treatment.
Astute American scientists like Lilly and others
 also
have found it overqualified, studied its
 language, investigated possibilities for contact,
and a research team has charted its brain
 literally and perfectly:
An Atlas of the brain of the dolphin,
'tursiops truncatus'.
Something must be allowed to exist without
 rational cause and apparent utility,
must keep on living, without economic
 justification and involvement in politics
 and war,
exist freely and free of interference and
 manhandling,
must be sacred to us, as the elders said,
 and what does sacred mean?
That something for inexplicable reasons
must not be crowded out or exploited,
that we must have clear and alert consciousness
 of limits,
visible and invisible,
material and mental,
and must be in continuous touch with such
 limits, and hence
in touch with the vitality, being, power and
 energy behind them,
which in their undisturbed state recharge the
 mind,
strengthening and expanding it, because that
 something is unlike us,
because we live as neighbors with it, in
 interchange with it,
without plans for subjugating it —
because it opens the mind's eye,
the eye behind the eye.

Then let us begin somewhere
 with some creature,

the dolphin, for example,
which has always been free and undaunted,
unimpressed and helpful, in relation to man
as though it were of the same species;
let us at long last make amends;
we have so little to lose,
so much to gain.
Let us continue with other places, other species,
where they can still be reached;
let us not shoot at the dolphin when it surfaces,
as men with rifles in boats along the American
 coasts
do when dolphins, curious creatures, springing
 up,
inexperienced in human behavior, think the
 men are playmates,
and not even at the sight of them have learned
to remain under water:
Have we misunderstood the role of the human being;
is it above all a killer,
in the last analysis, without regulation, by every
 imaginable means,
a killer?
No — a thousand times no —
let us consider the springing dolphin's
consummate curve over the surface of the sea
a sign and symbol,
as the rainbow once was,
a promise of life's continuity.

Translated from the Danish by William Jay Smith and Leif Sjöberg

Le Vray portraict du Daulphin.

Illustration by PIERRE BELON *from*
''L'Histoire Naturelle des Estranges
Poissons Marins'' (Paris, 1551)

TOM BUCHAN

Dolphins at Cochin

They crashed among the spider-nets
spluttering and breathing hoarsely,
chasing fish out of the water,
calling one another and disappearing.

Lime-green bellies and smiling mouths
sliced upwards obliquely;
calm humorous eyes regarded us for a moment
and splashed back.

Sea-marks of dolphins
moved among the dozens of jockeying sails:
a mile out, in the breaking waves,
we could see the flash of more dolphins.

On the bridge of our tanker
the grey paint blistered in the heat; above us
the siren mooed to come in at the jetty:
the water green and translucent.

The smell of crude oil, of ginger
drying in the yards; piles of coloured fish;
the creak of a wooden capstan,
monkeys quarrelling on top of the parked cars.

And suddenly there was a dolphin
inside our slow bow-wave: revolving, amused,
not realizing our incomprehension
of his vivid thoughts.

Two dolphins came skidding round the point,
screeched to a standstill
blowing vapour and circling each other;
then they raced on again, leaping.

We watched them helplessly
from our primitive element
able only to think up cold metaphors
or to anthropomorphize.

But they wheeled — dolphins!
their liquid backs, their arched fins
moving steadily out from the shore
towards the hilarious ocean.

DANIEL HOFFMAN

An Armada of Thirty Whales

DAVID MAMET

The Whale

(Galleons in sea-pomp) sails
over the emerald ocean.

The ceremonial motion
of their ponderous race is

given dandiacal graces
in the ballet of their geysers.

Eyes deep-set in whalebone vizors
have found a Floridian beach;

they leave their green world to fish.
Like the Pliocene midge, they declare

their element henceforth air.
What land they walk upon

becomes their Holy Land;
when these pilgrims have all found tongue

how their canticles shall be sung!
They nudge the beach with their noses,

eager for hedgerows and roses;
they raise their great snouts from the sea

and exulting gigantically
each trumpets a sousaphone wheeze

and stretches his finfitted knees.
But they who won't swim and can't stand

lie mired in mud and in sand,
And the sea and the wind and the worms

will contest the last will of the Sperms.

far right
HAP GRIESHABER
''Auftauchender Wal'' 1973
woodblock and ink, 41 x 27.5 cm

150

There's a big fat whale
And he lives in the Sea.
He's sharp as a tack,
And he's quick as a skate.
He lives in the water
And he eats the plants
That grow at the bottom of the Sea.

There's a hurricane brewing in the Indian Sea —
In the Indian Ocean where the water is warm.
Where the wind is danger
And the night is hot,
And the fish and the water are warm.

There's the moon of the Incas
And the Yucatan
Who shined on the Pharaohs
And the men of Blood —
Deserted the Mayans
And cursed the Kings.
She pulls on the Water
She lives in the Water;
Her life is the water of the Sea.

There's the flap of the sail
And the smell of blood
And the feel of copper —
Of a nail pulled loose
Of a rusted nail
In the fat of your foot —
Of terror in an unexpected place.
The flap of the sail
And the dumb fish eyes.
They're dead on the deck
And they're dead in the Sea.
The eye of the whale is blind with fear,
And he looks like a child in bed;
On the stair;
With a broken leg in the woods at night;
With an unearned guilt in his heart
And fear;
And putrefaction in his nose
From plants at the bottom of the Sea.

In the log of the Gods,
In the log of stars
In the atoms of plants
In the blood-warm stream

In the death of a bird
When the air goes chill;
When the winds cease the buttress of his wings;

When the air of his bones
Neither floats nor falls
Nor rises to the measure of the now-cold air;

In the fear of night,
In the fear of birth,
In the husbandry of drugs,
But the love of song,

In the smell of death,
In the *luxe* of plants,
In the blood of the whale,
In the pull of the moon,
In the fear of snakes
And the love of song,

In the swift recognition of the hurricane,

In the vehement custody of blood
Is the knowledge of the end of time.

IRVING LAYTON

If Whales Could Think on Certain Happy Days

As the whale surfaced
joyously,
water spouted from his head
in great jets of praise
for the silent, awesome
mystery
he beheld between sea and sky.

Thankfulness
filled his immense body
for his sense of well-being,

his being-at-oneness
with the universe
and he thought:
"Surely the Maker of Whales
made me for a purpose."

Just then the harpoon
slammed into his side
tearing a hole in it
as wide as the sky.

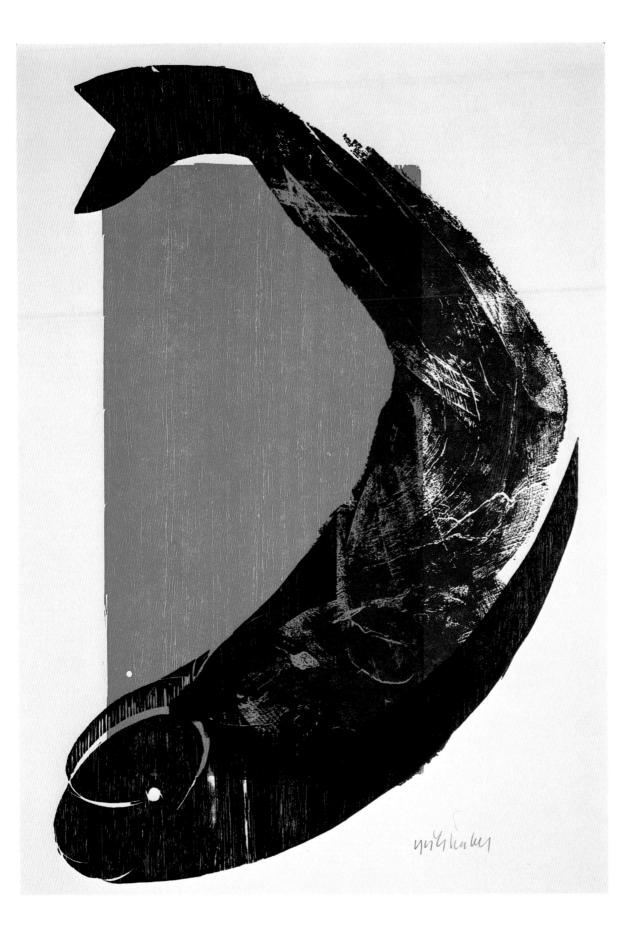

MARGARETE HANNSMANN

The Whale

Sometimes
in water
the memory is transformed

immersed
extracted
exchanged
all verticals upturned
all solids made fluid
so that fluids can take on form
Leviathan
unresisting
is met by every finless
harpoon lost
the shadow from the deep grazes me
father
brother god with your trident
bridegroom
flesh of the flesh from which I come
soft smooth fat
firm and supple
secretor of ambergris
raise me up
accept me
bear me a while
teach me your frequencies
play with me
head first
land over heels
the sea-days long
sometimes
a pool
as big as a room
is enough
an intercom swimming system
warmed by night storage heaters whilst
 all around
icicles glisten
the Great Bear
sends light from the Arctic
hval
Wal ballena Moby Dick
when will you
butcher the last father

Translated from the German by Michael Butler

151

WALTER HELMUT FRITZ

The Whale

This gray, black
gleaming vessel
with his jet of steam
one of life's experiments
you say, this whale,
this mountain in movement
and then this dance
he, together with others,
puts on, before wandering off
 again,
with his eyes
— blue — of enamel,
his brain larger
than that of all other beings,
his song, without vocal chords,
his laughter, his roar.
You know his ingenuousness
confronting humans
who senselessly pursue him.
He owes everything to water.
This frailty
when stranded he suffocates
lacking the power
to expand his chest cavity.

Translated from the German
by Agnes Stein

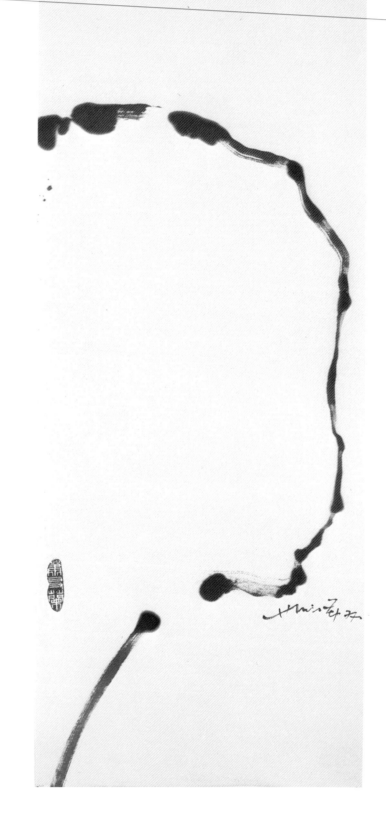

CHIN HSIAO
"Ch'an — 23" 1977
ink on canvas, 146 x 59 cm

152

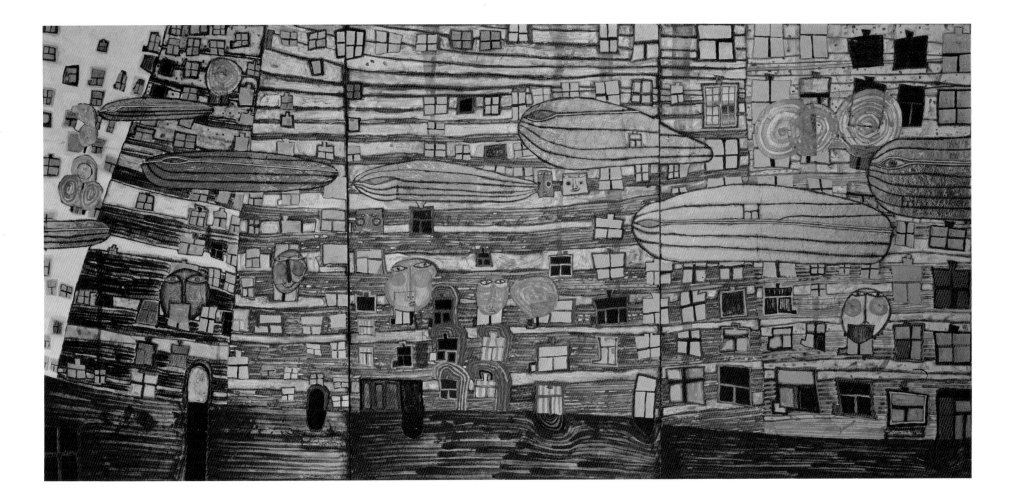

JOHN HAINES

The Whale in the Blue Washing Machine

There are depths in a household
where a whale can live...

His warm bulk swims from room
to room, floating by on the stairway,
searching the drafts, the cold
currents that lap at the sills.

He comes to the surface hungry,
sniffs at the table,
and sinks, his wake rocking the chairs.

His pulsebeat sounds at night
when the washer spins, and the dryer
clanks on stray buttons...

Alone in the kitchen darkness,
looking through steamy windows
at the streets draining away in fog;

watching and listening,
for the wail of an unchained buoy,
the steep fall of his wave.

HUNDERTWASSER
"777 Song of the Whales" 1975-78
mixed media: watercolour, egg
tempera, oil lacquer, silver foil glued
with Pattex, with pink chalk and
polyvinyl on cardboard in three parts,
70 x 147 cm
© 1980 by Gruener Janura
AG Glarius/Switzerland

153

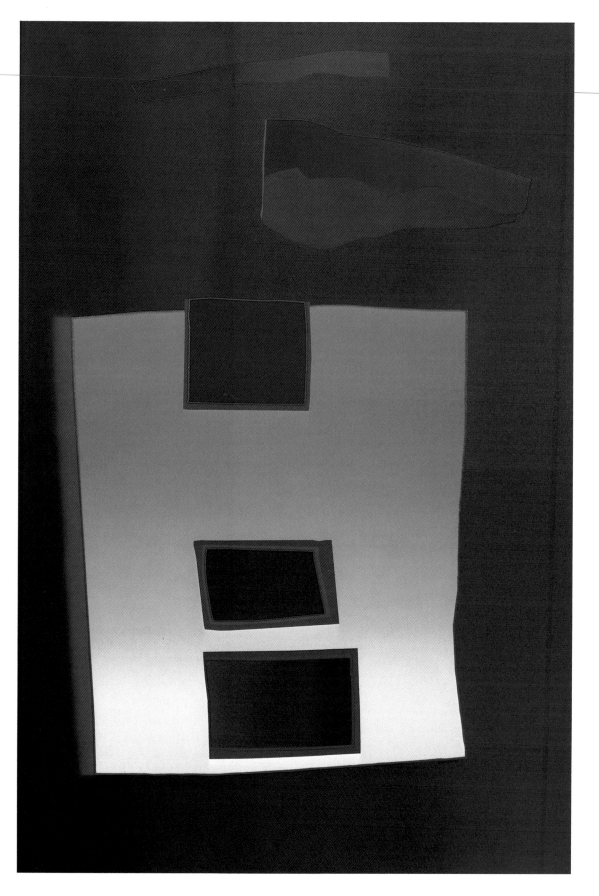

RICHARD OUTRAM

For All Creation is Divine Entire

THAT GOD imagining whales
In tireless migration by night
Would ever reflect on stars'
Ordinate light

To fasten glittering barbs
In that blackest prodigious back
Of the streaming beast in his driven
Infinite track

And further to burn in his small
Eye all the unbound
Brilliant Immortal wounds
That he may sound.

DEBORAH REMINGTON
"Auriga" 1980
oil on canvas, 1.9 x 1.3 m

154

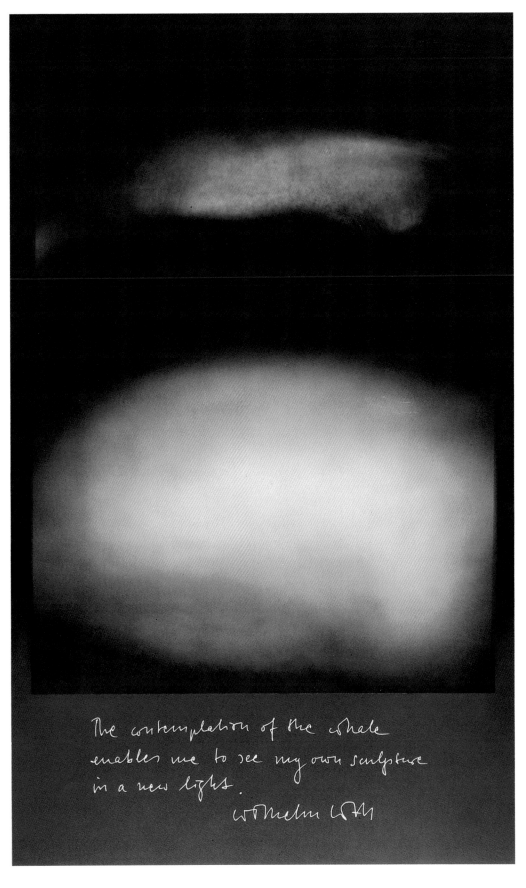

The contemplation of the whale enables me to see my own sculpture in a new light.

Wilhelm Loth

right
WILHELM LOTH
''10-69'' (detail), 1969
aluminum, 73 x 23 cm

left
J.R. SOTO
Untitled, 1980
serigraph, 30 x 30 cm

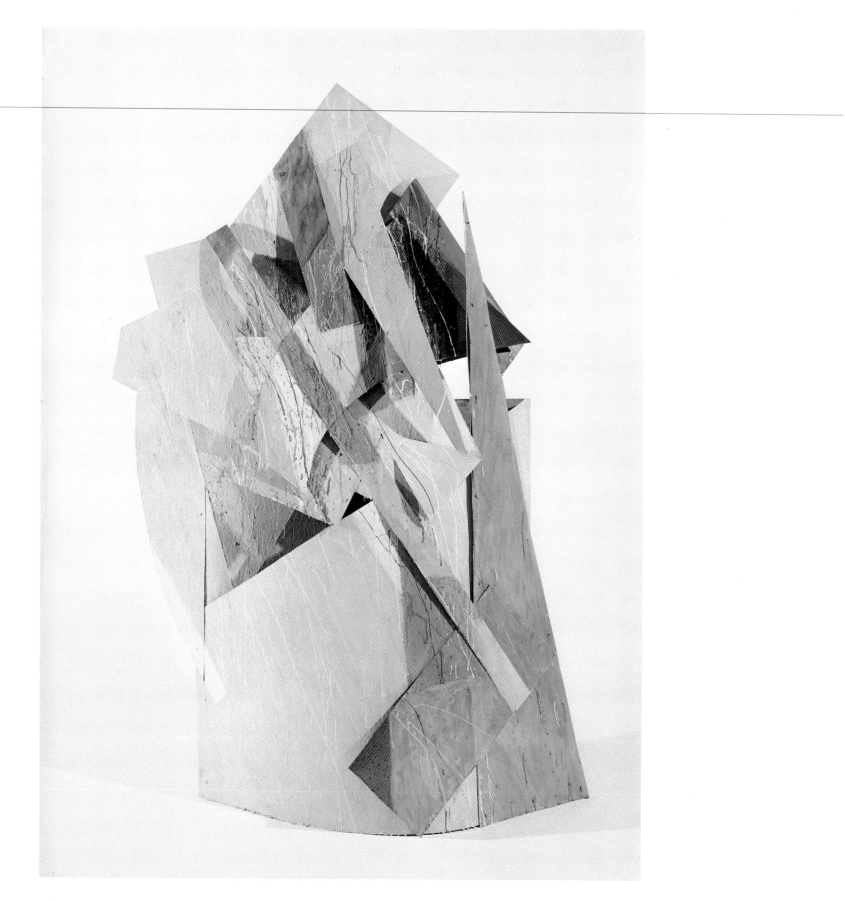

TOM HOLLAND
"Breach" 1980
epoxy paint on free-standing
aluminum,
216 x 158 x 55 cm

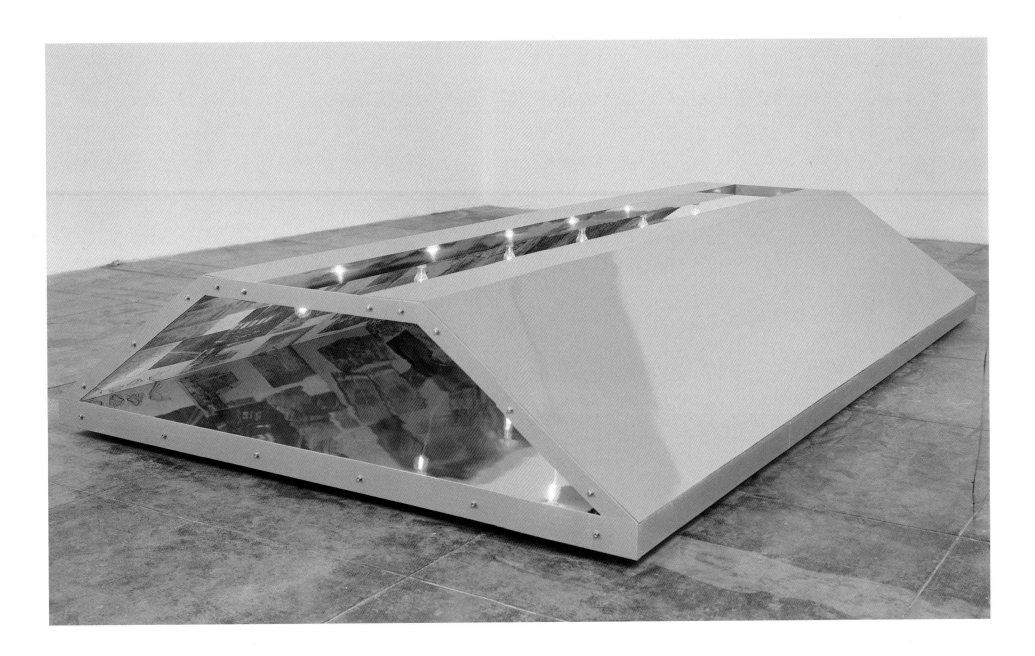

ROBERT RAUSCHENBERG
"Narwhal" 1977
mixed media, .65 x 4.3 x 2.4 m

161

THE HUNTING

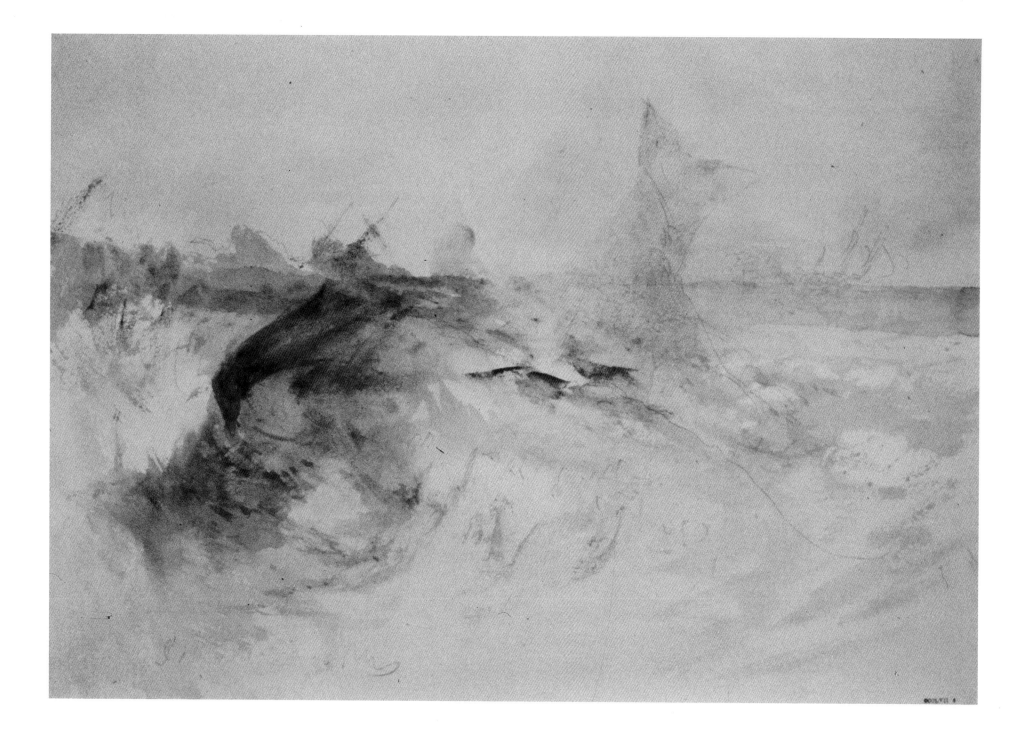

TAEKO KAWAI

A Vision of the Great Whale

In our gigantic Japanese supermarket
there is a gigantic basement
in this gigantic basement
there is a gigantic food department
in this gigantic food department
there is a gigantic fish counter
on this gigantic fish counter
there are hundreds of tiny slices
of whalemeat on tiny trays
of styrofoam covered with
transparent hygienic plastic foil.

O under the millions of blazing lights
and the avid eyes of a million
pitiless housewives the tiny slices
of dead, dark red whalemeat
lie motionless in death's perfect freezer
while rough indifferent fingers
of cruel housewives take them up
to look at the price labels — ¥426,
another ¥623, and that one ¥541 —
all different, but all flat, all dead.

Dead, the noble mammal of the deep,
the warm-blooded, air-breathing giants
that have the brains of genius.
Did your territorial ancestors take to the seas
over seventy million years ago in order
to escape this fate? O you great whales —
the blue, the fin, the humpback and the grey,
the right, the pygmy right, the bowhead, minke and sei —
all you of the Mysticeti family, the beautiful baleens,
you gentle creatures, enormous as any born on earth,
you were an object of veneration to
Stone Age man and ancient Greek
who saw in you a symbol of divine marine majesty
and gazed with awe upon you from their headlands.

Today, all reverence for you is dead or dying.
Wherever you speed and gracefully cavort
a floating factory, Japanese or Russian,
is never far behind you with its
superefficient modern technical equipment
(science has a lot to answer for) —
high speed chase boats, sonar tracking,
devastatingly accurate grenade-tipped harpoons.
Before you realize what has happened
you are passing through a gigantic floating factory,
even as we, poor humans, pass through the maws
of time, trouble, love, sickness, death,
imagining it is life we lead.
And so the great sperm whales of the Odontoceti family
that also includes the porpoises and dolphins
are slaughtered, gutted, boned, sliced and deepfrozen
for the gigantic supermarkets of the world's
gigantic basement fish counters. Your precious oils
grease the palms of armaments manufacturers
and the wheels of munitions factories. Your flesh
is thrown to cats and dogs, your bones, baleens,
are used for corsets, collars, fans and
modern scrimshaw kitsch. And humans, too, feast upon you.

But now as I was gazing upon those dead slabs of ticketed flesh
in a miraculous vision I beheld them all come to life again,
joining together, taking gigantic form, noble proportions,
and, under the millions of blazing lights,
turning once more into giant whales
while the entire basement fills with seawater
and you find again the ocean's way, the whale's way
in perfect peace and endless resurrection.

Meanwhile the terrified housewives with their cruel eyes
and indifferent fingers swim for dear life to the drowning exits
while you gaily pursue them, hunting once again
the micro-organisms of the Arctic deep.

Translated from the Japanese by James Kirkup, in collaboration with the poet

BUSON

Whale Haiku

Fresh-killed whale meat is offered
for sale. The clash of market knives
resounds.

*Translated from the Japanese
by Greg Gatenby*

''The Whale'' by J.M.W. TURNER,
*ca 1845. Pencil and watercolour,
23.7 x 33.5 cm. Courtesy of the
Trustees of the British Museum*

GEORGE MACKAY BROWN

Whales

Whales blundered across us, threshing lumps,
Blue hills, cartloads of thunder.
They trekked between the ice and the hidden shoals.

In the west the gold whale sank in welters of blood.
We killed that ghost each sunset.
At dawn our hands were red and empty.
Now the Dove faltered out of the blind fist.

We notched barbs on various sticks and staves.
We spread the deck with lashings of salt,
Made harpoonman of herdboy.
''Heave her to,'' sang the ribbed strenuous oarsmen.
The Dove dipped into the first whalequakes.

The women wondered at all these tons of love.
Gudrun crouched in the doveflank.
Every whale was a bolted slaughterhouse,
A winter of work for candle-makers.
The priest of Balder balanced a ritual point.
That sea was huge with sacrifice.
The Dove lappered in gules of sunset.

One thunderer rose athwart the spear rank.
The barbs broke on his bulk.
Sky jaw from sea jaw split, gigantic laughter!
His frolicking rudder deluged the Dove.
His mild lip sieved the waves.
He balanced a fountain southward on his skull.

Our fires slept in the golden jar.

Far back, those floating feast-halls belched.
Soon the stars flashed around like stalks of corn.

''Walrus Whale'' from ''Historia
Animalium'' by KONRAD GESNER.
An illustration of the confusion
between the large sea-mammal with
tusks and the whale

MARK STRAND

Shooting Whales

When the shoals of plankton
swarmed into St. Margaret's Bay,
turning the beaches pink,
we saw from our place on the hill
the sperm whales feeding,
fouling the nets
in their play,
and breaching clean
so the humps of their backs
rose over the wide sea meadows.

Day after day
we waited inside
for the rotting plankton to disappear.
The smell stilled even the wind,
and the oxen looked stunned,
pulling hay on the slope
of our hill.
But the plankton kept coming in
and the whales would not go.

That's when the shooting began.
The fishermen got in their boats
and went after the whales,
and my father and uncle
and we children went, too.
The froth of our wake sank fast
in the wind-shaken water

The whales surfaced close by.
Their foreheads were huge,
the doors of their faces were closed.
Before sounding, they lifted
their flukes into the air
and brought them down hard.
They beat the sea into foam,
and the path that they made
shone after them.

Though I did not see their eyes,
I imagined they were
like the eyes of mourning,
glazed with rheum,
watching us, sweeping along
under the darkening sheets of salt.

When we cut our engine and waited
for the whales to surface again,
the sun was setting,
turning the rock-strewn barrens
 a gaudy salmon.
A cold wind flailed at our skin.
When finally the sun went down
and it seemed like the whales had gone,
my uncle, no longer afraid,
shot aimlessly into the sky.

Three miles out
in the rolling dark
under the moon's astonished eyes,
our engine would not start
and we headed home in the dinghy.
And my father, hunched over the oars,
brought us in. I watched him,
rapt in his effort, rowing against the tide,
his blond hair glistening with salt.
I saw the slick spillage of moonlight
being blown over his shoulders,
and the sea and spindrift
suddenly silver.

He did not speak the entire way.

At midnight
when I went to bed,
I imagined the whales
moving beneath me,
sliding over the weed-covered hills of the deep;
they knew where I was;
they were luring me
downward and downward
into the murmurous
waters of sleep.

R.A.D. FORD

Whale Sighting

Barely decipherable, the Via Galactica,
Through the film of mist,
Shed little light enough
Off the Kamchatka coast.

Enough, though, to glimpse
a moving black island in the still
Blacker waters – whale!
The curious crowd to the rail,

Ogle the huge back
Before it plunges out of sight.
But how many of the curious ask
How long a respite

Before the murderous factory
Ship arrives, its radar spots
The mighty fins, and
The serious butchery begins.

JUDITH RODRIGUEZ

I've always wanted a brass dodo

It frisks in a girl's hand,
little pet, the whale
she bought for the cant of the tail,
the glide
of fingertips on brass
and look! her own gold face
melting and remaking along the fluent side;

decent she feels, reminded
you shouldn't hunt them
and if men do, whales haunt them
in museums.
Busy Taiwan's
buoyant upon these dollars;
maybe a whale's still blowing. *Carpe diem.*

DOUGLAS LIVINGSTONE

Beach Terminal

The old whaling station is shipwrecked:
corrugated roofs, tin walls rusting;
most of the cataracted panes smashed;
the sea clean now, the sand still tarry.

Time was the whole factory bustled
with butchers, profit-motive suspect;
these days: a slow-motion subsidence
into the vengeful foreshore bush.

At night, under arcs, the dead came in,
ushered towards the busy chimneys
– the new flesh arriving looked iron-pecked –
you could almost chew the oily smoke.

Bearded hackers, swift with fist and oath,
flensed, slashed, tore with hand-held
 power saws,
long knives and tongs: staggered on spiked
 boots,
slipped and swore – a thick-skinned breed,
 thick-necked.

For me it will always be blood-flecked
days and nights dodging towed low-level
platforms of the killed deep-sea sounders
betrayed by their young to the spotters.

Ripped by harpoon, grapple, lance and shark,
their tongues jutted toughly – the steel-decked
tongues stuck out at death affected me most
as I trudged the stained narrow-gauge rails.

Stumbling, weighed with the long sampling
 stick,
bottles, thermometer and notebook,
checking the surf slimy with reject,
with whale-washings, hereabouts unclean.

Intestines, hoses sliding about,
vats bubbling, crane-chains clattering
– all that has stilled: the factory closed,
but always, I think, a bad prospect.

ALAN GOULD

Eden in the Eighties

(The town of Eden is situated on the far south coast
of New South Wales, and was formerly
a whaling station.)

Skittish as unbroke horses in
the paying seas of New South Wales,
obedient to a discipline
as worldly as the helmsman's curse
and starvelings married to their sail
the whale-school set the whalers' course.

Now whale and whaleman roll beneath
the gun-black seas of New South Wales
and what were unobtrusive deaths
will lose the earth another voice
that conjured us unearthly tales
till death became a human choice.

OPAL LOUIS NATIONS

The Greenland Whale – Balaena Mysticetus

Since the advent of whaling ships, the
Greenland whale, like many other of its family
species, has been butchered mercilessly. One
true account of its destruction is as follows:
One of two whales (one male, the other
female) having been struck by a harpoon, the
wounded one made a long and terrible
resistance; it struck at the boat of five men,
hurling it and its occupants fifteen feet into the
air. From this single blow of its tail all went to
the bottom. The uninjured whale still attended
its companion and lent it every assistance, until
at last the whale that had been struck sank
under the pain of its wounds, while its faithful
companion, disdaining to survive the loss,
stretched itself out upon the dead animal, until
it itself was speared of life, staining the water
for a hundred yards about, with blood.

CARMEN NARANJO

Ballad for a Small Dead Whale

Sea and life arrive
 on each wave
On each wave also
comes death.
In the cold Atlantic
lies at anchor a great
dead whale.
Only a baby.
A piece of harpoon
agony solitude
and senseless death.
Profoundly sad
barren wasted
made old by fear
deep-voiced, she seems to be
 singing herself
a lullaby
a lullaby about water
a lullaby about safe harbour
a lullaby about an unfinished
 course.

Of the sea was I born free
 free
from the beginning I swam
descending ascending
leaping playing
breathing smiling
How grand the sea how grand!
I did no harm
Nobody free does harm
How long the ways how long!
The pod moves joyously
and I one more with it
How grand the sea how grand!
Wider next to the sky.
How grand where we all have
 room
without disturbing or doing
 harm!

Don't go away says my mother
don't go away and the sea
 rocks me
and the sun is strong
 and yellow.
Shadows approach

they are the clouds flowing
 through the sea.
Don't go away and I feel
 my strength
and my grace and my delight
in swimming fast
in frolicking
in splashing about
My tail makes glorious noise
with peals of joy.
I know the depths of the sea
I know the surface of the sea.
Don't go away
but the horizon calls
Like a gossamer boundary
How grand the sea how grand
How free the sea how free!
Like me.
I never did any harm
nobody free does harm.

Translated from the Spanish
by Margaret Cullen

KWAKIUTL INDIAN PRAYER

Prayer of a Man Who Found a Dead Killer Whale

"Oh, it is great how you lie there on the ground,
Great Supernatural One.
What has made you unlucky?
Why, great and good one, are you lying here
 on the ground?
Friend, Supernatural One,
Why have you been unlucky, friend, for I
 thought you
could never be overcome, by all the
 Short-Life-Maker Women.
Now, you great and good one, have you been
 overcome
by the one who does as he pleases to us, friend.
I mean this, that you may wish that I shall
 inherit
your quality of obtaining easily all kinds
 of game
and all kinds of fish,
you Great Supernatural One, friend,
you Long-Life Maker.
And also that you protect me,
that I may not have any trouble, Supernatural
 One,
And also that it may not penetrate me,
the evil word of those who hate me among my
 fellow men,
And that only may penetrate themselves
the curses of those who wish me to die quickly.
I mean this, friend,
Only have mercy on me
that nothing evil may befall me,
Great Supernatural One," says he.
"Wâ, I will do this," says the man
on behalf of the one he found dead.

Translated from the Kwakiutl by Franz Boas

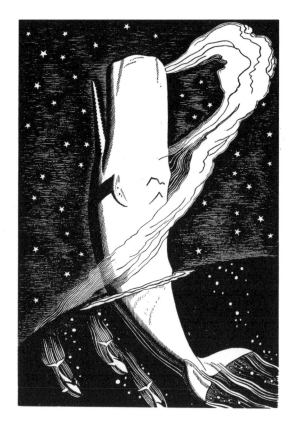

Woodcut by ROCKWELL KENT
from "Moby Dick" (New York, 1930).
Courtesy of the Rockwell Kent Legacies

JOHN BLIGHT

Death of a Whale

When the mouse died, there was a sort of pity:
the tiny, delicate creature made for grief.
Yesterday, instead, the dead whale on the reef
drew an excited multitude to the jetty.
How must a whale die to wring a tear?
Lugubrious death of a whale: the big
feast for the gulls and sharks; the tug
of the tide simulating life still there,
until the air, polluted, swings this way
like a door ajar from a slaughterhouse.
Pooh! pooh! spare us, give us the death of
 a mouse
by its tiny hole; not this in our lovely bay.
— Sorry we are, too, when a child dies;
but at the immolation of a race who cries?

Lost Whale Calf

''I am a Hundred Foot Blue Whale''

This piece must be performed on a grand piano so that the performer can work inside the case on the strings. It does not demand going beyond the dampers.

All pianos differ, and some may present problems. On most pianos the rack pushes back far enough so that one can play on the strings and still read the music. The bars of the piano often differ and may affect the glissando across the strings. The A may not be possible. If so, play the highest note that is possible.

In order to know the positions of the strings, stick little pieces of red masking tape on the bars by them.

The pedal must be kept down throughout the piece.

Scraping the wire around the low strings is done with the fingernail. The sound is better if done beyond the dampers. (Never touch the dampers!) One may scrape the strings in front of the cross bar if one has a short arm. If these low strings are not possible, choose the lowest strings that are.

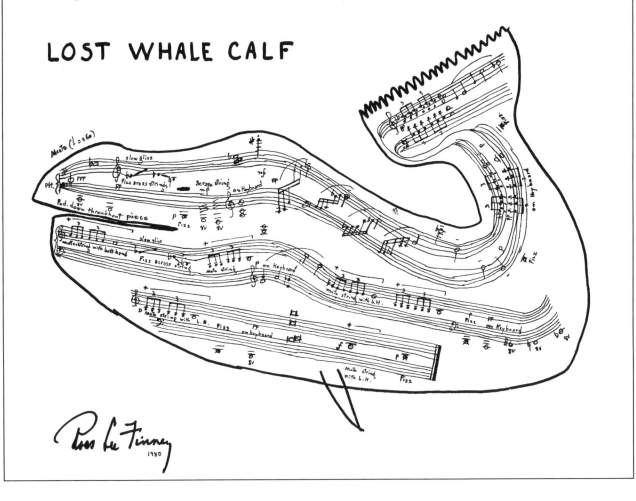

Ever noticed the hardboard fence
between pneumatic drills shuddering
staccato flack into granite
downtown between Shortland and Fort
and the hot leaden Queen Street traffic
drumming, as you jostle the pavement —

Good place for a billboard, slap on
the glue and a proclamation of disco
or rock or maybe transcendental meditation
at this joint or that anywhere in town —

This lean-to fence will come down
pretty quick, soon as the boys finish
their business on the other side; some
smart new bank perhaps with a high
discount will shoot up before you know it —

Funny thing though, the other day
on my way up from the bus station,
I glanced at the fence — someone
had painted a whopping great whale
a hundred feet long in kind of
sea colours — all blues and greens
along that fence, had a snout and a tail
and all that and the words read:

I AM A HUNDRED FOOT BLUE WHALE
HARPOON ME WITH YOUR POSTERS

Y'know, I stopped in my tracks and went
back to walk the length of the beast —
sure enough, there were posters right up
to the snout and tucked in round her tail
but no one had dared stick one up on the whale.

GARY SNYDER

Mother Earth: Her Whales

An owl winks in the shadows
A lizard lifts on tiptoe, breathing hard
Young male sparrow stretches up his neck,
 big head, watching —

The grasses are working in the sun. Turn it
 green.
Turn it sweet. That we may eat.
Grow our meat.

Brazil says "sovereign use of Natural Resources"
Thirty thousand kinds of unknown plants.
The living actual people of the jungle
 sold and tortured —
And a robot in a suit who peddles a delusion
 called "Brazil"
 can speak for *them*?

 The whales turn and glisten, plunge
 and sound and rise again,
 Hanging over subtly darkening deeps
 Flowing like breathing planets
 in the sparkling whorls of
 living light —

And Japan quibbles for words on
 what kinds of whales they can kill?
A once-great Buddhist nation
 dribbles methyl mercury
 like gonorrhea
 in the sea.

Père David's Deer, the Elaphure,
Lived in the tule marshes of the Yellow River
Two thousand years ago — and lost its home
 to rice —
The forests of Lo-yang were logged and
 all the silt &
Sand flowed down, and gone, by 1200 AD —

Wild Geese hatched out in Siberia
 head south over basins of the Yang,
 the Huang,
 what we call "China"

On flyways they have used a million years.
Ah China, where are the tigers, the wild boars,
 the monkeys,
 like the snows of yesteryear
Gone in a mist, a flash, and the dry hard ground
Is parking space for fifty thousand trucks.
IS man most precious of all things?
— then let us love him, and his brothers, all those
Fading living beings —

North America, Turtle Island, taken by invaders
 who wage war around the world.
May ants, may abalone, otters, wolves and elk
Rise! and pull away their giving
 from the robot nations.

Solidarity. The People.
Standing Tree People!
Flying Bird People!
Swimming Sea People!
Four-legged, two-legged, people!

How can the head-heavy power-hungry
 politic scientist
Government two-world Capitalist-Imperialist
Third-world Communist paper-shuffling male
 non-farmer jet-set bureaucrats
Speak for the green of the leaf? Speak for the
 soil?

(Ah Margaret Mead . . . do you sometimes
 dream of Samoa?)

The robots argue how to parcel out our Mother
 Earth
To last a little longer
 like vultures flapping
Belching, gurgling,
 near a dying Doe.
"In yonder field a slain knight lies —
We'll fly to him and eat his eyes
 with a down
 derry derry derry down down."

An Owl winks in the shadow
A lizard lifts on tiptoe
 breathing hard

The whales turn and glisten
 plunge and
Sound, and rise again
Flowing like breathing planets

In the sparkling whorls

Of living light.

ALLEN GINSBERG

from *Have You Seen This Movie?*

Help! Hurrah! What's Going on here? Samsara? Illusion?
 Reality?
What're all these trailers row'd up hillside, more people?
 How can Lyca sleep?
Cows on Canandaigua fields lactate into rubber stainless steel
 plastic milkhouse machinery vats ashine —
Revolutionary Suicide! Driving on Persian gasoline?
Kill Whale & ocean? Oh one American myself shits 1000 times
 more Chemical waste into freshwater & seas than any single
 Chinaman!
America Suicide Cure World Cancer! Myself included
 dependent on Chemicals, wheels, dollars.
metal Coke Cans Liquid propane batteries marijuana lettuce
 avocados cigarettes plastic pens & milkbottles — electric
in N.Y.C. heavy habit, cut airconditioners isolation from street
 nightmare smog heat study decentralized Power sources 10
 years
not atomic thermopollutive monolith. Om. How many species
 poisoned biocided from Earth realms?
O bald Eagle & Blue Whale with giant piteous Cat Squeak — Oh
 Wailing whale ululating underocean's sonic roar of Despair!
Sing thy Kingdom to Language deaf America! Scream thy black
 Cry thru Radio elecric Aether —
Scream in Death America! Or did Captain Ahab not scream
 Curses as he hurled harpoon
into the body of the mother, great White Whale Nature
 Herself,
thrashing in intelligent agony innocent vast in the oil-can sick
 waters?

MIROSLAV HOLUB

Whaling

There's a shortage of whales in some cities.
And yet, the whaling fleet cruises the streets.
A huge fleet in such a small town!
Or at least a harpoon creeps
from one sidewalk to the other,
and searches.
And finds.
The house is pierced and in tiny jerks
a weird creature quivers.
Tiny bits of blood soak into the wall.

And that is the Old Testament incident,
the elementary dream,
the essential event,
to be pierced and dragged away
between textbooks and copybooks,
between algae and halibut,
between mummy's cups and pictures,
between seaweed and cat's-paws,
between slippers and webs in the corner,
between the Morning Star and the Evening Star,
to be pierced and dragged to eternity,
in the stifling inner bellowing of the blood,
wanting to remain and with convulsing claws
clutching the water drop on the tap,
reflections in the window pane,
the first baby hairs
and fins.

But there is nothing but waves, waves, waves
and undoing
on that nameless other shore,
with nothing good or bad,
just the arcuation of bones,
the scraping of plaster under which
 come to light
still older and older medieval frescos,
sloughing of skins under which stands out
the sliminess of the fetus just conceived.

And the maledictory unisono of pipes is heard,
the music of whalers,
the fugue towering over one place
as an obelisk of the last breath
behind the curtains.

Nobody ever wrote
Antigone of whales, Electra of whales,
Hamlet of whales, Godot of whales,
Snow White of whales, not even
one flew over the whale's nest,

although the whale as such
is a sort of metaphor.

Metaphors die out
in a situation which is a metaphor.
And whales die out
in a situation which is a killer whale.

Translated from the Czech by Dana Hábova

GAVIN EWART

The Whales Have a Word for It

We are happy
blowing great chunks out of our brothers,
making a Northern Ireland of the ocean.
Are we happy?
exploding the guts of warm-blooded creatures,
cherishing the terrorist harpoons?

Man to man is a wolf,
they say, but there never was
a wolf like man —
the only creature that uses torture,
that kills for vengeance or for luxury,
not from necessity.

Belsen or Belfast.
In the language of whales
have they even found a word for it?
By now, they must have.

HANS JEWINSKI

Hell's Gates are Closed

they celebrate christmas
in the lee of an iceberg

we are the grax
smelling to high heaven

one day of peace for the whales
one day a season

we are the grax
clinging to their boots

the machines have stopped
and hell's gates are closed

we are the grax
under their fingernails

we are the grax
we do not stop
we do not celebrate
we fester in their wounds
we make them smell a different world

no accident could have produced
so much ugliness

we are the grax

they hide behind an iceberg
celebrating christmas

Dolphin lamp, cast in bronze,
probably in the Mediterranean; late
Roman or early Byzantine, ca 400-500
A.D. *Courtesy of Dr. Leo Mildenberg*

They Are Another Nation

They are not brethren; they are not underlings; they are other nations, caught with ourselves in the net of life and time, fellow prisoners of the splendor and travail of the earth.
HENRY BESTON, The Outermost House

As one grows old, there is no longer the time to seek solutions. It is enough to see with startling clarity the two strong channels, as unyielding as altitude or distance, that encircle the life of western man. Their total presence demands that he give a sign, both through his way of living and by the words he speaks, in which current he believes his hopes will be allowed the space to survive. He can choose between the channel of thundering trucks, of rigs as tall as condominiums, with the voices and klaxons of the men at the wheels in the top stories blaring out for help, and the other: a wide belt of salt water encompassing the freeway-desecrated land. The first is a current of furiously speeding cars, that pour, cheek by jowl, blinder than bats, over the slaughtered bodies of trees, over macadamized meadows, throttled creeks, for God knows what purpose, to God knows what end. This is the shallow current of the two, no deeper than a layer of asphalt and a coating of tar, but deadly in its momentum. The other is an avenue crowded with unhurried life, its intricate valleys lying in darkness three thousand feet below.

The surface of this current may be silent, but beneath the hush of its swells it is never without sound. The relentless rhythm of truck tires is not heard in its constant motion, or the screaming of brakes, or the explosion of painted tin colliding with painted tin. As one biologist describes it, "it is the snapping of and creaking of tiny shrimps and crablike organisms, the grunting and grating, puffing and booming, of a hundred fishes, the eerie whine and squealing of dolphins," and the "chatter" of the whale and those of his kind which is heard.[1] From the moment of a whale's birth, it is said, "it hears the endless orchestra of life around its massive form."[2]

This orchestra of life may soon be silenced, for the official estimate is that the harvest of ocean fish each year is over sixty million tons. Wolf Vishniac of the University of Rochester and Lamont Cole of Cornell believe we are fast approaching the limits of the sea. When they were asked if the wide, deep channel of salt water might one day be without life, if the outlook was gloomy, the answer was: "Hell, no, it's hopeless."

II

He said he was sure he was becoming an alcoholic since Myrtle died. Even if he was only fifty-five, he said his life was through. The sagging flesh of his cheeks, yellowed by the counterfeit gold of drink, hung like camel humps over the open collar of his fine linen shirt and quivered with anguish as he spoke. He said linen was the best thing to wear in Florida, because it let the air in. "Myrtle always said that," he whispered, and he filled his glass again from the frosted shaker. When he stirred in the imitation-leopardskin-covered chaise longue, the strands of his carefully combed hair slipped sideways on his naked skull. "I'm afraid I may be becoming an alcoholic," he said quite piteously. "A year this month, and I haven't been able to do anything, winter or summer, but just sit here on the patio thinking about her, just making it at night from bed to the john."

The cacti bearing witness to this (all in need of a shave) put their hands over their mouths and snickered. They stood there on the dividing line between shadow and sun, as flourishing as the tall bamboo trees at the entrance to the driveway, while he lay prone before them, as if on an operating table. He was saying he had no interest in anything at all, while far, far away, as far as life is from death, eight young porpoises twisted and turned in the tuna-fishermen's net, still not believing in the final sentence that had been passed on them.

"Myrtle was an alcoholic," the man was saying across the stagnant air, and his hand reaching for the shaker was the color and shape of an ancient toad. "This is the road I have to take to follow where she's gone." He was deaf to the sound of anything but the dreariness of his own voice saying that he had a slipped disc, but he wasn't going to let the butchers cut him up the way they wanted to, not him, not by a long shot.

The porpoises were no longer able to tell jokes to one another, nor did the violins and cellos of their music ride softly in the waves. They could no longer leap from the current in showers of diamond spray, for while the man was speaking, these witty creatures of the sea had drowned in the meshes of nylon web.

III

It is said that the world of beautiful people is also shrinking. Yet no cloud of doom or gloom could be seen hanging over the fifth annual candle-lit banquet, afloat with champagne, which honored those chosen as the twenty most elegant women and men of 1980. True, Mrs. Ronald Reagan, heralded as one of the best-dressed women of the year, was unable to attend because of her appointments with various decorators engaged to refurbish the White House; and Soraya, the former Iranian empress, also a winner of the coveted award, was smilingly noncommittal when asked about the fifty-two American hostages. But the overall mood was one of high spirits, and no hint was given by the French and Italian *haute couture* fashion designers' association, which hosted the gala occasion, that celebrities such as Countess Jacqueline de Ribes and Paris nightclub proprietor Régine (both 1980 award winners) might be in any sense an endangered species. The court beauty, Marquise Marie de Sévigné, was there in spirit at least in the luxurious eighteenth-century setting of what had once been her private mansion.

Consider the blue whale, 1700 of which are said to survive today, representing one sixth of its original population. It cruises through all the oceans, yet its lonely search may never lead to an encounter with one of its own kind.[3] (A doctor who worked with the British whaling

fleet reported that in one extreme case he witnessed "five hours and nine harpoons were required to kill a female blue whale in advanced pregnancy.")[4] The pilot whale, a large black dolphin which no international covenants protect, is mass-slaughtered for pet food and oil by Arctic and Antarctic whalers.[5] The Greenland right whale has been so ruthlessly hunted that only a small number is still to be found in the seas surrounding the North Pole. The fin whale, shy and solitary, is close to extinction because of the relentless massacre by Russian and Japanese whalers. The gray whale, found only in the Pacific, and once nearly extinct, has been saved by rigid hunting laws. The humpback whale sings long, complicated songs to keep in touch with its kind during migrations, but its kind has been reduced to only a few survivors. The sperm whale – Melville's whale – valued by a $150,000,000-a-year industry is high on the vanishing species list.[6] The minke is an exceptionally sociable whale, devoted to family life, and in times of crisis hastens selflessly to the aid of others of its kind. In moments of play, it leaps clear of the waters of the North and South Poles, and hangs suspended, thirty feet of agility and humor in the icy clarity of the air. The number of minke whales is fast being depleted, for thousands upon thousands of tons of sperm and minke meat are consumed each year by the Japanese and Scandinavians.

The orca whale has been named the "killer whale" by the most merciless killer on land or sea. The orca is large for a dolphin, but small in comparison with a sixteen-ton full-grown sperm whale, yet it is known to go deeper in its soundings than far mightier whales. True, the orca is singular among cetaceans in its taste for the blood of sea-lions, seals, and other warm-blooded creatures of the ice floes and seas. But the tone of a report filed by the greatest killer on planet Earth, and published in the *Naval Aviation News* of December 1956, is one of blood-thirsty exultation. "Another successful mission against killer whales off the coast," it reads, "…destroys hundreds of killer whales with machine guns, rockets, and depth charges." Despite the ambiguous wording of this sentence, it is not the whales which are armed with machine guns, rockets, and depth charges, but gently bred men in the uniform of a humane country.

There are countless other reports of killings at sea. One such incident describes a tuna-fishing boat on which its owner had mounted a cannon so that, in the four months of the year when sardines and tuna do not run, the boat could be used as a whaler.[7] It had been estimated that in one short season the catch of tons of whale meat, to be processed into dog

ROBERT STANLEY
"Steam" (detail), 1980
oil on canvas, 2.13 x 2.28 m

171

food, would net a fortune to the owner. On the first voyage out, the second bomb from the cannon mounted on the deck exploded deep in the muscles of a sperm whale, three feet above the heart, and the breath of the whale became a pink foam on the surface of the water. The broad, dark head, with its strangely human eye, sank in the surrounding swell, and the whale became one of the more than thirty thousand chronicled dead in a hundred and sixty years of slaughter.[8]

The end of this story is one of blood and lymph which would interest only a butcher, so the record goes. The manager of the operation was astonished by the massive size of the sperm whale's guts, and he instructed a workman to wind them back and forth around two distantly spaced poles, stretching them taut, and then measure their total length. It came to 1700 feet. The manager was dubious about the figure until he verified it for himself. Years later he read a book on whales, but could find no answer to the mystery of this biological fact. But he did learn that in Japan whale intestines are eaten as a delicacy in honor of the new year. The guts of this endangered species lend elegance, decade after decade, to an occasion as gala as the one in Paris which Mrs. Reagan, best-dressed though she was, was unable to attend.[9]

IV

Poor third-quarter results of the worldwide soft-drink market are not for a moment an indication of what lies ahead for the soft-drink industry, said Gerald Earnest, president of Apple-Peel, Inc., in an address to a Rotary Club luncheon this week. Mr. Earnest went on to explain that the sixteen per cent drop in third-quarter earnings was due to bad weather and other unusual disturbances in foreign countries. In Japan, for instance, he pointed out, the unseasonably cold weather during the summer months had cut into Apple-Peel's earnings. But despite this down-turn, Mr. Earnest continued, the company showed a twenty-two per cent return on stockholders'

equity. "Soft drinks are second only to water as the most popular beverage," he said, "and, according to *The New York Times*, soft drinks will soon overtake water."

Mr. Earnest told the exceptionally large and receptive audience that his company plans to expand its around-the-world markets, and that, as part of this ongoing international campaign, it has produced a Thai version of Apple-Peel's familiar American TV commercial, to be distributed in 1981 in Thailand, and eventually in Laos and Vietnam. The successful U.S. commercial has also been dubbed into Spanish, and will be telecast in Mexico. Future plans include special productions for Finland and Norway. Mr. Earnest also pointed out that the average American consumes thirty-nine gallons of soft drinks in a year, and his company hopes to expand the domestic market so that forty-five gallons will be consumed by the end of this year. Those present at the luncheon gave Mr. Earnest a standing ovation when he concluded his speech with the prediction that domestic sales of Apple-Peel in 1982 should provide fifty per cent of the company's profits instead of the current thirty-five per cent. "This will greatly enhance the public image of our country around the world," he said.

Far, far from the site of the Rotary Club lunch and the applauding men, two deaths were taking place. A young sperm whale, mortally wounded, sent out a shuddering cry of anguish, and her companions hastened to her side as she thrashed in her death throes. They defecated in compassion for her, and put their sleek shoulders under her body in a futile effort to keep her head above the surface of the pulsing sea. And far from the television screen on which Apple-Seed's well-known advertisement was being shown, a mother whale reared from the water before a whaling ship. Her dying calf was held in her open jaws, and the blood from the harpoon embedded deep in the infant whale's flesh stained red the wide channel of their lives.

3 Lowell Herrero, 1981 calendar *Whales and Friends*

4 Victor B. Scheffer, *The Year of The Whale*, N.Y. 1969

5 Lowell Herrero, 1981 calendar *Whales and Friends*

6 *idem*

7 Victor B. Scheffer, *The Year of the Whale*, N.Y. 1969

8 *idem*

9 Paraphrased from a small-town newspaper

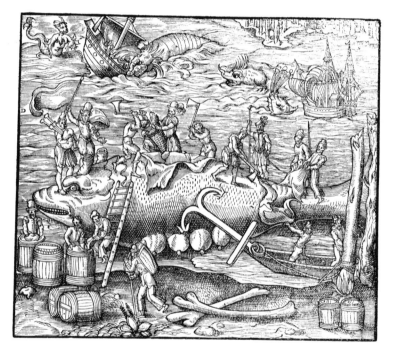

Illustration from "Opera Ambrosii Parei" by AMBROISE PARÉ *(Paris, 1582). Courtesy of the Thomas Fisher Rare Book Library, Toronto*

1 Victor B. Scheffer, *The Year of the Whale*, N.Y. 1969

2 *idem*

JAMES KIRKUP

The Whale's Way

There is a creature of the high seas
whose blood is warm as ours,
whose love of family and friends
is great as ours, indeed far greater.

This creature lives in social herds
whose lives are governed by
the tides of feeding, copulating, breeding.
They summer in Antarctic
and in Arctic waters, and in autumn,
season of grand migrations,
depart for warmer waters, there
to breed and calve.

Some of these creatures
form faithful pairs,
others keep harems.
Elaborate their courtship rituals —
rolling over one another,
sporting head to tail, fin to fin,
gently stroking and nuzzling,
suddenly shooting vertically from the depths
in an instant's ecstatic union, airy bliss.

The mother carries her baby for about
 twelve months
but she can bear a child
only once every two or three years,
and then only a single calf,
a miraculous offspring that can swim
 at birth.

The cows keep their young beside them,
feeding them milk that is rich in fats.
Even when fully grown
the offspring keep returning to their mothers
in times of sorrow and distress,
so close is their relationship.
So close, indeed, that the mother
will refuse to abandon a dying calf,
 as whalers
well know. A mother tending her ailing one
is easy prey for hunters and harpoons.

How loyal they are to one another!
(How unlike men in this respect.)
For members of the herd

will gather round an injured or an ailing
 member
and tenderly, repeatedly
lift him to the surface of the waves
 to breathe.
Or they may bite through the harpoon lines
embedded with their ravenous hooks
in a stricken comrade's flesh.

And if, to avoid drowning, one grievously
 sick or hopelessly mutilated
prefers to cast its precious life away
 upon a beach,
the whole herd will follow,
beach themselves beside their lost companion
and die devotedly beside him.
 — Man has no greater love than this.

Such is the loving, loyal creature
that men now hunt to death and to extinction
for ignoble ends, for pelf and profit.

May the spirit that once moved upon
 the waters
speak to these men, and give them
 consciousness
of shame, for all the murderous deeds
 they do!

HUGO DITTBERNER

O Sleeping Hair of Humanity

O sleeping hair of humanity, dreams,
do not forget the whales which are worth whole villages.
Butchered in thousands, in a cool
moment of ballistics, their places are empty.

Gods on the Orinoco, once on the Yangtze were worshipped,
symbols for what? Superlatives of the old created
world improved by hand, emaciated to skeletons
in state-supported museums — and could still be alive.

The art of their voices, this exultation, unending
chirping and sound of bells, has fallen silent
in the waters; no harbinger is borne here playfully
by them, happiness drawing joyfully near.

O hair of the sleepers, dream-visions without desire,
do not forget the great bodies, artists in swimming,
carefree surplus over human volume, high-
rolling mammals, the homeless cosmopolitans.

Translated from the German by Michael Butler

*Illustration from ''L'Histoire
Naturelle des Estranges Poissons
Marins'' by* PIERRE BELON *(Paris,
1551)*

*Belon was the first naturalist
to attempt a scientific description of
dolphins. Here, he drew what he
believed was a killer whale or orca
with a stillborn calf. Courtesy of the
Thomas Fisher Rare Book Library,
Toronto*

JOHN UNTERECKER

Dolphin

6 A.M.

The net eases, swaying into the sea,
a drift of loose cords, mouths opening
into blue hunger. Its memory of hands
sinks through schools of desire. (*Not yet.*
Now. *Not yet.* Now.) Lead facts
tug, a taste of suspended hands
flicking beneath the hull. A taste of hands shapes
into the gauze funnel of a sigh.

9 A.M.

Gliding, he rides wave crests' clashing,
a torpedo summer crashing
porcelain lace, turns shoreward, driving.
They shatter to mercury splinters, flashing
under the black thrust of his snout, diving.

He circles the ghost shroud that guards them.
A memory brushes his mouth. He is god, huge
in the shallows, baffled by ghost cords.
They shuttle in death harbor, gloved fears.
He puzzles a taste of wavering hands.

3 P.M.

How many hours prodding his goad snout into the yielding seine,
testing, circling a dream shroud, before its invitation mouth
flaps open to the black mouth driven in, the net
like a lace skin caught on his shoulders, sealing behind trapped tail?
A tussle of frenzy netted within the net, a roil
of thrashing darkness that changes the bright catch,
he becomes sea — starved, insatiable: mouth.
Teeth tear at fish, net, floats, though snarled cords weave pain.

6 P.M., 7 P.M., 8 P.M.

Drowned, he hung in the bruised sea, his catch of nets
 ripped like torn sleeves. He is strange on the beach.
"He ate all of the fish. Then he ate at the nets."
 Now he is netted by flies.
"He was so bad, we have a week mending." Nets tore; floats tore loose in his dying.
 In one stroke, an axe severs his tail.
"I never knew a fish like this one. My arms are sore from the dragging."
 When the head falls free,
a great tide of blood changes the sunlight.
 Four men drag the carcass to the truck.
"We sell him. He owes for the holes in the nets."
 Memory smears on the sea:
minnows flash in dark stains; something vanishes, as if dodging a question.
 The discarded tail and the worthless head
are not part of any dolphin now.
 The stiff tail, huge,
is an emblem on strange sand. (The nets have been dragged off, spread on rocks.)
 "He was proud, that one, though."
The sun is already behind the mountains. The black head is dry.
 It is black suede. Its eyes
stare away from the deserted sea, away from the nets, the empty beach — toward mountains.

Lamp with dolphins and sea-
monster; Roman, 50-0 B.C.
Courtesy of Yale University Art
Gallery, gift of Rebecca Darlington
Stoddard

GREG GATENBY

For Erica

The colour of old coins, lieutenants of the sea,
feral and ballistic, the dolphins arc gracefully,
then tamed and captive, startle with a vaulter's soar,
hint at mind, the thallasic genius Roman lore
and Greek sagely praised. An aural world we blindly

mud with sapient arrogance, born of a pre-
Darwinian chain of being become shackle. The
suburban thrill, the greed of aquaria for
the colour of old coins

and the grey bright of new demean the industry
and strength, more fluke than chance, of such nobility.
Where are the humans that will talk with them? Souls more
caught with their complex brain than monied albacore,
with that ancient reverence in change harmony
and the colour of old coins.

JENNY JOSEPH

Thinking of the Whales

I suppose they would've shot the moon down,
If they could have, into little pieces,
To make a new one
Even while saying isn't it strange, isn't it beautiful.

Come, I will show you a marvel / Of man.

There on the green
A huge contraption in a palisade.
"You have here a perfect replica of a whale.
Every branch of knowledge known to man
(You name it, we got it) has gone into this project
To bring you the fabulous wonders of the deep."

Yes, here's a panel
That tells you who gave grants for what to whom
And who the electrician was, and which boroughs
Raised a penny rate to send the team
To find the stuff to make the eyes — etcetera.
"Ask him not to touch, lady, would you mind?
Just to look at, son, so you know what they looked like —
We need a grant for a pool — more life-like, you see.
Three thousand the pool, and another two thou to get it
Buoyant, so it would *move*. Then, there's maintenance."

Far in perpetual waters a creature turned
Coasted and turned in perfect machinations
Moving, like clouds at the edge of the world, untended
Simply itself in its extraordinary being:
Easy, so easy moving through the water.

Stupid men. All you had to do
To get a whale, was not to spend one penny, not do anything
But let be what miraculously was there.

No one on earth can make a whale again.
And when, because of what you have made way for
The rats over-run us, think of the mild wonders
We could have let keep the world:
Unclever, not like us, yet much more skilful
And useful, alas, in all their parts to man.

But being no use would probably not have saved you:
That strange shining disc that lights you to your extinction
Far over your dark pathways,
And even whatever caused the moon's pull, the life of waters
To maintain the whale —
They would put it in their pocket if they could.

VAGN LUNDBYE

Song of Creation

In the same third state as Jonah
Before the Mene Tekel
Was left near Nineveh
The humpback whale is
 swimming
Neither awake nor sleeping
Dead or alive
In a circle with one eye closed

Taking in Heavens and Earth
She enters into the last forests
The half-life of plutonium
And the thirty seconds
 it takes
To flense the skin
From a whimpering baby seal

Deep in the maternal womb
The humpback whale begins to
 sing
A song without mankind

Divine tones
That without regret
Praise the very forces
 of Nature.

left

*Illumination from a 13th c. English
bestiary (MS Harl. 3244, fol 61),
ironically detailing the illuminator's
difficulties in depicting the whale.
Courtesy of the Trustees of the British
Museum*

175

OPPIAN

from *Halieutica*

The hunting of Dolphins is immoral and that man can no more draw nigh the gods as a welcome sacrificer nor touch their altars with clean hands but pollutes those who share the same roof with him, whoso willingly devises destruction for Dolphins. For equally with human slaughter the gods abhor the deathly doom of the monarchs of the deep; for like thoughts with men have the attendants of the god of the booming sea: wherefore also they practise love of their offspring and are very friendly one to another.

Translated from the Greek by A.W. Mair

Dolphin carved from rock crystal, probably North African, supposedly found in a well in Carthage; early Christian, 3rd-4th c. Courtesy of the Metropolitan Museum of Art, New York, bequest of Mrs. William Moore

JÖRG STEINER

Ando and the Dolphin *For Jörg Müller*

In my whole lifetime I have seen a whale only twice. The first time, the whale was carried by train from town to town, from city to city, handbills were circulated in the schools, and when we too made our way to the Güterhof Station a friendly gentleman, who knew everything there was to know concerning the scientific aspects of whale life, lectured us. His finger raised, he informed us that the whale was not to be called a "whale fish". Since it was a mammal with lungs it must be called just a "whale". He then cited families and their names: toothed whale, sperm, whalebone, blue, fin, etc.

Instead of chopping off his finger we wrote the names down in preparation for the next school examination. We were passing into a higher grade; even before their curiosity has been aroused and become uncomfortable, students in a higher grade must be prepared to take examinations.

No, the whale hunt did not come under discussion. No matter what your position on the subject of school examinations, the capture of whales is not an examination category. Not a word of grenade harpoons, whale-catcher fleets, radar, ultrasonic vibrations. Only that on the large factory ships with pressure-cooking facilities, the stench was unbearable, and that a 70,000-kilo whale yielded 24,000 kilos of blubber and 6,000 kilos of whalebone, to which amber, musk, and oil must be added. The question we had to answer was: accordingly, how much blubber did a 50,000 kilo animal deliver; because even if we ourselves were not going to be whale hunters, we had to understand the practical nature of this career.

Later, we read something in our texts about whale hunters, what brave men they were, that even with the best planning inherent dangers could not be avoided, and that the dolphin too was a small whale capable of great harm.

All this came back to me when my daughter, who has been attending school for two years now, came home to tell us, "At the Güter Station a train has arrived with a whale in it. Our teacher is taking us tomorrow but I want to see it today. You know what? He's swallowed a whole man."

It wasn't the same whale any longer. This one was larger, in better condition, and travelling in a far more modern railroad car.

My daughter stared at him just as we did at that time, and

that's how it came about that that evening I told her the story of the Japanese fisherman Ando, although not the whole story. One must take into account that children understand something about whales, children and whaling men, and because you may possibly wish to hear the story, I shall tell it once again here just as I told it to my daughter.

Ando lived in Japan, beneath smoking, fire-eating, and extinct volcanoes. In that land, rice, tea, and cotton grow, silkworms spin silk and the sea teems with fish. There Ando, along with the other fishermen, rode out to sea, laid out his nets, pulled them in again, and returned to port. And Ando also complained to the government about the dolphins that tore his nets in order to get to the fish which they needed to live, just as the fishermen did. The government promised to give the matter some thought. They sent a man to the fishermen who wrote down what the latter reported. He travelled from port to port and when he returned to the capital placed his report before the proper authorities. The authorities thought a long time about the problem without coming to a solution, and so they put the report into a drawer along with all the other reports for which the government had no solution. This drawer exists in all the countries of the world.

When the fishermen realized they would not get any help from the government they decided to help themselves.

They said, "There are too many dolphins. They eat our fish and leave very little behind for us. So there is only one thing to do: we must chase the dolphins away."

But that was easier said than done. The dolphins would not be chased away. They leaped high over the boats, and the closer the boats came and the madder the fishermen got, the more mischievous the dolphins grew.

The next morning when the fishermen rode out to sea the dolphins were again waiting for them; but where yesterday a hundred had played there were now thousands.

"And then? What happened then?" my daughter asked when she noticed I did not know how to go on.

"It's not true that dolphins have green blood," I said. "The story could be told another way. Dolphins are red-blooded. They're killed, with guns it happens; the dead animals are heaped on the shore, or they're chopped up and ground into meal which is fed to pigs.

"If we want the killing to end, perhaps we have to talk about the way things are going in the world today: that everyone wants more and more, more money, a larger house, what do I know; bloody tales in any case, stories of animals wiped out, of hungry, disturbed, destroyed people."

"But Ando!" My daughter hit the table with her small fists. "Ando did not kill the dolphins."

"No," I said, "not Ando. Ando stood up in his boat when the others brought forth their guns."

"Stop!" he cried but the shots rang out all around, the sound not so much loud as gay and chipper, as at a rifle range where nobody reflects too much. And because there were so many dolphins hurrying this way and that in the foaming red water, the fishermen found their aim difficult. That's how it happened that a bullet hit Ando in the back and he fell overboard into the water. The others rushed to save him but they came too late. Ando had disappeared in the waves. The fishermen deliberated for a long time before riding back to port, heavy-hearted and sad.

When they arrived at the port, the children, who used to play at the water's edge, told them what had happened. A dolphin had taken Ando onto its back, carried him back to shore, and then immediately swum back to sea. Tracks of blood were left behind, whether Ando-blood or dolphin-blood who could say?

"But he was saved?" my daughter asked.

"Ando, yes," I said.

"And the dolphins," she said. "The dolphins were saved too."

I turned away and said, "After a story like that, who would have the heart to doubt it?"

Translated from the German by Agnes Stein

Illustration by PIERRE BELON *from "L'Histoire Naturelle des Estranges Poissons Marins" (Paris, 1551)*

When I visited with the porpoises
I felt awkward, my hairy
angular body sprouting its skinny
grasping limbs like long mistakes.
The child of gravity and want I sank
in the salt wave clattering with gadgets,
appendages. Millenia past
they turned and fled back to the womb.
There they feel no fatigue but slip
through the water caressed and buoyed up.
Never do they sleep but their huge brains
hold life always turning it like a pebble
under the tongue, and lacking practice, death
comes as an astonishment.

In the wide murmur of the sea they fear
little. Together they ram the shark.
Food swims flashing in schools.
Hunger is only a teasing, endured
no longer than desired. Weather
is superficial decoration; they rise
to salute the thunder, romping their tails.

They ride through pleasure and plenty
secure in a vast courtesy
firm enough to sustain a drowning man.
Nothing is said bluntly.
All conversation is a singing.
Every exchange comes as an aria,
lyric, set piece, recitativo,
and even a cry for help is couched
in a form brief and terse,
strict as haiku.

Greed has no meaning when no one
is hungry. Thus they swim toward
us with broad grins and are slaughtered
by the factory ships
that harvest the tuna like wheat.

Happy captive
The dolphin bobbing
Glimpses the love
Of the sea and the sky

Towards death's horizon
A desperate ship set sail
Loving dolphins raced us

A dolphin
Heard the call of the pebbles
Now along the shore
He is basking in love and light

If the frenzied dolphin
Dies of love
The desolate sea
Will long for the sky

A harpoon
Is aimed at a dolphin
All the coral reefs
Shiver

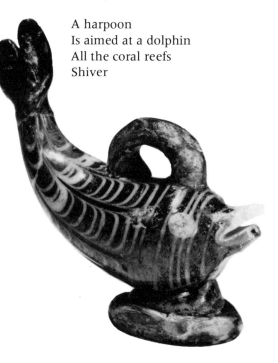

Islamic glass dolphin, provenance unknown; 7th to 9th c. A.D. *This is the earliest known depiction of a cetacean in Islamic art. Courtesy of Sotheby Parke Bernet, New York*

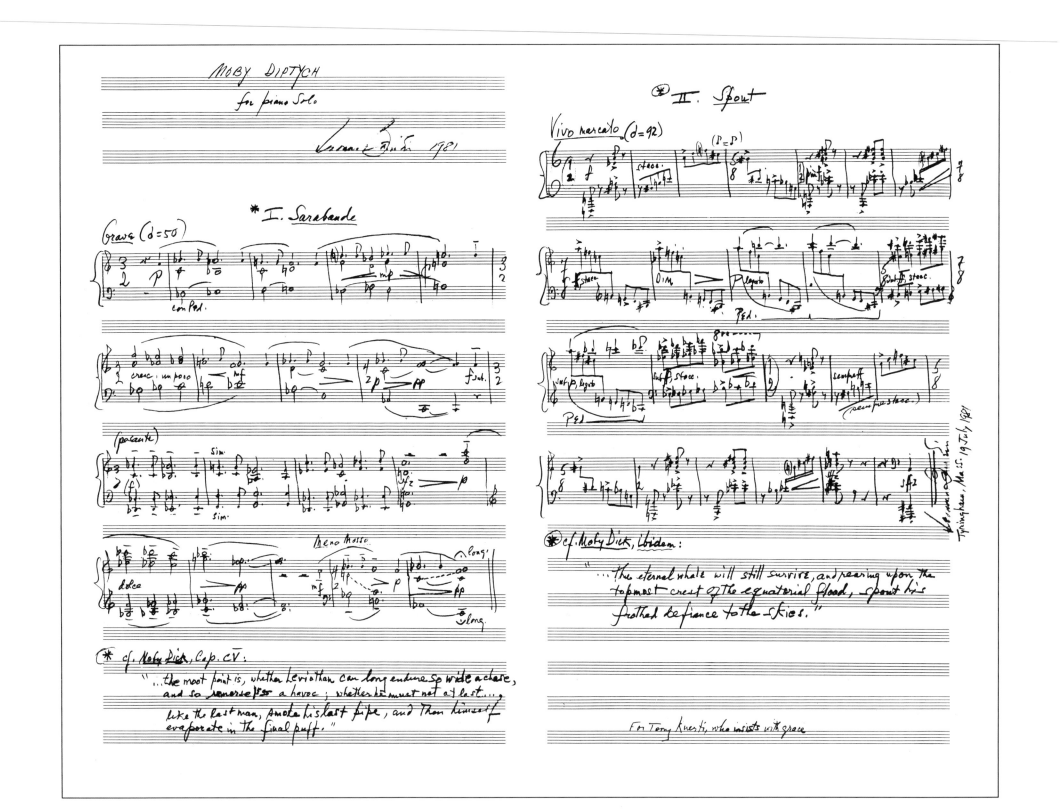

Whales

Huge floating tribes
 migrations
icebergs of flesh and bone
 melancholy islands

Through the sad night of the depths
 there rings
their elegy and farewell
 for the ocean
has been despoiled of whales

Survivors from another world's ending
 they took on the form of fish
without becoming fish

Surface they must to breathe
 cloaked in millenary algae
and then
 strikes the barbarity
of the explosive harpoon

And all the sea becomes
 a sea of blood
while they carry them off to the meat cutter
 to be made into lipstick
soap oil
 dogfood

His eyes are like the eyelids of the morning.
Out of his mouth go burning lamps, and sparks of
 fire leap out.
Out of his nostrils goeth smoke, as out of a seething
 pot or caldron.
His breath kindleth coals, and a flame goeth out of
 his mouth.
In his neck remaineth strength,
and sorrow is turned into joy before him.
(JOB, 41)

Translated from the Spanish by Margaret Cullen

KARL GERSTNER
''Captain Ahab the Other Way
Round'' 1980
26 x 70 cm

''I wanted to visualize one of the
chapters – about the colour 'white'
– of Melville's 'Moby Dick'. The
novel deals with whales, not quite
with their saving, but with their
killing. And yet, I think: that there
is nothing to be compared between
the passion of Captain Ahab and the
situation of today. And today's Ahab
is the one who fights against the
whale's white catchers. And maybe
someone will write the novel anew –
adjusted to the new circumstances?''

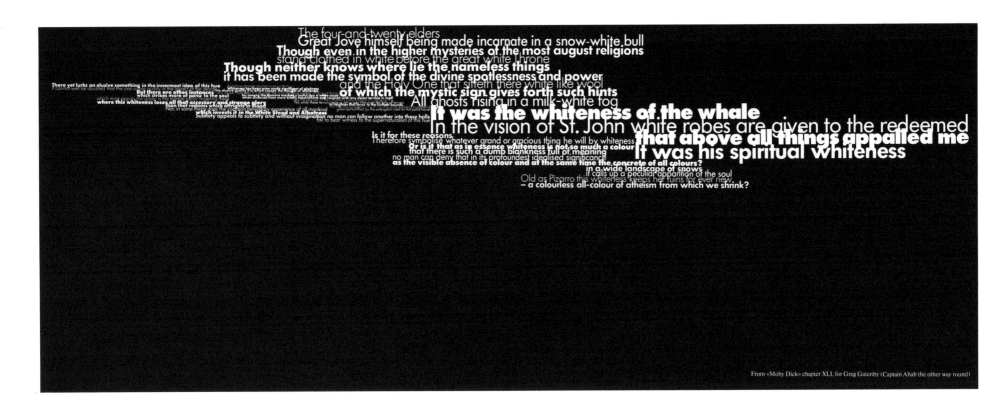

From «Moby Dick» chapter XLI, for Greg Gatenby (Captain Ahab the other way round)

from *The Dream Book*

Cemetery of Whales

Dreamt of
 Moby Dick the Great White Whale
 cruising about
 with a flag flying
 with an inscription on it
''I Am what is left of Wild Nature''
And Ahab pursuing in a jet boat with a ray gun
 and jet harpoons and super depth charges
 and napalm flamethrowers and electric
underwater vibrators and the whole gory
 glorious efficient military-political-
 industrial-scientific tech-
 nology of the great-
 est civilization the
 earth has ever
 known
 devoted to
 the absolute extinction and
death of the natural world as we know it
And Captain Ahab Captain Death Captain Anti-Poetry
 Captain Dingbat No Face Captain Apocalypse
 at the helm
 of the killer ship of Death
 And the blue-eyed whales
 exhausted and running
 but still
 singing to each other....

Aboard the James Bay anti-whaling vessel, October 4, 1977

A cemetery of whales:
 in a snowy graveyard
instead of crosses
 their own bones stand.
They couldn't be gnawed by teeth;
 teeth are too soft.
They couldn't be used for soup;
 pots are too shallow.
The straining wind bends them,
 but they keep their position,
rooted in ice,
 arching like black rainbows.
Thirsty for a snort,
 an Eskimo hunchback,
shaped like a question mark,
 huddles in them as in parentheses.
Who playfully clicked a camera?
 Restrain your photophilia.
Let's leave the whales in peace,
 if only after death.
They lived, these whales,
 without offense to people,
in infantile simplicity,
 reveling in their own fountains,
while the crimson ball of the sun
 danced in a torrent of rays...
Thar she blows!
 Come on, lads, let's get 'em!
Where can we hide?
 But you're broader than space!
The world doesn't hold enough water
 for you to dive under.
You think you're God?
 A risky bit of impudence.

One harpoon, smack in the flank,
 rewards enormity.
Enormity commands everyone
 to hunt for it.
Whoever is big is stupid.
 Who's smaller is wiser.
Sardines, like vermicelli,
 are an impossible target,
lost in the generic —
 but greatness is helpless.
On board, binoculars tremble
 as the crew takes aim;
streaming harpoon in his side,
 huge Tolstoy runs from the Kodak.
A baby whale, not full-fledged,
 though evaluated as a whale,
Esenin flutters and kicks,
 hoisted high on a harpoon shaft.
The title of Whale is a bloody dignity.
 Greatness kills greatness.
Mayakovsky himself
 pounds in the lance.
The shallows are also a menace:
 dashed on the shoals by the chase,
Gorky hawks and disgorges
 fragments of steel and hickory.
Without even moaning,
 gliding along the path of blood,
Pasternak with a snatch of lime
 sinks into Lethe.
Hemingway is silent;
 but from his grave a threatening shaft
shoots out of the grass,
 growing up from the coffin.
And hidden behind the mob,
 murder in his eye,
the Dallas whaler
 with a telescopic sight.
A big drive is on;
 we cherish their names posthumously.
Your law is more honest,
 cruel Alaska.
In the cemetery of whales
 by the hummocks of ice
there are no sanctimonious flowers:
 the Eskimos have tact.
Hey, Eskimo hunchback,
 white men have a funny custom:

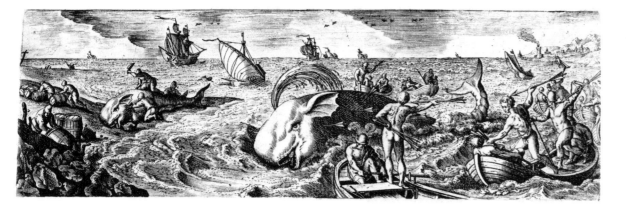

GEORGE MACBETH

The Whale

after planting the harpoon,
 they weep over the corpse.
Murderers mourn like maidens,
 and tearfully suck tranquilizers,
and parade in crêpe,
 and stand honor guard.
The professional hunters,
 who would look out of place,
send wreaths to the whales
 from the State Bureau of Harpoonery.
But the flowers are twisted together
 with steel cables and barbs.
Enough of such goodness!
 Let me live among Eskimos!

*Translated from the Russian by John Updike
with Albert C. Todd*

Illustration by ALEXANDER CALDER
*from ''Selected Fables of Jean de
La Fontaine'' (New York, 1957)*

far left
Engraving by THÉODORE DE BRY;
*ca 1602. One of the earliest depictions
of European shore whaling. Courtesy
of the Old Dartmouth Historical
Society Whaling Museum, New
Bedford, Massachusetts*

Three times they dragged its wounded body
Back to the water. It took a tarpaulin
And fifteen men to do it.
It wasn't any good: it gasped
One last time by the Boathouse Reach
And flopped on its back. They hauled it in

Dead to the shore: it lay in the mud
In front of that kiosk. They dug its grave
There and buried the headless body;
The head they took to be studied. Or so
A man said in the pub. I lean
On the bridge and stare at the swirling water

Pitching through the side arch below
My rubbered shoes towards the sea.
What made its sixteen feet of bone
And blubber thread the Port of London
Safely as far as this, then shrink
And sacrifice it on the mud

Of Kew Reach, God only knows.

RICHARD O'CONNELL

Almost an Allegory

Sometimes a lumbering whale gets rammed
By a swift ship that hardly feels the thud;
Or thinks to look back in its wake
For wreckage of a dumb brute churning blood.

Shocked into valiant life — but mortally hurt
By the blind death-blow riven in his side
Too deep — he struggles till his clogged heart
 bursts
A fountain, like an oilwell gushing dry.

Currents and winds will carry him to land
Sometimes still warm — tremendous on the sand;
And curious kids will come from miles around
To touch him and to worry at his wound.

GEOFFREY DUTTON

The Stranded Whales

for Maggie Matison

There were the whales, six of them,
 Stranded like panting mothers
On the amiable, deadly sand,
 And the word soon got around
In the deadly weekend town
 So the aniline Holdens and Datsuns
Disgorged all ages and sizes
 Thick as whitebait on the sand
Softly golden under the blueback whales.
 They ran up the sides of the gasping creatures
That had been three days dying already
 And had two more days to live.
They came armed with domestic weapons,
 Curved pruning saws, axes, kitchen knives,
Workshop hacksaws, some even with ladders,
 And these do-it-yourself amiable weekend people
Climbed up on the heaving whales and chopped out
 Bloody gussets of blubber and tossed them down to the kids
While the dying whales shook out slack spouts of bubbling breath.
 One lad with long blond hair, wobbling on a ladder,
Scooped out a whale's eye with a trowel
 And stuffed it down the front of his girlfriend's jeans,
While a leathery home carpenter of fifty,
 With separate hairs greased down across his skull,
Levered open the living jaws the size of his front door
 And with a hacksaw cut out a couple of teeth.
One man amiably fervid with patriotism
 Stuck a pole flying the Southern Cross
Straight down a whale's shuddering blowhole,
 And a lady teacher with a knowledge of biology
Succeeded at last in slicing, though slippery with blood,
 And giggly, a complete anterior fin,
Which will reveal, when cleaned down to the skeleton,
 An arm, a hand and five fingers, just like a human's.

At the end of the weekend, after five days,
 The whales were at last, though not moving,
Going from dying to dead.
 Only their blood had found the way back to the sea
Down the little ripply side channels

 Beyond the emerald shallows to stain the deep sapphire
Till the deadly hunters came after the treasure of blood,
 Beating the water into a pink froth of frustration.
The weekenders gouging their black mountains grew nervous,
 Slid down with their trophies and went off homewards.

181

Interface (III)

So the whales died, and putrefied, and quarrelling over their
carcasses
 The District Council said they had come from the sea
And thus were not a Council responsibility,
 While the Marine and Harbours Board said they had died
 on land
And thus were not a Marine and Harbours responsibility.

 No one wanted the whales at all.
Only the fire, when they were bulldozed into heaps
 And burnt, lovingly stayed with them
For as many days as they had taken to die.

Whales die of a sort of madness:
They choose their own beaching.
Watch them come in like liners
under deranged captains.

Try to turn such whales aside
back to deep waters –
obstinately, blindly, certainly
they'll find another beach.

Death is inside the whale,
some diseased directive,
some inner treachery,
some worm lodged in the brain.

Afterwards, the whole air
of the coast's tainted
with an enormity,
corruption's total takeover.

You cannot bury the whale
in the beach it chose.
No sand is deep enough.
Some king-tide will uncover it.

Men must come, wearing masks
against decay's contagion,
chop it into small portions,
bulldoze it into trucks.

Far off, please. Very far off
where the smell of death can't reach us.
It's a huge task
to do away with a whale.

Whales are great mammals
but no wiser than men.
Take the head, you scientists,
investigate its workings.

You may find, deep in there,
the secret of destruction,
the tiny burrowing worm,
the virus in the brain.

You may expound its reason,
but the whale's past cure.
It has finally rejected
the whale-road, the free seas.

If you mourn its choice, remember,
not only whales have made it.
Whole peoples, countries, nations
have died in the same way.
Galaxies may be strewn
with staring burned-out planets
which took that path.

But this is to mourn a whale –
only a whale.

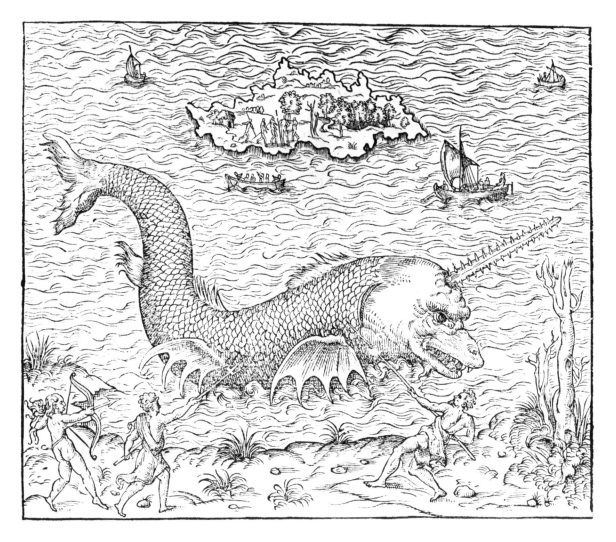

Whale

After an Incident in Lyall Watson's Gifts of Unknown Things

A whale lay cast up on the island's shore
 in the shallow water of the outgoing tide.
 He struggled to fill his lungs,
 he grew acquainted with weight.

And the people came and said, Kill it, it is food.
And the witch-doctor said, It is sacred, it must not be harmed.
And a girl came and with an empty coconut-shell
 scooped the seawater and let it run over the whale's blue bulk.

A small desperate eye showing white all round
 the dark iris. The great head flattened against
 sand as a face pressed against glass.

And a white man came and said, If all the people
 push we can float it off on the next tide.
And the witch-doctor said, It is taboo, it must not be touched.

And the people drifted away.
And the white man cursed and ran off to the next village for help.

And the girl stayed.
She stayed as the tide went out.
The whale's breath came in harsh spasms.
Its skin was darkening in the sun.
The girl got children to form a chain
of coconut-shells filled with fresh water
that she poured over his skin.

The whale's eye seemed calmer.

With the high tide the white man came back.
As the whale felt sea reach to his eye he reared
on fins and tail flukes, his spine arced
and he slapped it all down together, a great leap
into the same inert sand.
His eye rolled
in panic as again he lifted and crashed down,
 exhausted, and again lifted and crashed down,
 and again, and again.

The white man couldn't bear his agony and strode away,
 as the tide receded.
He paced and paced the island and cursed God.

Now the whale didn't move.
The girl stroked his head
and as the moon came up
she sang to him
of friends long dead and children grown and gone,
sang like a mother to the whale,

and sang of unrequited love.

And later in the night
 when his breaths had almost lost touch
 she leant her shoulder against his cheek

and told him stories, with many details,
of the mud-skipping fish that lived
 in the mangroves on the lagoon.

Her voice
and its coaxing pauses
was as if fins
were bearing him up to the surface of the ocean
to breathe and see,
as with a clot of blood falling on her brow
the whale passed clear from the body of his death.

*"Narwhal" (monodon monoceros)
from "Historia Animalium" by*
KONRAD GESNER

*far left
Illustration from "Opera Ambrosii
Parei" by* AMBROISE PARÉ *(Paris,
1582). Courtesy of the Thomas Fisher
Rare Book Library, Toronto.*

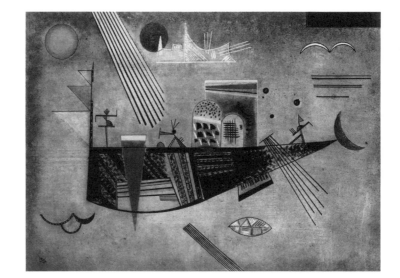

"Moody", by VASSILY KANDINSKY;
*1930. Oil on canvas. Courtesy of the
Martin Boymans Museum,
Rotterdam*

Der Wal

Auf dieser Erde wohnte manches Volk von Tieren.
Trat eins schon ab, dann hilft kein Zittern, hilft kein Flehen.
Starb jenes Volk durch Hitze, dieses durch Erfrieren?
Jetzt stirbt schon wieder eins im Abschuss-Handumdrehen!

Längst vor dem Menschen war die Welt umrahmt vom Wal;
er rettet Menschen, gleichfalls Säuger, auch gesellig.
Doch Zweibein-Ungeheuer, habgierkrank, brutal,
ermorden dieses Tiervolk! Widerstand ist fällig!

Das Volk der Wale existiert, damit es lebe!
Noch hält sein Ende sich dramatisch in der Schwebe!
Wer noch Gewissen hat, der macht den Zögerern Dampf!
Helft mit beim völkerweiten Anti-Tiermord-Kampf!

Words by Horst H. W. Muller

O E K E N Z A B U R O

from The Day When the Whales will be Extinct

I now realize that McVay, the tender-hearted poet from America, who brought us an international control plan for whale-fishing, had not come armoured as a rugged protester against our bloody huntings. I remember how McVay had talked a few years before about a science fiction project in which the ocean was to be divided by ultraviolet waves into two parts — one to be a plankton plantation, the other a pasture for whales. Most scientists would primarily be more interested in the latter proposal, but in the meantime, the anti-meat-eating "Saint" would appear and all the scientists would kneel down before him, and create the plankton plantation as a sort of home farm for the future World State.

I feel as if McVay had been drawn to Japan, dreaming of the "Saint" who would save the whales and Homo Sapiens as well.

Now I find myself longing desperately for the advent of the "Saint" as I listen at midnight to the crying of the whales in the recording McVay left us.

Sometimes I find myself crying like the whales, "wé! wé! wé! wééi, wééi!" straining my throat, bending my body backwards.

On another occasion I was crying in Nakagusuku Bay in Okinawa, alongside the helpless fishermen struggling against encroaching industries with their tremendous pollutions. Then in the middle of my crying-struggle, I felt a tinge of hope rising in me that through such struggles, only through such struggles, we may attain to the tree of life, surviving a series of sad destructions. Yes, I was a whale myself, crying, "wé! wé! wééi!" to encourage those honest fishermen.

I say to myself that I am not personally qualified to issue accusations against the Japanese for our self-destructive urge. Who among us is qualified to do so, when all the Japanese are choosing a course of self-destruction?

The sun has risen as the people here in Benares are still attending to their morning rituals. Then suddenly I begin to feel as if I heard that old familiar song of my dear old whales above the human sounds of these poverty-stricken people in Benares — people who have nothing to do with whales and do not hound them to extinction, but who may be able to find a way out, along with the whales, through the plain struggle for survival. Aren't they, like the whales, singing a song of innocent resistance? Who else on earth could sing like that along with the whales?

I try to imitate the singing of the whales: "wé! wé! wé! wééi!" prompting something essentially human to arise within me, and within my half-naked boatman singing along with me in Bengali.

Translated from the Japanese by James Kirkup and Akiko Takemoto

TED WALKER

The Harpooning

FARLEY MOWAT

from **A Whale for the Killing**

Where the seas are open moor
and level blue, limitless,
and swells are as soft grasses
rolling over with the wind,
often to the idleness
of Azorean summer

come the great whales. Long granites
grow, slowly awash with sun,
and waves lap long black skin
like the shine of a laving
rain upon a city pavement.
Together they come, yet alone

they seem to lie. Massively
still, they bask, breathing like men.
Silent among them there is one
so huge he enters the eye
whole, leaving the rest unseen.
His sons and his cows idly

loll, as if in wait. Inside
him, too, tethered now, there waits
the bulk and strength of a herd
of a dozen rogue elephant;
they strain taut thongs of his will,
pawing against such indolence.

An anger could snap them loose —
anger, or hunger. Jungles,
under a mile of ocean
where no light has ever been,
could splinter, and the blind squid
uncoil in him like oily trees

But the squint jaws close on bone
steady as a castle doorjamb;
and, bigger than a drawbridge,
his tailflukes are calm upon
the calmer water. While the sun
still pleases him, he will grudge

himself no pleasure. He blows
old air from his old lungs, comes
rising whitely. Through the black
final coursings of warm blood
the oars will not rouse him. Thick
blubber houses him like hot meringue.

There were no people at the Pond when we entered. The whale was circling in a counter-clockwise pattern and it was soon clear that something was amiss. Her movements were sluggish, lacking the powerful and fluid grace of earlier days. Also, she was blowing at very short intervals and her spout seemed low and weak. When she lethargically curved her way past our perch on a shore-side cliff, we saw that the full length of her spine showed clearly in a chain of knobby vertebral projections.

Another thing that troubled me was the presence of an irregular pattern of great swellings that showed under her gleaming black skin. Onie thought these might have resulted from bruising contacts with underwater rocks when she was being pursued by the speedboats or when she was trying to escape through the channel. I doubted it, but could think of no better explanation. Those peculiar swellings worried me, so we got back into the dory and rowed out to take a closer look. We let the dory drift directly in her path, for we had no fear that she would strike us, either deliberately or by accident.

On her first circuit she changed course slightly and passed fifty yards away but on her next she came straight for us. When she was about a hundred feet off, she did something we had seen her do only a few times before and then always at a distance. She rose to blow, but instead of breaking the surface with her hump, she thrust her whole head high out of the calm waters. The gleaming white, deep-pleated expanse of her throat, with its curving and apparently endless jaw line, seemed to belong to a creature three times her actual bulk, for such are the proportions of a Finner's head to the rest of its body. That gigantic head appeared to rear directly over us, like a moving, living cliff.

It might have been a moment of terror, but it was not. I felt no fear even when her eyes came out of water and she swung her head slightly so that one cyclopean orb looked directly at us. She had emerged from her own element as far as she could in order to see us in ours, and although her purpose was inscrutable, I somehow knew it was not inimical.

Then she sank forward and her head went under. The hump appeared, she blew and sounded and, a few seconds later, was passing directly under the dory. It seemed to take as long for the interminable sweep of her body to slip by as it does for a train to pass a railway crossing. But so smoothly and gently did she pass that we felt no motion except when the vast flukes went under us and the dory bobbed a little.

It was then I heard the voice of the Fin Whale for the third time. It was a long, low, sonorous moan with unearthly overtones in a higher pitch. It was unbelievably weird and bore no affinity with any sound I have heard from any other living thing. It was a voice not of the world we know.

When the whale had passed on, Onie sat as if paralysed. Slowly he relaxed. He turned and looked at me with an anxious and questioning expression.

"That whale...she spoke to we! I t'inks she *spoke* to we!"

I nodded in agreement, for I will always believe she deliberately tried to span the chasm between our species — between our distant worlds. She failed, yet it was not total failure. So long as I live I shall hear the echoes of that haunting cry. And they will remind me that life itself — not *human* life — is the ultimate miracle upon this earth. I will hear those echoes even if the day should come when none of her nation is left alive in the desecrated seas, and the voices of the great whales have been silenced forever.

right
SERGIO DE CAMARGO
Untitled, 1978
Carrara marble, 2.3 x 1.7 x 1.1 m

JOHN WAIN

Whale's Death

So many gallons of that thick warm blood
like a red velvet cloak pulled out from the
 wound
where the harpoon drove in.
 So hot, so rich:
you would almost expect it to warm the sea —
at any rate, for a little way around:
then the huge tortured body could gasp out
the last of its life in a gentler surrounding,
wrapped in that cloak, its own agony's fibres,
protected, even by an illusion of forbearance,
from the unpitying surgical clasp of the sea.

But no. The water stays cold as the heart
 of man.
When will it be enough, the pumped-out velvet,
to warm the one and bring the other to life?
Or is man's heart always to be dead,
 as the sea is always to be cold?
 If so, remember:
a dead heart putrefies. Its owner rots.
No cloak of generous blood can warm him then.
No sacrifice revives a putrid corpse.
Relent, relent, and let it be enough.

JOHN ROBERT COLOMBO

Acrostic

W here no fault is, there needs no pardon.

H e that slays shall be slain.

A thing is bigger for being shared.

L eave something for manners.

E verything is good for something.

S till fisheth he that catcheth one.

PETER PHILLIPS
"Harbourfront" 1980
pen and ink, 63 x 53 cm

188

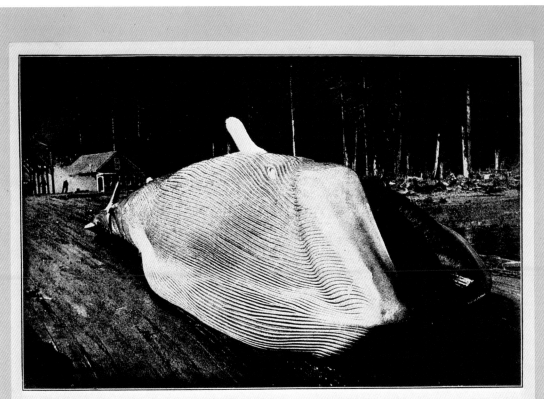

Ein Bartenwal oder Schwefelbauch von 24 Meter Länge

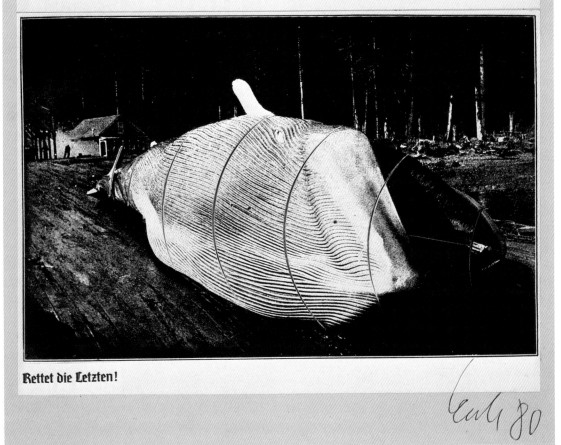

Rettet die Letzten!

UFFE HARDER

Question about Whales and about the World

When I was a child
whales were something
 miraculous
to think about

Their enormous bodies
their sounds and signals
their life with each other
the long journeys
and the water which they could
hurl high into the air

I don't think of them much
 any more
not because
whales are no longer miraculous
but because I feel shame
when I think of them
and impotence

Thus
we are deprived of the world
piece by piece

Who or what
shall take it over?

*Translated from the Danish by Uffe Harder
and Alexander Taylor*

THOMAS LENK
*"Rettet die Letzten!"
("Save the Last Ones!") 1980
photo-collage, 43 x 31 cm*

189

RON RIDDELL

On Seeing the Slaughter of Whales

Dear friend, the sea is red with blood;
The tide a bloody bed for these souls of the sea,

Who have no recall against the barbs
And spear-points which enter their flesh,

Who have no retreat but in the red-lipped
Waves that die upon the shore. There they

Are beached and the people from the village
Come to comb their bones. Knee-deep in

Blood they stand, their eyes like the eyes
Of dull-eyed hawks. Knee-deep they go, to

Uncover the flesh, the very being of these
Souls. They sing as they take everything apart.

Only the sea can answer their voices, only
The song of the sea can return their chant.

PABLO NERUDA

from *Leviathan*

O wondrous wound, hot spring
Stirring its defeated thunder
In the harpoon's realm, red
With the sea of blood, bled,
Sweet sleeping beast now led
Like a cyclone of torn hemispheres
To the whale-fat murky ships
Manned by rancour and pestilence.

Translated from the Spanish by Alberto Manguel

ALAIN LESTIÉ
Untitled, 1980
watercolour on paper, 98 x 49 cm

far left
MATTA
Untitled, 1981
pastel and paper, 29.5 x 21 cm

CONCETTO POZZATI
''Per Difendere Il Suo Blu'' 1980
mixed media, 24 x 32 cm

192

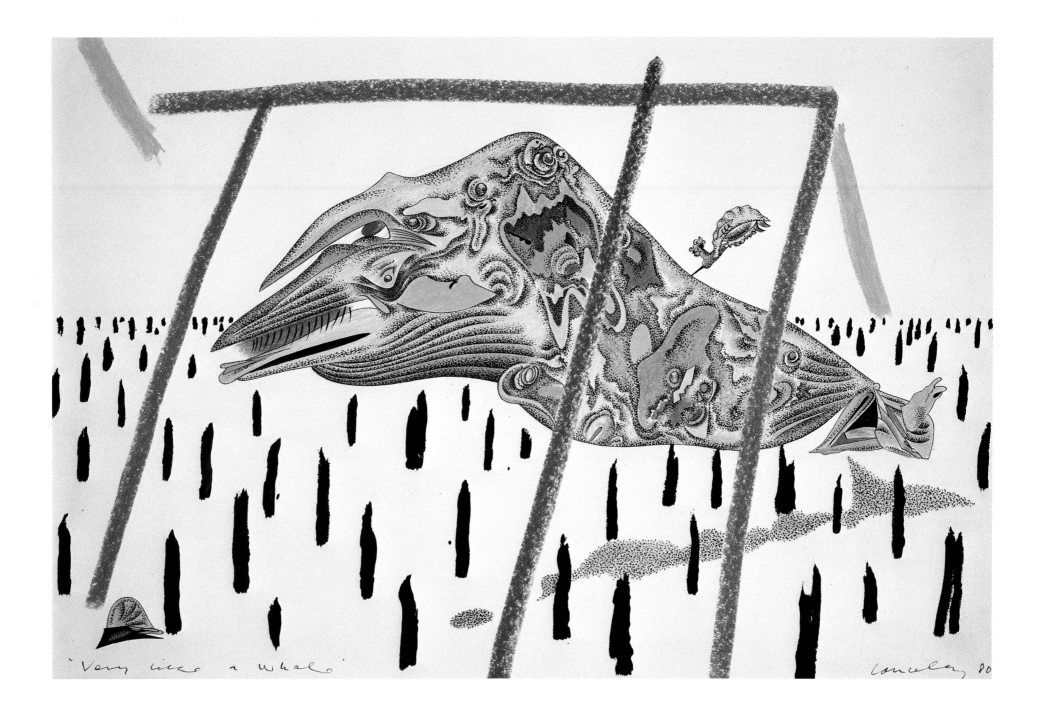

"Very like a whale"

Lanceley 80

COLIN LANCELEY
"Very Like A Whale" 1980
pastel, 40 x 60 cm

193

left
BEVERLY PEPPER
''Corten Horizons'' 1965
oil and fluorescent paint collage
50 x 70 cm

ROY ADZACK
''The End Will Be a Fossil'' 1980

''This work shows a dehydrated
fossilized fish suspended over its own
imprint of its original form.''

195

JOHN CHRISTOFOROU
''Le Sujet'' 1980
oil on canvas, 81 x 65 cm

far right
CURT STENVERT
''Der Kampf Mit Dem Fisch''
(''The Battle With The Fish'') 1975
acrylic on wood, 1.5 x 1.75 m

''The philosophy behind this picture
is this: Man, through greed and
stupidity, is destroying the marine
fauna and in so doing is only hurting
himself. But his cry for help will go
unheard, because, by the time he
realizes what is happening, it will be
too late. Only Man himself can save
himself.''

196

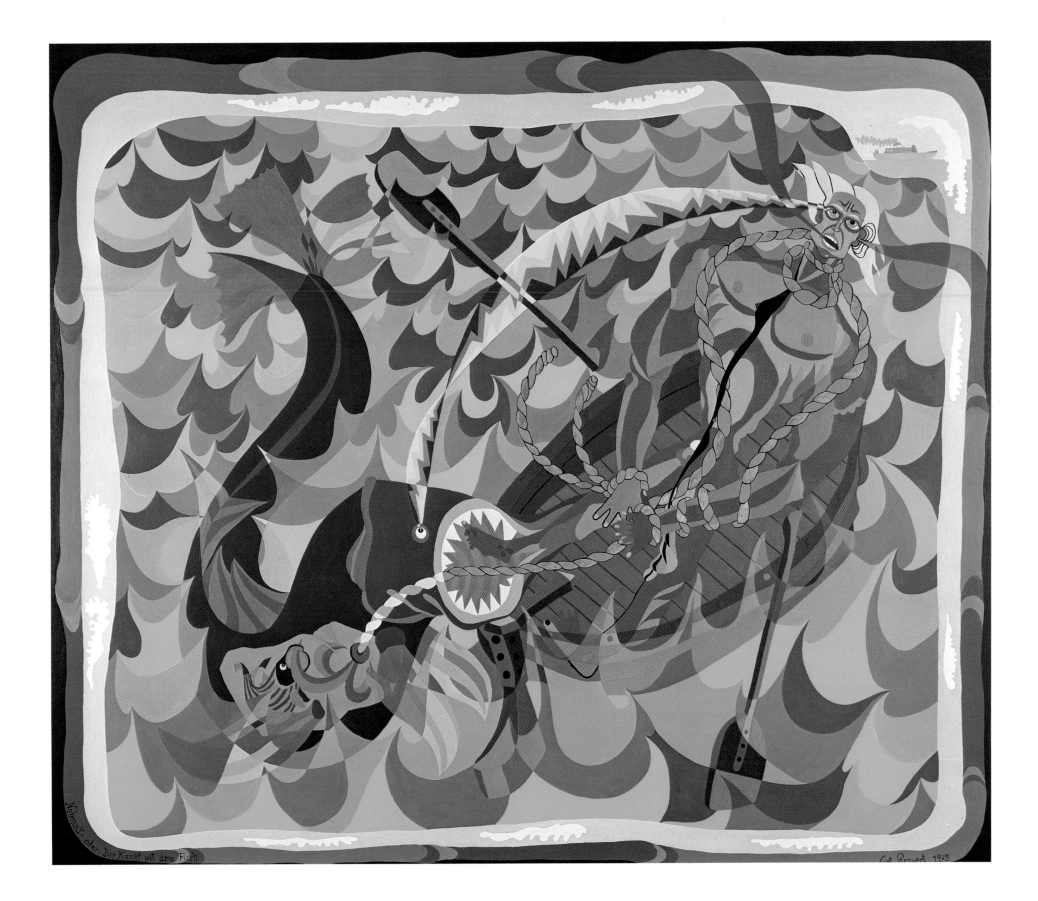

Männlich oder: Der Kampf mit dem Fisch Curt Prenzel 1925

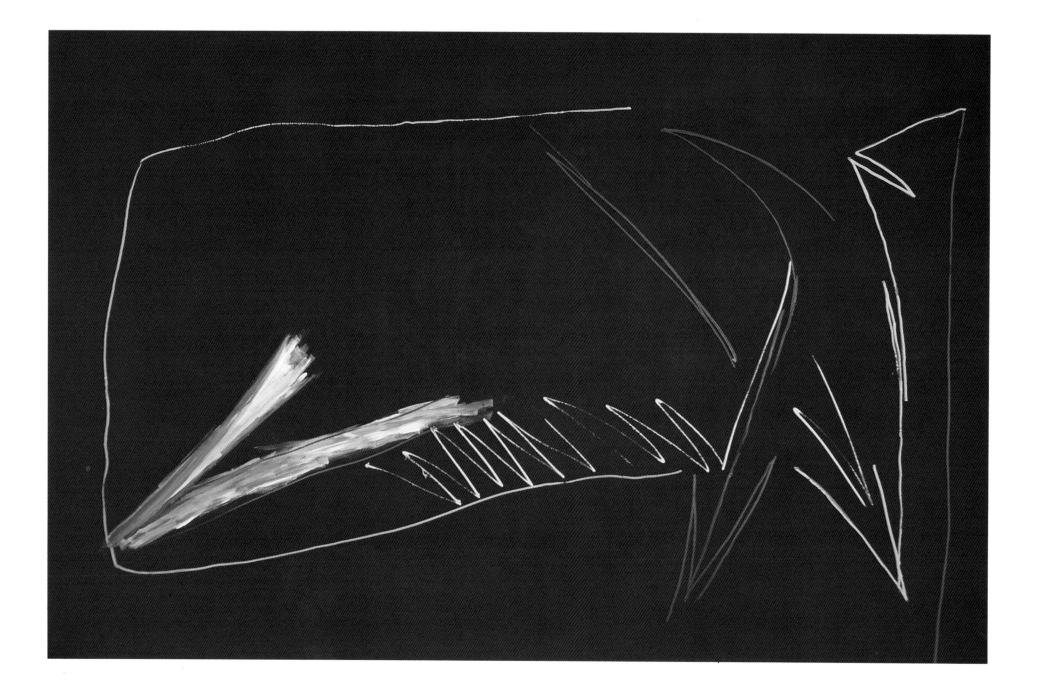

from *Halieutica*

This other excellent deed of the Dolphins have I heard and admire. When fell disease and fatal draws nigh to them, they fail not to know it but are aware of the end of life. Then they flee the sea and the wide waters of the deep and come aground on the shallow shores. And there they give up their breath and receive their doom upon the land; that so perchance some mortal man may take pity on the holy messenger of the Shaker of the Earth when he lies low, and cover him with mound of shingle, remembering his gentle friendship; or haply the seething sea herself may hide his body in the sands; nor any of the brood of the sea behold the corse of their lord, nor any foe do despite to his body even in death. Excellence and majesty attend them even when they perish, nor do they shame their glory even when they die.

Translated from the Greek by A.W. Mair

left
RONNIE LANDFIELD
"The Blue Whale Painting" 1973
acrylic on canvas, 2.7 x 4.2 m

Epitaph on a Dolphin

No more in delightful chase
 through buoyant seas
Shall I toss up my throat from the depths,
 nor blow around
The ornamented beak of the ship, exulting
In the carved figure-head, my image.
 But the sea's
Glittering blue has thronged me
 out of the moist element:
I lie stretched out
 on a narrow space of dry land.

Translated from the Greek by John Heath-Stubbs and Carol A. Whiteside

Coptic limestone relief of nymph riding dolphin; early 5th c. A.D. Greek art motifs, including dolphins, heavily influenced the art of the Copts. Also, compare this pose with that of the putto in Raphael's "Galatea".

from *The Greek Anthology*

I took his dripping corpse upon
my dolphin back and reached the strand;
the beast played saviour to the man;
the sea thing saved the thing of land;

the living helped the dead. And yet
it did me little good: I left
the water for the earth and got
my death as payment for my gift

of ferry-service. He and I
changed destinies: my friendly sea
destroyed him who was of the land,
and his earth proved the end of me.

Translated from the Greek by Robin Skelton

Courtesy of Yale University Art Gallery, gift of Mr. and Mrs. Fred Olsen

Portrait shields in mosaic from San Vitale, Ravenna; 525-550 A.D. Pairs of entwined dolphins separate portraits of apostles, prophets, and evangelists spanning the church's triumphal arch. While the iconography of the dolphins is disputed, since they were perceived as fish they probably represent Christ; in Greek (the language of the early Church) the word for fish, "ichthys", forms the initials of "Jesus Christ, Son of God, Saviour". Photo: Alinari: Editorial Photocolor Archive

DOROTHY AUCHTERLONIE

The Dolphin

Swiftness, diligence and love:
The gifts the dolphin brings
In simple joy and innocence
Are richer than a king's.

The foot is quick, the hand is deft
Where love has room and right;
The dolphin lives to serve a god
Whose absence is the night.

He who strikes the dolphin down
Blasphemes the generous sun,
The motion and the energy
By which his will is done.

The poet on the dolphin's back
Sets his course with ease
Through solitudes of sun and moon,
On dark prodigious seas.

Stay your hand before you cloud
The dolphin's candid eyes:
When swiftness, diligence and love
Are gone, the whole world dies.

ARCHIAS

from *The Greek Anthology*

No longer, dolphin, sea-foam darting,
will you startle deep sea shoals,
nor, dancing to the reedy piping,
splash up spume beside our hulls;
no longer will you, foam-clad, carry
Nereids on your back and bear
them off to Tethys, for tides high
as hills have cast you on the shore.

Translated from the Greek by Robin Skelton

JOHN FOWLES

Voices of the Deep

You wake up one morning, like the fellow in Kafka's *Metamorphosis*, to find you are something else. It can't be a cockroach, because you are hurtling through a liquid dusk. Your poor vision, like your lack of taste and smell, seems no loss, since you've been granted an unimaginably rich extension (twentyfold, to be exact) of a sense you hardly possessed in human form: that of hearing. It is now astoundingly sharp and covers a huge range of high frequencies. You are not alone, your travelling clan keeps up a constant whistling conversation all around you. Nor are you silent yourself. You have another splendid extension of your faculties: besides whistles you can emit 800 clicks a second and these clicks and their echoes are like sight. You asdic the sea-bottom and its contours; having an excellent memory, you know exactly where you are. It's like being an airline pilot on a clear day.

Now you echo-locate a shoal of herring ahead and you give the crescendo search-whistle to an invisible female friend beside you. You know that like you she is feeling excited and playful. Not having any of the paralinguistic visual aids to individual and emotional expression owned by other mammals (gesturing limbs, mobile facial features, and the rest), your kind have learnt to put it all into voice. Though in mid-Atlantic you are splendidly warm, at just the same temperature you had in your human body: but your new body is also superbly designed to eliminate all drag. Driving forward with an effortless lancing power at each dexterous flick of your elastic tail, you rise towards the shimmering herring, you take one, then you soar in ecstasy out of the water, twelve feet up, attempt a back-somersault, crash down with a gigantic splash, and squeal with laughter. It is such fun that you dive, gather speed and do it again, another glorious parabola, another thwacking pratfall. All around you your friends are doing the same. And you know why you're laughing. You have a bigger and more complicated brain than your previous human one; and unlike man, you are perfectly adapted to your element. You are freedom and delight, the most graceful and talkative

thing in all creation. You are a dolphin

Evolutionally the darkness and vastness of the oceans made an elaborately voiced search-and-find system essential if a species was to feed and breed. Fichtelius and Sjolander even argue that a trumpeting humpback might, at the right sound-layer beneath the sea, be heard the entire width of the Pacific. The notion of great voices baying menus and greetings through the endless submarine halls is very charming, though Gaskin doesn't confirm it; but nor does he explain how members of the more solitary species do manage to find each other. We know sadly little of the social and breeding life of even the commonest whales, and several rarer species have completely blank files beyond the anatomical evidence of the occasional stranded corpse.

In captivity, there is the unique rapidity with which dolphins learn to mimic and to perform tricks, including at least one, leaping out of their pools onto dry land, which denies all survival instinct. Their heat-insulation system is so good that they literally and very rapidly boil to death out of water, and their lack of fear (or capacity for trust) here is very remarkable. In the wild, too, they show some touchingly ''human'' behaviour patterns. Healthy dolphins will lift a sick one to the surface to breathe; females will act as midwives while another is giving birth, taking care of the calf as soon as it appears; they even have a crèche system, parents leaving their young in charge of a ''nurse'' in some sheltered inlet while they go out to sea to feed and play (the latter generally towards the evening, exactly like working humans). Their ancient friendship to man seems merely an extension of their loving kindness towards each other. Difficult, when reading about them, not to think in terms of a dawn of altruism in the marine struggle for life.

The huge cetacean brain cortex is probably connected with the need for a rich acoustic memory-bank on which to base hunting and navigational decisions. Bats use the same echo-system, but have no need for memory, whence their comparatively much smaller brains. A whale is really like a well-equipped modern strike-bomber, a swimming radar complex. The oil in the forehead of the sperm whale, for instance, is functionally a beaming-device used to home on the squid, which is what the species mainly feeds on (and also gets savaged by, since this whale can dive to a thousand fathoms and hunt the forty-foot monster *Architeuthis* at that depth). But the sperm whale is not really a good argument for intelligence, if we define the latter in terms of adaptive reaction. Though it did tend to swim upwind from the old sailing whalers and make itself harder to chase, it has never acquired — as it easily could in physical terms — an efficient flight behaviour when faced with man. At times, it will almost queue up to be gunned. Fichtelius and Sjolander try to interpret this divine pacifism as something conscious, but it is not convincing. The poor brutes just never learnt.

Outside the sexual clashes between the bulls, the lack of aggression in the whole order is striking. Not a single dolphin (even the so-called ''killer whale'') has ever turned on its trainer. Old horror stories of rogue cachalots, smashed boats, and towering tail flukes were always the result of bestial provocation on man's part first — a matter on which both books leave one with the same helpless rage. That the whaling nations didn't know any better in the unscientific past is understandable, but that we can still persecute these magnificent and harmless giants as they cruise through their meadows of krill soup, that since 1945 we have very nearly exterminated the blue (the largest creature in the entire history of the planet), the finback, and the humpback, that the Japanese and Russians are even today decimating the sei and are now turning to the smaller whales. . . . History will one day whale for us, and we shall deserve every barbed anathema it sinks into our selfish little monkey skulls.

right
''Giona'' engraving, BACCIO
BALDINI*(?); ca 1465. 14.5 x 9.5 cm.*
Courtesy of the Museum of Fine Arts,
Boston, Harvey D. Parker collection

Jonah

The whale is a gigantic supermarket
Crammed from top to bottom with desirable commodities.
Among them oil, as signalled by a gusher,
Whalebone and ivory, for diverse uses,
Flesh to be turned into fodder for cattle,
Bones to be turned into fertiliser,
And ambergris to conceal the odour.

But when you enter this famous supermarket
It is best to be circumspect.
Inside you may also find an unforgiving prophet
Bearing a message —
That repentance sometimes comes too late,
And they that cannot tell their right hand from their left
Shall put on sackcloth and ashes.

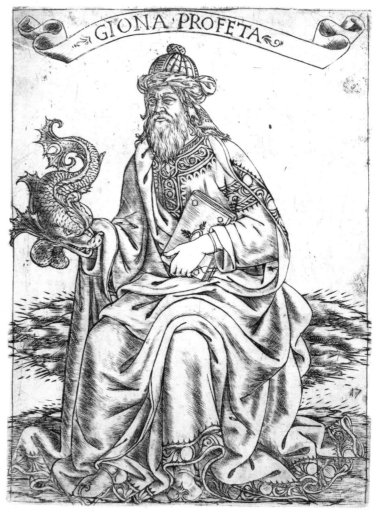

Extermination

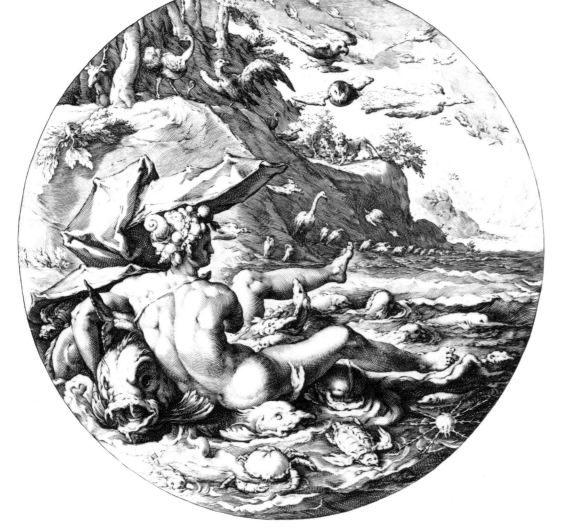

 By the Word was the life of the world created.
In those days man walked
among animals and things
trusting and joyous
and all responded with signs
of peace and content.
Until one day man began
to destroy life
and everthing started to fall silent, with the silence
of death.

 Where, since then, the voice of the wind
in the trees,
the musical note of the birds,
the many-tongued voice of the sea?
Who can learn the speech of the dolphins
and what counsel now from the whales
as they journey?

 Man has lost touch with life
and has chosen death.
He constructed a hermetic world
and declared war on all living things
from the tiny sparrow to the eagle,
from the periwinkle to the whale,
for gratification, for pleasure, or for profit.

 The silence of life extends
all around mankind
and within his very being, within his soul.

 Oh, greatest horror, is the silence of God,
Who will not say again, as on the fifth day,
 "Be fruitful, multiply and fill the waters
 of the seas; and let the birds multiply on the earth."

 Oh, greatest horror! For truly man
has chosen death.

Translated from the Spanish by Margaret Cullen

"The Creation of Fish, Birds, and Beasts" engraving, JAN MULLER; ca 1700. Courtesy of the Trustees of the British Museum

DAVID MALOUF

Natural History Museum

Sunday afternoon: late summer drizzle
burnishes the iron-spanned skylight glass, Victorian spaces
blaze with the breath
of children crouched in O delicious terror as they crawl

through the whale's jaw, go in under the arching, giant-ribbed gothic
 vertebrae
of the first bone cathedral, little Jonahs
braving the dark. What a view from here:
a view from the whale's belly, gloom of almost a thousand fathoms

under, midnight blue
and aqualung depths as the salt-sea plunger Leviathan
rises *de profundis*. Under the glimmer
of ice savannah spores sleep out a cold spell, giants

yawn, their big bones shine, as wired, unsteady,
they lumber towards us.
We are all exhibits here. In the greater dissolution
that spreads beyond these walls, the wrecker's ball like a pendulum

swings through our days,
the last of the nineteenth century
collapses, jars its box of servants' bells, huge insects move
the earth. All will be glass.

We shall look through into
the nightlife of computers, dreamless, docile, perfectly balanced
as they shift their chessmen over moonlit squares. We shall learn
their language; to stroke them

perhaps and give them names. But they will never join us here
like the loved ones murderously
hunted to extinction. Horn and fur pass into gluepots, into gloves,
the oven-heat of herds glows strangely in us,

illuminates our flesh.
The whale, a million candle-power city, shovels clouds
of thick smoke from its lungs, in the last barbarity of power
harpoons the sea spits blood and tallow-fat.

And the view through the whale's flapped side is of flensing poles,
the black seed of a species
frizzled and scrapped. Look towards zooparks, Rome, Vienna
at dusk. The dead come down to pools and drink.

Clear through the whale's vast skylit ribcage, night —
deep space where planets swarm
like plankton, kids on rainy afternoons drift back
to puzzle and gawp. *Here once*

were giants. Here once
was blue sky and sun. A Rubens landscape reconstructs
for them the glow of autumn (numbered arrows indicating
ploughhorse, clover, wren) where peasants work stacking the distance

in sheaves. Latecomers
— grave, uncomprehending
stare. There are no walls now. A light as of the next world falls
on bones, on birds' eggs speckled in glass-topped drawers locked on
 their wings.
A flutter under the lids. In the dark museum
our lives are imaginary. They will come
back here, seeking their small-boned scrapheap Edens,
Sydney, Babylon —

a blue sky mirrored only
in the eyes of survivors. And stranger than whale or dinosaur
our neighbours. In the gloom
of the great star-museum exhibit Earth, our fathers started out from
 here.

DE HYÆNA CETACEA.

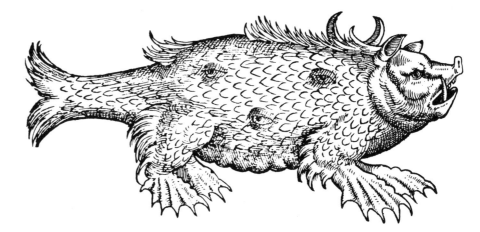

Illustration from ''Historia Animalium'' by KONRAD GESNER *(Frankfurt, 1604); the dreaded ''Hyena Whale'' complete with all-seeing eyes on its flanks, modelled after Sebastian Münster's ''Pig Sea Monster''. Courtesy of the Thomas Fisher Rare Book Library, Toronto*

DESMOND O'GRADY

The Whale as Artist

Illustration by KONRAD GESNER
from ''Historia Animalium'', 1604

I am the whale,
Merlin master of the seas'
mysteries in this sea
of various high singers,
dolphin dancer dazzlers.

I am that whale lore-maker.
My mate swims my constant
mother, mistress, madonna Magdalene
my lifelong odyssey to the shores of my origins.
I play with sea waves like book words,
poured bronze, palette colours of ballet
and trapeze artists for the canvas of eternity.

When I take my joyous lonely leap
I curve the sky's archibaleno.
Threatened, I'm that vertical deep depth
diver disappears like a druid — labyrinthine
Dedalus of my known Stonehenge fathoms.

My every movement's mime is mine
uniquely and though I hold no grudge
against my fellows, when provoked to strike
I devastate — then continue my perennial,
decided directions forgiving, forgetting, detached.
Nothing's random in my turn and wheel. Nothing's
chance. All's reason, rational rectitude.

Harpoon hit I dive and hide,
a silhouette beneath the surface
among my fellows. We're a school apart.
So few now we must protect each other.

Sometimes I swim timid sometimes
daring, alternately indifferent of attention.
Proud, I converse casually of our plight
with my fellows swim this daily dirtier sea
menaced by marauding moguls' murder.

I am the whale, solitary as an island
in an archipelago of historical difference
and distance. With my kind, in the long run,
there's no *rapprochement*, no *rapport*. My
domain's vast as the ocean of tradition.
Face to face I terrify, though timid and curious
I journey forward relentlessly Odyssean. Those who cling
on an extended fin never distract my dedicated
direction, drop away eventually anyway, clumsily.

I enjoy good talk, can sing with the best,
and listen intently to all interests me.
I like my love in the solitudes
of warm waters where I know my way
but all my loves, though constant, cause pain.

I have witnessed so much senseless slaughter
in our time, such distracted despair
among my friends from what's barbarian butchery
that many have driven themselves onto the shores
of desolation to die alone of sorrow.
I am the whale,
last of our kind
in this polluted sea,
Merlin master of old mysteries.

MILIVOJ SLAVICEK

On the Catcher of Moby Dick

In this immense sea I continue to catch you, Moby Dick
standing upright, motionless, letting one puff after another
 escape from my pipe
solitary in my mortal body, aimed against you over and over
 again
boldly thinking and feeling at the foot of the mast
Yes, it is myself who is standing here and talking and there
 is no other self to dissuade me

AT THE MOMENT YOU IDIOT WHEN EVERYTHING HAS BEEN
PLUNDERED, DEVOURED, DUG OUT, KILLED OFF,
EXHAUSTED, POLLUTED

At the moment you idiot when everything has been
 plundered, devoured, dug out, killed off,
 exhausted, polluted:
then what are you going to do, you great plunderer and polluter
renegade who sings, creates, kills, razes, and who is
 propagating, propagating

Translated from the Serbo-Croatian by Liljanka Lourincevic

SEN AKIRA

Three Whale Haiku

The whale skeleton:
I kneel to pray in it, as
in a cathedral.

The whale skeleton:
I walk slowly through it, as
in a bare forest.

The whale skeleton:
I lay here my own bones, as
in a sea's graveyard.

Translated from the Japanese by
James Kirkup in collaboration with the poet

204

FAY ZWICKY

Whale Psalm

I steer the chastened furrows
with my tail, coil
filamented upwards lift thrash
down to
crash the
heaving waste
behind.

My captors close
upon me, Sir, I call —
 Thew and sinew
peak and plunge: then softly softly
stealthy roll and glide, recoil to
coil again
 lift in subtle
curvature, plunge
downward:
my ponderous flukes subdue
the darkening flood.
 O Sir, you thus
prepared me, thus I churned your path
chanted your praise: my being
spoke your wonder.
 Unmoored from innocence,
from your sight cast, today I range
hell's belly.

Earth's nets tighten:
men forsake their mercy, shroud me dumb
who have so loved the habitation of
your waters.

Rein me from darkness now as once
you ransomed Nineveh lest
fishers mourn, nets languish
on the blackening sea.

HANS MAGNUS ENZENSBERGER

The End of the Owls

i do not speak of what's yours
i speak of the end of the owls.
i speak of turbot and whale
in their glimmering house,
in the sevenfold sea,
of the glaciers —
too soon they will calve —
raven and dove, the feathered witnesses,
of all that lives in the winds
and woods, and the lichen on rock,
of impassable tracts and the gray moors
and the empty mountain ranges:

shining on radar screens
for the last time, recorded,
checked out on consoles, fingered
by aerials fatally florida's marshes
and the siberian ice, animal
reed and slate all strangled
by interlinked warnings, encircled
by the last manoeuvres, guileless
under hovering cones of fire,
while the time-fuses tick.

as for us, we're forgotten.
don't give a thought to the orphans,
expunge from your minds
your gilt-edged security feelings
and fame and the stainless psalms.
i don't speak of you any more,
planners of vanishing actions,
nor of me, nor of anyone.
i speak of that without speech,
of the unspeaking witnesses,
of otters and seals,
of the ancient owls of the earth.

Translated from the German by Michael Hamburger

"Whale", ALEXANDER CALDER;
*1937. Standing stabile: painted sheet
steel, supported by a log of wood,
1.63 x 1.67 x 1.09 m. Collection of
the Museum of Modern Art,
New York, gift of the artist*

KATHLEEN RAINE

Whales

Under the ever-moving, mighty dreams,
You sound our seas,
Powers, strong angels of the world, thoughts
Of the undying one life, you rise
From what deep springs of ocean? Not yours
As our thoughts, who, slaughterous,
Have moved mountains to loose the Titans' fires
Wise gods of life locked underground.
We, of innocent immemorial green earth
Enact the suicide,
Maddened by fear of terrors we ourselves commit,
Ourselves we realize our own darkest prophecies:
"And the creatures which were in the sea, and had life, died."

IANNIS XENAKIS

For the Whales

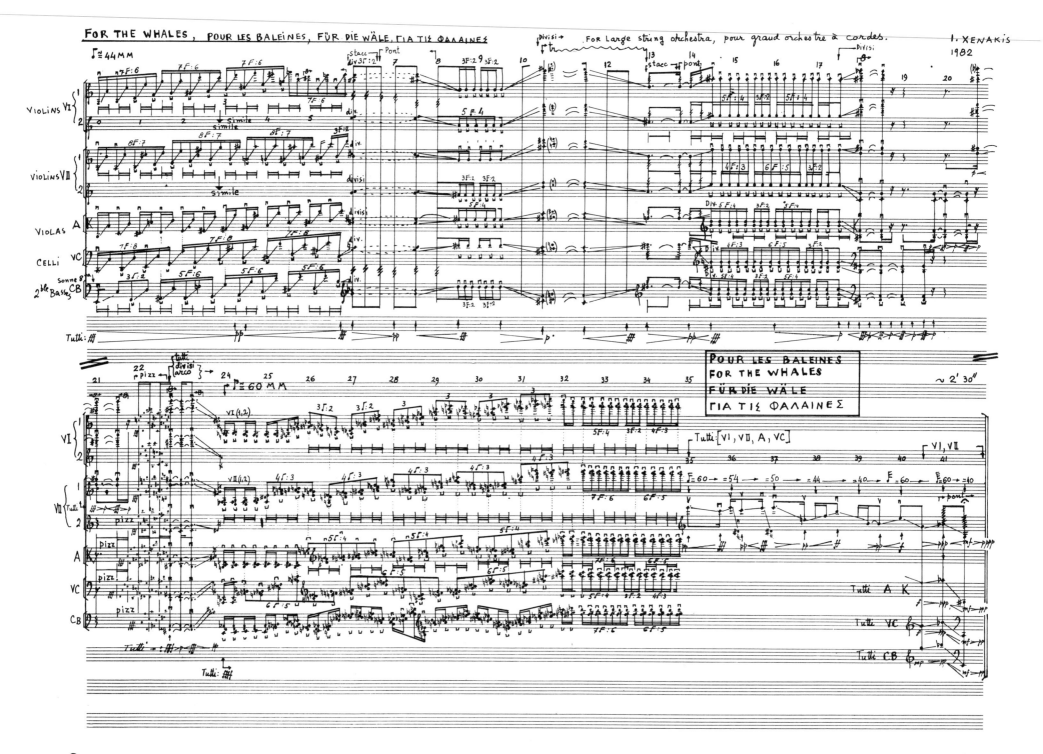

FLEUR ADCOCK

Whale, Cumbria

Whale is a village in Cumbria:
not a huge one, I imagine —
a few farms, a church perhaps,
a Post Office, a pub (called what?)
Today I might have found out:
"Whale" said the signpost
off the road from Haweswater,
that lake poured over a drowned village;
but a wet fog had settled
on trees and bracken and stone walls
and we were due in Shap.
We drove on, discussing names:
how Cumbria was Westmorland,
and Mardale meant a village
until Haweswater swallowed it.

This inland whale can wait;
better first to look at the real thing:
some villages last longer than some creatures.
Haweswater Reservoir was flooded
fifty years ago; another fifty
and "Whale" may mean no more than "Mardale".
Well, even a name is a memorial:
I know of no villages
called Mammoth, Dodo, Moa.

JUDITH HERZBERG

Interesting Novelties

He began fiddling with the knobs
fumbling with the tubes and
talking me into some kind of ventilation coil
promising that if the whales
ever actually died out something
very special and equally ingenious
would be invented, just wait and see.
Like what? An even more spontaneous
 leviathan?
As you must know, he said, we have developed
 vegetable oil.

Translated from the Dutch by Scott Rollins

TESS JARAY
"Save The Whale" 1980
pen and ink, 30 x 30 cm

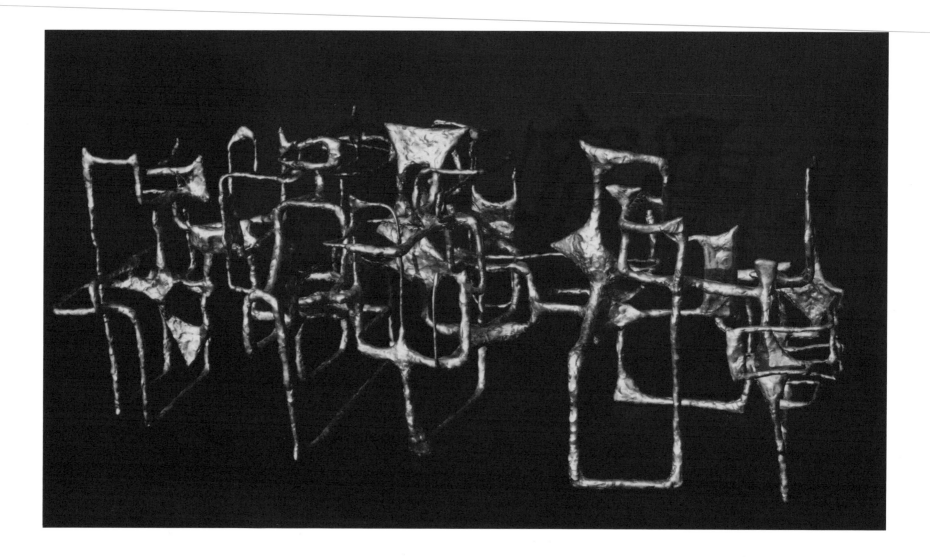

IBRAM LASSAW
''Galaxy in Ursa Major'' 1974
nickel silver, 38.75 x 100 x 32.5 cm
Collection: Julius Perlbinder

''I have been influenced by the
recording of whale songs which I
often play while I am working.''

208

far right top
Detail of a French engraving,
unattributed; dated 1627. Courtesy
of the Old Dartmouth Historical
Society Whaling Museum, New
Bedford, Massachusetts

JAVIER SOLOGUREN

in the style of (undesirable) in memoriam

of its grandeur
there will remain for us
a few
splendid pictures

the ghost images of the media
will make it dance before
our astonished eyes
(yes
that's what it was like
it was called whale)
furthermore
its description will be around
documented
in treatises and on catalogue cards

it was
a plaza of slate or blue granite
moving through the waters
and a fountain that was
a smile
the only blossom
of the lonely spaces
towering
under rooted skies
there will remain for us
also
the questions
the great surprise of learning
that there no longer exists
such a huge piece of anatomy
burnished and alive
such grace in the dark
fullness of bulk
and that in the end
the miracle
of technology
could achieve
nothing but its death
but could never
succeed in creating its replica
could never
launch it into the sea
for its now never to be repeated
jubilant
passage

Translated from the Spanish by Margaret Cullen

LAWRENCE SAIL

After the Whales

Again and again, the suffering of the innocents,
the harpoons blossoming grossly in their bodies –
and when at last the last of the whales is gone
what will they do, the swarming editors of
the lexicons of greed? Who then will queue
for the flesh rendered to words, the final candles,
corsets, shoe-polish, printer's ink and paint,
gelatine, perfume, pet-food, margarine?
How then will they house the great abstractions,
the faith of Sperm Whales drifting in calm sleep,
the Blue Whale's brave loyalty to its love?

Cherish each mortal love, oh cherish the whale,
lest all those unspoken assumptions by which words live
should be gone with barely a splash, the quick bright flukes
waving farewell again and again, until
we are staring, speechless, at an ocean emptied of song.

GEORGE CRUMB

Vox Balaenae (Voice of the Whale)

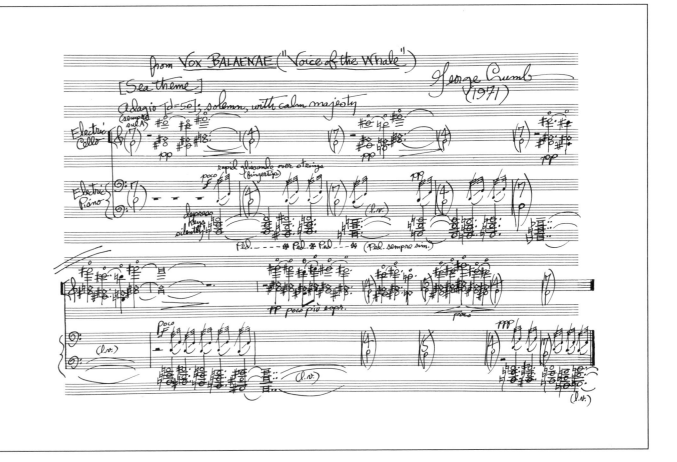

MARGARET ATWOOD

The Afterlife of Ishmael

After Ishmael had been rescued and brought ashore, he sold the account of his ordeal to the newspapers. The White Whale was a good enough story, and if he exaggerated a little, who was to know? With the proceeds he bought himself a small cottage on a hill overlooking the sea. He set up the jawbone of a whale as a gateway to the little garden where he grew sunflowers and a few vegetables, and at first he was happy enough.

When a number of years had passed, Ishmael realized that there was nothing for him to do on land. He wanted nobility and danger, he was an addict, and these things could be found only at sea. He went down to the harbour to ship aboard a whaler once more. There are no more whalers, they told him, not the kind you are suited for. No one stands in a rowboat and throws harpoons at whales any more, no one is that stupid. Now it's all done with radar and guns. It's a harvest, not a hunt. Anyway, what's so noble about dog food?

Disconsolate, Ishmael returned to his cottage. He couldn't understand how a century and a half had passed; he couldn't understand why time had failed to include him. Why wasn't he dead?

That night an angel appeared to him. It manifested itself as an oblong, huge, whitish, like a dirigible balloon, with a small eye on either side. He knew it was an angel because it glowed.

Who are you? he asked in a trembling voice.

I am your judge, said the angel. You have been condemned.

What for? asked Ishmael, with a slight whine, for apart from a few minor lies he didn't think he'd done much that was wrong.

Murder, said the angel.

But I've never killed anyone in my life, said Ishmael. As God is my witness.

Ah, said the angel. Exactly the problem. I was not sent by the God of men but by the God of the whales. Your mistake, as well as your crime, was to believe only in the first.

Ishmael, despite his terror, found the notion of a God of the whales so ridiculous that he couldn't help smiling. Well then, what is my sentence? he asked, as if indulging a small child. He had ceased to believe in the angel; he thought he was having a bad dream.

Your sentence has almost been carried out already, said the angel. You are condemned to remain alive forever in a world empty of whales. Your sentence is much worse than that pronounced upon Ahab, because your guilt is greater.

But why? said Ishmael peevishly. I admired the whales, he hated them. Why am I not more innocent than he? I after all did nothing.

Precisely, said the angel.

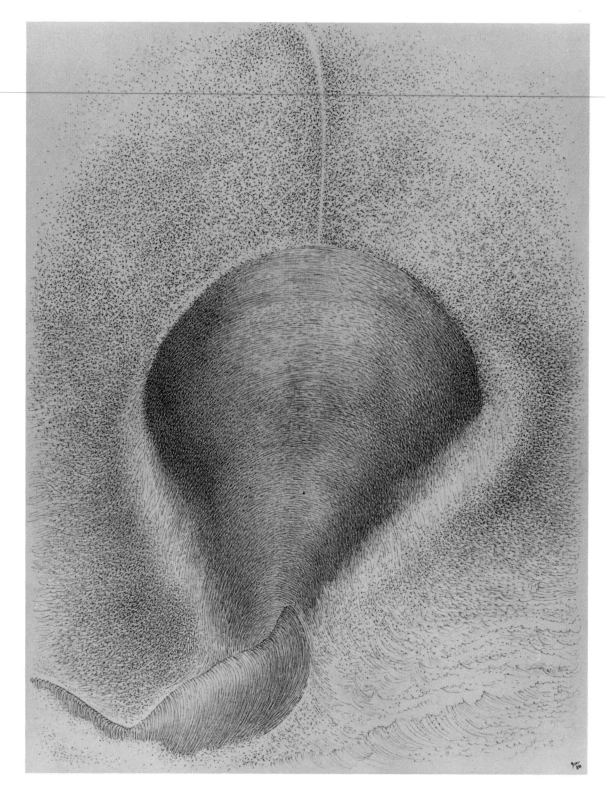

GREGORY MASUROVSKY
''Whale'' 1980
pen and ink, 62.5 x 48 cm

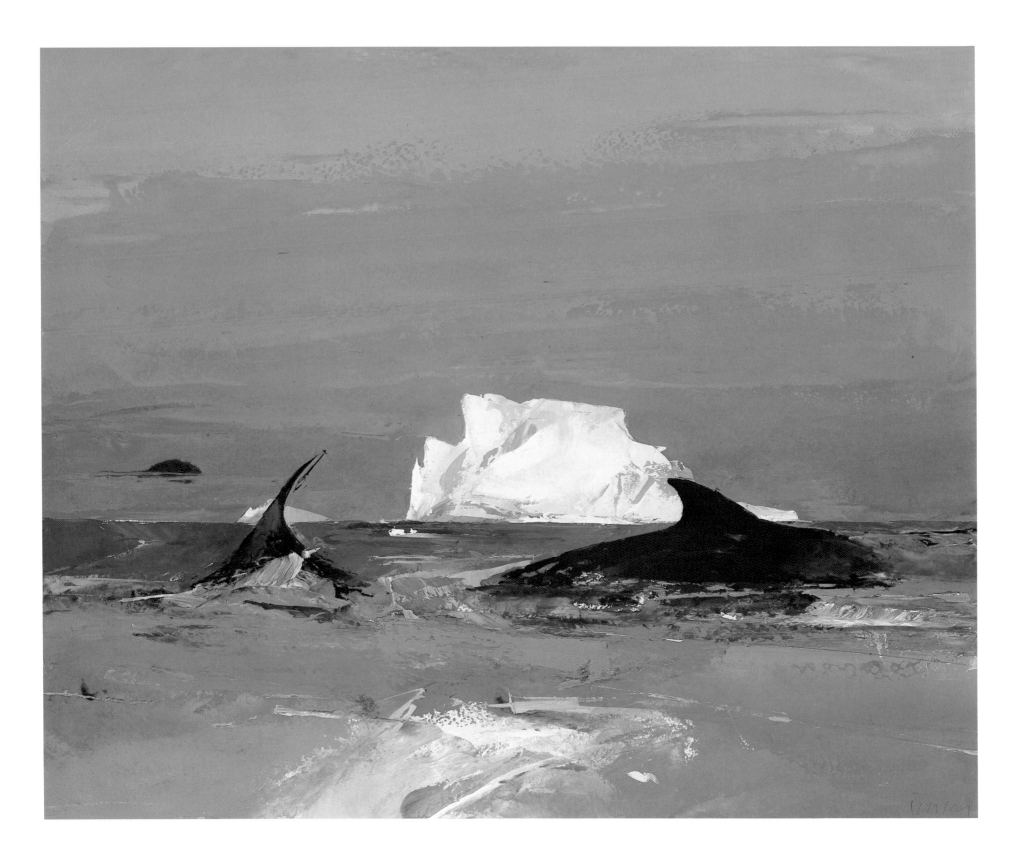

DONALD HAMILTON FRASER
"Arctic Seascape" 1980
oil on paper, 40 x 50 cm

211

HERNANDEZ PIJUAN
"Homenaje al mar"
("Homage to the Sea") 1981
watercolour and pencil, 30 x 23 cm

"To the Greenpeace Foundation,
in support of its efforts to save
whales and dolphins."

212

LILIANE LIJN
*''Project for a Memorial to all the
Species of the Order of Cetacea''* 1980
pastel and ink, 47.5 x 38.8 cm

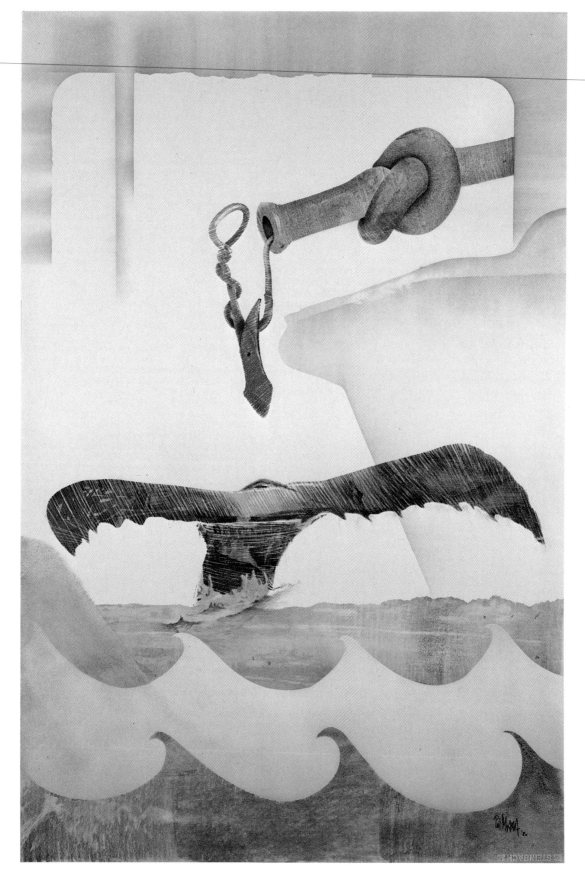

POL MARA
''Que la beauté soit sauvée'' 1980
watercolour and pencil, 110 x 73 cm

far right
KENNETH ARMITAGE
''Imaginary Whale'' 1980
watercolour and ink on paper
20.3 x 22.8 cm

''Since making this contribution,
more research photographs have
become available. If only one had the
gratification of seeing a whale in
reality — and close to.''

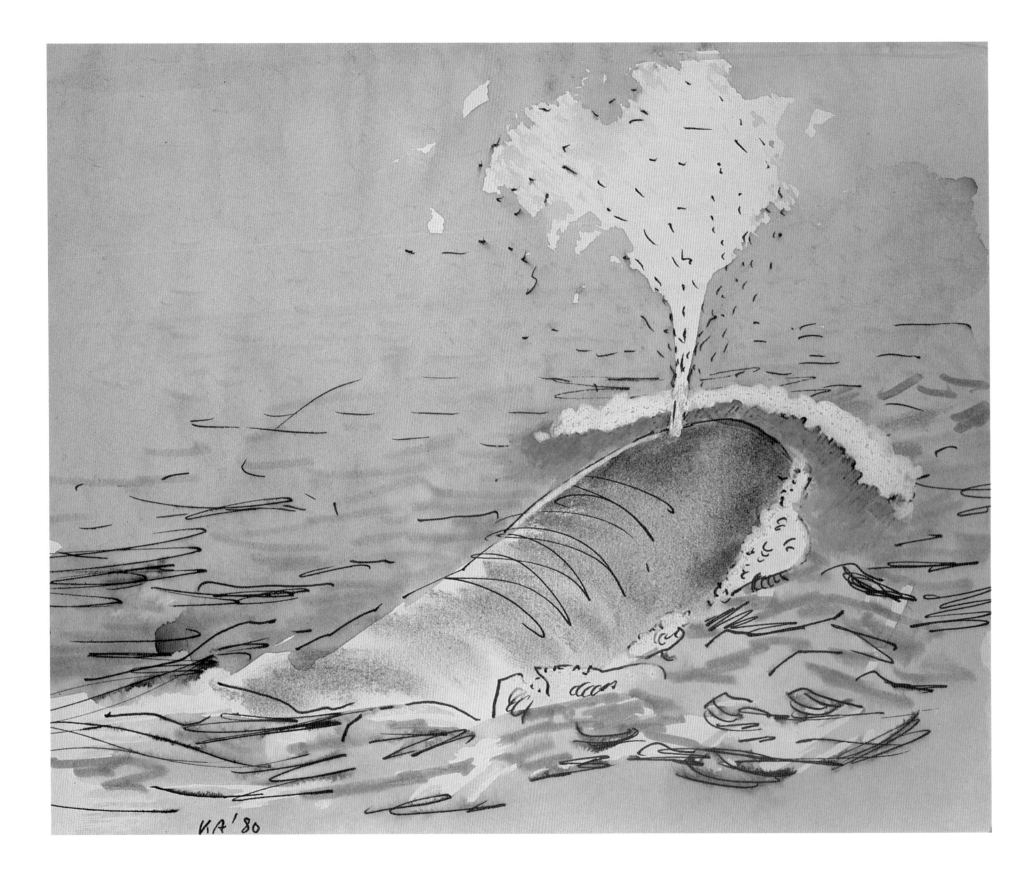

KA '80

DON NICE
''Greenpeace Dolphin'' 1980
watercolour on paper, 99 x 150 cm

216

WINFRED GAUL
"Drawing" 1979
pencil on paper, 70 x 100 cm

217

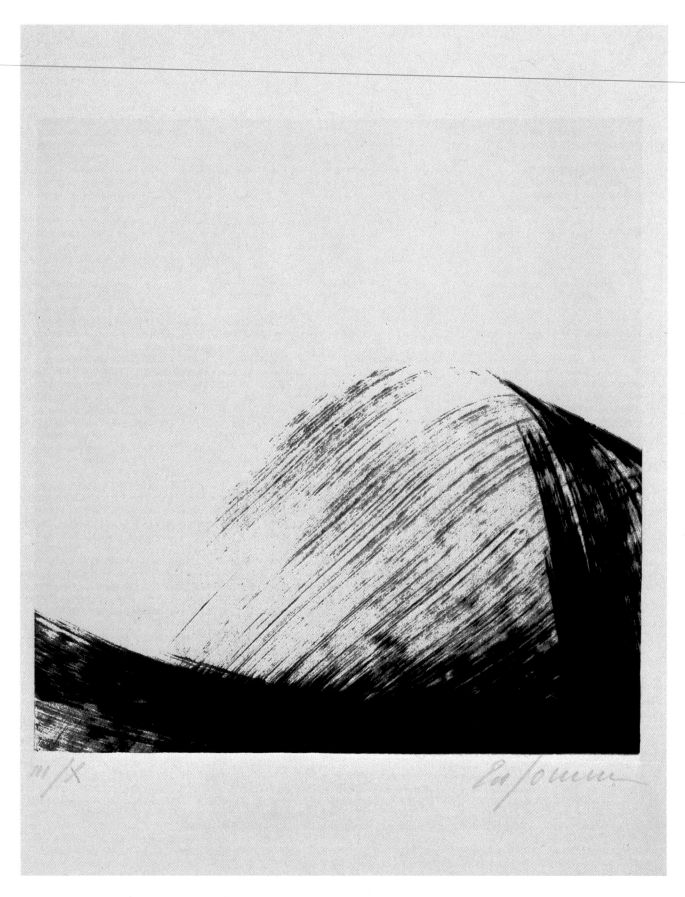

A Whale in Auckland

(for Jan Kemp, who stuck hers *on the bill-board)*

When you've written your poem / naturally
you want to see it / riding there / right
with the whale on Queen Street
where he blows in the sun
sharp on the blue wall stretching
maybe 50 feet of protest.

A whole universe on a railing.
For simple people the limits of the world /
floating where the news is made
and shouted
daily on the corner.

An ancient spirit / sole survivor
of all those dead by Ahabs' spears
slashing for continents of loot
in the plentiful cathedrals
sounding their grave music
with the seawaves sweet
as ambergris.

A whale of a deity drifting there
where Maui might have fished before
the light got crowded out
by steel and glass competing for the sky.

An island, psalm leviathan as gentle
focus in a busy street / stretched far beyond
a local history marked on a paling wall —
the scaffold of crude time
when seas were torn with flinching flesh
slapping their circles of blood.

See how his eye is turned back
as if some vague disquiet stirred
anxious at centres of water boiling
in outrage among headlands
exploding
in splay of shot and iron / ripped open /
gashed
by grabs clawing the marks on maps
charted perhaps an hour ago.

He has no need to fear.
Your poem right there / on the narrow horizon /
stuck in the belly of the whale.
A tiny Jonah casting misfortune's spell
on all who would deny this lord
the reign in Neptune's realm.

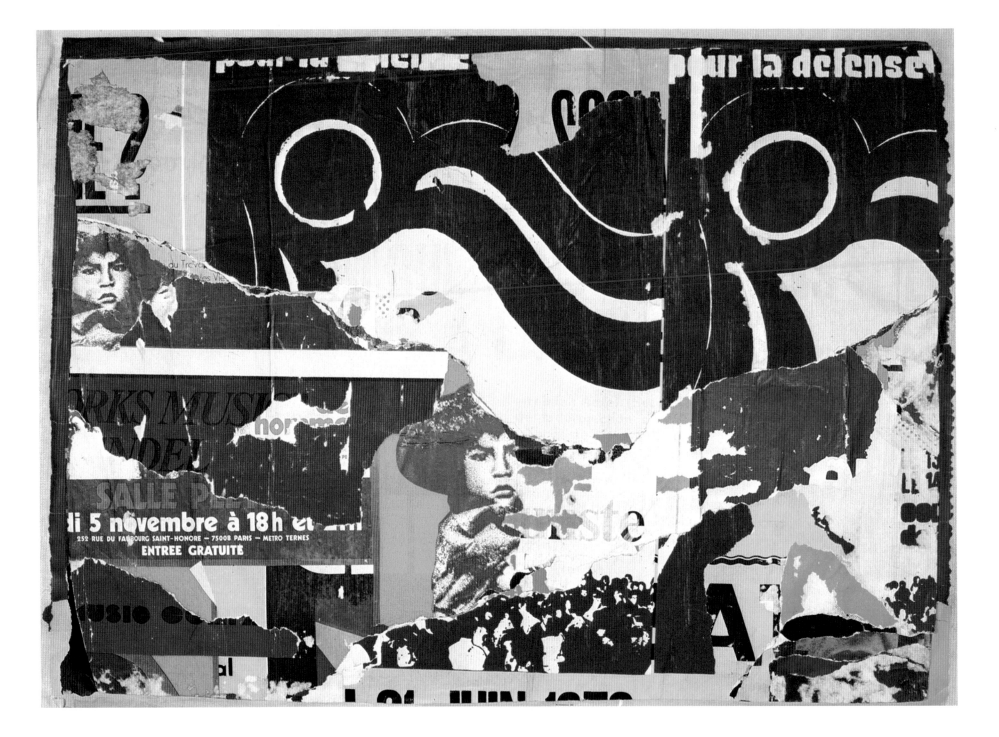

JACQUES DE LA VILLEGLÉ
''Affiche lacérée,
 rue Simon-le-Franc'' 1974
collage, 55 x 75 cm

left
ED SOMMER
''wave / whale'' 1980
silkscreen 10 x 10 cm

''The billboard, that 'News Of The
World' of the street, cannot be raped
except when it is stabbed and thereby
escapes from commerce and politics.
Advertising images – civilization in a
nutshell – change into cock-and-bull
stories, and words themselves play
their last cards, and become illegible.''

219

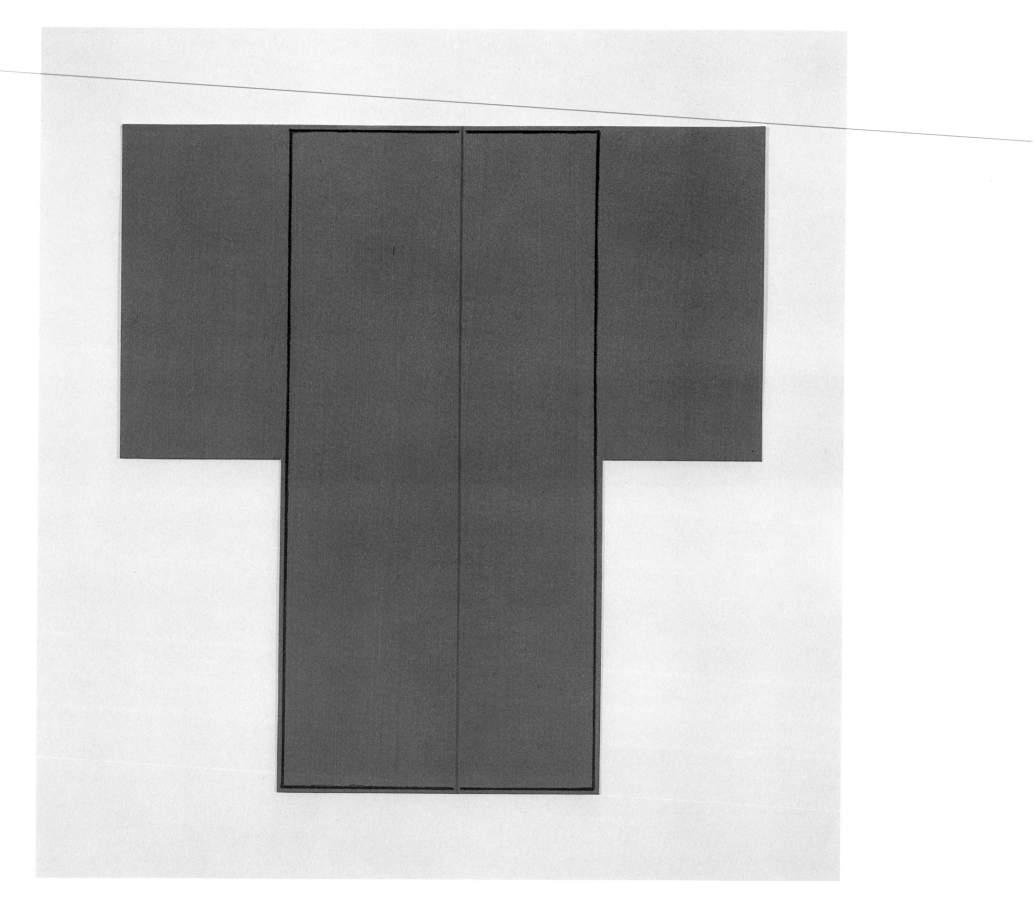

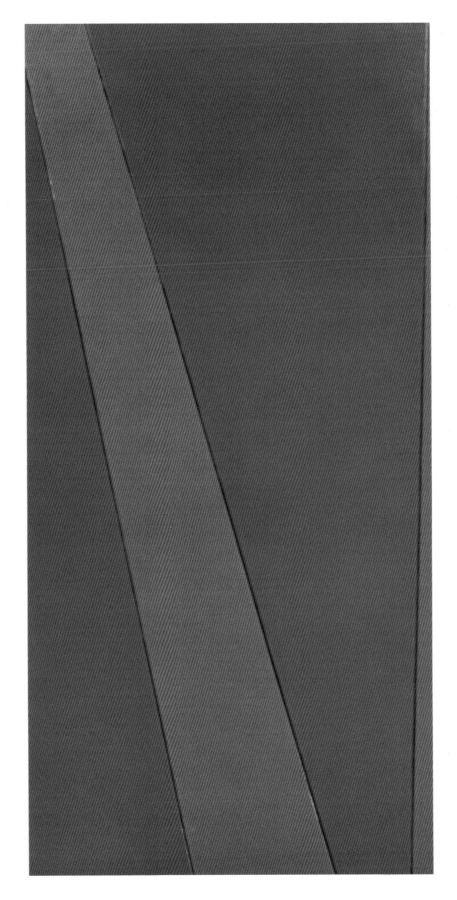

right
OLLE BAERTLING
"Kiak" *1975*
oil on canvas, 195 x 97 cm

left
ROBERT MANGOLD
Untitled, 1980
acrylic and pencil on paper
38.8 x 38.8 cm
Photo: Leslie Harris

WHALE WHALE WHALE WHALE WHALE WHALE WHALE
WHALE WHALE WHALE WHALE WHALE WHALE WHALE
WHALE WHALE WHALE WHALE WHALE WHALE
WHALE WHALE WHALE WHALE WHALE WHALE WHALE
WHALE WHALE WHALE WHALE WHALE WHALE WHALE
WHALE WHALE WHALE WHALE WHALE WHALE WHALE
WHALE WHALE WHALE WHALE WHALE WHALE WHALE
WHALE WHALE WHALE WHALE WHALE WALE WHALE
WHALE WHALE WHALE WHALE WHALE WHALE WHALE
WHALE WHALE WHALE WHALE WHALE WHALE WHALE
WHALE WHALE WALE WHALE WHALE WHALE WHALE
WHALE WHALE WHALE WHALE WHALE WHALE
WHALE WHALE WHALE WHALE WHALE WHALE WHALE
WHALE WHALE WHALE WHALE WHALE WHALE WHALE
WHALE WHALE WHALE WHALE WHALE WHALE WHALE
WHALE WHALE WHAIL WHALE WHALE WHALE WHALE
WHALE WHALE WHALE WHALE WHALE WHALE WHALE

WAIL: ONLY ONE LEFT ?!

MICHAEL SNOW '77

222

MICHAEL SNOW
Untitled, 1977
pen and ink, 20 x 28 cm

University of Washington Press

Verlag Eremiten-Presse

Allard Pierson Museum, Amsterdam, The Netherlands
Archaeological Museum, Thessalonika, Greece
Archaeological Research Unit, Johannesburg,
 South Africa
Arctic Institute of North America, Calgary, Canada
Ashmolean Museum, Oxford, England

Biblioteca Medicea Laurenziana, Florence, Italy
Bodleian Library, Oxford, England
Boymans Museum, Rotterdam, The Netherlands
British Library, London, England
British Museum, London, England
Brooklyn Museum, Bróoklyn, U.S.A.
Bronson Museum, Attleboro, Mass., U.S.A.

Canterbury Museum, Christchurch, New Zealand
Centre for Maritime Studies, Haifa, Israel
Codrington Library, All Souls College,
 Oxford, England

Editorial Photocolor Archives, New York, U.S.A.

Hebrew University, Jerusalem, Israel

Irish Tourist Board, Dublin, Ireland
Isabella Stewart Gardner Museum, Boston, U.S.A.

Kejimkujik National Park, Nova Scotia, Canada
Kendall Whaling Museum, Sharon, Mass., U.S.A.

Lambeth Palace Library, London, England
Louvre, Paris, France

Martin von Wagner Museum, Würzburg,
 West Germany
Metropolitan Museum of Art, New York, U.S.A.
Musée de la Civilisation Gallo-Romaine,
 Lyon, France
Museo Antropologico, Quito, Ecuador
Museo Nazionale, Palermo, Sicily
Museum of Art, Cleveland, U.S.A.
Museum of Fine Arts, Boston, U.S.A.

Museum of Modern Art, New York, U.S.A.
Museum of Natural History, Santa Barbara, U.S.A.

National Gallery, London, England
National Gallery of Art, Washington D.C., U.S.A.
National Gallery of Ireland, Dublin, Ireland
National Museum, Victoria, Australia
National Museum of Man, Ottawa, Canada
Nationalmuseum, Stockholm, Sweden

Port Elizabeth Museum, Humewood, South Africa
Provincial Museum of British Columbia,
 Victoria, Canada

Rockwell Kent Legacies, New York, U.S.A.
Royal Library, Windsor Castle, England
Royal Ontario Museum, Toronto, Canada

Slater Memorial Museum, Norwich, Conn., U.S.A.
Society of Antiquaries, London, England
South African Museum, Cape Town, South Africa
Stiftsbibliothek, St. Gallen, Switzerland

Thomas Fisher Rare Book Library, Toronto, Canada
Transworld Art Inc., New York, U.S.A.

University Museum of National Antiquities,
 Oslo, Norway
University of Toronto, Toronto, Canada

Warburg Institute, London, England
Westminster Abbey Muniment Room and Library,
 London, England
Whitney Museum of American Art,
 New York, U.S.A.

Yale University Art Gallery, New Haven,
 Conn., U.S.A.

The following deserve special mention for
the help they tendered:

The Bulletin of the Association of Art Historians
The New Zealand Listener

I would also like to thank the following for
their expert advice and assistance:

Professor F. Andersen, Univ. of Queensland,
Australia, and Editor of Book of Jonah, Anchor
Bible; Easin Atil, Curator, Islamic Art, Smithsonian
Institute, Washington D.C.; Amable Audin, Conser-
vateur du Musée Archéologique de Lyon, France;
Dr. Tamar Avner, Dept. of Art History, Univ. of
Haifa, Israel; E.J. Barnes, Associate Editor, *Classical
News and Views,* Toronto, Canada; Dr. Piero
Bartolini, Centro de Studio per la Civiltà Fenicia e
Punica, Rome; Patricia Batson, Andover Historical
Society, Andover, Mass.; Dr. Guntram Beckel,
Martin von Wagner Museum; David Bennett,
Bibliographer, Australian Institute of Aboriginal
Studies, Canberra; Prof. Ronald M. Berndt,
Anthropology Dept., Univ. of Western Australia;
Dr. Anna Maria Bisi, Director, Scuola di
Perfezionamento Archeologiche, Urbino; Anthony
Blunt, author of *Baroque and Rococo, Nicolas Poussin,*
etc.; Prof. John Boardman, Ashmolean Museum;
Hans Olaf Bostrom, Associate Curator, National-
museum, Stockholm; Noelle Brown, Director,
Photographic Archives, Ashmolean Museum; Lucy
Bullivant, Fine Arts Dept., British Council, London;
Dr. Sheila Campbell, Pontifical Institute of Medieval
Studies; Tony Campbell, author of *Early Maps*; Dr.
Madeline Caviness, Prof. of Fine Arts, Tufts Univ.,
Medford, Mass.; Henry Collins, Archaeologist,
Smithsonian Institute; B.F. Cook, Keeper, Greek
and Roman Antiquities, British Museum; Pamela
Courtney, Director, Assoc. of Art Historians,
London; Harry Crosby, author of *The Cave Paintings
of Baja California,* La Jolla, California; Edward H.
Dahl, Map Specialist, Public Archives of Canada,
Ottawa; Dr. L.R. Dams, Docteur d'Archéologie
Préhistorique, Brussels; Margaret Davis, Dept. of
Western MSS, Bodleian Library; Lawrence Dawson,
Senior Anthropologist, Lowie Museum, Univ. of
California, Berkeley; Prof. Gabriele Del Re, Italian
Cultural Institute, Toronto; Maude de Schaunesee,
Near Eastern Collections, Univ. of Pennsylvania;
Dr. Ines Dölz-Blackburn, Spanish Dept., Univ.
of Colorado; Allison Eason, Greek and Roman
Department, Univ. of Toronto; K. East, Research
Assistant, Medieval and Later Antiquities, British
Museum; G. Roger Edwards, Mediterranean Section,

Univ. of Pennsylvania; James Fairley, author of *Irish Whales and Whaling,* Limerick, Ireland; Greta Ferguson, Curator, Textile Dept., Royal Ontario Museum; Robert Finlay, Reference Librarian, Mountford-Sheard Collection, State Library, Adelaide; Dr. William Fitzhugh, Anthropology Dept., Smithsonian Institute; Edith Fowke, editor of *Canadian Folktales*; P.M. Fraser, author of *Rhodian Funerary Monuments,* Oxford; G.S.P. Freeman-Grenville, author of *The East African Coast*; Dr. H.E. Frenkel, Keeper, Allard Pierson Museum; Dr. Wilma George, author of *Animals and Maps,* Oxford; Prof. R.L. Gordon, Univ. of East Anglia, Editor of *Journal of Mithraic Studies*; Dr. A. Kirk Grayson, Near Eastern Studies, Univ. of Toronto; Rosalie Green, Director, Index of Christian Art, Princeton Univ., Princeton, N.J.; S. Guillaume, Conservateur, Musée des Beaux Arts, Nancy, France; Martin Hall, Dept. of Archaeology, South African Museum; Dr. Peter Harbison, Archaeologist, Irish Tourist Board, Dublin; Francis Haskell, Prof. of the History of Art, Oxford Univ.; Dr. John Hayes, Curator, Greek and Roman Dept., Royal Ontario Museum; A.E. Healey, Librarian, Joint Library of the Hellenic and Roman Societies, London; Archbishop Bruno Heim, author of *Heraldry in the Catholic Church,* London; Dr. Christine Hogarth, Acting Curator in Anthropology, National Museum of Victoria; Olaf Holm, Director, Museo Arqueologico del Banco Central, Guayaquil, Ecuador; Dr. Alan Hoover, Associate Curator, Ethnology Dept., Provincial Museum of British Columbia, Victoria; Prof. Cliff Hospital, Sanskrit Studies, Queen's Univ., Kingston, Ontario; Dr. James Hsu, Curator, Far Eastern Dept., Royal Ontario Museum; Michael Jones, Dept. of Islamic Art, Sotheby Parke Bernet, New York; Philip Jones, Research Officer, Australian Ethnology, South Australian Museum, Adelaide; Dr. E.J. Keall, Dept. of West Asian Studies, Royal Ontario Museum; Prof. D. Killam, Editor, *World Literature Written in English,* Univ. of Guelph; Jan Knappert, School of Oriental and African Studies, Univ. of London; Dr. Arielle Kozloff, Curator of Ancient Art, Cleveland Museum; J. Kugler, Curator, New Bedford Whaling Museum; Prof. Matti Kuusi, Finnish Literature Society, Helsinki; D.U. Kuyken-Schneider, Keeper, Dept. of Decorative Arts, Boymans Museum; Prof. Peter Levi, Classics Dept., Campion Hall, Oxford Univ.;

André Lheritier, Conservateur, Bibliothèque Nationale, Paris; Dr. Elisha Linder, Chairman, Center for Maritime Studies, Univ. of Haifa; Elizabeth Little, Research Director, Nantucket Historical Assoc.; Dr. F.D. McCarthy, former Curator in Anthropology, Australian Museum, Sydney; Robert McGhee, Director, Archaeological Survey of Canada, Ottawa; Dr. James Mack, Director, Dowse Art Gallery, Lower Hutt, New Zealand; M.D. McLeod, Keeper, Museum of Mankind, Ethnography Dept., British Museum; José Maillot, Specialist in Montagnais-Askapi Legends, Quebec; R.J. Mason, Director, Archaeology Dept., Univ. of the Witwatersrand, Johannesburg; Susan Matheson, Ancient Art and Dura-Europos Collections, Yale Univ.; Dr. Otto Mazal, Director, Austrian Nationalbibliothek, Vienna; Betty Meggers, Museum of Natural History, Smithsonian Institute; Prof. G. Meredith-Owens, Dept. of Middle East and Islamic Studies, Univ. of Toronto; Dr. Egil Mikkelsen, University Museum of National Antiquities, Oslo; Dr. Nicholas Millet, Curator, Egyptian Studies, Univ. of Toronto; Dr. Charles Moffet, European Paintings Dept., Metropolitan Museum of Art; Jennifer Montagu, Curator, Photograph Collection, Warburg Institute; Dr. Antonietta Morandini, Director, Biblioteca Medicea Laurenziana; Dr. Bezalel Narkiss, Director, Centre for Jewish Art, Hebrew Univ. of Jerusalem; Dr. Ottfried Neubecker, Pro Heraldica, Stuttgart, West Germany; Hilary Ney, European Paintings, Metropolitan Museum of Art; R.V. Nicholls, Fitzwilliam Museum, Cambridge, U.K.; Howard Nixon, Librarian, Muniment Room and Library, Westminster Abbey; Marie Noyes, Slater Memorial Museum, Norwich, Conn.; Prof. John O'Meara, Latin Dept., University College, Dublin; Linda Paulsen, Dorset County Museum, Dorchester, U.K.; Dr. Weldon Perry, Dept. of Classics, Univ. of Toronto; Prof. Carlo Pietrangeli, Director General, Monumenti Musei e Gallerie Ponteficie, Vatican; G. Pilleri, Brain Anatomy Institute, Univ. of Berne, Switzerland; Anne Rainey, author of *Mosaics in Roman Britain*; J.E. Reade, Western Asiatic Antiquities, British Museum; Dr. Gunsel Renda, Visiting Prof., Johns Hopkins; Dr. Hilary Richardson, Dept. of Archaeology, University College, Dublin; Dr. Brunilde Sismondo Ridgway, Prof. of Classical Archaeology, Bryn Mawr College;

Dr. Maurice Robbins, Director, Massachusetts Archaeological Society; Helen Roe, Coolfin, Ireland; Dr. E.S. Rogers, Curator, Ethnology Dept., Royal Ontario Museum; Dr. Andree Rosenfeld, Dept. of Prehistory, Australian National Univ., Canberra; Anne Ross, author of *Pagan Celtic Britain*; Graham Ross, Deputy Director, Port Elizabeth Museum; Ione Rudner, Editor, South African Museum; Dr. E. Rynne, Dept. of Celtic Archaeology, University College, Galway, Ireland; Dr. P. Schledermann, Executive Director, Arctic Institute of North America; Asis Sen, West Bengal, India; Frederick Shaffer, author of *Indian Designs from Ancient Ecuador,* Sarasota, Florida; Father Michael Sheehan, Institute of Medieval Studies, Univ. of Toronto; Dr. D.R. Simmons, Assistant Director and Ethnologist, Auckland Institute and Museum; Dr. Ronald Singer, Prof. of Anthropology, Univ. of Chicago; James Smith, Curator, Museum of the American Indian, Bronx, N.Y.; Dr. Whitney Smith, Flag Research Center, Winchester, Mass.; Dean R. Snow, Prof., Anthropology Dept., SUNY, Albany; William Spence, author of *Harpooned*; Dorota Starzecka, Assistant Keeper, Museum of Mankind, London; Brian Stone, author of *Medieval English Verse,* Surrey, England; F.H. Thompson, General Secretary, Society of Antiquaries of London; Jan Timbrook, Associate Curator, Anthropology, Santa Barbara Museum of Natural History; Prof. Jocelyn Toynbee, author of *Animals in Roman Life and Art,* Oxford; Michael Trotter, Prehistory Dept., Canterbury Museum; Prof. Vicenzo Tusa, Director, Soprinten-denza Archeologica, Regione Siciliana, Palermo, Sicily; William Voelkle, Associate Curator, Pierpont Morgan Library; Dietrich von Bothmer, Chairman, Greek and Roman Art, Metropolitan Museum of Art; Dr. Charles Wagley, Center for Latin-American Studies, Univ. of Florida, Gainsville; Dr. A.K. Warder, Dept. of East Asian Studies, Univ. of Toronto; Dr. David Waterhouse, Dept. of East Asian Studies, Univ. of Toronto; Stephen Williams, Curator, North American Archaeology, Peabody Museum, Harvard; Barry Wilson, Director, National Museum of Victoria, Australia; Dr. Florence Wolsky, Dept. of Classical Art, Boston Museum of Fine Art; Bert Woodhouse, author of *Art on the Rocks,* Cape Town, South Africa

Index of Artists

Index of Authors

Index of Composers

Index of Translators

Design by The Dragon's Eye Press, Toronto

Typeset in 10 pt. Meridien by Fleet Typographers Limited, Toronto

Film & colour separations by Graphic Litho-Plate Inc., Toronto

Printed on Warren's 80 lb. Flokote and

Domtar 80 lb. Byronic Text by Norgraphics (Canada) Ltd., Toronto

Binding by W.S. Konecky Associates

and Publishers Book Bindery Inc., New York

Production by Paula Chabanais Productions, Toronto